CHARLES DEAS AND 1840s AMERICA

THE CHARLES M. RUSSELL CENTER SERIES ON ART AND PHOTOGRAPHY OF THE AMERICAN WEST

B. Byron Price, General Editor

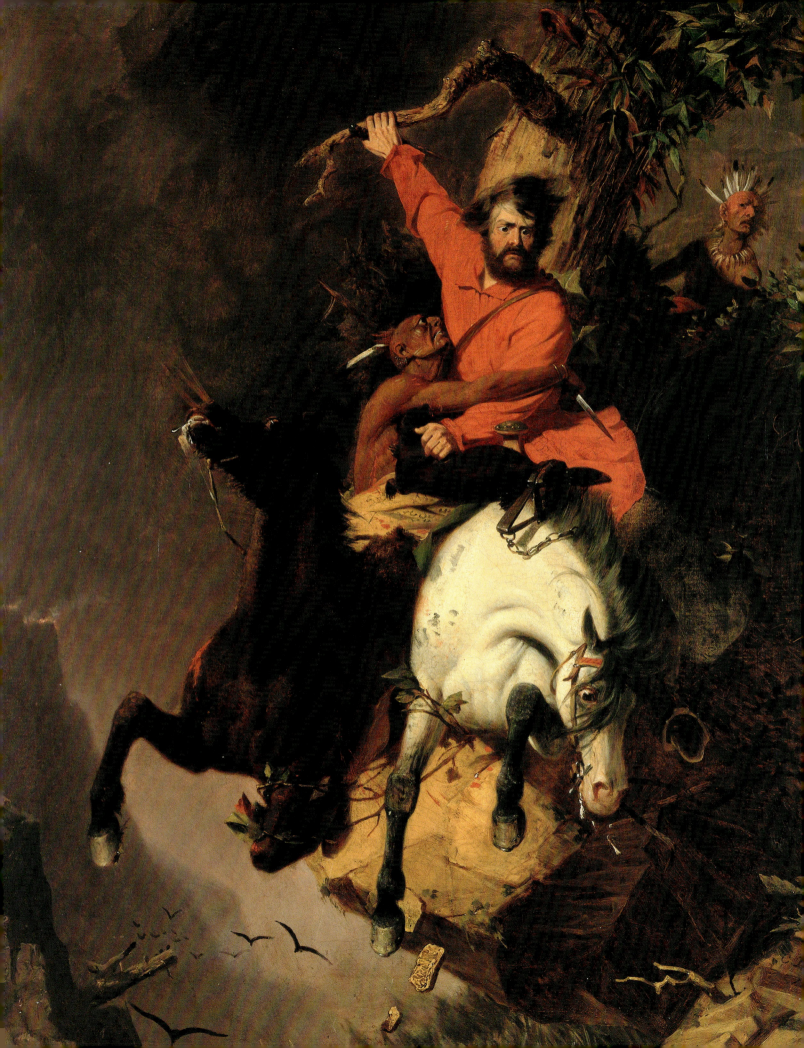

Charles Deas

AND 1840s AMERICA

Carol Clark

With Contributions by Joan Carpenter Troccoli, Frederick E. Hoxie, and Guy Jordan
Foreword by Lewis I. Sharp and Peter H. Hassrick

UNIVERSITY OF OKLAHOMA PRESS : NORMAN
In Cooperation with the Denver Art Museum

PUBLICATION OF THIS BOOK HAS BEEN AIDED BY A GRANT FROM THE WYETH FOUNDATION FOR AMERICAN ART PUBLICATION FUND OF THE COLLEGE ART ASSOCIATION.

Page i: detail of Charles Deas, *The Trooper* (fig. 3.15, p. 85).

Page ii: detail of Charles Deas, *The Death Struggle* (fig. 3.25, p. 100).

Page vi: *left,* detail of Charles Deas, *Self-Portrait* (fig. 1.1, p. 2); *middle,* detail of Henry Louis, *Saint Louis in 1846* (fig. 2.2, p. 58); *right,* detail of Charles Deas, *Prairie on Fire* (fig. 3.51, p. 124).

Page vii: *left,* detail of Charles Deas, *Walking the Chalk* (fig. 3.7, pp. 78–79); *middle,* detail of Charles Deas, *Long Jakes, "the Rocky Mountain Man"* (fig. 3.16, p. 87); *right,* detail of Charles Deas, *Winnebago (Wa-kon-cha-hi-re-ga) in a Bark Lodge* (fig. 1.18, p. 24).

Page xvi: detail of Charles Deas, *Indian Group* (fig. 3.37, p. 112).

Library of Congress Cataloging-in-Publication Data

Clark, Carol, 1947, July 21–
Charles Deas and 1840s America / by Carol Clark ; with contributions by Joan Carpenter Troccoli, Frederick E. Hoxie, and Guy Jordan ; foreword by Lewis I. Sharp and Peter H. Hassrick. -- 1st ed.
p. cm. — (The Charles M. Russell Center series on art and photography of the American West ; v. 4)
Catalogue of an exhibition to be held at the Denver Art Museum in 2010.
"In cooperation with the Denver Art Museum."
Includes bibliographical references and index.
ISBN 978-0-8061-4030-8 (hardcover : alk. paper)
1. Deas, Charles, 1818–1867—Exhibitions. 2. Frontier and pioneer life in art—Exhibitions. I. Deas, Charles, 1818–1867. II. Troccoli, Joan Carpenter. III. Hoxie, Frederick E., 1947– IV. Jordan, Guy. V. Denver Art Museum. VI. Title.
ND237.D333555A4 2009
759.13—dc22
 2008040513

Charles Deas and 1840s America is Volume 4 in the The Charles M. Russell Center Series on Art and Photography of the American West.

The paper in this book meets the guidelines for permanence and durability of the Committee on Production Guidelines for Book Longevity of the Council on Library Resources, Inc. ∞

1 2 3 4 5 6 7 8 9 10

To Charles Parkhurst, in loving memory

Contents

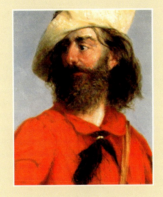

FOREWORD

Lewis I. Sharp, Frederick and Jan Mayer Director, Denver Art Museum
Peter H. Hassrick, Director, Petrie Institute of Western American Art, Denver Art Museum

Exploration of the narrative tradition in American western painting has received careful study only in the past generation. Beginning in the mid-1980s, exhibitions such as *Treasures of the Old West* at the Denver Art Museum and the Buffalo Bill Historical Center (Cody, Wyoming) and the more seminal subsequent project *American Frontier Life: Early Western Painting and Prints,* co-organized by the Amon Carter Museum and the Buffalo Bill Center, increased understanding and appreciation of western narrative art and established a high standard for scholarship in the field. These exhibitions demonstrated the tremendous contribution made by nineteenth-century artists who looked west for inspiration, shaped public perceptions of the frontier through their paintings and prints, and simultaneously enriched the canon of American art with cultural complexity and diversity as well as aesthetic quality.

Since the 1980s, individual narrative artists of the West, including George Caleb Bingham, Alfred Jacob Miller, and William Tylee Ranney, have benefited from insightful reviews of their work by art historians and museum curators in ambitious exhibitions and carefully considered catalogues. Now it is the turn of genre and history painter Charles Deas, a profoundly observant painter who lived in Saint Louis in the mid-1840s, to step

into the limelight. The illuminating chapters, essays, and catalogue raisonné in this volume reveal in full measure Deas's uncommon artistic talent, his perceptive view of the world west of the Mississippi River, and his role in helping Americans understand the symbolic and cultural relevance of the frontier experience.

The research leading to this publication was made possible by a substantial grant from the the Henry Luce Foundation, and by generous gifts from Mrs. J. Maxwell Moran, Ranney R. Moran, the Blue Sky Foundation, and the citizens who support the Scientific and Cultural Facilities District. Publication of this book was aided by a grant from the Wyeth Foundation for American Art Publication Fund of the College Art Association. For its generous support of the Denver Art Museum, we also wish to thank Wells Fargo.

We are most grateful to Carol Clark for her undaunted enthusiasm for Deas and her devotion to researching his biography as well as the art through which he communicated his complex and sometimes weighty pictorial messages. Her labors have been legion, and the fine results of her scholarship are ever present in her chapters and catalogue raisonné. We are also grateful for the efforts of Joan Carpenter Troccoli, the Senior Scholar in our Petrie Institute of Western American Art, who has served as co-curator for the accompanying exhibition, an indispensable editor of this volume, and author of the essay on Deas's masterpiece of 1844, *Long Jakes*.

We would like to extend thanks to each individual lender and to each of the lending institutions and to their generous staff members, to whom we owe a special debt of gratitude. Thank you to the following: Michael Altman; at the American Antiquarian Society, Andrew W. Mellon Curator of Graphics Art Georgia B. Barnhill; at the Amon Carter Museum, Director Ron Tyler and Senior Curator of Western Painting and Sculpture Rick Stewart; at the Autry National Center, President and CEO John L. Gray and Curator Amy Scott; at The Brooklyn Museum, Director Arnold Lehman and Andrew W. Mellon Curator and Chair of American Art Teresa Carbone; at Colby College, Director and Chief Curator Sharon Corwin; David Kodner; Betty Krulik; at the Minnesota Historical Society, CEO and Director Nina M. Archabal and Curator of Art Brian Szott; at the Museum of Fine Arts, Boston, Director Malcolm Rogers and John Moors Cabot Chair of Art of the Americas Elliot Bostwick Davis; at The Museum of Fine Arts, Houston, Director Peter Marzio and Curator of American Painting and Sculpture Emily Neff; at the National Academy Museum, Director Carmine Branagan; at the Peabody Museum of Archeology and Ethnology at Harvard University, Howells Director William L. Fash; Gerald and Kathleen Peters; Thomas A. and Jane Petrie; at the Shelburne Museum, Director Stephan Jost; at the Stark Museum of Art, Director Sarah Boehme; at the St. Louis Mercantile Library, Director John Neal Hoover; at the Thomas Gilcrease Museum, Director Duane King and Collections Manager Randy Ramer; at the Virginia Museum of Fine Arts, Director Alexander Nyerges; Richard P. W. Williams; and several other private lenders.

And to our own dedicated staff members who shape and execute the program of the Petrie Institute of Western American Art, we owe enormous thanks. Special tribute goes to Nicole A. Parks, whose brilliance, enthusiasm, and managerial skills facilitate and expedite departmental functions and who has assisted the Deas exhibition with poise and assurance; and to Holly Clymore, whose hard work and organizational flair ensure the success of projects like the Deas publication. Our gratitude runs deep within the museum's ranks, and we are pleased to acknowledge the assistance of Michele Assaf and Kara Kudzma in Exhibitions and Collections Services; Lori Iliff, Associate Director of Exhibitions and Collections Services/Registrar, Laura Paulick Moody, Associate Registrar for Exhibitions, and their colleague Becky Ceravalo; Carl Patterson and David Turnbull in Conservation; Lisa Steffen, Master Teacher for Western American Art; Kristin Bassuener and Andrea Kalivas Fulton in the Communications

Department; and Megan Cooke, Jennifer Darling, Melanie Ulle, Chiara Robinson, Sally Chafee, and Amy Stewart in the Development Department. All of these colleagues have provided indispensable contributions to this effort.

Volunteers Nancy DeLong, Debbie Gray, Stacy Skelton, and Mary Willis have served the cause unstintingly and in wonderful good humor. Our thanks to all.

ACKNOWLEDGMENTS

Carol Clark

Two unrelated events a dozen years ago inspired this exhibition and book: the Denver Art Museum acquired Charles Deas's painting *Long Jakes,* and my temporary office at Columbia University overlooked the former grounds of New York City's Bloomingdale Asylum for the Insane, where Deas died in 1867. That coincidence returned my thoughts to Deas's art and his life.

My interest in Deas's pictures extends over more years than he spent painting them. It gives me pleasure to acknowledge the many friends and colleagues who over this span of time helped me track down paintings and ponder their meanings. I am grateful to James Maroney, who, in 1980, sold to the Amon Carter Museum, where I was a curator, a small, intriguing picture by Deas now called *Indian Group.* At that moment, I could locate fewer than twenty paintings by Deas, but two important pictures, *Long Jakes* and *Winnebagos Playing Checkers,* came to light in time to be included in the 1987 exhibition American Frontier Life, organized by the Amon Carter Museum and the Buffalo Bill Historical Center. A few years later, in 1993, *A Solitary Indian, Seated on the Edge of a Bold Precipice,* last recorded in a daguerreotype in 1847, appeared on the market as further evidence of Deas's interest in Indian subjects. In 1996, when John Hoover and I determined that four extraordinary portraits in the collection of the St. Louis Mercantile Library were by

Deas, the artist's career took a clearer shape that pointed toward a possible exhibition. John encouraged me about the show and book at every turn, and I am pleased to acknowledge his collaboration.

I developed my ideas about Deas's art in a series of talks, the first of which I gave at a conference at the St. Louis Mercantile Library in 1996. In 2001, I gave papers on aspects of the artist's work at the American Culture Association annual conference and at the American Antiquarian Society, and I presented the Anne Burnett Tandy Lecture in American Civilization at the Amon Carter Museum. In 2003, I spoke about Deas's art at the annual meeting of the Western History Association and at the Southwest Art History Conference, and in 2005, at the College Art Association's annual conference, I presented a paper on ways to interpret the artist's psychological evaluation. For their comments on these papers, I especially want to thank Georgia Barnhill, Dorinda Evans, Joni Kinsey, Kevin Mulroy, Caroline Sloat, and Barbara Zabel.

Amherst College's generous Faculty Research Award Program supported my research through the H. Axel Schupf '57 Fund for Intellectual Life. I received additional funding in the form of a fellowship at the St. Louis Mercantile Library and from the Amon Carter Museum, to whose staff, particularly Ron Tyler, Rick Stewart, and Jane Myers, I am very grateful.

Two scholars, Anne Monahan and Scott Lannon Wands, gave me invaluable research and organizational assistance with the bibliography and catalogue entries, many of which they drafted. They (and I) relied on the help of Amherst College's reference and interlibrary loan librarians, whom Anne, Scott, and I gladly thank. Many scholars generously shared research, answered questions, and dug through archives on my behalf. I take pleasure in extending thanks to Kenneth Ames, Nancy Anderson, Carol Walker Aten, Linda Ayres, Claire Barry, Linda Bantel, Russell Burke, Teresa Carbone, Adrienne Ruger Conzelman, John Davis, David Dearinger, John Driscoll, Stuart Feld, Debra Force, James Gehrlich, Abigail Booth Gerdts, William Gerdts, Bob Gibson, Richard Halgin, Nancy Halli, Patricia Junker, Betty Krulik, Rebecca Lawton, William MacKinnon, Merl M. Moore, Anne Morand, James Nottage, Gwendolyn Owens, Julie Schimmel, Paul Staiti, William Styple, Kevin Sweeney, and Thomas Vennum. Descendents of Deas's family and of two of his early patrons welcomed me into their homes, as did collectors of his work, to each of whom I offer thanks. I am grateful to Nancy Lurie for introducing me to the world of the Ho-Chunk, and to David Penney not only for guiding me to contemplate the possible meanings of Native objects in a white painter's art but also for his steadfast support of the exhibition. I am indebted to Frederick Hoxie, Guy Jordan, and Joan Carpenter Troccoli for their contributions to this volume and to my own thinking about Deas and his times. Allen Guttmann, Marni Sandweiss, and William Truettner read parts of the manuscript; Joan Troccoli read every word. For the acumen of these four friends and colleagues, and for the editorial advice that Joan Holt delivered with sharp wit, my deep thanks.

I am grateful to Charles Rankin and to three anonymous readers of the manuscript at the University of Oklahoma Press for their good counsel. Steven Baker and his colleagues at the press skillfully managed the publishing process, which Byron Price had deftly set on course with added support from the Charles M. Russell Center for the Study of Art of the American West.

At the Denver Art Museum's Petrie Institute of Western American Art, Mindy Besaw (now curator of art at the Buffalo Bill Historical Center), Nicole Parks, and Holly Clymore saw to myriad publication and exhibition details, and Joan Troccoli and Peter Hassrick gave their complete support to my scholarship and to the show. The museum and its director, Lewis Sharp, have been the best exhibition partners I could have imagined.

I am lucky in family ties, and I owe more than I can say to Andy, Bruce, and Brooke and to Rich and Kay. Most of all, I want to express my boundless debt to Chuck: this is for him, in memory, for everything.

INTRODUCTION

Carol Clark

For a moment in the mid-1840s, a group of paintings by Charles Deas matched America's expansionist fervor. On view at commercial galleries and at the American Art-Union in New York City, the images of trappers and Indians that Deas cast in western historical narratives of his own invention gave substance to a region whose future, his contemporaries believed, would determine the nation's physical boundaries and political reach as well as its social and cultural identity.

This book considers how and why Deas's paintings came to be such effective cultural expressions of economic and political ambition. In the 1840s, the West was contested space, where race occupied the unstable center of debates over the fate of African American slaves, of hard-pressed Indians, and of Mexicans on the nation's borders. What would America be? Who would be an American? Deas's contemporaries sought answers to these questions in his art. The ambiguity in many of his pictures reveals an undercurrent of deep uncertainty about the nation's future.

Charles Deas lived literally and figuratively on borders. He was born in Philadelphia to a prominent, slaveholding South Carolina family but had to make his own living because his father had squandered the family's fortune. Never moving past the fringes of success in the New York City art market of the late 1830s, Deas abandoned its center and settled

in the border state of Missouri, where he flourished as an outsider. When he sent paintings from St. Louis for exhibition in New York beginning in 1844, his contemporaries believed that they came from the hand of a westerner and from a place one called "the outer verge of our civilization." Although Deas returned to New York in 1847, he soon slipped into insanity.

He was gone from society before he reached the age of thirty, leaving behind as many as one hundred paintings and drawings. The devastating fact that he was confined to asylums for the rest of his life defined his reputation, contributed to its eclipse, and caused much of his work to disappear from view. The essays in this book reclaim the artist and his pictures by seeking to understand the way that Deas's paintings, which, like the artist, usually occupied the edges of the American art world, illuminate issues central to their time.

The subjects of Deas's paintings range from literature to landscape, from Indians and European Americans to stories of western life. All share a theatrical, often melodramatic presentation of the darker side of economic and social competition. Deas's life story may shed light on the themes of his paintings. Did his family's slide down the economic ladder alert him to the perils of economic competition? Did his descent into madness, which began as early as 1845, make violence an irresistible subject? Did his pictures enact escape from internal demons as much as they embodied the external conflicts of his single decade of work? Deas's paintings rightly resist explanation: his mental state does not account for his art any better than do the social conditions in which he lived. Yet considering his pictures in these contexts brings us closer to understanding the power they exerted in Deas's time as well as their resonance today.

A dozen of Deas's narrative paintings form the core of this book. Looking backward and forward from two of the pictures that established his reputation—*Long Jakes* and *The Death Struggle*—in "Telling Tales in 1840s America" I consider the evolution of the stories he told, from those inspired by literature to narratives

of his own invention, alongside economic pressures, definitions of race and manhood, and the lure of the West for commerce, conquest, and escape in the 1840s. Deas's contemporaries encountered his work in the context of both elite and popular cultures, and I do the same here, thinking through the way his pictures simultaneously inhabit the worlds of James Fenimore Cooper and the tall-tale author who wrote under the pseudonym "Solitaire." Following a path well staked out by Elizabeth Johns, I also bring into play contemporary figures of speech to shine light into the corners as well as on the center of Deas's work.

For my story of Deas's life, treated in a separate chapter, I mined the biographical chronicle set down by Henry Tuckerman in 1846 to glean the facts it contains as well as to understand Tuckerman's essay as a cultural construction. With my own biases, I add the evidence of many more pictures than Tuckerman mentioned to locate Deas in time and space and give form to the young artist's career. I also draw on newly discovered correspondence, contemporary notices and reviews, census data, and institutional and psychiatric records, all bound together by a good bit of grounded speculation.

Three contributing scholars enrich, expand on, and challenge my interpretations. Frederick Hoxie presents the decade of the 1840s as one of deep disquiet about the nation's identity and future. Beginning with an analysis of an important map of 1840, he considers the broad implications of four European empires and three independent nations vying for influence in the vast spaces of the West, as well as the particular conditions of St. Louis, the "outer edge of the United States," which was simultaneously the capital of a slave state, the headquarters of the western fur trade, and a site for Native passage, trade, and treaty negotiation. Guy Jordan reflects on the elements of American democracy that were forged in a site popular in both art and fact: the tavern. By looking at the ways in which Deas's *Walking the Chalk* (1838) deviates from other depictions of American taverns, where alcohol "facilitated social cohesion," Jordan

focuses our attention on the unrelieved moral lapses of Deas's characters, who are "precariously positioned on the edge of society." Joan Carpenter Troccoli takes us to another divide, one that Deas imagined but never visited: the Rocky Mountains. Presenting the rich mix of ideas about the Rockies that had become current by the mid-1840s, she considers the landscape setting of *Long Jakes* as well as the figure of the trapper to reposition Deas's work as a history painting that highlighted the role of the independent trapper in western exploration and conquest.

Deas's paintings beg to be interpreted, to have stories spun about and around them, as his contemporaries did and we do here. The story of Deas's art is glaringly incomplete, and this book concludes with a catalogue of the works that I believe he painted, as well as those we know to be his. To aid in the recovery of the dozens of his pictures that are lost to us today, I include in this list every description of them that I have discovered. My colleagues and I offer this material and the interpretations we propose as threads for spinning future stories.

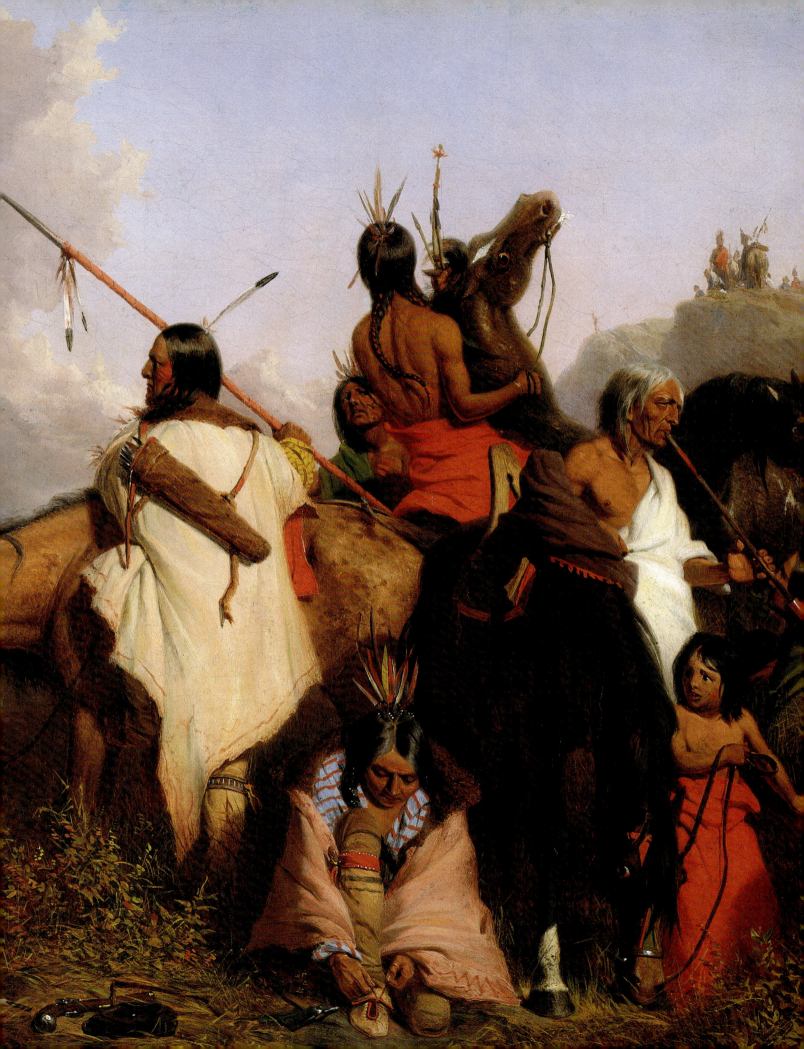

CHARLES DEAS AND 1840s AMERICA

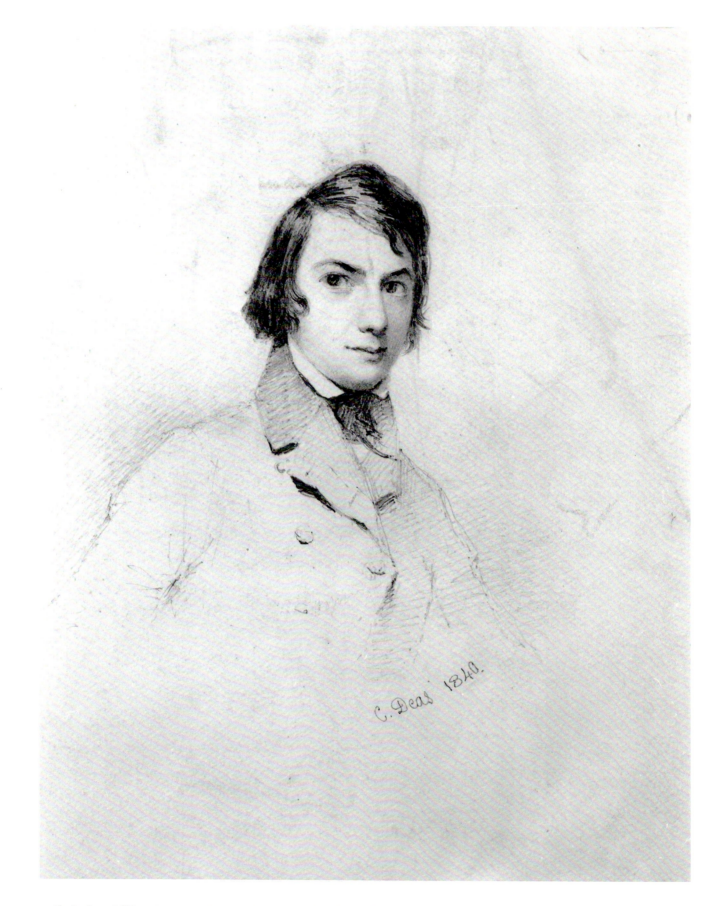

1.1. Charles Deas, *Self-Portrait,* 1840. Graphite on buff wove paper, 9½ × 6¹¹⁄₁₆ in. (sheet). National Academy Museum, New York (1981.86).

1

CHARLES DEAS

A Life

Carol Clark

There is only one portrait of Charles Deas, a self-portrait that he drew at the age of twenty-one (fig. 1.1). He gave the drawing to the National Academy of Design to meet his obligation as a new associate member, and it marked the first success of his professional career. The image shows an intense young man of serious demeanor, fashionably dressed in a double-breasted coat. His hair, in a youthful style of the 1830s, frames wide-set eyes that he emphasized further by arching his left eyebrow, giving himself an expression bordering on the quizzical. There is little here to distinguish him from other young professional men in New York. Like other artists of his time, Deas fashioned himself as a gentleman without referring specifically to his budding career.

By 1844, the conventionally refined young man of the 1840 self-portrait had transformed himself into an unrestrained westerner. "Rocky Mountains. . . . The soldiers called Mr. Deas by this name. Probably from his riding a horse which 'had done the State some service'—had a broad white hat—a loose dress, and sundry 'traps and truck' hanging about his saddle, like a fur-hunter. Besides, he had a Rocky Mountain way of getting along; for, being under no military restraint, he could go where he pleased, and come back when he had a mind to."[1] Lieutenant J. Henry Carleton, who wrote this description in the summer of 1844, recognized or fantasized that Deas had broken free and exchanged his urban

attire for the trappings of a "fur-hunter," who was by then a mythical western character.

The passage of four more years brings this clinically cool description from Deas's 1848 admission records to the Bloomingdale Asylum in New York City: "Medium stature, very dark brown hair, hazel eyes, sanguine bilious temperament, ordinary disposition and intellect." His physician also recorded his bizarre behavior, the result of mania and delusions during his three-month stay. He improved enough to live for fifteen years in a smaller, rural asylum, but he returned to Bloomingdale in 1863 and died there in 1867. At the end, he was described as "rarely speaking" and classified as suffering from "dementia."[2]

Much of what we know about Deas's life comes from a brief biography that Henry Tuckerman, America's leading cultural critic of the mid-nineteenth century, published in 1846. This piece was one of a series of unsigned articles entitled "Our Artists" that Tuckerman wrote for *Godey's Magazine and Lady's Book,* a Philadelphia monthly with an unusually large national audience. The article was reprinted the following year in Tuckerman's book *Artist-Life; or, Sketches of American Painters.* Embedded within the twenty-three profiles that constitute this volume, which begins with Benjamin West and ends with George Loring Brown, were broad questions about the role of the arts in a democracy. What was the relationship between "elaborate works" that only a few might appreciate and art created "in the service of utility" for "the good of the greatest number"? Was art less worthy in its "popular" than in its "highest" forms? How could American artists wean themselves from "imitation" and express true "originality of mind?"[3] Tuckerman accepted that most American art need not be "original," for it properly derived from the taste of Anglo-Saxons, "the race whence we sprung." Yet to distinguish themselves abroad, American artists had to paint new and distinctive themes, which were found only in "our border life."[4] These subjects were certainly new, but what was it about them that represented the nation in 1846? The story

Tuckerman used to introduce his biographical sketch of Deas points to an answer.

He recounted the American travels of an English visitor who discovered nothing "characteristic or original" until he

found himself in the Far West. There life assumed a new aspect, and nature presented striking phases. He received what he earnestly sought—vivid and lasting impressions. There was a moral excitement awakened [that was] quite different from the luxurious dreams he had known on the shores of the Bosphorus, the mental stimulus derived from the intellectual circles of London, and the suggestions of art and antiquity in Italy. He saw, for the first time, majestic rivers flowing through almost interminable woods; seas of verdure decked with bright and nameless flowers; huge cliffs covered with gorgeous autumnal drapery.... He became acquainted with the hunter and the Indian. The guest of a frontier garrison, he heard the cry of wolves, while sharing the refined hospitality of the drawing-room; and often passed from the intelligent companionship of an accomplished officer to the lodge of an aboriginal chief. He witnessed the grave bearing of a forest-king and the infernal orgies of a whole intoxicated tribe. The venerable sachem, the graceful squaw, the lithe young warrior; the war chant, the council fire and the hunter's camp, furnished ample materials to his senses and imagination.[5]

Tuckerman believed that this western American combination of familiar refinement and new wildness defined "our border life" and that Deas had "seiz[ed] upon themes essentially American" by painting "the juxtaposition of civilized and savage life," in a dichotomy that echoed the racial assumptions of Tuckerman's time.

Tuckerman fashioned a biography for Deas that emphasized Deas's ancestry, his natural talent, his diligent study, and his devotion to experience in nature. He judged Deas predisposed to an artistic calling, with the correct "tastes and

habits" and "the soul of a painter." Tuckerman claimed that his study of phrenology enabled him to recognize these tendencies in Deas, particularly the artist's "great sensibility to color." The critic further argued that "the era of manhood brought with it a revelation to the moral nature of the student, and he learned to recognize the authority of the higher sentiments." After "more or less success" with showing "cabinet pictures" in New York City, Deas found his true calling: "to taste the wild excitement of frontier life." Deas's real achievements were his pictures of western subjects because, according to Tuckerman, "there is a wildness and picturesque truth about many of these specimens [of Indian or hunter life], in remarkable contrast to the more formal and hackneyed subjects around them."[6]

Within this moral and philosophical structure, Tuckerman focused his essay on Deas's firsthand experiences in the West. Tuckerman's biographical sketch is specific enough to suggest that artist and critic met—perhaps on an unrecorded trip Deas took to New York—or at least that they corresponded. Some of Tuckerman's biographical facts are confirmed elsewhere, while others exist as the only evidence of moments in Deas's life, to which I now turn to offer a new reconstruction, one with different biases.

THE ARTIST'S early life was marked by his family's great wealth and then its slide down the economic ladder. His maternal grandfather, Ralph Izard (1742–1804), controlled vast plantations from the family's home near Charleston, South Carolina, where Izard was born. Educated at Cambridge, he returned in 1771 with his New York–born wife, Alice DeLancey (ca. 1746–1832), to live in England, where he was pulled into the brewing political crisis. When the Izards traveled to Italy in 1774–75, they met a fellow colonist, the artist John Singleton Copley, who had left Boston in the politically tense year of 1774 and was on his grand tour. Copley and the Izards visited Herculaneum, Pompeii, and Paestum together, and when they all settled in Rome in the spring of 1775, Copley painted the Izards' double portrait (fig. 1.2), a work that proclaimed the glories, tensions, and ambiguities of privileged English colonial life abroad on the eve of revolution.

Copley and the Izards together fashioned a self-image for the couple that included sumptuous contemporary furnishings and ancient artifacts, with a glimpse of the Roman Colosseum in the background. Copley focused attention on the antique sculptural group on the table between Ralph and Alice Izard. While the pair of marble figures—of Papirius and his mother—may be seen as emblematic of contemporary debates about loyalty on the eve of colonial revolution, it also exemplifies the Izards' dedication to the study and appreciation of art. The couple highlighted the prominence of this sculptural pair by their intimate connection to the drawing that reproduces it: he holds the drawing firmly and looks prepared to pronounce on its quality; she gently reaches toward it. Making, contemplating, and understanding art's many metaphorical meanings and uses are all lessons that Charles Deas may have taken from his grandparents' lives. The double portrait remained in England until another Izard grandson took it to Charleston in 1831. Deas might have seen the picture if he visited his family in South Carolina, as I believe he did about 1833. But he surely must have learned from his grandmother, near whom he lived in Philadelphia, something of the role that art played in his family's heritage.[7]

Politically engaged at first on behalf of a peaceful solution to colonial grievances, Ralph Izard, while still abroad, actively sought American independence. He returned to the United States in 1780, continued to advise George Washington, and served as U.S. senator from South Carolina from 1789 until 1795, when he went back to Charleston. He died there in 1804.[8] Like other elite South Carolina families, the Izards suffered financial reversal in the turbulent revolutionary period. Although they recovered their land, they never fully regained the affluence asserted in Copley's double portrait. After her husband's death, Alice DeLancey

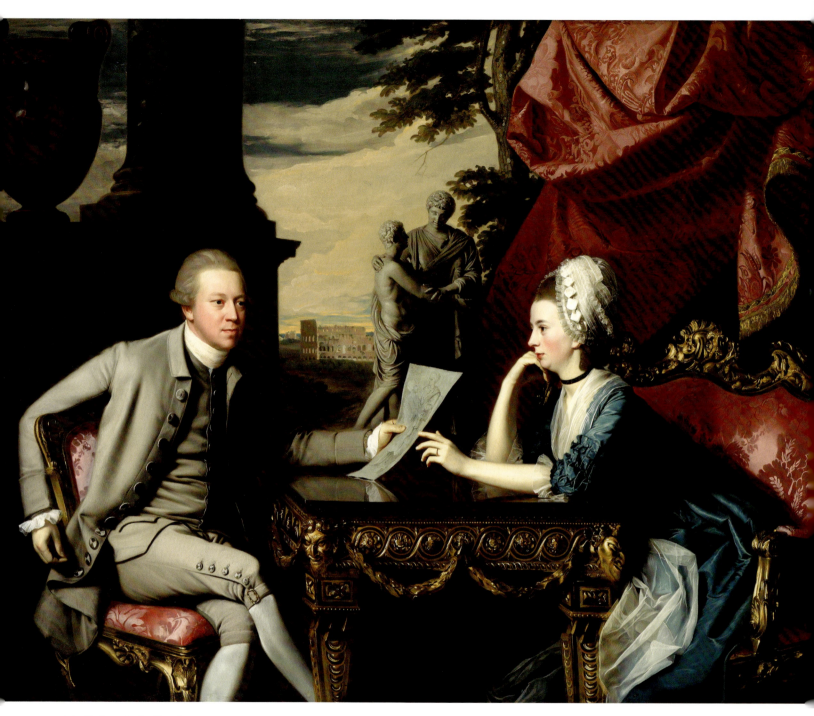

1.2. John Singleton Copley (American, 1738–1815), *Mr. and Mrs. Ralph Izard*, 1775. Oil on canvas, 68¾ × 88 in. Museum of Fine Arts, Boston, Edward Ingersoll Brown Fund; photograph © Museum of Fine Arts, Boston (03.1033).

Izard divided her time between their home in South Carolina and a new life in Philadelphia, the city where she and her husband had lived when he served in Congress. She dwelt in the midst of many friends and relatives on Spruce Street, which was dubbed "Carolina Row."[9] Among Alice Izard's nearby children was Anne, who in 1798 had married Charleston attorney William Allen Deas. Charles, the last of Anne and William Allen Deas's nine children (five of whom survived to adulthood), was born in Philadelphia on December 22, 1818, and baptized at Christ Church (Episcopal) on May 11, 1819.[10]

What little we know of Deas's Philadelphia childhood comes from Henry Tuckerman's 1846 sketch:

[He] received his education from the lamented John Sanderson [a Philadelphia teacher who likely tutored Deas privately]. His first ideas of art were derived from some good copies of the old masters belonging to his family, and from a habit, acquired very early, of diverting himself by drawing at school on a slate, and modeling little horses in beeswax at home. . . . Visits to the old Pennsylvania Academy, to Sully's rooms, and loiterings on holiday afternoons before the print-shop windows in Chestnut street; drawings from casts of the antique, and experiments in portraying his playmates, were among the significant tendencies of our painter's boyhood.[11]

However Tuckerman got his information, he told this story of an idyllic boyhood with knowledge of Deas's New York success. Tuckerman showcased early artistic talent, to be sure, but he also highlighted a privileged upbringing of access to books, art, and the benefits of a private, classical education.[12] Tuckerman mentioned the prominence of Deas's maternal grandfather and that his correspondence had recently been published. Demonstrating that Deas and his mother valued their heritage, Anne Izard Deas arranged for the 1844 publication of her father's letters and wrote the accompanying memoir; Charles Deas designed the frontispiece—an emblematic portrait of his grandfather (fig. 1.3).[13]

In describing his background to Tuckerman, Deas may have underscored his bond with Thomas Sully as a link to the old masters whose techniques the prominent Philadelphia portraitist studied, wrote about, and carried on in America.[14] Deas was, in effect, establishing his own artistic lineage. The young Deas probably visited "Sully's rooms" with the members of the Izard family who patronized the older artist.[15] In

addition, the Pennsylvania Academy of the Fine Arts collection of paintings and plaster casts included ones donated by his maternal uncle.[16] Deas's education, then, began in his family's world of ease and connections: Tuckerman's description of "loiterings on holiday afternoons

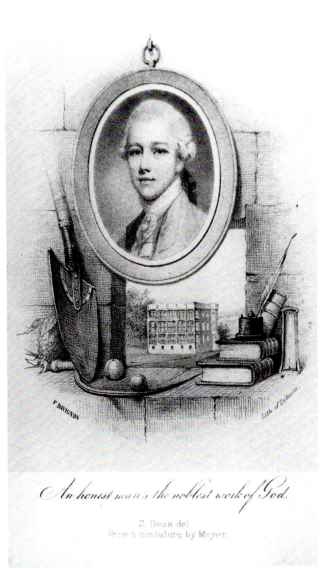

An honest man's the noblest work of God.

C. Deas del
From a miniature by Meyer

1.3. Francis D'Avignon (American [b. France], ca. 1813–after 1865), after Charles Deas, *Emblematic Portrait of Ralph Izard*. Lithograph on paper, 7⅜ × 4½ in. Frontispiece to *Correspondence of Mr. Ralph Izard, of South Carolina, from the Year 1774 to 1804,* ed. Anne Izard Deas (New York: Charles S. Francis, 1844). Courtesy of Amherst College Library, Amherst, Massachusetts.

before the print-shop windows in Chestnut street" best captures the sense of leisurely pursuit of artistic knowledge that Deas's fortunate early life allowed him.

This way of life did not last long. Charles's father, William Allen Deas, is listed as head of his Philadelphia household in the 1820 federal census, but he may have continued to conduct

1.4. Charles Deas, *Drawing from Cast of the Apollo Belvedere,* ca. 1838. Charcoal, brown chalk, and white chalk highlights on buff wove paper, 23 × 17¹³⁄₁₆ in. (sheet). National Academy Museum, New York (1981.87).

business in South Carolina. He died, perhaps traveling to or from South Carolina, in Bedford, Pennsylvania, in 1827.[17] Anne Deas's economic situation apparently declined precipitously after her husband's death, and she faced a plight not uncommon at the time.[18] A glimpse of her life is found in a group of letters in which she sought support for her son Edward's appointment to the United States Military Academy at West Point. She wrote of her "recent misfortune"[19] as she begged the help of influential friends, such

as Henry Clay, then secretary of state, and James Hamilton, a congressman from South Carolina. One supplicant on her behalf made clear the source of her problem: her husband, he wrote, "after having squandered an ample fortune, is dead. The mother, with half a dozen children, is reduced from affluence to absolute penury, and not one of her relatives is able, if willing, to afford a pittance."[20]

Anne Deas was successful in this pursuit: Edward entered West Point in 1828 and graduated four years later. By 1831, still with dependent children, she had moved from Philadelphia to Ulster, New York (a village on the Hudson River known before and later as Saugerties), perhaps to be near some of her DeLancey relatives.[21] If Deas described these times to his biographer Tuckerman, he did so in ways that construct his life's continued, unhurried preparation by simultaneously honing his visual and his gentlemanly skills: while "wandering equipped with gun, fishing-rod and sketch-book . . . his leisure was wholly given to exploring expeditions amid the beautiful scenery by which he was surrounded."[22] The existence of two small paintings of African Americans, later described as "plantation scenes" (cat. nos. 2 and 3), suggests that Deas may have paid a visit to the South Carolina branch of his family when he was about fifteen years old. Tuckerman certainly did not mention that Deas had painted slave subjects. Nor did he hint at the artist's family situation as it is portrayed in letters supporting Anne Deas's efforts to secure her youngest child, Charles, an appointment at West Point. The writers describe Anne Deas as relatively needy, and one claimed that she was unable "to afford to give her son all the advantages of education he merits."[23]

NEW YORK CITY

Despite these efforts on his behalf, Deas was not admitted to West Point. He shifted his goals, and by 1837 he was living in New York City, where he began receiving formal instruction in

art. He returned often to his mother's home in Ulster and probably depended on his family for financial support. He boarded in New York with members of the family of his brother-in-law, Robert Watts, Jr., a physician whose marriage to Deas's only sister, Charlotte, may have stabilized the financially precarious position of both Charles Deas and his mother.[24] He also sought professional help in the orbit of family friends whose influence he used to approach the city's leading artist, Samuel F. B. Morse, president of the National Academy of Design, in an effort to establish himself in the city's artistic community. Morse apparently did not reply.[25] Whether or not Morse remembered the name, in the National Academy's President's Report of May 2, 1838, he wrote that Deas was one of three competitors (not the winning one) for the Large Silver Palette, awarded that year for the best large drawing in black and white chalks of the Apollo Belvedere (fig. 1.4).[26] Deas probably drew it in the National Academy's rooms after the plaster cast recently acquired by the academy. The drawing's size and prominent signature, which simulates three-dimensional letters, literally projects the nineteen-year-old's ambition and attests to his devotion to early-nineteenth-century notions of the ideal male body.

Deas followed his spring 1839 election as an associate member of the National Academy by enrolling in the academy's recently established Life School that fall. He had studied plaster casts after antique sculpture, and he then began to draw from the model and to study anatomy. Beginning with the 1839–40 session, Robert Watts, Jr., newly appointed professor of anatomy at the College of Physicians and Surgeons, lectured to academy students. Not yet financially independent, Deas continued to rely on family support, as evidenced by his residence at 33 Pearl Street, a house that his brother-in-law's family owned.[27]

Reviews of the paintings that Deas exhibited in New York between 1838 and 1840 were mixed and emphasized his future promise rather than present accomplishment. Although he was a newcomer to the city's art community, the fact

that his last name was mistakenly recorded in one exhibition catalogue by its phonetic spelling—"Days"—tells us that his new audience knew enough about him to at least pronounce it correctly.[28] Other notices, too, show that he was getting attention: the critic for the *New-York Mirror* characterized Deas as a promising painter of humorous genre pictures and an ex-

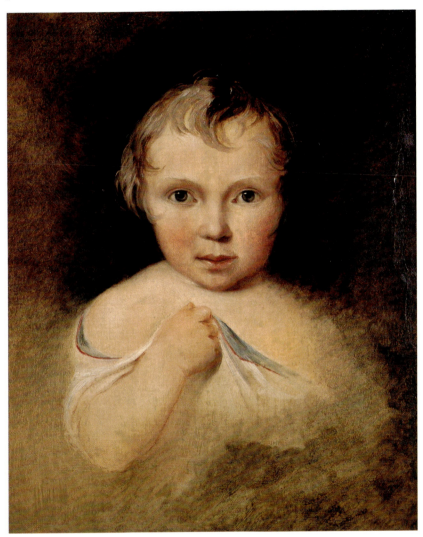

1.5. Charles Deas, *Portrait of Robert Watts,* 1838. Oil on canvas, 17 × 14 in. From the collections of the St. Louis Mercantile Library at the University of Missouri–St. Louis.

cellent portraitist. This critic further noted that Deas had been elected to the National Academy of Design and expressed pleasure that the artist was a resident of New York City. The brief review ended with Deas's address at 63 Franklin Street, an invitation to potential patrons.[29]

Deas's arrival in the city coincided with the start of a period of national economic turmoil,

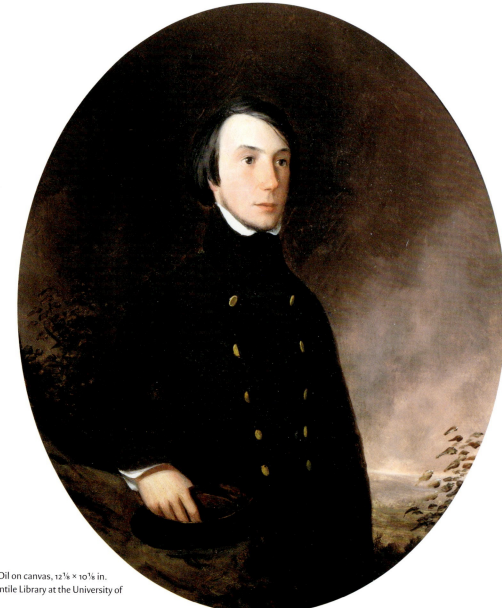

1.6. Charles Deas, *Portrait of a Man,* 1839. Oil on canvas, 12⅛ × 10⅛ in. From the collections of the St. Louis Mercantile Library at the University of Missouri–St. Louis.

beginning with the bank panic of 1837 and lasting, with short periods of stability, until after his departure for the West in 1840. It is difficult to determine how well Deas's pictures sold in this financial climate, but he found at least one patron among the city's elite. The patrician Peter Gerard Stuyvesant (1778–1847), who was the great-grandson of the last Dutch governor of New York and among the wealthiest men in the city, purchased Deas's painting *Turkey Shooting* in 1838.[30] Tuckerman later

noted with apparent pleasure that the picture "was so graphically delineated as at once to hit the fancy of a genuine Knickerbocker whose ancestors were among the early colonists."[31] Suited to Stuyvesant's tastes and aristocratic Knickerbocker roots, the subject was a scene Deas extracted from one of James Fenimore Cooper's stories of early-eighteenth-century life in upstate New York, published in his perennially popular 1823 book, *The Pioneers.*

Stuyvesant is Deas's only recorded private

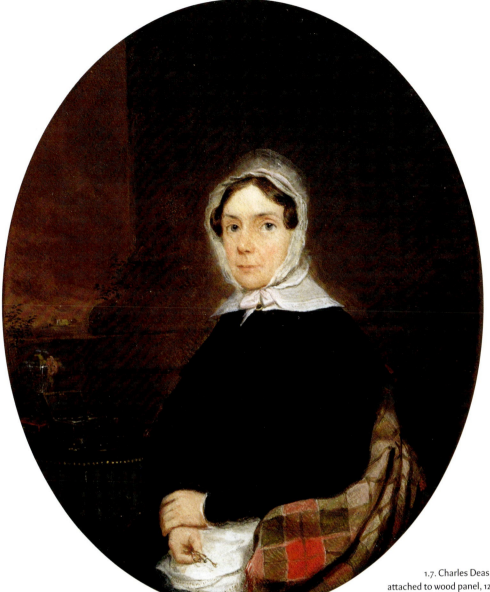

1.7. Charles Deas, *Portrait of a Woman*, 1840. Oil on paperboard attached to wood panel, 12⅛ × 9¾ in. From the collections of the St. Louis Mercantile Library at the University of Missouri–St. Louis.

patron in the first years he lived in New York, although portrait commissions may have brought him some other income. Two of Deas's surviving portraits of this period are of his nieces and nephews and owe a stylistic debt to Thomas Sully (fig. 1.5), but two others may have been commissioned outside his family circle. *Portrait of a Man* and *Portrait of a Woman* (figs. 1.6 and 1.7) are finely crafted pictures that express the promise the youthful Deas showed as a portrait painter. He posed these unidentified sitters formally and attired them soberly, but on close inspection we see that he included small domestic details that animate each sitter, revealing typical gender distinctions of the period. The woman, who is mature, directly returns our gaze and brings us into her contained and comfortable world, while the young man looks abstractly into the distance as if to the future ahead of him. He charmingly displays a youthful disregard for sartorial propriety by leaving unfastened three of the

buttons on his jacket. The woman's skills are more concretely specified: still-life attributes alert us to the fact that she sews, reads, and tends flowers. In his portrayal, Deas succeeded in conveying a dignified yet approachable humanity in two sitters, a skill that might have drawn others into his studio.

While Deas probably took private portrait commissions such as these to help support himself, he also enjoyed modest success with his genre pictures at public exhibitions in New York City. Of the two paintings he had on view at the fledgling Apollo Association's gallery in the city in 1839 and 1840, one was purchased and distributed in the association's annual lottery. His greatest exposure by far was at the National Academy of Design, where he exhibited eleven pictures in three years, 1838 through 1840. Only four of these pictures are known to survive, but to judge from these four and from the titles and critics' descriptions of others, Deas was developing as a painter of literary and domestic genre scenes, many of which were humorous. He tried his hand at scenes from Shakespeare and from the English satirist Samuel Butler, but the only two pictures of literary narratives that are extant draw on contemporary American fiction—by Cooper *(Turkey Shooting)* and by Washington Irving *(The Devil and Tom Walker).* Deas may have relied on a yet unidentified literary source, or he may have allowed his own imagination and experience to shape *Walking the Chalk,* a picture of a bar full of drunks and gamblers.

The Trooper, one of the four surviving pictures from Deas's early National Academy submissions, appeared there at the 1840 annual exhibition. Its compositional drama and detailed accoutrements connect it to the works he showed in 1838 and 1839, but its subject—two mounted soldiers in bloody combat—signals a new direction for the artist. The picture reveals Deas's fascination with military action, perhaps an enthusiasm for the kind of life that his rejection by West Point had denied him. With the picture still on view at the academy, Deas left New York City and headed west in the spring of 1840.

Deas's motivations for traveling west were probably both personal and professional. Tuckerman later credits the inspiration of George Catlin's traveling collection of paintings he called his "Indian Gallery," which was on view in New York in the late 1830s; in fact, during the summer of 1839 a newspaper carrying a review of the Indian Gallery also mentioned works by Deas.[32] But the lives and works of two other artists also might have been compelling to Deas. One was Seth Eastman. A successful soldier/artist (and West Point graduate) who exhibited at the National Academy of Design when Deas showed there, Eastman would have been a powerful role model. Other western pictures may have inspired Deas as they did the New York public, which enthusiastically welcomed Alfred Jacob Miller's large-scale paintings of the Rocky Mountain gatherings of Indian and European American trappers and traders, known as rendezvous, shown at the Apollo Gallery in 1839, where Deas also had a work on view.[33]

Perhaps economic forces propelled Deas west. At least one contemporary art patron was discouraged about the market for art in the East during the late 1830s: "It is a dreadful time for selling anything," Jonathan Mason wrote to Thomas Cole in the fall of 1839. "While the best notes are discounted at $2\frac{1}{2}$% per month, [the men in the city] laugh at my face when I talk of pictures."[34] Deas may have sensed diminishing prospects for making a living as an artist when the country remained mired in an economic depression. Or perhaps he was affected by cautionary reviews of his work in the 1840 National Academy of Design's annual exhibition, particularly one by the *Knickerbocker*'s influential critic Lewis Gaylord Clark. Attaching the usual adjective "promising" to Deas, Clark qualified his praise with a stern warning: "We admire his genius, and only fear lest he may fall into bad habits, which he may find it difficult hereafter to overcome, and which have too often proved the grave of early genius and bright promise." Clark specified what he meant by "bad habits": he disparaged Deas's work as "hastily and imperfectly-executed sketches." Deas might have concluded from Clark's stinging words and

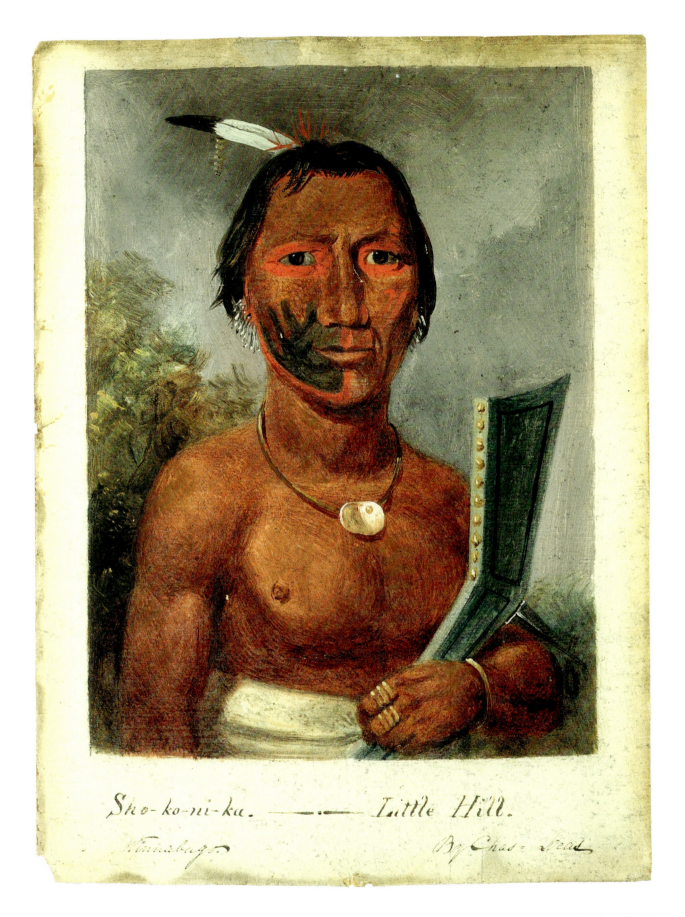

Sho-ko-ni-ka. ———— *Little Hill.*

Winnebago. By Chas. Deas

1.8. Charles Deas, *Sho-ko-ni-ka / Little Hill,* by 1841. Oil on paper, 8¼ × 6¼ in. Courtesy of The Lunder Collection, Colby College Museum of Art, Waterville, Maine.

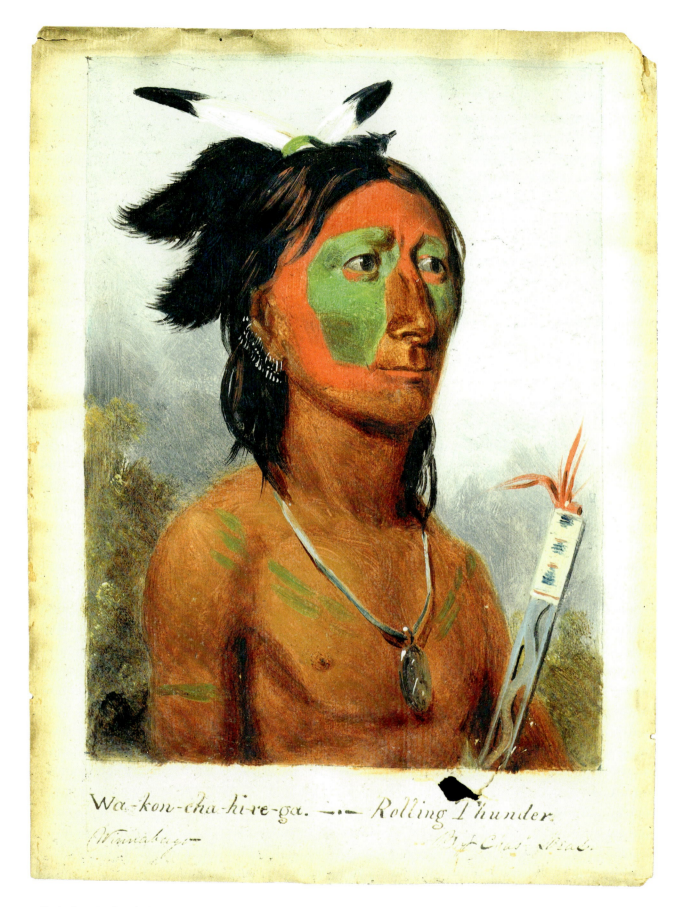

1.9. Charles Deas, *Wa-kon-cha-hi-re-ga / Rolling Thunder*, by 1841. Oil on paper, 8¼ × 6¼ in. Courtesy of The Lunder Collection, Colby College Museum of Art, Waterville, Maine.

from the generally poor reviews that genre pictures received at this annual exhibition of the National Academy that following the path he had established would bring him neither critical nor financial reward.[35] New subjects beckoned in the West.

"A Tour on the Prairies"

Deas was twenty-one years old and chose to follow a path that led other young American men to define their manhood in the West. Washington Irving expressed the lure, even the necessity, of this path in *A Tour on the Prairies* (1835): "We send our youth abroad to grow luxurious and effeminate in Europe; it appears to me, that a previous tour on the prairies would be more likely to produce that manliness, simplicity, and self-dependence, most in unison with our political institutions."[36] Deas's destination was Fort Crawford, on the Mississippi River at Prairie du Chien in Wisconsin Territory, where his brother George was stationed with the army. Tuckerman is once again the source of information for this phase of Deas's life. It is a story the artist may have told him, but it also accorded with Tuckerman's belief that American artists had to distinguish themselves from European models. In his biographical sketch of Deas, Tuckerman dwelled on the artist's western travels because he judged the knowledge Deas gained there to be necessary to paint new subjects that represented the nation to itself and also to Europe.

It was a long journey by steamship and schooner on rivers and lakes, then by stagecoach and horseback overland.[37] Tuckerman provided few details in his summary of Deas's itinerary. When Deas stopped at the village of Mackinac, the point of transfer from the Great Lakes to the overland leg of his journey, he likely met the ethnographer and government official Henry Rowe Schoolcraft, who could have provided information about Native life to an artist hungry for it. According to Tuckerman, Deas visited Fort Winnebago

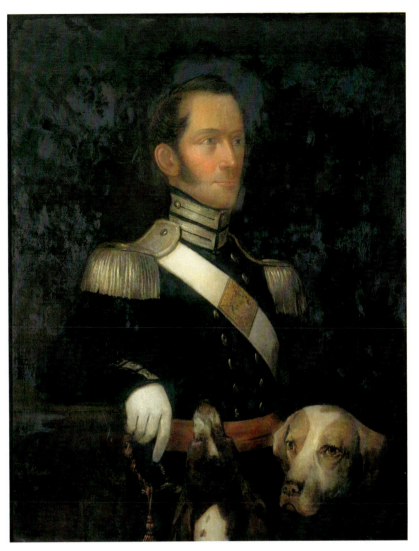

1.10. Charles Deas, *Portrait of Thornton Alexander Seymour Hooe,* 1840. Oil on canvas, 35 × 27½ in. Board of Regents, Gunston Hall Plantation, Mason Neck, Virginia, gift of Paula Chase Fielding.

and Fort Atkinson, where he used the surgeon's room as his studio. He also traveled out from his base at Fort Crawford in all seasons to see the West and to find material for future pictures. Tuckerman portrayed Deas's experience as a romantic if purposeful adventure: "[H]e was enabled to collect sketches of Indians, frontier scenery, and subjects of agreeable reminiscence and picturesque incident, enough to afford material for a life's painting." Two sketches of identified sitters (figs. 1.8 and 1.9) may have been among the "prominent members of the tribe" that Tuckerman reported Deas painted in the winter of 1840–41 at Fort Winnebago. No other work from this period appears to have survived, but Deas undoubtedly drew on his

1.11. Charles Deas, *Portrait of Lieutenant Henry Whiting,* ca. 1841. Oil on canvas, 14 × 10½ in. Private collection.

left, right arm resting on a support and right hand holding an object. The picture has been damaged and is difficult to read well today, but Deas obviously struggled with the figure's proportions: compared to the stiffly posed and poorly proportioned Hooe, his canine companions are lively and engaging.

The other surviving portrait of an officer is of Second Lieutenant Henry Whiting, probably painted in 1841, when Whiting was stationed with the army at Fort Snelling (fig. 1.11). Whiting, in dress uniform, rests his white-gloved left hand on a conveniently placed tree stump. Deas set him between two clumps of lush, broad-leafed plants that anchor the foreground corners, a convention he followed in at least two other pictures—*Lion* and *Fort Snelling*—that he painted at this time. Whiting, in Deas's presentation, is an official, white force in a natural world where Indians, specified by three tipis in the middle ground, are just other landscape elements. The presence of these tipis, however, is important to the picture's meaning. They may evoke Indian settlements around Fort Snelling or possibly an expedition that took Deas and Whiting beyond the fort to witness one of a series of treaties the government made with bands of Sioux in the region.

This was called the Doty Treaty, after James Duane Doty, the new governor and superintendent of Indian affairs for Wisconsin Territory, whom the secretary of war had authorized to negotiate the purchase of twenty-five million acres of land previously ceded to the Sioux. Doty took along a few men from Fort Snelling (Deas and Whiting among them) to help record the signatures. The government planned to settle Indians then living in northern states east of the Mississippi on this land in an all-Indian territory where European American settlement would be strictly prohibited. Deas, then, participated in an effort that was radical because it stipulated that these Indians, once settled into their new agricultural lives, would gradually be granted citizenship and the right to govern themselves. The treaty was signed (and witnessed by Deas and others) at Traverse des

experience in the field and on the sketches he made there for pictures he later showed in St. Louis, then in New York City.

Deas probably earned his living in this period by painting portraits. His first known commission in the West was a portrait of one of his brother George's fellow U.S. Army officers stationed with the Fifth Infantry at Fort Crawford. Deas presented Captain Thornton Alexander Seymour Hooe (fig. 1.10) in the same pose he had employed in the *Portrait of a Man* (1839; see fig. 1.6): a three-quarter view facing

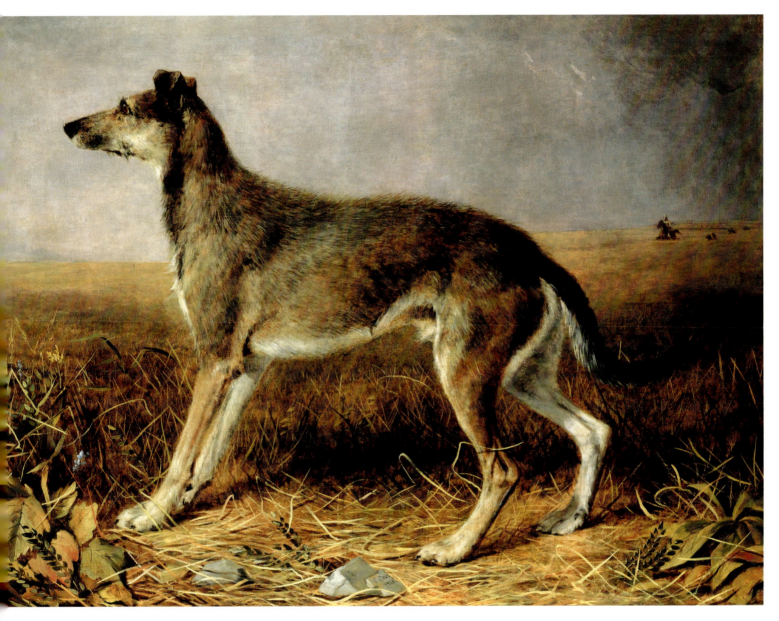

1.12. Charles Deas, *Lion*, 1841. Oil on canvas, 49½ × 67½ in. Art Collection of the Minnesota Historical Society.

Sioux, a trading post on the Minnesota River, on July 31, 1841. But a northern Indian Territory remained Doty's dream: the Senate never ratified his treaty. A decade later, the government did purchase this vast tract of land from the Dakotas, but for European American, not Indian, settlement.[38] I do not know what Deas thought of political maneuvers such as the Doty Treaty that he helped, in a small way, to orchestrate. But I do know that he associated with men who wielded political and economic power in Wisconsin Territory.

One of those powerful men was Henry Hastings Sibley, another member of Doty's party, who became Deas's primary patron with one singular commission—a portrait of his dog Lion (fig. 1.12).[39] Sibley was one of the most influential figures in the territory and later became the first governor of the state of Minnesota. In 1841, when Deas met him, he was a partner in the American Fur Company's Western Outfit and headed the post at Mendota, across the river from Fort Snelling. There he had built a large stone house, where he established

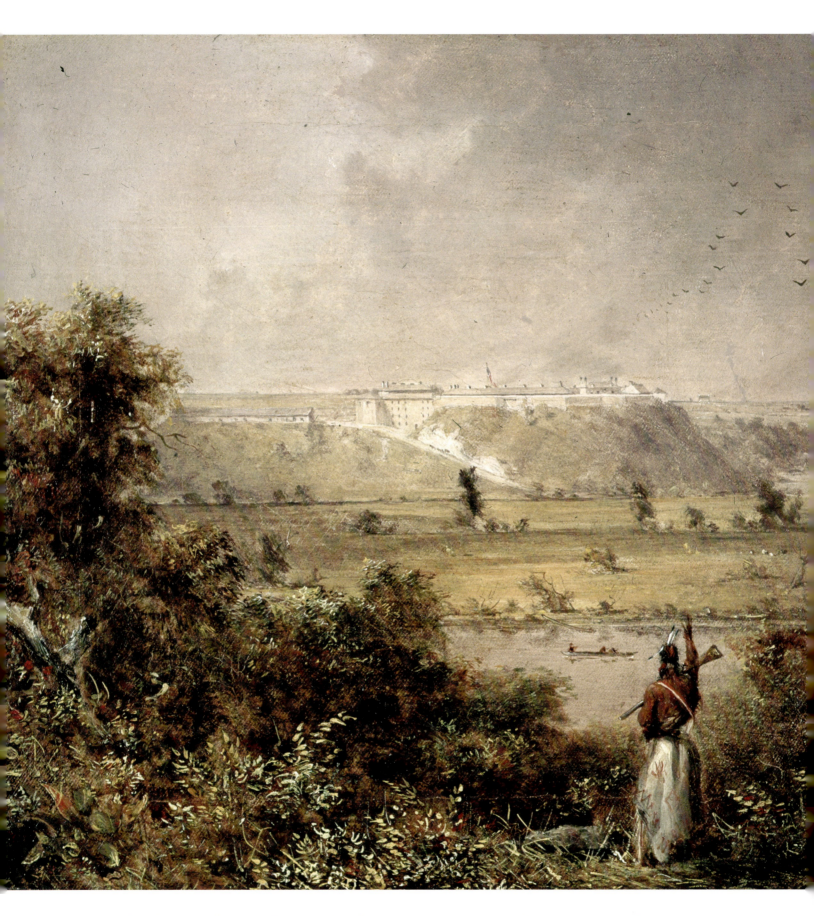

1.13. Charles Deas, *Fort Snelling,* ca. 1841. Oil on canvas, 12¼ × 14¼ in. © 2007 Harvard University, Peabody Museum (Photo 41-72-10/69T355.1).

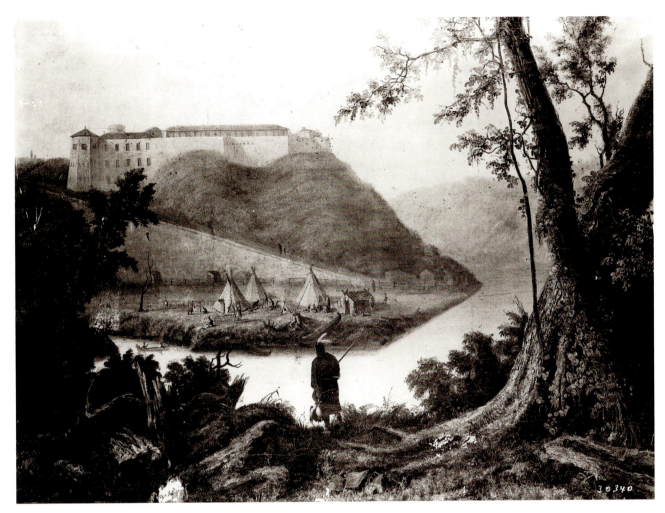

1.14. Seth Eastman (American, 1808–1875), *Fort Snelling on the Upper Missouri [sic]*, 1838. Oil on canvas, approx. 22 × 30 in. Unlocated; photo courtesy of the Frick Art Reference Library.

his life as a bachelor, conducted his business, and welcomed travelers. Sport hunting was one of Sibley's favorite pastimes, and he imported dogs from England as his hunting companions. The most famous of these dogs was Lion, an Irish wolfhound and Scottish deerhound mix of great size. Memorialized in published stories, Lion became a legendary creature. He was praised for his hunting prowess and, in the words of John C. Frémont, for his "companionable and affectionate disposition and almost human intelligence." Frémont went on to recount, apparently not facetiously, the parting of man and dog: when Sibley married, the resentful Lion abandoned his house, swam across the river, and lived out his days at Fort Snelling.[40] Deas ennobled his subject in the more exciting days of Sibley's bachelorhood by posing the alert canine in the midst of a hunt: the life-sized, painted dog commands the foreground of tangled grasses, having far outpaced the tiny hunting party in the background. The portrait of Lion had pride of place in Sibley's house, in which Deas may have been a guest as well as a working artist.

Fort Snelling (fig. 1.13) is Deas's only surviving image of the several forts that sheltered him in 1840 and 1841. His inspiration appears to be an image that Seth Eastman exhibited at the National Academy of Design in 1838 (fig. 1.14). He generally followed Eastman's composition, which includes an Indian in the foreground looking into the scene. But by subtly shifting Eastman's point of view, Deas achieved a starker contrast between the or-

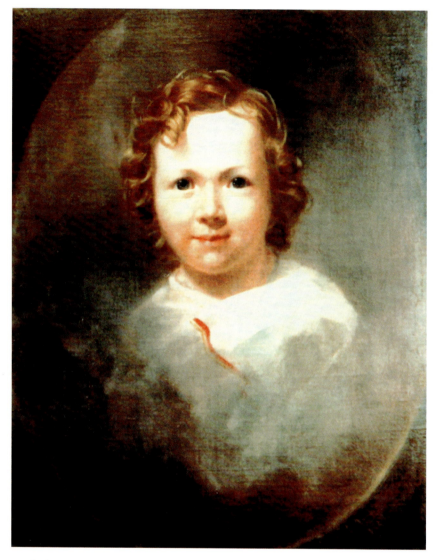

1.15. Charles Deas, *Portrait of Gratz A. Moses*, 1842. Oil on canvas, 19 × 15 in. (sight). Courtesy of Edna Moses.

By the fall of 1841, Deas had given up the full-time adventures, and undoubtedly the trials, of a traveling painter. He may have sought new patrons, longed for opportunities to exhibit his work, or simply yearned for city life. In not returning to New York City, Deas joined the exodus of young eastern men searching for new lives in the West. If he, like others, sought continuity as well as change, he would have been aware that many of his new neighbors were former Philadelphians.[41] One was S. Gratz Moses, a physician who moved to St. Louis in 1841, the same year Deas did. The oral history of the Moses family records that Dr. Moses, in need of companionship for his young wife, befriended Deas because the young artist shared her southern heritage and, like her, spoke fluent French. Deas relied on influence and connections to make his way in St. Louis just as he had in New York City. The young artist may have approached Moses, a civic leader, for help and introductions in his new hometown. The Moses family history reports that Deas gave Dr. and Mrs. Moses a portrait of their son, Gratz A. Moses (fig. 1.15), as a token of the artist's thanks. Whatever reason underlay the gift of the portrait, it is the only physical evidence of Deas's connection to the family.[42] This painting of a three-year-old boy with a sweet, open expression and with ringlets framing his face owes a stylistic debt to Thomas Sully and carried with it the cultural entwining of the artist's and his patron's Philadelphia roots.

St. Louis experienced unparalleled growth in the six years Deas lived there (fig. 1.16). The city's population topped 16,000 in 1840 and then expanded rapidly. From the moment he arrived in the fall of 1841, Deas took part in the cultural life that burgeoned along with the population. St. Louis's first large commercial exposition opened in November, and newspaper coverage of the objects on view is the earliest evidence of his presence in the city. The mechanics' fair was a major civic event, promoted locally as "the first attempt ever made

derly disposition of the fort, which reconfigured the river bluff into an architectural pile, and the overgrown landscape in which his Indian figures navigate. Deas positioned the viewer, as did Eastman, to share the perspective of the standing Indian in a romanticized identification. Yet Deas's audience understood that power resided in the fort. The picture expresses a widely held contemporary view that Natives would retreat and their numbers gradually diminish in the face of an increasingly aggressive European American presence.

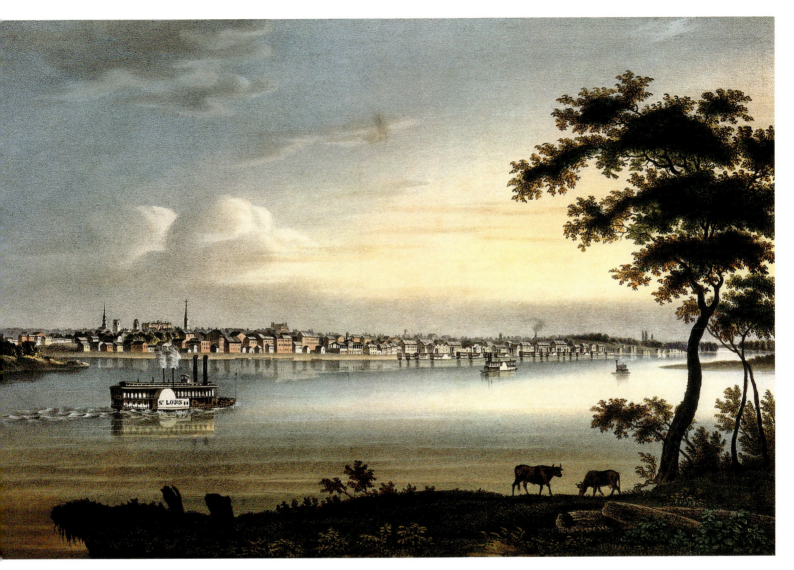

1.16. John Caspar Wild (American [b. Switzerland], 1804–1846), *Southeast View of St. Louis from the Illinois Shore,* 1840. Lithograph, 11$\frac{15}{16}$ × 5$\frac{3}{16}$ in. Missouri Historical Society, St. Louis.

at any thing [*sic*] of the kind on this side of the Mississippi."[43] The fair's sponsor was the city's Mechanics' Institute, which was founded in 1839 to encourage innovation in the design and production of locally manufactured goods, as well as to support their sale. The institute's most public activities were its annual fairs.[44] The fairs featured all types of marketable goods; although paintings were isolated, being elevated to the upper story of the exhibition hall, they, too, were for sale. By associating paintings with "useful" wares, the fairs offered American artists a new place in St. Louis's world of commerce.

Deas exhibited in at least four mechanics' fairs during the time he lived in St. Louis. To the first fair he contributed portraits, some of which were of Indians.[45] At the next fair, staged at the courthouse in 1842, he showed a wider range of subjects—portraits of Indians, landscapes, and genre pictures. Among the paintings he exhibited in the second fair was a group that I believe included the only near-life-sized portraits of Indians by Deas that are known today. These four paintings (figs. 1.17–1.20) appear to be of Winnebagoes; at least one is based on an oil sketch (see fig. 1.9) that he probably made

at or near Fort Winnebago about 1841. The set of four may be part of a larger venture, perhaps an unrealized Indian gallery. Deas's inspiration for grouping portraits of Indians was certainly Catlin's Indian Gallery. His approach to the individual portrait followed the tradition of Native portraiture widely known in the lithographs that Thomas L. McKenney and James Hall made after paintings by, among others, Charles Bird King,[46] which Catlin had codified and further popularized: the formal, bust-length presentation of a sitter in full regalia who holds a weapon or a pipe. Deas's four portraits may be the survivors of a larger group, but they cohere as a set that expresses the stages of man's life from early adulthood to old age.

By 1842, Deas had become known in St. Louis as an artist whose paintings of Indian subjects were "fine" as well as "accurate in delineation."[47] He received public tribute for these skills in the first volume of poetry published west of the Mississippi. In one of the notes that Lewis Foulk Thomas appended to his long poem *Inda: A Legend of the Lakes* (published in St. Louis in 1842), he cited Deas as his source for an unusual detail of Indian appearance:

A full-blooded Indian with "short curled hair," is a rara avis in terra. Among many thousands I have never seen but one with this peculiarity. Mr. C. Deas, of St. Louis, an artist of great merit, and a close observer, who has passed much time among the tribes of the head waters of the Mississippi, informs me that he never observed but one Indian who was thus marked. I may mention, en passant, to the curious in Aboriginal matters, that Mr. D. has a large and elegant collection of Indian portraits and graphic sketches, illustrative of their manners and customs, all drawn from nature, and with remarkable skill and fidelity.[48]

Thus, Thomas suggests that Deas's academic training and recognition at the National Academy of Design combined with his firsthand knowledge of Indians would serve him well.

The artist added his own assertions of authority to those written by others. After titling, signing, and dating his 1842 *Winnebagos Playing Checkers,* probably one of the genre paintings he exhibited at the mechanics' fair in 1842, Deas inscribed "from nature" and "St. Louis" on the back of the canvas. With these words, the artist proclaimed his work to be truthful and laid claim to his new, western home. He further settled in by accepting membership in the Mechanics' Institute. He painted portraits of the city's elite, such as one of Thomas lithographed for *Inda* (fig. 1.21), but he also realized his ambition to exhibit and sell pictures of purely western subjects. Deas's association with Thomas, following his appearance at the first mechanics' fair, shows how quickly he entered into the cultural and commercial life of St. Louis. By 1844, he had set up a studio on Chesnut Street, and he signaled his growing ambition by later changing his professional designation in the city directories from "portrait painter" to "artist." All this evidence suggests that he intended to pursue his career in St. Louis, at least for a while.[49]

Art criticism was slow to develop in St. Louis, although the *Reveille* began cultural reporting when it was first published in 1844. It gave Deas only one notice in that year. The sometime humorist and Indian agent Richard S. Elliott, writing under the pseudonym "John Brown," reported from Council Bluffs on September 10, 1844, on the condition of the Indians and their troubled relationship with the U.S. government. In his piece, "Movements among the Red Skins," Elliott noted the arrival from Fort Leavenworth of Major Clifton Wharton and five companies of dragoons, who were there to display the government's military strength and to council with the Indians—Otos and Potawatomies. Elliott noted early in his article that "Mr. Deas, the Artist," was a member of Wharton's group.[50] The press, then, affirmed Deas's authority as a painter with experience in the West.

While Elliott's article gave the St. Louis public news of Deas's presence in the territories, the artist recorded and interpreted this presence

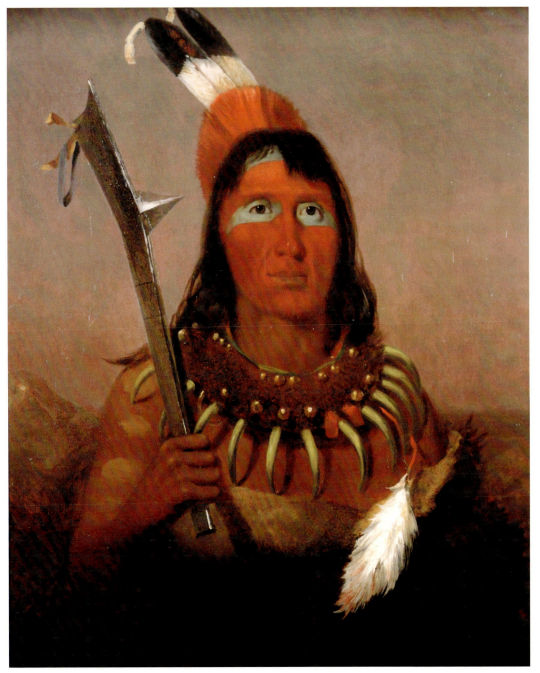

1.17. Charles Deas, *Winnebago with Bear-Claw Necklace and Spiked Club,* by 1842. Oil on canvas, 36 × 30 in. From the collections of the St. Louis Mercantile Library at the University of Missouri–St. Louis.

in *Dragoons Fording Stream* (fig. 1.22), a small picture that later belonged to Philip Kearny, who was one of Wharton's officers on the expedition. The publication of the diaries of another of Wharton's officers, Lieutenant J. Henry Carleton, offered the artist even wider exposure when Deas resumed his career in New York City. Writing anonymously as "an officer of the U.S. Army," Carleton sent his journal entries to the popular magazine *Spirit of the Times* for serial publication soon after the expedition ended. In his first entry, dated August 12 and published on November 9, 1844, he commented on Deas's presence: "Mr. Charles Deas, the distinguished artist of the West, also accompanies the dragoons on this campaign.

1.18. Charles Deas, *Winnebago (Wa-kon-cha-hi-re-ga) in a Bark Lodge,* by 1842. Oil on canvas, 36 × 30 in.
From the collections of the St. Louis Mercantile Library at the University of Missouri–St. Louis.

1.19. Charles Deas, *Winnebago with Bear-Claw Necklace and Spear,* by 1842. Oil on canvas, 36 × 30 in. From the collections of the St. Louis Mercantile Library at the University of Missouri–St. Louis.

1.20. Charles Deas, *Winnebago with Peace Medal and Pipe*, by 1842. Oil on canvas, 36 × 30 in. From the collections of the St. Louis Mercantile Library at the University of Missouri–St. Louis.

He will, no doubt, make many fine additions to his already extensive and truly beautiful gallery of paintings."[51] In wide-ranging descriptions of these experiences that included many instances of Deas sketching, Carleton recorded that from mid-August to late September 1844, Wharton and his troops traveled from Fort Leavenworth up the Missouri, then out along the Platte River to the Grand Pawnee Villages, which is probably as far west as Deas ventured. Wharton stated that his orders were "to impress upon such Indian tribes as we may meet the importance of their friendly treatment of all white persons in their country, to convince them of the power of the U.S. Government to punish them for aggressions on such persons, [and] to urge upon them the policy of peace among themselves & their neighbors." He described Deas as a "partner in our expected toils and pleasures."[52] On this, the only military expedition Deas accompanied, he gained firsthand experience in the strong enforcement of the government's Indian policies.

In 1844, after an absence of four years, Deas exhibited a painting in New York City at the National Academy of Design. Critical reaction to the only picture he showed there, *Group of Indians Playing Ball* (likely *Sioux Playing Ball*), was less than tepid: "Farther than that the drawing and attitudes are good, nothing more can be here seen worthy of comment."[53] Perhaps hoping for a better reception with a different audience, Deas sent his next picture, *Long Jakes*, to the American Art-Union; but it appeared first in a commercial venue, a shop on Broadway, where the press called it a "masterpiece" and noted the "hundreds crowding around the window" to see it.[54] *Long Jakes* successfully reestablished Deas's New York career in the fall of 1844. Readers of the New York press met him as a military man and a westerner: the critic for the *Broadway Journal* expressed hope that the artist he mistakenly referred to as "Lieut. Deas" would "send us some companions to keep [Long Jakes] company from the far West."[55] Carleton reported that the artist had earned the nickname "Rocky Mountains" on the Wharton expedition. And

so the aura of military expeditions and the romance of the West attached themselves to Deas and to his picture of a mountain man.

The American Art-Union accelerated Deas's career. Unlike its rival, the National Academy of Design, the Art-Union bought many of the pictures it exhibited and distributed them by lot-

tery to its dues-paying subscribers. Although Deas regularly had pictures at the Art-Union between 1844 and 1850, his only critical successes were the first three he showed there—*Long Jakes, The Indian Guide,* and *The Death Struggle.*[56]

Deas's association with the Art-Union gave him a presence in New York that attracted private and commercial patrons to his work. The

1.21. John Caspar Wild, after Charles Deas, *Portrait of Lewis Foulk Thomas,* 1842. Lithograph, bound into *Inda: A Legend of the Lakes* (St. Louis, 1842), 7 × 4½ in. From the collections of the St. Louis Mercantile Library at the University of Missouri–St. Louis.

press reviewed pictures that the Art-Union had on display and also covered the December distribution to members. Private collectors took note: two men who later became Art-Union managers acquired *Long Jakes* and *The Death Struggle* for their personal collections. Magazine editors offered Deas still more exposure, if not (as far as I know) financial support. *Long Jakes* and *The Death Struggle* were reproduced in the *New York Illustrated Magazine of Literature and Art* in 1846. *The Rose of Sharon,* an annual gift book, published an engraving of Deas's now-lost painting *The Watcher by the Sea* alongside a poem of the same title (fig. 1.23).[57] Thus, a middle-class literary public could look at reproductions of Deas's paintings as they did other mid-nineteenth-century visual imagery, integrally bound to a prosaic or poetic narrative structure that directed their visual experience.

Successes such as these in New York City enhanced Deas's reputation back in St. Louis. Beginning in May 1845, the same month Deas signed and dated a drawing entitled *The Hunter* (fig. 1.24), the St. Louis press gave glowing reviews to the work he exhibited locally. In a single day, one critic claimed, Deas's painting "attracted the attention of hundreds, and received from connoisseurs high praise as a work of art."[58] The *Reveille* championed Deas, making sure its readers knew that he was "of our city" and that he was "the only artist in the country whose paintings are truly imbued with the spirit of western *heroic* adventure."[59]

Deas worked to expand his public in New York and St. Louis. He did more than submit his pictures for exhibition and sale and pay his Art-Union dues. He also participated in the bureaucracy of art promotion, specifically to increase subscribers in St. Louis. Deas wrote to the Art-Union's corresponding secretary in November 1846 to advance what he regarded as a campaign for "the cause of the Fine Arts in St. Louis."[60] He recommended a St. Louis attorney and editor, Charles D. Drake, with whom he was working to promote the benefits of membership in the American Art-Union, to be the organization's area agent. Deas's recommendation

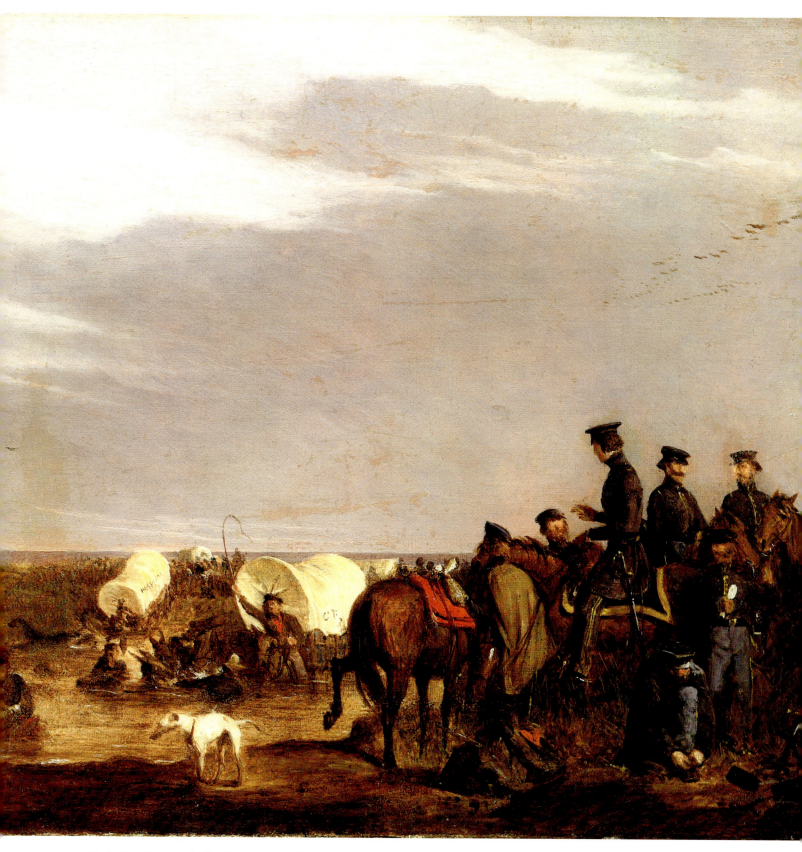

1.22. Charles Deas, *Dragoons Fording Stream,* ca. 1844. Oil on canvas, 12¼ × 18 in. Courtesy of Gerald and Kathleen Peters.

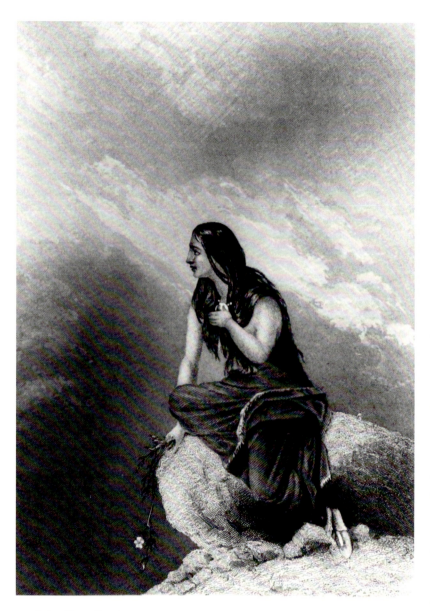

1.23. De Lay Glover (American, ca. 1823–ca. 1863), after Charles Deas, *The Watcher by the Sea,* ca. 1847. Steel engraving bound into *The Rose of Sharon: A Religious Souvenir* for 1847, 6⅞ × 4¼ in. Courtesy of American Antiquarian Society, Worcester, Massachusetts.

No one was better able than the young Deas, an artist "of a high order of genius on the western banks of the Mississippi," to carry this essential part of the nation's story into the Capitol. A sketch of the work was reported to have been put on view in the Library of Congress, but it is lost, and the image is known today only through written descriptions. Deas's bid was not successful: the commission went to another westerner, William Powell of Ohio.[61]

The Capitol Rotunda case is one in a pattern. After 1845, Deas's career declined markedly in New York but remained vibrant in St. Louis. *The Death Struggle* earned Deas accolades in the New York press. But after that, eastern critics were at a loss to explain what they saw as a sharp decline in his art. The *United States Magazine and Democratic Review,* for example, made this point: "Visitors to [the American-Art Union] exhibition of last year will have remembered Mr. Deas' picture of the 'Death Struggle,' which was one of the most spirited and effective works ever hung upon its walls. This painting displayed powers of a very high order, and the admiration it elicited was general and enthusiastic. The same artist shortly afterwards produced one entitled the 'Oregon Pioneers,' which was so inferior as to have led us at first to doubt that it was executed by him. There has seldom been a more lamentable falling off."[62] The magazine's critic went on to detail every flaw of *Oregon Pioneers.* The *St. Louis Weekly Reveille,* however, referred to this review as making "honorable mention of our western artist, Charles Deas," and proceeded to quote only the positive statements, excising all the derogatory words.[63]

Similarly, St. Louis embraced Deas's *Last Shot,* a picture he completed in the summer of 1846. It is now known only from written descriptions, as a deadly encounter between Captain Samuel H. Walker and a ranchero during the Mexican War. The *Reveille* called the violent scene "wild and picturesque" and praised it as "a highly spirited and striking picture."[64] When the painting went on view in New York City at the Art-Union in 1847, one critic admired its execution and predicted that "it would find a ready purchaser" but cautioned that "its subject

came two weeks before Drake returned the favor and led a petition to Congress to support Deas's bid to fill the one remaining vacant panel in the Rotunda of the U.S. Capitol.

Drake's was the first of 120 signatures of Missouri citizens on petitions made to the U.S. Senate and the House of Representatives in November 1846. Their brief, introduced in the Senate by Missouri's own Thomas Hart Benton, asserted the "claims of the West": these citizens argued that Deas's subject—General George Rogers Clark's suppression of a threatened Indian uprising circa 1780—would give their region its rightful place in the nation's history.

C. Deas - St. Louis. May 23. 1845

1.24. Charles Deas, *The Hunter*, 1845. Pen and brown ink on paper, 8⁹⁄₁₆ × 6⅝ in. Private collection.

may not be so desirable for a permanent collection."[65] Another critic ridiculed its horror as excessive.[66]

Response to the three paintings Deas submitted to the National Academy of Design in 1847 followed this pattern of high praise in St. Louis and generally unsympathetic critique in New York City.[67] The only one of these three pic-

tures for which the current location is known is *Voyageurs* (fig. 1.25). The *Reveille,* true to form, described this picture with apparent pleasure and lingered over each detail. Deas's characters, clad in "rude habiliments, with unshaven chins, and their long hair hanging in disordered masses about their necks," were "striking"; the standing steersman in particular was "a model

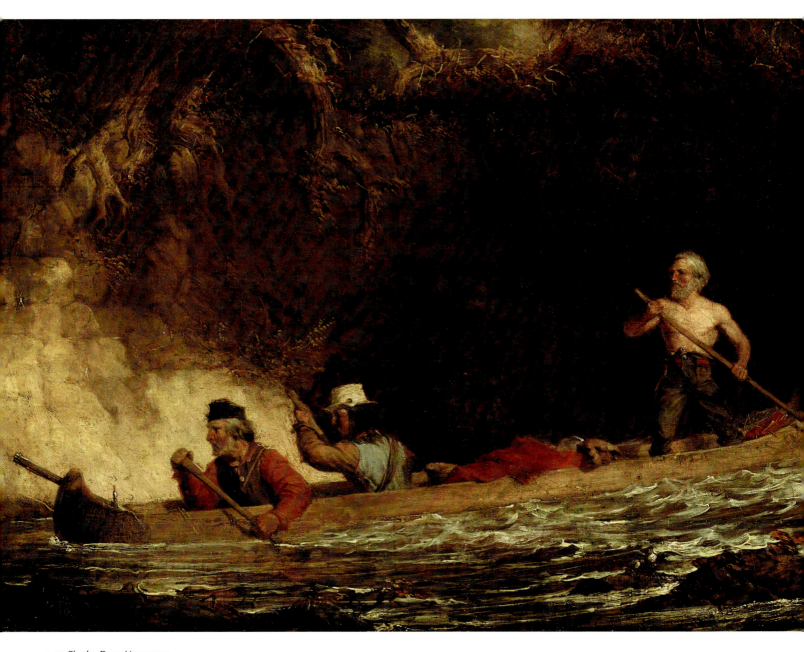

1.25. Charles Deas, *Voyageurs,* 1846. Oil on canvas, 13 × 20¼ in. Photograph © Museum of Fine Arts Boston, Gift of Maxim Karolik for the M. and M. Karolik Collection of American Paintings, 1815–1865 (46.855).

of strength and vigor." For this St. Louis critic, and presumably for his audience, Deas's voyageurs were "true to life," and the painting embodied the West: "The whole scene is wild and picturesque as nature itself in the solitary regions of the west."[68]

The picture's New York reception was decidedly cooler. Critics who saw the painting in the annual exhibition of the National Academy of Design addressed only its pictorial qualities, and most found fault with them. One critic mocked the color of all of Deas's National

Academy entries: "All appear to have been dipped into some maiden lady's carmine saucer, so roseate are they."[69] Yet another reviewer left open the possibility that the colors in Deas's landscapes "may be correct enough in the West,"[70] a statement that sounds snide although its context suggests that it was not. Still another critic, addressing *Voyageurs* specifically, found fault with the artist's figural proportions, pointing out that he had not succeeded in fitting his stumpy figures into the boat. "Not one of Mr. Deas' best pictures" was the conclusion.[71]

1.26. Thomas Cole (American [b. England], 1801–1848), *Voyage of Life: Manhood,* 1840. Oil on canvas, 52 × 78 in. Munson-Williams-Proctor Arts Institute, Museum of Art, Utica, New York (55.107).

The turbulent waters and difficult passage of *Voyageurs* may reflect the increasing turbulence in Deas's professional and personal life. Deas's anthropomorphic trees reach and threaten in ways that suggest they owe their existence to Thomas Cole, whose landscapes appear to have set an example for Deas from the start of his career. The *Voyageurs* of 1846 may be Deas's homage to Cole's *Voyage of Life:* specifically, to *Manhood* (fig. 1.26), the third in Cole's series of four. Yet unlike Cole's everyman who clasps his hands in prayer from the stern of a boat with a broken tiller, Deas's bare-chested man at the stern controls his own passage through rough water: his comrades paddle, and he guides their course. Deas's men, in effect, navigate life's rough waters without the spiritual guide promised by Cole's *Voyage of Life.*[72]

The response of New York critics may have been disappointing, but Deas's career was go-ing better in St. Louis. In early 1846, the newly formed St. Louis Mercantile Library affirmed his position in the city by conferring on him a "beneficiary" membership, which made him the first artist to join the library.[73] By that time, Deas had works on view in the shop of George Wooll, who supplemented his primary business of framing, cleaning, and repairing pictures by exhibiting and selling works for artists including Deas and George Caleb Bingham.[74] At least one local notable, Judge Luke Lawless (fig. 1.27), commissioned a portrait from Deas. But little else is known of the artist's St. Louis patronage. He probably told Tuckerman what he undoubtedly wanted a national readership to know—that he had found "all that a painter can desire in the patronage of friends and general sympathy and appreciation."[75] Perhaps it was true. In the 1850s and 1860s, after Deas had left the city, some of his paintings were in the hands of St.

1.27. Charles Deas, *Judge Luke E. Lawless,* ca. 1846. Oil on canvas, 30 × 25 in. Missouri Historical Society, St. Louis.

Louis leaders—among them David D. Mitchell, an Indian agent; John How, a former mayor; and James Yeatman, a banker, the first president of the Mercantile Library, and a founder of the Western Academy of Art.[76]

RETURN TO NEW YORK CITY

One of Deas's 1847 pictures had the potential to revive his reputation in New York City. A "correspondent" reporting from St. Louis to the *Literary World* in April described *Prairie on Fire* as "thrilling and exciting"; it was "the best to our mind which we have had from the easel of

Deas." *Prairie on Fire* was then on view at the mechanics' fair, but this correspondent hoped "that the lovers of the Fine Arts in New York will have an opportunity of seeing and examining this production of the 'Far West.'"[77] Perhaps Deas traveled to New York with *Prairie on Fire* full of hope for its reception. Or perhaps declining mental health drove him home: notes on his admission to the Bloomingdale Asylum in 1848 specify that he was "troubled with a religious anxiety" as early as 1844. Whatever his motivation to leave the West, in May 1847 Deas was back in New York City, never to return to St. Louis.[78]

He arrived in time to read the poor reviews of his work at the National Academy of Design, but he might also have taken pleasure in his appearance in two notable American books and in a British journal. Charles Lanman, artist and travel writer, recounted a visit of June 1846 to Deas's St. Louis studio in a narrative of his summer adventures that was published in 1847. Lanman lavished praise on Deas's pictures of trappers and Indians as displaying a "strongly marked national character." But he also firmly positioned Deas as a regional artist—"the bright particular star, who uses the pencil here."[79] Tuckerman's published views positioned Deas in a national context: as an artist who portrayed American life in western scenery. In the summer of 1847, Deas earned his first international recognition: the critic for London's *Art-Union Monthly Journal* commented that Deas's pictures, even more than James Fenimore Cooper's novels, embodied "half-savage life and freedom from the restraints of civilization."[80]

If life in the West represented "freedom," then Deas was currently accepting, perhaps of necessity, "the restraints of civilization." With *A Solitary Indian, Seated on the Edge of a Bold Precipice* still on view in St. Louis,[81] he enrolled once again in the National Academy of Design's Life School for the session that ran from the fall of 1847 through the following spring. Although his renewed artistic training in New York City suggests continuity with his past, the work that Deas showed at the National Academy's annual

exhibition of 1848 portended a dramatic change in his life. For the first time, he showed paintings of religious subjects. Deas's choice was not uncommon among his artistic contemporaries, but his treatment of this theme was distinctive.[82] The first notice of the artist's mental illness came in a review of his now-lost painting *The Lord* (also known as *The Saviour*), which the critic for the *Literary World* could not bring himself to discuss. Instead, the critic attributed the picture's strangeness to "the late melancholy circumstances of [Deas's] derangement," which might "shield it from the shafts of criticism." The *New York Express* was explicit in its review: Deas had been committed to an insane asylum. By stating that "the illness of Mr. Deas has thrown a gloom over his friends," the critic for the *Express* perhaps revealed the source of specific information about the nature of Deas's illness: "[T]he original cause of his malady is attributed to a settled melancholy and an unnecessary anxiety about the new science of *magnetism*."[83]

BLOOMINGDALE ASYLUM

Deas's career ended in New York as it had begun, in the care of his family. On May 23, 1848, he entered the Bloomingdale Asylum (fig. 1.28), with support guaranteed by his brother-in-law, Robert Watts. Bloomingdale was a benevolent institution that admitted patients from all walks of life and charged a sliding scale of fees. Following contemporary theories that patients must be separated from society and that a beautiful rural setting was the most salutary for treating mental illness, the asylum's founders choose a site overlooking the Hudson River on the west side of upper Manhattan, in an area

1.28. James Smillie (American [b. Scotland], 1807–1885), after Robert Walter Weir (1803–1889), *Lunatic Asylum, New York,* 1834. Engraving 7¾ x 9¾ in. Picture Collection, The Branch Libraries, The New York Public Library, Astor, Lennox and Tilden Foundations.

the Dutch had called Bloomingdale, or "Vale of Flowers."[84] (Its buildings, only one of which stands today, occupied what is now the campus of Columbia University.) Bloomingdale's orderly exterior mirrored the routine that patients followed inside its walls: the "internal arrangements of the Asylum," wrote the physician who directed Bloomingdale from 1844 to 1849, "are nearly the same as those of a well-regulated family."[85]

That director was Pliny Earle (fig. 1.29), who admitted Deas and oversaw his care. Earle's goal was to cure—not just tend—his patients so that they might quickly return to productive lives. Patients were medicated to quiet and ready them for the "moral treatment" that Earle believed would heal them. Intellectual stimulation was essential to this kind of treatment. An extensive library was available for patients' use, and Earle gave lectures on a wide range of topics. Therapy also included writing, drawing, physical exercise, and all sorts of amusements—inmates played organized games and gathered regularly for socializing, and once a month those who were able to danced at a ball

ABOUT 1849.

Pliny Earle.

1.29. *Portrait of Pliny Earle*, ca. 1849. Photomechanical reproduction of a lost photograph, in *Memoirs of Pliny Earle, M.D.* (Boston: Damrell and Upham, 1898). 8⅞ × 5⅞ in. Courtesy of Amherst College Library.

also attended by Earle's visitors. Work was not compulsory but was encouraged as a form of treatment. Earle believed that patients would improve if they were cared for "as much as possible as if they were still in the enjoyment of the healthy exercise of their mental faculties."[86]

Earle kept meticulous records.[87] They began with observations upon admission of a patient's physical characteristics: Deas was of medium stature and had very dark brown hair and hazel eyes. The records continued with the "form" and "exciting cause" of the disease that brought a patient to Bloomingdale: Deas's malady was "mania, supervening upon monomania," and the cause—I understand this to mean what precipitated the monomania—was "unknown."

Although the critic for the *Express* attributed the "cause" of Deas's illness to a "settled melancholy," Earle classified Deas as of "sanguine" temperament, a category that was distinct from the "exciting cause" of illness. We know more of Deas's condition upon admission because he was among the patients for whom Earle wrote an expanded report (fig. 1.30). In this document, Earle explained that the artist had been "troubled with a religious anxiety" four years before admission; that he had experienced "inflammation of [the] brain" two years before; and that for more than a year he had been "a monomaniac, on the subject of mesmerism."

The symptoms of mania, the most frequently diagnosed mental disease in the early nineteenth century, included intense, sometimes violent agitation, often accompanied by delusions or hallucinations.[88] Deas's first days at Bloomingdale must have been harrowing. According to Earle's notes, Deas slept underneath his bed on his first night and "shouted fire and murder" into the next day. Earle administered medications to Deas, which was in keeping with the commonly accepted midnineteenth-century belief that insanity had underlying somatic causes. (Earle's diagnosis of "inflammation of brain" fits this conviction.) Deas quieted, and his mania subsided, but his underlying monomania persisted and took the form of delusions.

Earle specified the object of Deas's monomania—the artist was obsessed with the subject of mesmerism. Popularized in America in the mid-1830s, mesmerism was founded on a belief in the existence of "animal magnetism," a substance resembling electricity that caused illness if it was unbalanced within the human body. Those gifted as mesmerists (who were also called "magnetizers") could activate this substance by passing their hands or specially treated rods over the body of a sufferer and so return him, or more usually her (most patients were female), to a healthy equilibrium. This equilibrium was viewed as spiritual at its core; mesmerism formed part of a wave of individual religious experiences that crested in the 1840s. Deas's condition exemplified this connection

1.30. Pliny Earle Papers, Lists of Patients and Notes on Cases: Charles Deas. Courtesy of American Antiquarian Society, Worcester, Massachusetts.

Charles Deas. Admitted May 23d. 1848

Previous History. Constitution strong — health generally good. — Four years since was troubled with a religious anxiety; two years since had inflammation of brain — for more than one year has been a monomaniac, on the subject of mesmerism. Is very abstemious of food, but smokes and snuffs tobacco excessively — and applies himself very closely to the study and practice of his art. No medical treatment before admission.

State when Admitted. — May 24th. Admitted last evening; got out of his bed and slept on the floor beneath it. Shouted two or three times in the night. Now lies quietly, his eyes closed, the lids and his limbs, having a tremulous motion, does not speak even when spoken to, nor open his eyes when asked, head too warm, feet cool. pulse rapid, full and strong.

Symptoms and treatment while in the Asylum. 25th. At the morning visit yesterday Cal. gr viij et Ol. Rig. gtt ij were administered. Soon afterwards he began to shout fire and murder, and continued to shout occasionally through the day. Medicine operated freely in the afternoon, was quiet through the night and is so now — orders the people who come into the room to go out, says he was poisoned yesterday, that the medicine contained arsenic enough to kill twenty men. Skin and eyes sallow, tongue covered with white fur, pulse 85 irregular, pupils somewhat contracted. R blue mass gr. iij. t.d. 26th. Pulse 90 soft, bowels not moved since night before last, talks rationally on his present condition, but is evidently not free from delusions, take mass and aloe pill No. 3. 27th. Stop blue mass. His subsequent treatment consisted of sedatives, and simple cathartics. In a few days he became perfectly quiet; his maniacal excitement having subsided, leaving an apparent monomania. He imagined himself a chosen instrument of the deity. Said that the Saviour was personally in the city, and communicated intelligence to him by means of mesmerism.

 Discharged Improved Aug 30th. 1848

between mesmerism and religion. Earle wrote that his patient "imagined himself a chosen instrument of the deity. Said that the Saviour was personally in the City, and communicated intelligence to him by means of mesmerism."

Religion and mesmerism each offered hope for the cure of spiritual ills, and Deas probably followed both paths in an attempt to relieve his mental suffering. Earle wrote about the dangers of excess, especially of religiosity. The physician also documented an earlier case of mesmerism as the precipitating cause of disease in his account of a young man of high intellect who declined into a state of mania under the care of a mesmerist, precipitating his admission to Bloomingdale.[89] Was Deas's case like this one? The St. Louis and New York newspapers were full of stories about and advertisements for mesmerists. Perhaps the distressed young artist had been attracted to their curative claims as he sought, and thought he had found, God's voice speaking to him in mesmeric communication. If Deas had consulted a mesmeric operator in an attempt to cure his mental maladies, he would have been one of many nineteenth-century sufferers to do so.[90] That he came away deluded into believing that he was "immediately directed by God in all his actions" changed the course of his art as well as his life.[91]

All that is known of Deas's activities at Bloomingdale after his mania subsided comes from the institution's tabulated record. He did not "work" or go to organized parties, but he did attend "some lectures" and religious worship. On August 30, 1848, after three months of treatment, he was considered "improved" and "requested" discharge. But he was well enough only to be "taken to Dr. MacDonald's at Flushing." It was not the last that Deas saw of Bloomingdale.

SANFORD HALL IN FLUSHING

The physician James Macdonald operated Sanford Hall in a sumptuous private residence he had purchased to house his patients in the rural village of Flushing on Long Island (fig. 1.31). Deas joined about thirty patients in an establishment that was smaller and more exclusive than Bloomingdale. Macdonald had been a resident physician at Bloomingdale, and his philosophy of patient care seems to have been much the same as Earle's: "I almost consider my own little establishment a younger & lesser branch of the same family," he wrote to Earle in 1845. Macdonald died not long after Deas's arrival, and little else is known about this place where the artist lived for fifteen years. But because the Macdonald family continued to operate Sanford Hall, the atmosphere there was probably similar to the Bloomingdale Asylum's, in which patients were encouraged to pursue their life's work. For Deas, of course, this meant that he probably painted.[92]

PLAN FOR AN INDIAN GALLERY

Deas was living at Sanford Hall in the last months of 1848, when a few friends and family members tried to promote his career by soliciting funds for a proposed Indian gallery. Perhaps he was still painting Indian scenes. More likely, these friends wanted to offer him professional purpose and a means of support when, as they must have hoped, he would be released. In November 1848, Henry Deas Lesesne, the artist's cousin, wrote to a fellow Charlestonian, the attorney and state legislator James Simons, to remind Simons of a plan that he had "kindly consented to take charge of, with a view to procure some subscribers at Columbia [South Carolina] during the session of the Legislature." In this letter, Lesesne detailed a strategy to solicit subscribers for a series of paintings that Deas would create to constitute an Indian gallery. Lesesne recommended Deas because of the artist's impeccable credentials: his work was based on experience in the West, he had succeeded at the American Art-Union, and he had earned the admiration of the cultural arbiter Henry Tuckerman. Despite these points in his favor, Lesesne noted that Deas "labors

under the lot, so common to genius, of narrow fortune" and as a result was forced to seek sponsors who would pay him a total of five thousand dollars over five years to create his gallery. The proposal, called "Plan for an Indian Gallery" (fig. 1.32), assured prospective patrons that they were making a risk-free "investment . . . in Our Country" that would "save from oblivion a Race, now fast disappearing from the face of the Earth." This language echoed Tuckerman's description of Deas's fateful encounter with George Catlin's Indian Gallery—and, indeed, Catlin's description of his lofty goals. Deas's supporters followed Catlin's business model by imagining that Deas's Indian gallery would tour Europe, "where, no doubt, it would excite great curiosity, and yield a handsome profit."[93]

The plan boasted that "the Artist"—Lesesne specified Deas's name only in the letter—had made "a large number of sketches" while he was in "our vast Western Country." Lesesne noted that these sketches, which would be the basis for the pictures Deas would paint for the gallery, were still in the artist's possession. Although two small oil-on-paper sketches (see figs. 1.8 and 1.9) could be those (or like those) referred to in the plan and the four portraits of Winnebago leaders now at the St. Louis Mercantile Library (see figs. 1.17–1.20) could be related in some way to Deas's proposed Indian gallery, nothing came of the scheme. This is not at all surprising if news of the artist's commitment to an asylum had reached potential investors. If Lesesne knew about the artist's circumstances, he chose not to reveal them.

A Vision

It seems, however, that Deas had created in an asylum, either Sanford Hall or Bloomingdale, a painting far removed from anything that might hang in an Indian gallery. Of all the critics who tried to describe the apparently odd

Plan for an Indian Gallery.

The Artist who proposes to form this Gallery, has had uncommon opportunities of seeing the different tribes that inhabit the Forests of our vast Western Country. He passed several years among them, and was engaged in taking a large number of sketches, which he still possesses, and he has it much at heart to save from oblivion a Race, now fast disappearing from the face of the Earth. His plan is as follows. He wishes to associate himself with a number of gentlemen, (Say 20) who will agree to pay him $1000. a year for five years; at the end of which time, there would be a sufficient number of Pictures to form a fine Gallery, which would then be exhibited, and the profits be equally divided between him and the subscribers; the $5000. to go against his labor and the cost of the materials. His opinion is, that it would prove a better investment than any other in our Country. In order to guard against any loss to the subscribers, he would agree to work at the Gallery for one year, before receiving the first $1000. In case of his death, the pictures would be sold, and the subscribers be reimbursed, before his heirs would have a right to claim any part of the sums, arising from their sale. The subscribers would, in like manner, bind their heirs to fulfil the contract they shall enter

enter into. After the Exhibition had been seen a sufficient length of time in our own Country, it would be taken to Europe, where, no doubt, it would excite great curiosity, and yield a handsome profit.

1.33. Charles Deas, *Harbor Scene*, 1865.
Oil on canvasboard, 18 × 24 in. Collection
of Roger and Susan Ferguson.

and compelling now-lost picture called *A Vision*,
which Deas showed at the National Academy of
Design's annual exhibition of 1849, only one—
the critic for *Holden's Dollar Magazine*—wrote
that the artist had painted it during confine-
ment in an insane asylum.

Like other critics who saw *A Vision*, the re-
viewer in *Holden's* found it beautifully painted
but terrifying. He went on to specify its night-
marish terror: "The principal figure in the pic-
ture is the body of a naked youth which is ap-
parently falling into the bottomless pit and is
clenched by indescribable monsters that are
striving to pull it in opposite directions." The
image of falling brings to mind the plunging
horses in *The Death Struggle*, and the critic's fur-
ther designation of the picture as "a vision of

Hell" recalls Pliny Earle's description of the art-
ist's delusions as religious.

The *Holden's* critic was the only writer to attri-
bute both the picture's horror and its beauty to
the particular qualities of an insane mind:

No mind to which the realities of the world did
not present themselves in a distorted and con-
fused shape could have conceived such terrific
and unearthly forms. It makes the blood chill
and the brain ache to gaze upon the unnatural
horrors depicted upon the canvass [*sic*] when
it is remembered that they are but the reflec-
tions of a diseased mind, which carries about
with it such dire impressions. Some of the
countenances in this wild and terrific picture
are fearfully expressive of hopeless despair,

1.34. Charles Deas, *Temple Scene*, 1865. Oil on canvasboard, 18 × 24 in. Collection of Roger and Susan Ferguson.

and it is filled with those dim and half-revealed shapes of horror which afflict the feverish minds of the insane.[94]

Earle shared the conviction expressed here—that illness itself could foster imagination and creativity.[95]

A Vision was the last painting Deas showed at the National Academy of Design. The Art-Union continued to exhibit and to purchase Deas's work after he was confined to asylums, yet that organization still favored his western subjects. When Deas or a member of his family offered *A Vision* to the Art-Union managers, they declined to purchase or even to show it.[96] Did Deas paint other works like this? The only title that invites such speculation is *The Maniac,* a painting exhibited by its owner, a physician named John S. Clark, in Chicago in 1859. What this presumed portrait looked like, when Deas painted it, and how this midwestern physician acquired it are all pieces of a puzzle that currently defies solution.[97]

Deas painted religious and visionary subjects only as he deteriorated mentally, before and during his confinement to insane asylums. His visionary pictures exist, however, in contexts other than the asylum. About 1849, a few American artists painted pictures of terror in response to the cholera epidemic raging through New York and to a more generalized fear of a coming apocalypse.[98] *A Vision,* then, was embedded in its cultural moment and extends the ideas and emotions that Deas expressed in

1.35. Leopold Grozelier (American [b. France], 1830–1865), *Western Life, The Trapper*, ca. 1855 (after Charles Deas, *Long Jakes*). Lithograph printed in colors, 23⁹⁄₁₆ × 29⁵⁄₁₆ in. (sheet). Yale University Art Gallery, Mabel Brady Garvan Collection (1946.9.636).

works he painted before his mental illness. Like *The Trooper, The Death Struggle,* or *Prairie on Fire,* it is this artist's response to the terrors of unsettled times.

RETURN TO THE BLOOMINGDALE ASYLUM

The census takers recorded Deas in residence at Sanford Hall in 1850 and 1860, revealing nothing more than that he was there among thirty-four patients and a slightly greater number of caretakers. Perhaps in an effort to protect their privacy, the census taker in 1850 listed inmates of the Macdonalds' "Private Insane Institution" in Flushing by their initials. In 1860, the census taker restored Deas's identity and his profession: he is "Charles Deas, Artist." But as in 1850, he is categorized as "insane."[99]

Anne Deas died in 1863. In her will, she directed her entire estate to her daughter, Charlotte, with the provision that the proceeds be used for the "support and maintenance of

[her] son Charles."[100] In some way, financial or otherwise, his mother's death may have influenced Deas's move: in November 1863, he returned to Bloomingdale. According to the asylum's records, written sometime during his final three-and-a-half-year residency, he suffered from "dementia" and exhibited "mental and physical lethargy—keeps [to] his room— rarely speaks—has not been out of doors for years." There is, however, evidence that Deas was productive in his last years. A pair of paintings is signed and dated 1865 (figs. 1.33 and 1.34). These two pictures, completely different from anything else Deas is known to have made, document the profound change in his art over the course of his most severe mental illness— from an image of a naked youth attacked by monsters in the 1849 *A Vision* to two mild, derivative views of a port and of a temple complex that look as if they were inspired by prints, perhaps illustrations from volumes in the library at Bloomingdale.[101]

Except for the uncomprehending responses to *A Vision* in 1849, the press took little notice of Deas the few times his work was on public view between his confinement in 1848 and his death in 1867. One of these appearances, however, stimulated a new life for *Long Jakes.* The picture was shown in New York City in 1853 as part of an exhibition that celebrated, among other things, the painted image of George Washington. The critic for the *New-York Times* admired *Long Jakes,* and although he did not mention a connection, I wonder whether some of the patriotic fervor suffusing the exhibition might have rubbed off on the western trapper.[102] The art dealer Michael Knoedler may have encountered Deas's picture at the Washington Exhibition, for soon afterward, he published a fine, large lithograph of the picture (fig. 1.35). This lithograph, in turn, apparently inspired many folk artists to pay homage to Deas's trapper (see catalogue of works, cat. no. 55B).

A decade later, two of Deas's pictures were shown at exhibitions that benefited the Union cause during the Civil War: *Long Jakes* at New York's Metropolitan Fair and *Voyageurs* at the Mississippi Valley Sanitary Fair in St. Louis. Yet a mention of the artist in the *Crayon* in 1856 reads like the beginning of a story that conjures a painter from the distant past: "Some years ago, a young man by the name of Deas, sent to New York some excellent pictures of Western Indian life."[103] Two years later, Deas had a Mark Twain moment when his biographer, Tuckerman, mistakenly included his name among the dead.[104]

Deas, in fact, died of "apoplexy," perhaps a stroke or a cerebral hemorrhage, at the Bloomingdale Asylum on March 23, 1867, at the age of forty-eight.[105] To the end, his occupation was recorded as "artist." An obituary notice in the *New-York Times* invited "relatives and friends" to his funeral two days later at the Episcopal Church of the Ascension in New York City. His death certificate states that he was to be buried that day nearby, at St. Mark's Church cemetery. But like so much else about this artist that has been forgotten, St. Mark's Church has no record of his burial there and cannot find the site.

In May 1867, six weeks after Deas's death, the National Academy of Design's president, Daniel Huntington, commemorated the life of his fellow associate at the academy's annual meeting. Huntington noted Deas's achievement, citing his "characteristic pictures of wild border life." But Huntington dwelled more on the illness that had caused the artist to be "lost to the profession for many years" than on his art and offered his own diagnosis: Deas's "excessive devotion to his studies acting on a naturally nervous and sensitive temperament, disordered his body and mind."[106] Huntington might not have remembered that he and Deas had both been elected associate members of the academy in 1839, but the contrast between their careers might have occurred to him as he gave the brief eulogy.

Tuckerman published a new edition of his book on American artists the year that Deas died. To his earlier biographical sketch he added a single paragraph. He announced that the artist had died after living for years in asylums, but he also expressed belief that Deas's "talent even when manifest in the vagaries of a

diseased mind, was often effective; one of his wild pictures [probably *A Vision*] . . . was so horrible, that a sensitive artist fainted at the sight."[107] Tuckerman had the last word on Deas's life and art for many years.

NOTES

1. [J. Henry Carleton], journal entry dated August 16, 1844, "Occidental Reminiscences: Prairie Log Book; or, Rough Notes of a Dragoon Campaign to the Pawnee Villages in '44," *Spirit of the Times* 14, no. 40 (November 30, 1844): 475.

2. Records of the Bloomingdale Asylum, Medical Center Archives of New York–Presbyterian/Weill Cornell. (I extend thanks to archivist James Gehrlich.)

3. These quotations come from Tuckerman's unsigned sketch of John Gadsby Chapman, "Our Artists—No. II: Chapman," *Godey's Magazine and Lady's Book* 33 (September 1846): 117–20; reprinted in Henry T. Tuckerman, *Artist-Life; or, Sketches of American Painters* (New York: D. Appleton, 1847), 146–56. On *Godey's* circulation, see Frank Luther Mott, *A History of American Magazines* (Cambridge, Mass.: Harvard University Press, 1938), 1:581.

4. [Henry T. Tuckerman,] "Our Artists—No. V: Deas," *Godey's Magazine and Lady's Book* 33 (December 1846): 250–53; reprinted in Tuckerman, *Artist-Life*, 202–14.

5. Tuckerman, "Our Artists—No. V: Deas."

6. Tuckerman, "Our Artists—No. V: Deas." On Tuckerman and phrenology, see Charles Colbert, *A Measure of Perfection: Phrenology and the Fine Arts in America* (Chapel Hill: University of North Carolina Press, 1997). Colbert specifically mentions Tuckerman's assessment of Deas on p. 112.

7. Maurie D. McInnis illuminates this double portrait's political and cultural power and interprets it anew in "Cultural Politics, Colonial Crisis, and Ancient Metaphor in John Singleton Copley's *Mr. and Mrs. Ralph Izard,*" *Winterthur Portfolio* 32, nos. 2–3 (Summer–Fall 1999): 85–108. The Izards and their patronage figure prominently in the publication accompanying an exhibition at the Gibbes Museum of Art; see Maurie D. McInnis, Angela D. Mack, J. Thomas Savage, Robert A. Leath, and Susan Ricci Stebbins, *In Pursuit of Refinement: Charlestonians Abroad, 1740–1860* (Columbia: University of South Carolina Press, 1999).

8. Joyce E. Chaplin, "Ralph Izard," in *American National Biography Online* (Oxford University Press for the American Council of Learned Societies, 2000), www.anb.org/articles/02/02-00191.html; Anne Izard Deas, "A Memoir," in *Correspondence of Mr. Ralph Izard, of South Carolina, from the Year 1774 to 1804; with a Short Memoir,* ed. Anne Izard Deas (New York: Charles S. Francis, 1844), v–xiv and in letters therein. See also Langdon Cheves, "Izard of South Carolina," *South Carolina Historical and Genealogical Magazine* 2, no. 3 (July 1901): 205–40.

9. They "occupied a series of the very small houses between Ninth & Tenth Sts. on Spruce," near the winter residence of Anne Izard Deas's sister, Margaret Izard Manigault, whose "taste for literature made her house the centre of all the educated men and women of her time." See "Memoir of Joshua Francis Fisher," Cadwalader Collection, Historical Society of Pennsylvania, Philadelphia, excerpted in *The Diary of Harriet Manigault, 1813–1816,* ed. Virginia Armentrout and James Armentrout (Rockland, Maine: Colonial Dames of America, 1976), 141–45. See also Betty-Bright P. Low, "The Youth of 1812: More Excerpts from the Letters of Josephine du Pont and Margaret Manigault," *Winterthur Portfolio* 11 (1976): 173–212, and "Of Muslins and Merveilleuses: Excerpts from the Letters of Josephine du Pont and Margaret Manigault," *Winterthur Portfolio* 9 (1974): 29–75. (I am grateful to Robert Schwarz for bringing these articles to my attention.) Mrs. Izard is listed as a Philadelphia resident in many of the city's directories after 1809; she died there in 1832.

10. Anne Izard Deas was born in Paris in 1779 and died in New York in 1863. William Allen Deas (born in South Carolina in 1764; died in Pennsylvania in 1827) is listed as a merchant and a planter in many of the Charleston city directories between the years 1802 and 1816, though in some of those years his residence is listed as the same as that of Ralph Izard. Deas was a lawyer who practiced in Charleston and London, and he served in the South Carolina House of Representatives from 1790 to 1792 and from 1797 to 1800 and in the state senate from 1800 to 1804. See Emily Bellinger Reynolds and Joan Reynolds Faunt, *Biographical Directory of the Senate of the State of South Carolina, 1776–1964* (Columbia: South Carolina Archives Department, 1964), 204. In 1818 and 1819, he appears in the Philadelphia city directory at the northeast corner of Tenth and Spruce, very near his widowed mother-in-law, Alice DeLancey Izard, and he is listed as head of household in the 1820 census. Charles Deas's baptism is recorded on p. 71 in the Christ Church registry of baptisms (Historical Society of Pennsylvania).

11. Tuckerman, "Our Artists—No. V: Deas."

12. Tuckerman's mention of John Sanderson suggests that Deas might have followed the classical course

of training Sanderson advocated, very possibly in private tutoring. Sanderson held appointments in Philadelphia at the Clermont Seminary and later at the Philadelphia High School for Boys, but not during the time Deas would have been a pupil, which leads me to believe that Sanderson might have taught him privately. For information on Sanderson, see J. Thomas Scharf and Thompson Westcott, *History of Philadelphia, 1609–1884* (Philadelphia: L. H. Everts, 1884), 2:1139–40; Joseph Jackson, *Encyclopedia of Philadelphia* (Harrisburg, Penn.: National Historical Association, 1931), 2:473–74; and Henry Simpson, *The Lives of Eminent Philadelphians, Now Deceased* (Philadelphia: William Brotherhead, 1859), 865. (I am grateful to Nancy J. Halli for her help with the archives at the Historical Society of Pennsylvania, Philadelphia.)

13. Ralph Izard, *Correspondence of Mr. Ralph Izard, of South Carolina, from the Year 1774 to 1804; with a Short Memoir,* vol. 1, ed. Anne Izard Deas (New York: Charles S. Francis, 1844).

14. See Sully's *Hints to Young Painters and the Process of Portrait-Painting as Practiced by the Late Thomas Sully* (Philadelphia: J. M. Stoddart, 1873).

15. The Izards patronized Sully in Philadelphia and in Charleston. See Angela D. Mack and J. Thomas Savage, "Reflections of Refinement: Portraits of Charlestonians at Home and Abroad," in McInnis et al., *In Pursuit of Refinement,* 34–35, and "Catalogue of the Exhibition," 100–102.

16. Joseph Allen Smith, Anne Izard Deas's brother-in-law, possessed one of the most important art collections in early-nineteenth-century America. Part of the collection went to the Pennsylvania Academy of Fine Arts. See McInnis, "'Picture Mania': Collectors and Collecting in Charleston," in McInnis et al., *In Pursuit of Refinement.* See also Anna Wells Rutledge, *Cumulative Record of Exhibition Catalogues: The Pennsylvania Academy of the Fine Arts, 1807–1870; the Society of Artists, 1800–1814; the Artists' Fund Society, 1835–1845* (Philadelphia: American Philosophical Society, 1955; 1988–89 reprint with revisions) and *In This Academy: The Pennsylvania Academy of the Fine Arts, 1805–1976* (Philadelphia: Pennsylvania Academy of the Fine Arts, 1976).

17. The circumstances of the Deas family's life in the 1820s appear to have been unhappy. Correspondence in 1827 and 1828 concerning Edward Deas's application to West Point suggests severe financial and family trouble immediately following William Allen Deas's death on March 6, 1827 (his obituary appeared in *Poulson's American Daily Advertiser,* March 12, 1827). A rare look at William Allen Deas's life is included in a memoir written soon after the Civil War, in which he is remembered as someone of "melancholy aspect. He had killed

his uncle in a duel, which he engaged in to avenge an insult to his Father's honour, and never could get over the effects of it." The memoir went on to characterize the family: "They had a number of sons,—some in the Naval and Military service, one an Artist, all, I believe, unhappy in their career, and one daughter, Charlotte, a very handsome girl, married to Dr. Watts of New York." Quotations are from "Excerpts from a Memoir of Joshua Francis Fisher (1807–1873)," in *Diary of Harriet Manigault,* 143.

18. Stuart Blumin, "Mobility and Change in Ante-Bellum Philadelphia," in *Nineteenth-Century Cities: Essays in the New Urban History,* ed. Stephan Thernstrom and Richard Sennett, 165–208 (New Haven, Conn.: Yale University Press, 1969).

19. Anne Izard Deas, Philadelphia, to Henry Clay, Washington, D.C., April 4, 1827 (National Archives, Record Group 94).

20. Abraham Eustis, Fortress Monroe, Virginia, to Major Charles J. Nourse, Washington, D.C., February 18, 1828 (National Archives, Record Group 94).

21. According to the archives of Trinity Episcopal Church, Saugerties, Anne Deas was among the first communicants in the new church, which was dedicated in 1831. The family name appears in the archives in the 1830s for pew payments, baptisms, confirmations, and deaths. Charles Deas was confirmed on July 21, 1836. (I am grateful to Ulster County historian Karlyn Knaust Elia, Amanda Jones, Audrey Klinkenberg, and Rev. Jeffrey R. Turczyn for their generous help during my visit to Saugerties in June 2003.)

22. Tuckerman, "Our Artists—No. V: Deas."

23. Henry Barclay, Saugerties, New York, to Nathaniel P. Tallmadge, December 9, 1835 (National Archives, Record Group 94). Barclay was a member of Anne Izard Deas's extended family. Anne Deas had some resources. At her mother's death in 1832, she inherited the house in Philadelphia and the bulk of the estate (a microform copy of Alice DeLancey Izard's will is at the Historical Society of Pennsylvania). By 1835, two of her four sons had entered the military (Edward graduated from the United States Military Academy in 1832 and was in the army; Fitz Allen had risen to the rank of lieutenant in the navy). Charles was the youngest of the three children who may have been living at home in 1835. (Thanks to William P. MacKinnon for bringing to my attention records concerning the military careers of Deas's brothers and to Merl M. Moore, Jr., for locating the records in the National Archives.)

24. Their July 7 marriage at Chesnut Lodge (the home of Anne Izard Deas) in Ulster, New York, was recorded in the *New-York American,* July 11, 1836, 2. Watts inherited $25,000 that year from his uncle's very substantial

estate; see *The Letters and Journals of James Fenimore Cooper,* ed. James Franklin Beard (Cambridge, Mass.: Harvard University Press, 1964), 3:241n3. National Academy of Design catalogues and enrollment records give the following addresses for Deas in these early years: 33 Pearl Street (spring 1838 NAD annual); Saugerties, Ulster County (spring 1839 NAD annual); and 63 Franklin Street (fall 1839 enrollment at the NAD Life School and spring 1840 NAD annual). He is never listed in the New York City directories. He is recorded as a sponsor at the baptism of another nephew, William Allen Deas, son of his brother Fitz Allen, at Ulster's Trinity Episcopal Church on June 8, 1839.

25. Peter Augustus Jay, a prominent attorney in New York City, wrote to Morse to introduce Deas, who, he wrote, "has come to this city for the purpose of studying the beautiful art." Letter of November 3, 1837 (Samuel Finley Breese Morse Papers, Manuscript Division, Library of Congress, Washington, D.C.). Jay proclaimed himself a friend of the family but professed not to have met the young artist; Jay may even have confused him with one of Charles's brothers, for Jay called him George. I am grateful to Paul Staiti for his transcription of this letter, cited in Donald Ross Thayer, "Art Training in the National Academy of Design, 1825–1835," Ph.D. dissertation, University of Missouri, 1978, 271n72. Thayer did not mention that Jay referred to George and may have assumed, as I do, that Jay meant Charles. George, one of Charles's older brothers, entered the army from Pennsylvania on August 1, 1838, so it is possible, though unlikely, that Jay actually meant to introduce him.

26. My thanks to John Davis for the citation to Morse's report.

27. Robert Watts, Jr., was associated with the National Academy, to which he was elected an honorary member in 1845, as professor of anatomy from 1839 to 1852; see Lois Marie Fink and Joshua C. Taylor, *Academy: The Academic Tradition in American Art* (Washington, D.C.: Smithsonian Institution Press for the National Collection of Fine Arts, 1975), 111–12. (I am grateful to Abigail Booth Gerdts, David Dearinger, and Mark Mitchell for the generous help they have given me over the years in navigating the academy's archives. I am indebted to Stephen E. Novak, head of archives and special collections at the A. C. Long Health Sciences Library at Columbia University, for information about Watts's professorship at the College of Physicians and Surgeons, which began in 1839 and lasted until his death.)

28. *Catalogue . . . of the Exhibition of Select Paintings, by Modern Artists* (New York: Stuyvesant Institute, 1838). This is the so-called Dunlap Exhibition, organized to raise funds for art historian William Dunlap. Peter G. Stuyvesant lent *Turkey Shooting* to this show.

29. "Charles Deas," *New-York Mirror,* November 9, 1839, 159.

30. The year he purchased *Turkey Shooting,* Stuyvesant also commissioned from Thomas Cole the pair of elegiac pictures *Past* and *Present* (currently at Mead Art Museum, Amherst College), which Alan Wallach has argued "allegorized aristocracy in decline, idealizing aristocratic strength and authority while at the same time mourning their passage." Wallach, "Thomas Cole and the Aristocracy," *Arts Magazine* 56, no. 3 (November 1981): 98. On aristocratic patronage and the assertion of cultural power in American art during these years, see also Wallach, "Thomas Cole: Landscape and the Course of American Empire," in *Thomas Cole: Landscape into History,* ed. William H. Truettner and Alan Wallach, 23–111 (New Haven, Conn.: Yale University Press; Washington, D.C.: National Museum of American Art, Smithsonian Institution, 1994). On Stuyvesant, see *National Cyclopedia* (1893), 8:462; R. W. G. Vail, *Knickerbocker Birthday: A Sesqui-Centennial History of the New-York Historical Society, 1804–1954* (New York: New-York Historical Society, 1954), 77–82; and *Catalogue of American Portraits in the New-York Historical Society* (New Haven, Conn.: Yale University Press for the New-York Historical Society, 1974), 2:783–84. On the patrician class of which Stuyvesant was a member, see Edwin G. Burrows and Mike Wallace, *Gotham: A History of New York City to 1898* (New York: Oxford University Press, 1999), chap. 28 ("The Medici of the Republic") and 712–13.

31. Tuckerman, "Our Artists—No. V: Deas."

32. The *New-York Commercial Advertiser* carried an announcement on June 17, 1839, that Catlin's Indian Gallery was on view at the Stuyvesant Institute. The same issue included Deas's *Devil and Tom Walker* and *Walking the Chalk* in a review of the annual exhibition at the National Academy of Design. For a summary of Catlin's shows and lectures in New York, see Paul Reddin, *Wild West Shows* (Urbana: University of Illinois Press, 1999), chap. 1, "'The Raw Material of America': George Catlin and the Beginnings of Wild West Shows."

33. Deas's *Scene from Shakspeare* [sic]—*Hamlet and Polonius* is recorded in the *Catalogue of Paintings &c. by Modern Artists* (New York: Apollo Association, 1839). On the exhibition and reception of Miller's pictures in New York, see Ron Tyler, "Alfred Jacob Miller and Sir William Drummond Stewart," in *Alfred Jacob Miller: Artist on the Oregon Trail,* ed. Ron Tyler (Fort Worth, Tex.: Amon Carter Museum, 1982), 36–39.

34. Quoted in Lillian B. Miller, *Patrons and Patriotism: The Encouragement of the Fine Arts in the United States,*

1790–1860 (Chicago: University of Chicago Press, 1966), 164.

35. [Lewis Gaylord Clark?], "National Academy of Design," *Knickerbocker* 16, no. 1 (July 1840): 82. David Dearinger proposes Clark, the *Knickerbocker*'s editor and publisher, as the author; see Dearinger, "Annual Exhibitions and the Birth of American Art Criticism to 1865," in *Rave Reviews: American Art and Its Critics, 1826–1925,* ed. David B. Dearinger (New York: National Academy of Design, 2000), 68. Clark praised the genre paintings of Francis William Edmonds; on the reception of William Sidney Mount's pictures at this show, see Elizabeth Johns, *American Genre Painting: The Politics of Everyday Life* (New Haven, Conn.: Yale University Press, 1991), 57. More generally on Mount's patronage, see Franklin Kelly, "Mount's Patrons," in *William Sidney Mount: Painter of American Life,* by Deborah J. Johnson, with essays by Elizabeth Johns, Franklin Kelly, and Bernard F. Reilly, Jr., 109–31 (New York: American Federation of Arts, 1998).

36. See chapter 10 of Washington Irving, *A Tour on the Prairies* (1835), ed. John Francis McDermott (Norman: University of Oklahoma Press, 1956); quotation is from p. 55.

37. Eliza R. Steele's description of her trip from New York City to St. Louis (and beyond) in the summer of 1840 is a useful guide to a possible reconstruction of Deas's experiences; see Steele, *A Summer Journey in the West* (New York: John S. Taylor, 1841).

38. National Archives, Record Group 75, manuscript 234, roll 79. The treaty gives the site's name as "Oeyoowarha," which must be a phonetical translation of "Oiyuwege," the Dakota name for Traverse des Sioux. The 1851 treaty ratified by the Senate is called the Treaty of Traverse des Sioux. (My thanks to Lisa Krahn, formerly the site manager at Sibley House Historic Site, for bringing this information to my attention, and to Bob Sandeen, research coordinator at the Nicollet County Historical Society, Minnesota, for untangling the Dakota names for me.) See also Rhoda R. Gilman, "A Northwestern Indian Territory—The Last Voice," *Journal of the West* 39, no. 1 (January 2000): 16–22.

39. Deas followed a tradition of heroic dog portraits established in England by George Stubbs (1724–1806). The English practice of domestic animal portraiture was taken up in America by Thomas Doughty, among others. A recent biography of Sibley is Rhoda R. Gilman, *Henry Hastings Sibley: Divided Heart* (St. Paul: Minnesota Historical Society, 2004).

40. John C. Frémont, *Memoirs of My Life,* vol. 1 (Chicago: Belford, Clarke, 1887), 32–33.

41. For a discussion of continuities between East and West during the time Deas moved to St. Louis, see Andrew R. L. Cayton and Peter S. Onuf, *The Midwest and the Nation: Rethinking the History of an American Region* (Bloomington: Indiana University Press, 1990); and Richard C. Wade, *The Urban Frontier: The Rise of Western Cities, 1790–1830* (Cambridge, Mass.: Harvard University Press, 1959). Wade develops the idea that the "special source of municipal wisdom was Philadelphia" (318).

42. History relating to Deas and the Moses family comes from the family archives, related to me in an interview with Edna Moses in Daphne, Alabama, on March 3, 2001. Information on the Gratz family in St. Louis may be found in J. Thomas Scharf, *History of Saint Louis City and County, from the Earliest Periods to the Present Day* (Philadelphia: L. H. Evarts, 1883), 2:1531–32 and 1548–50; William Hyde and Howard L. Conard, *Encyclopedia of the History of Saint Louis* (New York, Louisville, and St. Louis: Southern History Company, 1899), 3:1574–75; and Walter Ehrlich, *Zion in the Valley: The Jewish Community of St. Louis,* vol. 1 (Columbia: University of Missouri Press, 1997).

43. *Daily Missouri Republican,* November 27, 1841, 2.

44. Documentary material on the St. Louis Mechanics' Institute is fragmentary. Newspaper reviews record the contents of the fairs, for which there were no published catalogues. The few records that survive are held by the Jefferson National Expansion Memorial Archives and the Missouri Historical Society. On the history and consequence of mechanics' institutes, particularly in New York, see Ethan Robey, "The Utility of Art: Mechanics' Institute Fairs in New York City, 1828–1876," Ph.D. dissertation, Columbia University, 2000.

45. "Mechanics' Institute," *Daily Missouri Republican,* November 27, 1841, 2.

46. Thomas L. McKenney and James Hall, *History of the Indian Tribes of North America* (Philadelphia: Edward C. Biddle [etc.], 1836–44).

47. "List of Articles Exhibited at the Fair of the Mechanics' Institute, Concluded," *Daily Missouri Republican,* November 7, 1842, 2.

48. Lewis Foulk Thomas, *Inda: A Legend of the Lakes; with Other Poems* (St. Louis: Vespasian Ellis, 1842), 18n4. Emphasis in the original.

49. Deas was elected a resident member of the Mechanics' Institute of St. Louis on November 17, 1842 (typescript of the constitution and by-laws of the Mechanics' Institute of St. Louis, 1839, Missouri Historical Society). He accepted the offer of membership in a letter dated December 1, 1842, to George W. West (Mechanics' Institute of St. Louis Records, circa 1830–1894, box 1, folder 21, National Park Service, Jefferson National Expansion Memorial Archives). Deas is listed in *Green's Saint Louis Directory for 1845*

(St. Louis, 1844) and *Green's Saint Louis Directory for 1847* (St. Louis, 1847). His address is listed there as 97 Chesnut Street, with "upstairs" added in 1847. (The spelling of the street's name was changed to "Chestnut" in 1893.)

50. John Brown [Richard S. Elliott], "Movements among the Red Skins," *St. Louis Weekly Reveille,* October 7, 1844, 97. On Elliott and the *Reveille,* see Nicholas Joost, "Reveille in the West: Western Travelers in the *St. Louis Weekly Reveille, 1844–1850,*" in *Travelers on the Western Frontier,* ed. John F. McDermott, 203–40 (Urbana: University of Illinois Press, 1970).

51. [J. Henry Carleton], journal entry dated August 12, 1844, "Occidental Reminiscences: Prairie Log Book; or, Rough Notes of a Dragoon Campaign to the Pawnee Villages in '44," *Spirit of the Times* 14, no. 37 (November 9, 1844): 439.

52. Clifton Wharton, "The Expedition of Major Clifton Wharton in 1844," *Collections of the Kansas State Historical Society* 16 (1923–25): 272–73.

53. "National Academy of Design," *New York Herald,* May 26, 1844, 1.

54. "The Extraordinary Masterpiece of Art . . ." *New Mirror* 3, no. 24 (September 14, 1844): 384.

55. "The Art Union Pictures," *Broadway Journal,* January 4, 1845, 13.

56. Deas's association with art unions began with the acceptance of his work at the Apollo Association's shows in 1839 and 1840. By 1844, the association had changed its name to the American Art-Union. Early studies of the American Art-Union are Charles E. Baker, "The American Art-Union," *American Academy of Fine Arts and American Art-Union,* vol. 1, by Mary Bartlett Cowdrey, 95–240 (New York: New-York Historical Society, 1953); and Maybelle Mann, *The American Art-Union* (Otisville, N.Y.: ALM Associates, 1977). Recent critical assessments include Rachel N. Klein, "Art and Authority in Antebellum New York City: The Rise and Fall of the American Art-Union," *Journal of American History* 81, no. 4 (March 1995): 1534–61; and Patricia Hills, "The American Art-Union as Patron for Expansionist Ideology in the 1840s," *Art in Bourgeois Society, 1790–1850,* ed. Andrew Hemingway and William Vaughan, 314–39 (Cambridge: Cambridge University Press, 1998).

57. *The Rose of Sharon: A Religious Souvenir,* ed. S. C. Edgarton (Boston: A. Tomkins, 1847), 109–110.

58. *St. Louis Weekly Reveille,* August 31, 1846, 980. The picture reviewed is *The Last Shot,* now unlocated.

59. *St. Louis Weekly Reveille,* October 12, 1846, 1032. Emphasis in the original.

60. Charles Deas, St. Louis, to R. F. Fraser, corresponding secretary, American Art-Union, November 7,

1846 (American Art-Union papers, New-York Historical Society).

61. Both manuscript petitions, with slight variations between them, are dated November 25, 1846. (The Senate copy is in the archives of the Architect of the Capitol, Requests for Commissions and Appointments, 1841–1928, and the House copy is in the National Archives, Record Group 128 (House), 29th Congress, On the Library. Each was referred to the committee on the library, where it died. I am grateful to Rodney A. Ross for helping me locate the two petitions. See also Charles E. Fairman, *Art and Artists of the Capitol of the United States of America* (Washington, D.C.: Government Printing Office, 1927), 107. Vivien Green Fryd offers context for Deas's entry in *Art and Empire: The Politics of Ethnicity in the United States Capitol, 1815–1860* (New Haven, Conn.: Yale University Press, 1998).

62. "American Works of Painting and Sculpture," *United States Magazine and Democratic Review* 20, no. 103 (January 1847): 64.

63. "The Trapper—A Picture by Mr. Deas," *St. Louis Weekly Reveille,* February 8, 1847, 163.

64. "A New Picture by Deas," *St. Louis Weekly Reveille,* August 31, 1846, 980.

65. "Fine Arts," *Anglo American* 8, no. 16 (February 6, 1847): 381.

66. "The Art Union Pictures," The Fine Arts, *Literary World* 2, no. 39 (October 30, 1847): 303.

67. One of the few surviving letters in Deas's hand reveals his exhibition and sales plan for these pictures. He wrote to the National Academy's curator, John F. E. Prud'homme, on February 1, 1847, to inform Prud'homme that he had just sent two works (*Voyageurs* [cat. no. 73] and *The Mountain Pass* [cat. no. 75]) to New York for exhibition at the academy's spring annual. He priced them at $200 each and asked Prud'homme to send them to the Art-Union at the close of the academy exhibition if they had not sold (John F. Kensett Papers, Manuscripts and Special Collections, New York State Library, Albany). (My thanks to Wendy Owens for alerting me to this letter.)

68. *St. Louis Weekly Reveille,* February 15, 1847, 171.

69. "Gossip of the Month: The Arts," *United States Magazine and Democratic Review* 20, no. 107 (May 1847): 464.

70. "National Academy of Design," *Anglo-American* 9, no. 3 (May 8, 1847): 69.

71. "Exhibition at the National Academy," The Fine Arts, *Literary World* 1, no. 17 (May 29, 1847): 397.

72. For an interesting comparison between the spirituality of Cole's *Manhood* and the secular voyage of George Caleb Bingham's *Fur Traders Descending the Missouri,* see David Lubin, *Picturing a Nation: Art*

1790–1860 (Chicago: University of Chicago Press, 1966), 164.

35. [Lewis Gaylord Clark?], "National Academy of Design," *Knickerbocker* 16, no. 1 (July 1840): 82. David Dearinger proposes Clark, the *Knickerbocker*'s editor and publisher, as the author; see Dearinger, "Annual Exhibitions and the Birth of American Art Criticism to 1865," in *Rave Reviews: American Art and Its Critics, 1826–1925,* ed. David B. Dearinger (New York: National Academy of Design, 2000), 68. Clark praised the genre paintings of Francis William Edmonds; on the reception of William Sidney Mount's pictures at this show, see Elizabeth Johns, *American Genre Painting: The Politics of Everyday Life* (New Haven, Conn.: Yale University Press, 1991), 57. More generally on Mount's patronage, see Franklin Kelly, "Mount's Patrons," in *William Sidney Mount: Painter of American Life,* by Deborah J. Johnson, with essays by Elizabeth Johns, Franklin Kelly, and Bernard F. Reilly, Jr., 109–31 (New York: American Federation of Arts, 1998).

36. See chapter 10 of Washington Irving, *A Tour on the Prairies* (1835), ed. John Francis McDermott (Norman: University of Oklahoma Press, 1956); quotation is from p. 55.

37. Eliza R. Steele's description of her trip from New York City to St. Louis (and beyond) in the summer of 1840 is a useful guide to a possible reconstruction of Deas's experiences; see Steele, *A Summer Journey in the West* (New York: John S. Taylor, 1841).

38. National Archives, Record Group 75, manuscript 234, roll 79. The treaty gives the site's name as "Oeyoowarha," which must be a phonetical translation of "Oiyuwege," the Dakota name for Traverse des Sioux. The 1851 treaty ratified by the Senate is called the Treaty of Traverse des Sioux. (My thanks to Lisa Krahn, formerly the site manager at Sibley House Historic Site, for bringing this information to my attention, and to Bob Sandeen, research coordinator at the Nicollet County Historical Society, Minnesota, for untangling the Dakota names for me.) See also Rhoda R. Gilman, "A Northwestern Indian Territory—The Last Voice," *Journal of the West* 39, no. 1 (January 2000): 16–22.

39. Deas followed a tradition of heroic dog portraits established in England by George Stubbs (1724–1806). The English practice of domestic animal portraiture was taken up in America by Thomas Doughty, among others. A recent biography of Sibley is Rhoda R. Gilman, *Henry Hastings Sibley: Divided Heart* (St. Paul: Minnesota Historical Society, 2004).

40. John C. Frémont, *Memoirs of My Life,* vol. 1 (Chicago: Belford, Clarke, 1887), 32–33.

41. For a discussion of continuities between East and West during the time Deas moved to St. Louis, see Andrew R. L. Cayton and Peter S. Onuf, *The Midwest and the Nation: Rethinking the History of an American Region* (Bloomington: Indiana University Press, 1990); and Richard C. Wade, *The Urban Frontier: The Rise of Western Cities, 1790–1830* (Cambridge, Mass.: Harvard University Press, 1959). Wade develops the idea that the "special source of municipal wisdom was Philadelphia" (318).

42. History relating to Deas and the Moses family comes from the family archives, related to me in an interview with Edna Moses in Daphne, Alabama, on March 3, 2001. Information on the Gratz family in St. Louis may be found in J. Thomas Scharf, *History of Saint Louis City and County, from the Earliest Periods to the Present Day* (Philadelphia: L. H. Evarts, 1883), 2:1531–32 and 1548–50; William Hyde and Howard L. Conard, *Encyclopedia of the History of Saint Louis* (New York, Louisville, and St. Louis: Southern History Company, 1899), 3:1574–75; and Walter Ehrlich, *Zion in the Valley: The Jewish Community of St. Louis,* vol. 1 (Columbia: University of Missouri Press, 1997).

43. *Daily Missouri Republican,* November 27, 1841, 2.

44. Documentary material on the St. Louis Mechanics' Institute is fragmentary. Newspaper reviews record the contents of the fairs, for which there were no published catalogues. The few records that survive are held by the Jefferson National Expansion Memorial Archives and the Missouri Historical Society. On the history and consequence of mechanics' institutes, particularly in New York, see Ethan Robey, "The Utility of Art: Mechanics' Institute Fairs in New York City, 1828–1876," Ph.D. dissertation, Columbia University, 2000.

45. "Mechanics' Institute," *Daily Missouri Republican,* November 27, 1841, 2.

46. Thomas L. McKenney and James Hall, *History of the Indian Tribes of North America* (Philadelphia: Edward C. Biddle [etc.], 1836–44).

47. "List of Articles Exhibited at the Fair of the Mechanics' Institute, Concluded," *Daily Missouri Republican,* November 7, 1842, 2.

48. Lewis Foulk Thomas, *Inda: A Legend of the Lakes; with Other Poems* (St. Louis: Vespasian Ellis, 1842), 18n4. Emphasis in the original.

49. Deas was elected a resident member of the Mechanics' Institute of St. Louis on November 17, 1842 (typescript of the constitution and by-laws of the Mechanics' Institute of St. Louis, 1839, Missouri Historical Society). He accepted the offer of membership in a letter dated December 1, 1842, to George W. West (Mechanics' Institute of St. Louis Records, circa 1830–1894, box 1, folder 21, National Park Service, Jefferson National Expansion Memorial Archives). Deas is listed in *Green's Saint Louis Directory for 1845*

(St. Louis, 1844) and *Green's Saint Louis Directory for 1847* (St. Louis, 1847). His address is listed there as 97 Chesnut Street, with "upstairs" added in 1847. (The spelling of the street's name was changed to "Chestnut" in 1893.)

50. John Brown [Richard S. Elliott], "Movements among the Red Skins," *St. Louis Weekly Reveille,* October 7, 1844, 97. On Elliott and the *Reveille,* see Nicholas Joost, "Reveille in the West: Western Travelers in the *St. Louis Weekly Reveille, 1844–1850,*" in *Travelers on the Western Frontier,* ed. John F. McDermott, 203–40 (Urbana: University of Illinois Press, 1970).

51. [J. Henry Carleton], journal entry dated August 12, 1844, "Occidental Reminiscences: Prairie Log Book; or, Rough Notes of a Dragoon Campaign to the Pawnee Villages in '44," *Spirit of the Times* 14, no. 37 (November 9, 1844): 439.

52. Clifton Wharton, "The Expedition of Major Clifton Wharton in 1844," *Collections of the Kansas State Historical Society* 16 (1923–25): 272–73.

53. "National Academy of Design," *New York Herald,* May 26, 1844, 1.

54. "The Extraordinary Masterpiece of Art . . ." *New Mirror* 3, no. 24 (September 14, 1844): 384.

55. "The Art Union Pictures," *Broadway Journal,* January 4, 1845, 13.

56. Deas's association with art unions began with the acceptance of his work at the Apollo Association's shows in 1839 and 1840. By 1844, the association had changed its name to the American Art-Union. Early studies of the American Art-Union are Charles E. Baker, "The American Art-Union," *American Academy of Fine Arts and American Art-Union,* vol. 1, by Mary Bartlett Cowdrey, 95–240 (New York: New-York Historical Society, 1953); and Maybelle Mann, *The American Art-Union* (Otisville, N.Y.: ALM Associates, 1977). Recent critical assessments include Rachel N. Klein, "Art and Authority in Antebellum New York City: The Rise and Fall of the American Art-Union," *Journal of American History* 81, no. 4 (March 1995): 1534–61; and Patricia Hills, "The American Art-Union as Patron for Expansionist Ideology in the 1840s," *Art in Bourgeois Society, 1790–1850,* ed. Andrew Hemingway and William Vaughan, 314–39 (Cambridge: Cambridge University Press, 1998).

57. *The Rose of Sharon: A Religious Souvenir,* ed. S. C. Edgarton (Boston: A. Tomkins, 1847), 109–110.

58. *St. Louis Weekly Reveille,* August 31, 1846, 980. The picture reviewed is *The Last Shot,* now unlocated.

59. *St. Louis Weekly Reveille,* October 12, 1846, 1032. Emphasis in the original.

60. Charles Deas, St. Louis, to R. F. Fraser, corresponding secretary, American Art-Union, November 7, 1846 (American Art-Union papers, New-York Historical Society).

61. Both manuscript petitions, with slight variations between them, are dated November 25, 1846. (The Senate copy is in the archives of the Architect of the Capitol, Requests for Commissions and Appointments, 1841–1928, and the House copy is in the National Archives, Record Group 128 (House), 29th Congress, On the Library. Each was referred to the committee on the library, where it died. I am grateful to Rodney A. Ross for helping me locate the two petitions. See also Charles E. Fairman, *Art and Artists of the Capitol of the United States of America* (Washington, D.C.: Government Printing Office, 1927), 107. Vivien Green Fryd offers context for Deas's entry in *Art and Empire: The Politics of Ethnicity in the United States Capitol, 1815–1860* (New Haven, Conn.: Yale University Press, 1998).

62. "American Works of Painting and Sculpture," *United States Magazine and Democratic Review* 20, no. 103 (January 1847): 64.

63. "The Trapper—A Picture by Mr. Deas," *St. Louis Weekly Reveille,* February 8, 1847, 163.

64. "A New Picture by Deas," *St. Louis Weekly Reveille,* August 31, 1846, 980.

65. "Fine Arts," *Anglo American* 8, no. 16 (February 6, 1847): 381.

66. "The Art Union Pictures," The Fine Arts, *Literary World* 2, no. 39 (October 30, 1847): 303.

67. One of the few surviving letters in Deas's hand reveals his exhibition and sales plan for these pictures. He wrote to the National Academy's curator, John F. E. Prud'homme, on February 1, 1847, to inform Prud'homme that he had just sent two works (*Voyageurs* [cat. no. 73] and *The Mountain Pass* [cat. no. 75]) to New York for exhibition at the academy's spring annual. He priced them at $200 each and asked Prud'homme to send them to the Art-Union at the close of the academy exhibition if they had not sold (John F. Kensett Papers, Manuscripts and Special Collections, New York State Library, Albany). (My thanks to Wendy Owens for alerting me to this letter.)

68. *St. Louis Weekly Reveille,* February 15, 1847, 171.

69. "Gossip of the Month: The Arts," *United States Magazine and Democratic Review* 20, no. 107 (May 1847): 464.

70. "National Academy of Design," *Anglo-American* 9, no. 3 (May 8, 1847): 69.

71. "Exhibition at the National Academy," The Fine Arts, *Literary World* 1, no. 17 (May 29, 1847): 397.

72. For an interesting comparison between the spirituality of Cole's *Manhood* and the secular voyage of George Caleb Bingham's *Fur Traders Descending the Missouri,* see David Lubin, *Picturing a Nation: Art*

and *Social Change in Nineteenth-Century America* (New Haven, Conn.: Yale University Press, 1994), 59–62. See also Joy S. Kasson, "*The Voyage of Life:* Thomas Cole and Romantic Disillusionment," *American Quarterly* 27 (March 1975): 42–56; and Wallach, "Thomas Cole," esp. 39–42.

73. Records of the St. Louis Mercantile Library Association, meeting of March 10, 1846.

74. Wooll had a shop in St. Louis by 1842, and by 1846 Deas's paintings were on view there, perhaps as single showings. See "A New Picture by Deas," *St. Louis Weekly Reveille,* August 31, 1846, 980. Deas may have also shown his work at Jones's, which was very close to Wooll's on Fourth Street. See mention of Bingham's work at Jones's in "Very Fine Paintings," *St. Louis Weekly Reveille,* March 23, 1846, 798.

75. Tuckerman, "Our Artists—No. V: Deas."

76. How and Mitchell are associated with the four portraits of Winnebagoes now at the Mercantile Library. Yeatman lent *Voyageurs* to the First Annual Exhibition of the Western Academy of Art (St. Louis, 1860) and to the Art Gallery of the Mississippi Valley Sanitary Fair (St. Louis, 1864).

77. "Mr. Deas," *Literary World* 1, no. 12 (April 24, 1847): 280; reprinted as "Mr. Chas. Deas," *St. Louis Weekly Reveille,* May 10, 1847, 270.

78. The *New York Morning Express* (May 20, 1847) reported that Deas was "on a visit to this city, where, we believe he intends to spend the summer" (1). The *St. Louis Weekly Reveille* reported on August 23, 1847, that Deas was at Newport, Rhode Island, and that "he does not intend to return to St. Louis, but will settle in New York" (390).

79. Charles Lanman, *A Summer in the Wilderness: Embracing a Canoe Voyage up the Mississippi and around Lake Superior* (New York: D. Appleton, 1847), 15–17.

80. *Art-Union Monthly Journal* (London), June 1, 1847, 216.

81. "A New Painting, by Deas," *St. Louis Weekly Reveille,* November 1, 1847, 468.

82. My two guides through religious art in the 1840s have been David Carew Huntington, *Art and the Excited Spirit: America in the Romantic Period* (Ann Arbor: University of Michigan Museum of Art, 1972); and Gail E. Husch, *Something Coming: Apocalyptic Expectation and Mid-Nineteenth-Century American Painting* (Hanover, N.H.: University Press of New England, 2000).

83. The quotations are from "National Academy Exhibition," The Fine Arts, *Literary World,* June 3, 1848, 350; and "Charles Deas, the Artist," *New York Evening Express,* June 27, 1848, [3] (emphasis in the original). (The *Express* story had a national life: the *Boston Transcript* cited it in a mention of Deas's health on June 28, and St. Louis's *Daily Missouri Republican* picked up and reprinted the notice on July 6, 1848.) The *Catalogue of the Twenty-Third Annual Exhibition* (New York: National Academy of Design, 1848) lists Deas's address as "N.Y. University." However, Deas's name does not appear on the roster of tenants of the University Building at New York University. Assuming that the National Academy of Design address is correct, Deas might have rented space there and not been recorded (the register is not complete), or he may have used someone else's address in the months before he entered Bloomingdale. (I am grateful to Nancy Cricco and Teresa Mora of the New York University Library for their help in searching through the rosters.)

84. For an early description of the Bloomingdale Asylum, see William Logie Russell, *The New-York Hospital: A History of the Psychiatric Service, 1771–1936* (New York: Columbia University Press, 1945), 132–34. Conditions of housing varied according to social position and illness. By the time Deas arrived, paupers had been moved to the new building of the city's public asylum on Blackwell's Island. See also Gerald Grob, *Mental Institutions in America: Social Policy to 1875* (New York: Free Press, 1972). On the site and architecture of Bloomingdale, see Andrew S. Dolkart, *Morningside Heights: A History of Its Architecture and Development* (New York: Columbia University Press, 1998), 13–35.

85. Governors of the New York Hospital "Annual Report," 1842, 7, quoted in David J. Rothman, *The Discovery of the Asylum: Social Order and Disorder in the New Republic* (Boston: Little, Brown, 1971), 152.

86. Pliny Earle, *History, Description and Statistics of the Bloomingdale Asylum for the Insane* (New York: Egbert, Hovey and King, 1848), 26. Much can be learned of Earle's practices from the four annual reports he wrote (24th–27th) for the years 1844–47. There seems to have been no report published for the year 1848, the one during which Deas was admitted, perhaps because, according to his biographer, Earle (who went on to continue his distinguished career at the state hospital for the insane in Northampton, Massachusetts) left Bloomingdale in 1849 after a period of depression. See *Memoirs of Pliny Earle, M.D.,* edited and with an introduction by F. B. Sanborn (Boston: Damrell and Upham, 1898).

87. Records of the Bloomingdale Asylum, Medical Center Archives of NewYork–Presbyterian/Weill Cornell; and Pliny Earle Papers, American Antiquarian Society, Lists of Patients and Notes on Cases, box 5, folder 3.

88. A contemporary treatise that defines mania is E. Esquirol, *Mental Maladies, a Treatise on Insanity,* trans. E. K. Hunt (Philadelphia: Lea and Blanchard,

1845; facsimile ed., New York: Hafner Publishing, 1965), 378. On the meaning of various diagnoses in the nineteenth century, see John Charles Bucknill and Daniel H. Tuke, *A Manual of Psychological Medicine* (Philadelphia: Blanchard and Lea, 1858; facsimile ed., New York: Hafner Publishing, 1968); and Norman Dain, *Concepts of Insanity in the United States, 1789–1865* (New Brunswick, N.J.: Rutgers University Press, 1964). See also Rothman, *Discovery of the Asylum,* chaps. 5 ("Insanity and the Social Order") and 6 ("The New World of the Asylum").

89. Earle, *History,* 91–92.

90. A contemporary defense of mesmerism that also cites its cure of insanity is George Sandby, *Mesmerism and Its Opponents; with a Narrative of Cases* (London: Longman, Brown, Green, and Longmans, 1844). Mesmerism was used in the institutional treatment of insanity, although there is no evidence that it was employed at Bloomingdale. Studies of mesmerism include Robert Darnton, *Mesmerism and the End of the Enlightenment in France* (Cambridge, Mass.: Harvard University Press, 1968); Robert C. Fuller, *Mesmerism and the American Cure of Souls* (Philadelphia: University of Pennsylvania Press, 1982); and Alison Winter, *Mesmerized: Powers of Mind in Victorian Britain* (Chicago: University of Chicago Press, 1998).

91. For specific statistics on Bloomingdale, see Earle, *History,* 101–102; and Russell, *The New-York Hospital,* 164. The artist's obsessive religiosity, quick deterioration, and delusions suggest an ex post facto diagnosis that Deas was, in current nomenclature, schizoaffective. Bloomingdale's records also reveal that Deas smoked and used snuff excessively, practices that associate his case with recent studies on nicotine's tranquilizing effect on people with schizophrenia (Records of the Bloomingdale Asylum, Medical Center Archives of NewYork–Presbyterian/Weill Cornell). (My thanks to Professor Richard P. Halgin and Dr. Michael Barberie for their insights into Deas's condition.)

92. James Macdonald, Sanford Hall, to Pliny Earle, Bloomingdale Asylum, September 5, 1845 (Pliny Earle Papers, American Antiquarian Society). On Sanford and Macdonald, see Medical Register, New York and Vicinity, 1870–71, 163; and G. Henry Mandeville, *Flushing, Past and Present: A Historical Sketch* (Flushing, N.Y.: Home Lecture Committee of 1857–58, 1860), 136–38. A promotional brochure, *Sanford Hall* (Queens Borough Central Library, Long Island Division), was published later, probably in the 1910s. It provides specific information on the living environment and on the treatment of patients, and it includes photographic illustrations. (I am grateful to James Driscoll of the Queens Historical Society and Erik Huber of the

Long Island Division of the Queens Borough Public Library for their help in my search for information about Sanford Hall.) An obituary of Dr. Macdonald appeared in the *American Journal of Insanity* 6 (July 1849): 71–92. I discovered no records for Sanford Hall, and I am not able to report any details of Deas's residence there. Evidence that he lived there continually from August 1848 until November 1863 include his listing in the censuses of 1850 and 1860 and a notation in the Bloomingdale Asylum records when he was readmitted on November 27, 1863: "since [August 1848] at Sanford" (Records of the Bloomingdale Asylum, Medical Center Archives of NewYork–Presbyterian/Weill Cornell).

93. Letter from Henry D. Lesesne, Charleston, November 28, 1848, to James Simons, and "Plan for an Indian Gallery" (private collection). Lesesne referred to the publication of Tuckerman's *Artist-Life; or, Sketches of American Painters* (New York: D. Appleton, 1847). Tuckerman described the paintings in Catlin's Indian Gallery as "trophies as eloquent of adventure as of skill, environed with the most national associations, and memorials of a race fast dwindling from the earth" (p. 208). Catlin's "To the Reader" in *A Descriptive Catalogue of Catlin's Indian Gallery* (London: C. Adlard, 1840) includes the following statement: "I sat [*sic*] out alone, unaided and unadvised, resolved, (if my life should be spared), by the aid of my brush and my pen, to rescue from oblivion so much of their primitive looks and customs as the industry and ardent enthusiasm of one lifetime could accomplish, and set them up in a *Gallery unique and imperishable,* for the use and benefit of future ages" ([p. 3]; emphasis in the original).

94. "Topics of the Month," *Holden's Dollar Magazine* 3, no. 5 (May 1849): 315. The *Holden's* critic wrote that Deas "has been an inmate of the Insane Asylum at Bloomingdale nearly a year, and during his confinement there the picture of which we speak was painted." Because Deas moved to Sanford Hall in August 1848, having lived at Bloomingdale for three months, I conclude that he may have painted *A Vision* at Bloomingdale or at Sanford Hall.

95. Among Earle's writings on this topic is "The Poetry of Insanity," *American Journal of Insanity* 1 (January 1845): 193–224.

96. Register, Works of Art, American Art-Union, September 3, 1849, and March 20, 1850, record the submission and the rejection of *A Vision* (American Art-Union Papers, New York Historical Society).

97. For a reproduction of a possibly similar image, Fitz Henry Lane's illustration of an imprisoned madman in chains on Henry Russell's sheet music entitled "The Maniac," see Lynn Gamwell and Nancy Tomes, *Madness in America: Cultural and Medical Perceptions*

of *Mental Illness before 1914* (Ithaca, N.Y.: Cornell University Press, 1995).

98. Gail E. Husch makes both connections in *Something Coming,* 79.

99. Federal Census, New York State, Queens County, Town of Flushing, recorded on August 29, 1850, and on September 5, 1860.

100. Anne Izard Deas's will was dated August 15, 1861, and probated on February 9, 1863. Transcript, Surrogate's Court, New York City, Liber 147, p. 499.

101. Records of the Bloomingdale Asylum, Medical Center Archives of NewYork–Presbyterian/Weill Cornell. When Deas returned to Bloomingdale in 1863, Dr. D. Tilden Brown had been the asylum's medical director for eleven years. Brown was not as influential or as prolific a writer as Earle, but moral treatment and the encouragement of individual interests continued to guide patient care at Bloomingdale. Deas's last two known pictures are evidence of this kind of environment. On Brown's tenure at Bloomingdale, see Russell, *New-York Hospital.*

102. "The Washington Exhibition at the Art Union Rooms," The Fine Arts, *New-York Times,* March 17, 1853, 2.

103. "Sketchings: The Indians in American Art," *Crayon* 3, no. 1 (January 1856): 28.

104. *Catalogue of the Art Gallery* (St. Louis: Mississippi Valley Sanitary Fair, 1864), cat. no. 42; *Catalogue of the Art Exhibition at the Metropolitan Fair, in Aid of the U.S. Sanitary Commission* (New York, 1864), cat. no. 10; Tuckerman, "Art in America: Its History, Condition, and Prospects," *Cosmopolitan Art Journal* 3, no. 1 (December 1858): 2.

105. Deas's death certificate identifies the date, place, and cause of his death, as well as his place of burial. An obituary notice in the *New-York Times* (March 24, 1867, 5) gives notice of his funeral.

106. President's Report, Annual Meeting, National Academy of Design, May 8, 1867. Notice of Deas's death had been given at the Council Meeting of March 25 (National Academy of Design Archives).

107. Henry T. Tuckerman, *Book of the Artists: American Artist Life* (New York: G. P. Putnam and Son, 1867), 429.

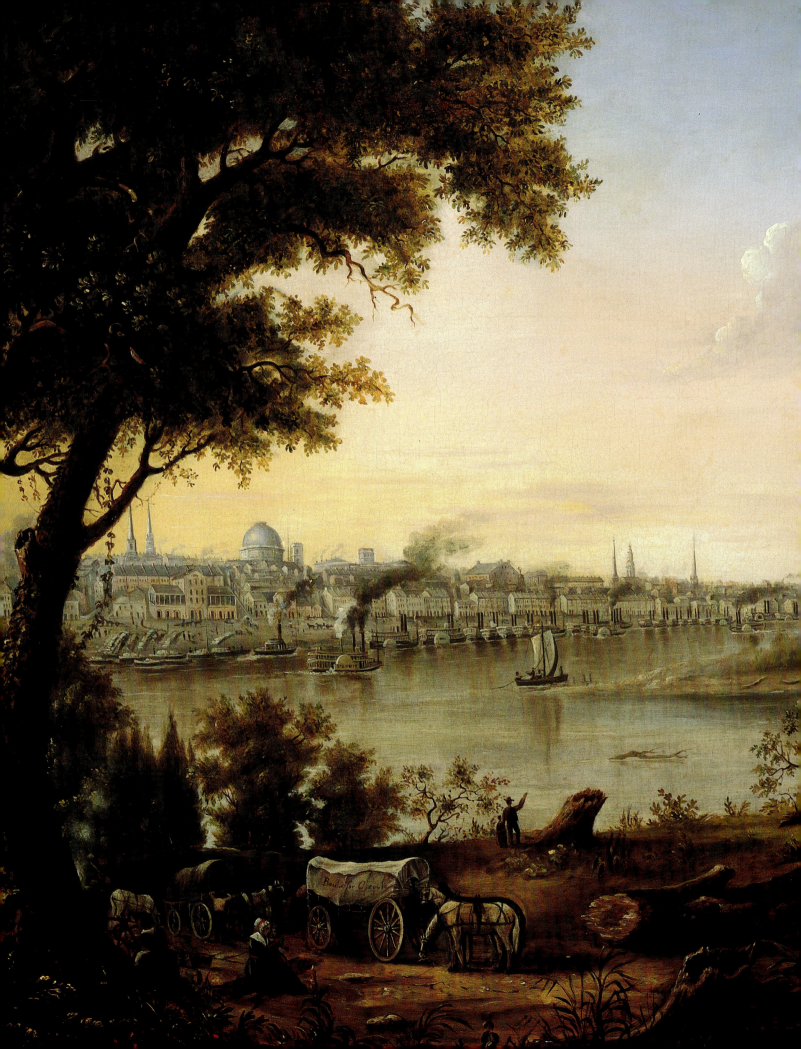

2.

A WORLD OF FRAGMENTS

America in the 1840s

Frederick E. Hoxie

Charles Deas's journey west in 1840 occurred at an obscure moment in the history of the United States. The founding generation of American leaders had passed from the scene, and with the polarizing presence of Andrew Jackson gone as well, national politics was increasingly the province of sectional chauvinists and party hacks. The bulk of the nation's seventeen million citizens lived east of the Ohio Valley (the Census Bureau places the center of American population in 1840 near modern Clarksburg, West Virginia), and the crises of expansion and slavery had yet to emerge as the dominant issues of the day. Retrieving this moment of quiet—and tension—is difficult, but it is a crucial starting point for anyone wishing to understand Deas and his world.

When Charles Deas traveled to St. Louis, he moved to the outer edge of the United States. At the time of his journey, America's western border was defined by the limits of the Louisiana Territory, the immense landscape made up of the Mississippi River drainage, which Thomas Jefferson had acquired from France in 1803. The exact limits of the great river's drainage area were anybody's guess, but all could clearly see that the United States ended somewhere on the far side of the "Great American Desert" that extended westward to the Rockies. Nevertheless, the country did not yet stretch "from sea to shining

Detail of fig. 2.2, Henry Lewis, *Saint Louis in 1846*.

2.1. Eugène Duflot de Mofras (French, 1810–1884), *Exploration du territoire de l'Orégon, des Californies, et de la Mer Vermeille exécutée pendant les années 1840, 1841 et 1842* (Paris: A. Bertrand, 1844), vol. 1, p. 1. Newberry Library (Vault Graff 1169; Vault Ayer 160.5.06 D7 1844).

sea." Texans to the south, Mexicans to the west, the English and Russians to the north—and Native peoples in all of these areas—obscured the borders of the young republic.

Even though it had been a state for twenty years, Missouri, America's western outpost on the Mississippi, remained remote. In 1841, Deas's new home was encircled on the north and west by unorganized federal territory. To be sure, Arkansas and Louisiana also hugged the river's western shore, but their plantation-based economies were intimately tied to the cotton kingdom taking shape among their southern neighbors. By contrast, Missouri bordered on thinly settled Illinois, a land that impressed visitors more by its vast emptiness than its enterprise. When Charles Dickens visited St. Louis in 1842, for example, he called the Illinois prairie on the other side of the river "lonely and wild" and declared that "its flatness and extent . . . left nothing to the imagination."[1]

Modern, jet-propelled Americans who can begin their workdays in New York and end them in Seattle or Los Angeles have difficulty imagining the bounded and uncertain country their predecessors inhabited in the 1840s. Twenty-first-century citizens of a continental nation cannot appreciate how differently Charles Deas must have viewed his weak and divided country and how complicated the landscape of his era appeared. Fortunately, history has provided a window on his era in the form of a remarkable map of western North America, drawn by an impartial observer just as Deas took up residence along the Mississippi (fig. 2.1).

The author of this map, Eugène Duflot de Mofras, was a French diplomat serving in Mexico City in 1839 when he received orders from his superiors in Paris to travel north along the Pacific Coast and report on what he found. The foreign ministry ordered Duflot de Mofras to take an "independent point of view" and to investigate "what opportunities might exist in this little known region for trade, shipping, and the establishment of trading posts." Duflot de Mofras was delighted with the assignment, and he set to work with enthusiasm. He wrote later,

"It was an entirely new diplomatic task." When he published an account of his travels in 1844, Duflot de Mofras pointed out that "there is a great deal unknown concerning the west coast of New Spain, the Gulf of California, the internal provinces of Mexico, the two Californias, and the Russian settlements, as well as the Oregon Territory." Not only did he describe all of these areas for his readers, but he also produced a map of the entire western half of the continent that vividly displayed the complex social and political reality of the moment.[2]

Duflot de Mofras drew his map when the United States had no standing army, a tiny navy, and little interest in foreign affairs. At the same time, the continent seemed alive with potential rivals to the young American nation. Weakened by the calamitous Panic of 1837 and the beginnings of an angry debate over the future of slavery, the United States did not so much dominate the eastern half of the continent as stretch to cover and control it. In an age with few national institutions beyond the federal courts and postal system, Chicago was a struggling commercial outpost that had neither a rail connection to the East nor a water link to the Mississippi. St. Louis (fig. 2.2) contained 16,469 people; although steamboats provided it with reliable fair-weather commercial ties to the outside world, the bulk of the city's trade moved south, away from the nation's largest urban markets. New Orleans, the busiest port in the South, anchored America's western border, but the city's preoccupation with cotton exports tied it more firmly to Europe and the demands of overseas customers than to Boston and New York.

The economies of the lower South were similarly focused on cotton exports. The "heartland" prairies of Indiana, Illinois, and Missouri were occupied primarily by subsistence farmers who planted their seeds and cultivated their crops by hand. The seed drills, multirow cultivators, reapers, and combines that would fuel the growth of commercial agriculture in the region had not yet appeared, nor had financial and transportation systems matured sufficiently to

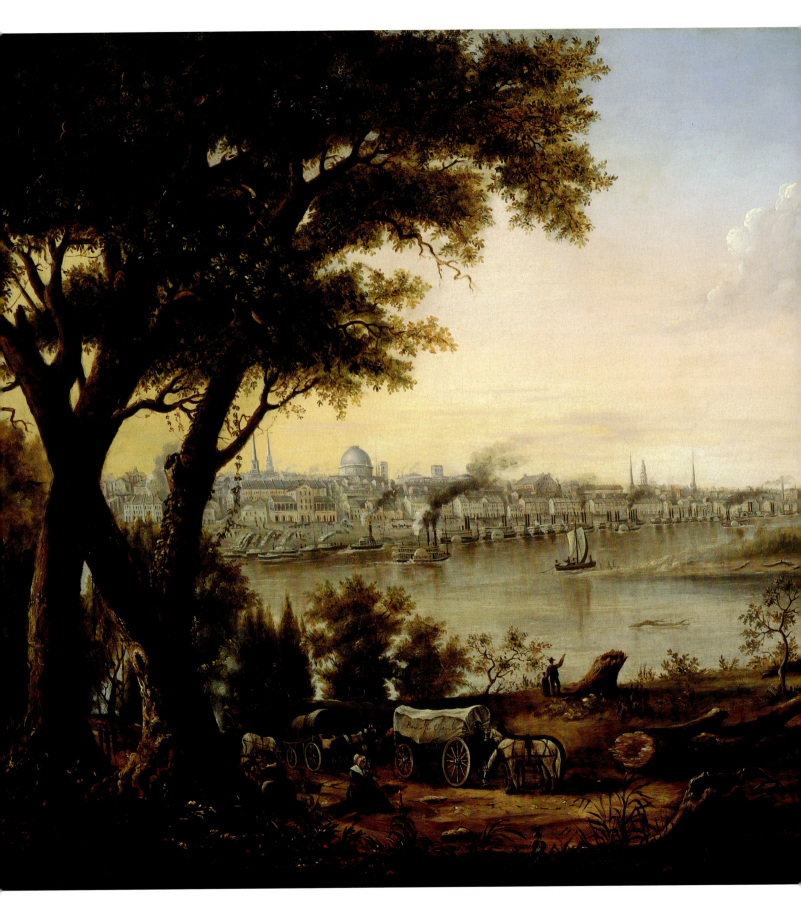

2.2. Henry Lewis (American, 1819–1904), *Saint Louis in 1846*, 1846. Oil on canvas, 32¼ × 42¼ in. Saint Louis Art Museum, Eliza McMillan Trust.

haul their produce to eastern cities. The nation boasted hundreds of miles of railroad tracks in 1837, but none of these lay in the Midwest.

The fragility and expanse of United States territory east of the Mississippi can be deduced from the historical record. The complicated reality of the western landscape is more difficult to grasp. Here Duflot de Mofras's map is instructive. The French diplomat painted a picture that almost no one recalls today. This portrait begins in the South with Texas. Led by President Mirabeau Lamar, this new nation was eagerly recruiting slave-owning settlers to its seemingly limitless farmlands. Americans who dreamed of using slaves to get rich were leaving their country in unprecedented numbers to become citizens of the republic of Texas. The population of Texas tripled in the ten years following its independence from Mexico in 1836, but more telling is the fact that during those same years its slave population increased more than sevenfold.

To the west, the northern provinces of Mexico (independent since 1821) stretched across the modern "Southwest" from Texas to Colorado and California. Like Texas, these territories were eager to recruit both immigrants and foreign capital. Throughout the 1830s, St. Louis merchants loaded their trademark Missouri mules with goods bound for Santa Fe, while at the same time they extended their traditional ties with fur-trading Indians across the southern plains. New England's expanding fleet of whaling and trading ships were calling at Los Angeles, Monterey, and other Mexican ports, taking on water and supplies and exchanging foodstuffs and textiles for hides and tallow. Farther north, Russia's

Pacific outpost at Fort Ross (near San Francisco) supplied its Alaskan trading centers with local produce while marking the southernmost point of the czar's vast American empire (fig. 2.3).

Beyond Fort Ross lay the Oregon country, dominated by the Hudson's Bay Company and forming the southwestern anchor of England's continental realm. From their posts at the former American fort at Astoria near the mouth of the Columbia River and at Forts Vancouver and Walla Walla farther upstream, Hudson's Bay traders maintained active alliances with Chinook-speaking and Sahaptin-speaking tribes and conveyed the furs they gathered to distant markets. Duflot de Mofras noted on his map that jurisdiction over the Oregon country was "in litigation" in 1840. Advocates of American fur interests, such as Missouri's Thomas Hart Benton, were eager to see their constituents replace the Canadians in Oregon, but with few settlers living there and no credible American military force available to back up their dreams, Benton and his allies could do little but give florid speeches about their country's "destiny" in the West. The situation was similar in other parts of the Hudson's Bay domain. In "British America" north of Oregon (modern British Columbia) and its neighbor, "The Country of the Hudson's Bay Company" (more than 1.5 million square miles of Canadian prairies that were privately owned by Hudson's Bay shareholders), European agents and Native hunters captured, processed, and transported American furs for sale across Europe and Asia.

With his "independent point of view," Duflot de Mofras added one additional layer of complexity to his picture of western North America by acknowledging that large areas remained under the control of indigenous peoples. Standing outside the American ideology of expansion, the French diplomat portrayed the West as a vast landscape tied together by trade and occupied by Native groups who had long since adapted to—and profited from—the presence of Europeans. The Osages and Mandans noted on his map, for example, had from the eighteenth century onward been central players in the transformation of prehistoric trade centers into international meeting grounds, where representatives of European and North American merchants exchanged goods with Native farmers, horse breeders, and craftspeople. These tribes had also played a central role in the diplomatic interplay between outsiders and indigenous communities. Although some of the information on Duflot de Mofras's map was out of date by the time it was published (the Mandans, for example, were hit by a devastating smallpox epidemic in 1837), the Frenchman accurately portrayed the scale and pervasiveness of the American Indian presence.

Duflot de Mofras described a continent made of fragments. While his vision of a complex and divided continent might have appealed to his superiors—a divided continent, after all, might prove fertile ground for France's aggressive diplomats—the young man's map captured an essential truth: in the early 1840s, the continent largely remained a collection of imperial outposts. It was not yet a landscape dominated by settler nations that had extended their control over everyone within their borders. North and west of the United States, thinly populated territories participated in imperial systems based either on trade (as was the case in Oregon, Alaska, and Canada) or on national tribute and taxation (such as in New Mexico and California). Founded by slave owners, Texas was a nation of a different kind. Its institutions were nominally democratic, but its exclusion of African and Native Texans (be they mestizo or American Indian) from the political system signaled that the Lone Star Republic was to be an empire of slavery.

Largely ignored by Duflot de Mofras was an additional western settlement, a polyglot fragment containing elements of several indigenous communities. Indian Territory occupied the eastern half of what would later become the state of Oklahoma. Long the homeland of Comanches and Osages, the territory had recently been set aside as a place where nearly 100,000 members of eastern tribes could find refuge from hostile white settlers and grasping state governments. Some groups migrated to Indian Territory voluntarily, but most of the

tribes living there in 1841 had been forced out of their eastern homes. The most famous of these removals had occurred in Georgia in 1838, when state politicians urged on by President Andrew Jackson had pushed the Cherokees onto the "trail of tears" that cost the tribe one-third of its members. The Cherokees were preceded on that trail by Choctaws, Chickasaws, and Creeks and were followed later by large groups of Seminoles. Several midwestern groups had walked a similar road, so that by 1841, Delawares from Pennsylvania, Potawatomis from Michigan and Illinois, Miamis from Indiana, Sauks and Meskwakis from Illinois, and Shawnees and Wyandots (or Ottawas) from Ohio had taken up residence in settlements west of the Mississippi.

The communities scattered across North America in 1841 were each the product of more than three hundred years of contact and interaction between various groups of Europeans and Native Americans. At the time of Deas's arrival in St. Louis, four European empires (England, Spain, France, and Russia) and three independent nations (the United States, Mexico, and Texas) vied for influence across an immense landscape, dispatching citizens, traders, and diplomats to every spot that might prove profitable or strategically important. At the same time, Native communities negotiated arrangements with outsiders (and their American Indian allies) that attempted to ensure access to valuable manufactured items and weapons while preserving their cultural autonomy. Looking at the Duflot de Mofras map, one could imagine that the coming decade would be characterized by continuing cross-cultural accommodations and complex, shifting borders.

But the borders drawn on Duflot de Mofras's map were not only the products of imperial ambition and Native resistance. They were, after all, in flux: some were growing stronger, others weaker; some reflected expansion, others contraction. Most prominent in this process were powerful new social and political forces unleashed by events in the United States. These new—or newly energized—forces accelerated the desire of U.S. citizens to move into new

Native areas even as these forces simultaneously undermined the alliances and customs that had governed the Indian country for decades. These new forces had two important points of origin within the United States. First, the young democracy's market economy linked urban manufacturing centers to commercial farms through an array of technological and mercantile reforms—from railroads to free banking laws. As it emerged from the devastating depression of the late 1830s, the economy's move toward mechanized, market-oriented agriculture and industrialization accelerated the migration of rural workers to urban factories and spurred the rate of economic growth.[3] Second, in the aftermath of Andrew Jackson's two terms in the White House, the young nation had come to embrace the ideal of universal suffrage for white males. Even though the idea of popular democracy still terrified Europeans, who recalled the twin upheavals of the French Revolution and the age of Napoleon, Americans increasingly believed that the enthusiasms of "the people" should set the course for the nation.[4]

Duflot de Mofras's 1844 map of the West was a snapshot taken moments before the forces of economic expansion and democratization began to remake the geography of the continent. During Deas's time in St. Louis, the construction of the Illinois and Michigan Canal began near Chicago, Texas was annexed by the United States, Oregon was opened to emigrants from the United States, and U.S. leaders began to threaten the conquest of Mexico's northern provinces. These events drew new attention to the western territories and amplified Americans' ambitions for the region. In their wake, the world described by Duflot de Mofras's map began to disappear. This dramatic shift took place while the artist studied the expansive landscapes around him and made sketches of the Indians and settlers who passed through his city. When Deas arrived in Missouri, the continent appeared as a collection of fragments; during his stay there, powerful forces began to connect those fragments in unprecedented ways.

The first new current that Deas would have sensed as he traveled west was the rapidly

expanding reach of the American market economy. Of course, fostering enterprise and protecting property rights had been cornerstones of the American republic since the ratification of the U.S. Constitution in 1787, but the Panic of 1837 seriously damaged many Americans' faith in the future. During the 1830s, Americans had cheered Andrew Jackson's assault on the power of the Bank of the United States, and they had applauded as the president vetoed the bank's charter and shifted U.S. Treasury deposits to state banks. Jackson's actions inaugurated a surge of easy credit. State banks eagerly competed for state and federal deposits and happily issued loans to their political patrons, who used the moneys to purchase newly surveyed agricultural lands in the Midwest and South. When Jackson moved to curtail this wave of speculation in the summer of 1836 by requiring that all future land purchases be paid for in gold specie, worried depositors in both the United States and Europe began to retreat. Before long, a full-scale panic—the first in American history—was under way. By early 1837, the drop in investment and business activity had forced the nation's banks to suspend payments in gold coin. This unprecedented shutdown further discouraged new investment and brought the economy to a standstill.

By 1840, new state regulations on banks had restored the public's confidence sufficiently to enable the credit system to begin operating again. A federal law passed in 1841 also gave frontier settlers a "preemption" right to purchase new public lands, thereby discouraging the wild speculations by absentee real estate investors that had created the paper boom a decade earlier. At the same time, the combination of expanding urban markets (fed in part by legions of new emigrants recently arrived from Germany and Ireland), new transportation systems based on canals and the first rail lines, and the advent of technologies that boosted agricultural productivity were laying the foundation for a continental economy.

The most exciting economic innovation of the 1840s was the dramatic expansion of an all-weather transportation system that could link western and southern farmers to eastern factories, freeing both producers and consumers from the continent's rivers and primitive turnpikes. Railroads also took advantage of state reforms that enabled investors to pool their assets by forming private corporations that functioned independent of state governments. Railroads required enormous investments in an uncertain and rapidly developing technology and generally ran on rights-of-way granted by local governments whose approval could be eased by lobbyists and community shareholders. Corporations were able to assemble both the capital and the political influence necessary to accomplish these tasks. Funded by American and European investors, railway corporations in the 1830s constructed roads that began to link factories to urban centers. During that decade, railroads connected the mill town of Lowell, Massachusetts, to Boston and the suburb of Germantown, Pennsylvania, to Philadelphia. During the 1840s, these nascent systems would spawn extensions and imitators that covered the eastern seaboard and made their first moves to the West.

While Charles Deas painted in St. Louis, the railroad revolution inched its way into the Midwest. In 1836, Illinois granted rights-of-way for a rail line and a canal running west from Chicago, but both projects fell victim to the depression that began the following year. When the rail line and the canal were revived and completed a decade later, they provided an initial link between Lake Michigan and the farmers moving onto the lonely western prairies across the river from St. Louis. This small beginning drew settlers west during the 1840s and signaled that the economic changes taking place in the Northeast would soon be repeated in Chicago, Cleveland, and Detroit. In 1850, each of these cities anchored local railroads that connected them to surrounding communities, but none of them was yet linked to networks in the East.

The same forces that inspired railroad investors caused eastern merchants to look west. Much as modern businesspeople flock to

Mumbai or Shanghai to get in "on the ground floor" of new opportunities, so too did agents of eastern merchant and banking houses rush to the Mississippi Valley in the 1840s to participate in the new commercial economy. A recent study of the nearly 2,100 businesses started in St. Louis before 1860, for example, revealed that New Yorkers and New Englanders established fully 55 percent of them, while the city's traditional trading partners in the shipping centers of New Orleans and Philadelphia accounted for less than 5 percent.[5] Charles Deas no doubt witnessed this influx of new capital and new people from the Northeast as he worked in his St. Louis studio.

A second force disrupting traditional boundaries and creating new ways of life in the 1840s was an expansive ideology rooted in Jacksonian popular democracy and dedicated to the proposition that the United States was destined to become the preeminent power in North America. By the time Charles Deas journeyed west, American politicians had begun to commonly argue that the European settlers who had founded the United States exercised a special claim to the continent based on their membership in an expanding and prosperous political democracy. Political leaders argued that because the United States was independent of the European powers that fought it for control of the continent, U.S. citizens should be viewed as the agents of human progress (the *Novus Ordo Seclorum,* "new order of the ages," displayed on the great seal of the United States). Those citizens alone—and not Native Americans or the inhabitants of rival communities in British, Russian, or Mexican America—deserved the name "American," and their communities— not the Indian tribes that had preceded them or the French- and Spanish-speaking settlements elsewhere in the Mississippi Valley—embodied the continent's progressive destiny. These U. S. "Americans" came to believe that only they had been ordained to shape the continent's future.

Faith in a unique destiny had been a feature of Anglo-American cultural life throughout the colonial era, but after the American Revolution this argument was reinvigorated and recast in shades of red, white, and blue. Its most famous articulation appeared immediately following Washington's victory at Yorktown, when J. Hector St. Jean de Crèvecoeur, a French traveler, published a pamphlet that asked, "What is an American?" Crèvecoeur answered, in part,

> *He* is an American, who leaving behind him all his ancient prejudices and manners, receives new ones from the new mode of life he has embraced, the new government he obeys, and the new rank he holds. . . . Here individuals of all nations are melted into a new race of men, whose labors and posterity will one day cause great changes in the world. Americans are the western pilgrims, who are carrying along with them that great mass of arts, sciences, vigor, and industry which began long since in the east; they will finish the great circle.[6]

In the first years of the American republic, the self-serving idea that U.S. citizens were a new race of people, that is, "western pilgrims" destined to "finish the great circle" of civilization, was appealing but had little impact on national politics or foreign policy.

Before 1815, Americans generally accepted the colonial custom of viewing Native communities as permanent features of the cultural landscape and interacting with them through official emissaries and diplomats. Leaders from George Washington onward used federal treaties (ratified by the U.S. Senate) both to formalize agreements and to prevent ambitious state governors from challenging the supremacy of the national government in this area. Early presidents wished to avoid conflicts with powerful tribes (most of whom continued to maintain diplomatic contacts with European powers) and to use the military as a buffer force to police the behavior of both settlers and tribal citizens.

But most of these customary practices changed after 1815, the year Britain ended its three-year war with the United States, formally accepting the young nation's northern borders and withdrawing from its alliances with

tribes that could threaten the American state. In the same year, the peace agreements negotiated in the wake of Napoleon's final defeat at Waterloo effectively ended imperial rivalries in the New World. France accepted a minor role in the hemisphere, while England moved to develop its Caribbean sugar colonies and to create stable governments in the provinces of Canada. By contrast, Spain attempted the nearly impossible task of saving its fading empire by sending troops to put down rebellions across Latin America. During the 1820s, the oldest empire in the Americas was being challenged on two continents and was in full retreat. Spain ceded Florida to the United States in 1819; two years later, Mexico became independent. Gradually, the balance of power in the North American interior shifted to the advantage of the United States, giving life to the young nation's pretensions.

Faith in the special destiny of the United States was particularly intense west of the Appalachian Mountains, where new states were joining the Union and new leaders were emerging onto the national scene. By 1820, senators from Alabama, Mississippi, Indiana, and Illinois had begun to lobby for a new approach to Indian policy making. If "Americans" represented progress and Indians did not, they reasoned, the time had come to stop accommodating the tribes and begin removing them from the United States. The most outspoken advocate of this position was Andrew Jackson of Tennessee.

Soon after his election to the presidency in 1828, Jackson proposed that the federal government remove all eastern tribes to lands west of the Mississippi. Two years later, Congress adopted his approach, approving a law that authorized the president to exchange the Indians' eastern homelands for territory west of the Mississippi that "the United States shall forever secure and guarantee to them."[7] A slave-owning planter who had become a national hero following his victories over rebellious Creek Indians in 1814 and the invading British at New Orleans the following year, Jackson did not believe in

negotiating with Native people. He did not believe that Indian tribes—however "civilized"—could live peacefully alongside American settlements: they were too easily corrupted and prone to violence. In his view, the government was compelled to force the tribes west for their own good. Jackson insisted that "the farce and absurdity of holding treaties with the Indians residing within our territorial limits" should end.[8]

Many tribes along the Mississippi had long traditions of hunting and traveling west of the river. In the early nineteenth century, several of these, including groups of Sauks from Illinois and Chickasaws from Mississippi, had begun to relocate voluntarily. Bands from larger tribes also followed this path. Small groups of Cherokees, for example, unhappy with their tribal leadership and hostile to the Americans, had begun migrating west in 1817. Shawnees from Ohio had made a similar journey in the 1820s. But the first groups to be coerced into giving up all their eastern lands in exchange for land in the newly designated Indian Territory were the Choctaws and Chickasaws, who left Mississippi in 1830 and 1832, and the Creeks, who began leaving Alabama in 1832. Similar pressure in Illinois, applied to a Sauk band led by the veteran war leader Black Hawk, sparked a parallel conflict in the Midwest. Black Hawk had long resisted the decision by other Sauk bands to accept the American demand that they move west. His presence in Illinois during the summer of 1832 triggered attacks by American soldiers, who killed hundreds of Black Hawk's followers and drove the remnants of his band across the Mississippi. During the rest of the decade, the remaining lands of the Potawatomies and Miamis, who had long been settled in Michigan and Indiana, and those of Wisconsin's Ho-Chunks (Winnebagoes), Delawares, and Munsees were signed away by separate removal treaties, and the tribes faced the prospect of making new homes west of the river (fig. 2.4).

The struggle over Cherokee removal was most dramatic both because it was the longest of the tribal disputes (lasting for a decade follow-

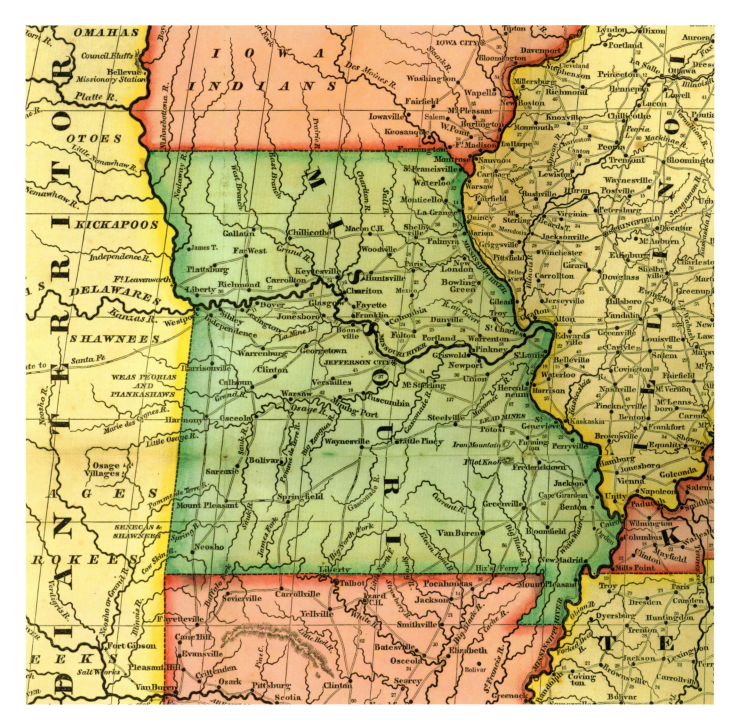

ing Jackson's election in 1828) and because it was punctuated by eloquent petitions from the tribe's highly educated leadership and by two landmark decisions by the U.S. Supreme Court. Throughout the controversy, the Cherokees insisted that their treaties with the federal government entitled them to the protection of the United States; Cherokee leaders called on fed-eral authorities to restrain—rather than encourage—Georgia politicians as they pursued their campaign to send the tribes west. John Ross, the tribe's principal chief, declared in 1833, for example, that no American leader "can ever absolve the United States from the sacred obligation of extending [its] protection" over the tribe.[9]

2.4. Mitchell's *National Map of the American Republic,* 1843, showing Indian Territory, Iowa, Arkansas, and Illinois, with Missouri. Newberry Library (Vault Graff 2838).

In 1830, the state of Georgia adopted a series of laws extending its authority over the Cherokee territory and barring the tribe from continuing to function as an independent government. In response, tribal leaders—assisted by Andrew Jackson's political opponents in Washington, D.C.—appealed to the courts. But led by John Marshall, the justices refused

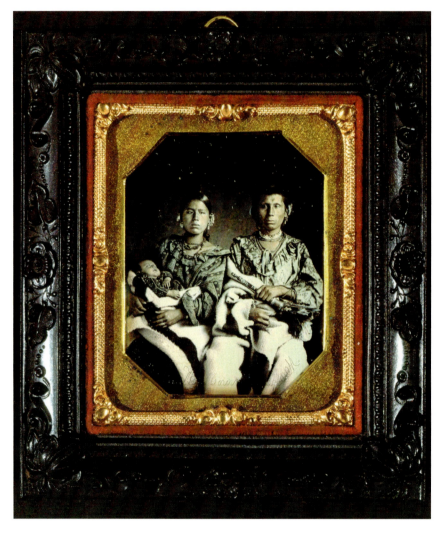

2.5. Thomas M. Easterly (American, 1809–1882), *Make and Kan-zan-ya, Iowa,* 1849. Daguerreotype (hand-colored sixth plate). Edward E. Ayer Collection, Newberry Library (vault AP 3653).

to strike down Georgia's edicts. In early 1831, the Supreme Court ruled in *Cherokee Nation v. Georgia* that "the relation of the Indians to the United States is marked by peculiar and cardinal distinctions which exist no where else. . . . [T]hey occupy a territory to which we asert a title independent of their will. . . . [T]hey are in a state of pupilage. Their relation to the United States

resembles that of a ward to his guardian."[10] While the court's decision turned on a narrow legal issue—were the Cherokees legally a "nation" entitled to the jurisdiction of the courts?— Marshall's formulation confirmed a popular conception that Indians were only bit players in the drama of American progress. Resembling "wards" (despite their educated, mostly Christian, leadership) and "occupying"—not owning—territory to which the United States held ultimate title, the Cherokees could not expect their treaties with the United States to be enforced by the nation that had signed and ratified them. The history of Indian removals thus illustrates that as Americans came to believe in their special destiny, they also came to view the brutal expulsion of Native peoples from their homes as an inevitable consequence of progress.[11]

Deas in St. Louis was a witness both to the power of the expanding American market economy and to the appeal of this aggressive, nationalist ideology. He saw around him the rising tide of trade and the growing fascination with commercial agriculture and railroad development. At the same time, he worked in a city that was a way station for hundreds of Indians who were moving east and west (fig. 2.5). As the seat of federal courts and the headquarters of the western fur trade, the city was a frequent site of meetings, conferences, and negotiations. Tribal representatives from Indian Territory passed through St. Louis on their way to plead their case in Washington, D.C. Midwestern tribes resettled in Kansas and Nebraska drew their supplies from St. Louis warehouses, and news and emissaries from the northern plains came down the Missouri to meet with merchants and government officials. As he watched these groups passing through the city, Deas probably viewed them as casualties of American expansion.

Finally, anyone living in St. Louis in the 1840s would also have been aware that the economic growth and political rivalries of the age were occurring in a society that was deeply dependent on chattel slavery. Not only was Missouri a slave state (the 1820 constitution guaranteed

Missourians the right to own slaves), but life there was punctuated with incidents of violence that regularly reminded its citizens that white supremacy was as deeply held a community value as faith in the market economy or universal white male suffrage. A violent, year-long controversy that erupted five years before Deas's arrival had attracted national attention and underscored the community's continuing sensitivity to the proliferating controversy over slavery. In the spring of 1836, a mob burned a young African American named Francis McIntosh to death after chaining him to a tree at Tenth and Market streets. McIntosh had stabbed and killed two sheriff's deputies and was being held in the city jail awaiting trial at the time of his execution.

When city leaders tried to downplay McIntosh's murder, Elijah Lovejoy, an outspoken local abolitionist editor (and rabid anti-Catholic) used his newspaper, the *St. Louis Observer,* to condemn those who tried to justify the lynching. In response, proslavery mobs attacked Lovejoy's offices on three separate occasions, and the young editor retreated across the river to Alton, Illinois. Lovejoy continued to use his paper to attack McIntosh's killers, but angry gangs twice more invaded his newspaper's offices, each time ending the attack by throwing his printing press into the Mississippi. Finally, on August 7, 1837, Elijah Lovejoy was murdered while attempting to defend his printing press from yet another attack. Because Lovejoy's death took place just as the abolitionists were beginning to organize a national campaign against slavery, the movement's leaders circulated his story throughout the country and condemned the city's citizens for their violence and lawlessness (fig. 2.6).

Throughout the 1840s, abolitionists criticized St. Louis for its hostility to their views and for its deep involvement in businesses dependent on slave labor. The slave trade had a growing presence in the city, with slaves being sold in lots bound for southern plantations and traders such as Bernard Lynch operating slave pens at several locations in the center of the city. (Lynch's pens were so extensive that they were used as a military prison during the Civil War.) Like other slave states, Missouri did not

2.6. *The American Anti-Slavery Almanac for 1840,* p. 23. Courtesy of Special Collections, W.E.B. Dubois Library, University of Massachusetts, Amherst.

recognize slave marriages or protect the rights of individual slaves. Laws affecting free blacks were similarly harsh. Free people of color were not permitted to testify against whites in court and could not live in St. Louis without a license. In 1847, new legislation made it illegal to educate African Americans or to permit free blacks to take up residence in the state. (St. Louis, of course, was also the city where the infamous *Dred Scott* decision was initiated in the 1850s.)

As a way station for Indians struggling to survive amid rapid economic and political change, and a flash point in the increasingly polarized dispute between advocates of slavery and free

labor, St. Louis would have put the racial tensions of the mid-nineteenth century vividly on display for even the most casual observer. Situated at the border between the East and West as well as between the economies of the North and South, Missouri would witness an accelerating pace of conflict and violence throughout the 1850s and thereafter. Although we cannot know the details of Deas's reactions to the events of his day, we can measure the direction of the events that took place around him. Economic expansion, robust political activism, and growing racial tension would have been evident outside his studio window throughout the 1840s. One could begin to imagine how the fragments of the Duflot de Mofras map might be connected in the future in new ways. American commerce, ambition, and racial ideology seemed poised to exert a growing hold on the western landscape.

James Fenimore Cooper was one artist whose reflections on the nation's past and its accelerating pace of change we do know. In 1846, toward the end of Deas's stay in St. Louis, Cooper published *The Redskins, or Indian and Injin,* a novel that captured the author's pessimistic view of the economic dynamism and political rivalries that were disrupting both St. Louis and his home territory of upstate New York. *Redskins* presented a fictional version of the struggle between large landowners in the Hudson Valley and tenants who were trying to gain title to their farms through political agitation. In Cooper's view, this struggle was a contest between an established and respectable class of landowners—embodied by the protagonist, Hugh Rover Littlepage—and vulgar, unruly but "democratic" rabble-rousers. Cooper wrote that he opposed the tenants' cause because he believed they threatened the "whole structure of society," in which the wealthy and cultured maintained society's cultural standards and virtue. "The notion that every husbandman is to be a freeholder, is as Utopian in practice as it would be to expect that all men were to be on the same level in fortune, condition, education and habits," Cooper wrote.[12] In its closing scenes, his novel

likewise comments on the shifting status of Indians in an age of rising "freeholders."

As the plot of *Redskins* reaches its climax, Cooper introduces a group of New York Indians who appear at Littlepage's estate on the eve of their departure for the West. The Native visitors are dignified and eloquent; they represent the settled order of the preremoval era. Prairiefire, the delegation's leader, typifies this image: "Father . . . we are about to quit you. Our squaws and papooses on the prairies wish to see us; it is time for us to go. . . . Our journey has been one of peace . . . [and] we shall travel toward the setting sun satisfied. Father, our traditions are true; they never lie. A lying tradition is worse than a lying Indian. What a lying Indian says, deceives his friends, his wife, his children; what a lying tradition says, deceives a tribe."[13]

Suddenly, a group of rebel tenants dressed as Indians ("Injins") come into view—the epitome of a "lying tradition." (The tenants sought both to intimidate the landowner and to exploit the public's negative stereotype of Indians.) The white "Injins" are determined to replace Littlepage and redistribute his estate among themselves.

Landlord Littlepage stands his ground in this final confrontation, but it is one of the noble Indians—rather than the well-armed aristocrat—who rises to confront the "Injins" and the changes they represent. "The wicked spirit that drove out the red man is now about to drive off the pale face chiefs," an elder in the group named Susquesus declares. "It is the same devil and it is no other. He wanted land then and he wants land now." The speech stops the rebels in their tracks.[14] As the "Injins" consider their next move, the sheriff arrives and drives them away. In the wake of Susquesus's speech, Cooper wrote that the chief became "an object of great hatred to all the anti-renters far and near. The 'Injin' system has been broken up . . . but the spirit which brought it into existence survives under the hypocritical aspect of 'human rights.'"[15]

This scene of fictive "Indians" confronting fictive "Injins" seeking to break up the old or-

der of a New York estate in the name of "human rights" neatly summarizes the social and cultural tensions that coursed through the United States during the decade of the 1840s. At one extreme stood the world symbolized by Littlepage and described by Duflot de Mofras: it was characterized by diplomatic arrangements, economic alliances, and ties of mutual obligation that ensured the persistence of a continent occupied by diverse powers and within which Indians could continue to live as autonomous communities. At the other extreme lurked rebellious "Injins," activists dressed like the American heroes of the Boston Tea Party, who were eager to preserve their "rights" to their piece of the national real estate. In pursuit of their destiny, they would use violence and appeal to white supremacy. Deas may not have shared Cooper's pessimism about the outcome of the confrontation between these two visions, but he would surely have recognized the world created in the New Yorker's novel—a world of fragments being remade by the market and the ballot box, where noble Indians spoke for the past and seemed to have no future.

NOTES

1. Charles Dickens, *American Notes and Pictures from Italy* (1842; reprint, London: Oxford University Press, 1970), 182.

2. Eugène Duflot de Mofras, *Exploration du territoire de l'Orégon, des Californies, et de la Mer Vermeille exécutée pendant les années 1840, 1841 et 1842* (Paris: A. Bertrand, 1844), 1:1.

3. See Diane Lindstrom, "Macroeconomic Growth: The United States in the Nineteenth Century," *Journal of Interdisciplinary History* 13, no. 4 (Spring 1983): 692.

4. It is not accurate to assume that Indian people—or any group at any time—simply responded to outside forces. Agency, after all, is in the hands of all historical actors. Nevertheless, the processes unfolding in the middle of the nineteenth century were impossible for Native Americans either to ignore or to escape.

5. Jeffrey S. Adler, "Capital and Entrepreneurship in the Great West," *Journal of Interdisciplinary History* 25, no. 2 (Autumn 1994): 196.

6. J. Hector St. Jean de Crèvecoeur, *Letters from an American Farmer* (New York: Fox, Duffield, 1904), 3:54-55. Emphasis added.

7. Indian Removal Act, May 28, 1830; 4 U.S. Stat., 411-12.

8. For Jackson's views, see Robert V. Remini, *Andrew Jackson and His Indian Wars* (New York: Viking, 2001). For the quotation, see *American State Papers,* vol. 2 (Washington, D.C.: Gales and Seaton, 1832), 243.

9. Annual Message, October 15, 1833, in Gary Moulton, ed., *The Papers of Chief John Ross* (Norman: University of Oklahoma Press, 1985), 1:270.

10. *Cherokee Nation v. Georgia* (1831), 5 Peters, 15-20, quoted in Francis P. Prucha, *Documents of United States Indian Policy,* 3rd ed. (Lincoln: University of Nebraska Press, 2000), 58, 59.

11. The Cherokee cases are difficult to summarize. Following its defeat in *Cherokee Nation,* the tribe hoped to appeal the criminal conviction of one of its citizens in state court. Unfortunately, the object of this appeal—a man named Corn Tassel—was executed by Georgia before the tribe's appeal could be heard in Washington, D.C. In the wake of Corn Tassel's execution, the tribe appealed the conviction of a white missionary in state court for violating a state statute requiring him to obtain a license from local authorities before venturing into Cherokee territory. This case—*Worcester v. Georgia*—was decided in 1832. In that decision, Marshall and his colleagues struck down the state law under which the missionary had been held, declaring that the federal government had exclusive jurisdiction over relations with Indian tribes. Georgia refused to recognize the court's decision, but the state's governor avoided a confrontation by pardoning Worcester. In 1835, a small group of tribal leaders signed a removal treaty with federal authorities; three years later, the Cherokees were forced to move west. Upon their arrival in Indian Territory, several of the "treaty men" who had agreed to removal were executed by followers of Chief John Ross. Finally, it should be noted that the entire removal controversy had a racial subtheme. Despite the fact that many Cherokee leaders were slave owners, federal officials and national leaders insisted that because they were not white, Indians could not live in the settled portions of the United States.

12. James Fenimore Cooper, *The Redskins, or Indian and Injin* (1846; reprint, New York: Lovell, Coryell, [189_]), 10.

13. Ibid., 396.

14. Ibid., 422, 426.

15. Ibid., 440.

3
TELLING TALES IN 1840s AMERICA

Carol Clark

The extraordinary masterpiece of art, now exhibiting in Colman's, the red-shirt hunter on his horse in the prairie, is the work of Mr. Deas, we understand, an artist residing in St. Louis. From what we can see of it over the shoulders of the hundreds crowding around the window, it is a chef d'oeuvre that is enough of itself to make a name. There certainly has been nothing so striking in New-York for some time.

New Mirror, SEPTEMBER 14, 1844

In this brief review, which granted an American picture the stature of a French master-piece, the *Mirror*'s critic conveyed the welcome that New York City extended in 1844 to Charles Deas's *Long Jakes*. Moreover, the writer enticed his readers with something new: a picture of a westerner painted by a westerner.

Long Jakes was the first of a series of western paintings that Deas exhibited in New York City. These paintings were narratives peopled with characters like this tough trapper who came from what another critic described as "the outer verge of our civilization."[1] Deas's pictures of trappers, voyageurs, and Indians told tales that satisfied the hunger of eastern audiences for the physical and the mythical West that this phrase conjures. Deas's paint-ings of the mid-1840s tapped national concerns, but a close look at the works of his brief career—from *Turkey Shooting,* exhibited in New York in 1838, to *Prairie on Fire,* shown in

Detail of fig. 3.51, Deas, *Prairie on Fire.*

3.1. Charles Deas, *Turkey Shooting,*
by 1838. Oil on canvas, 24¼ × 29½
in. Virginia Museum of Fine Arts,
Richmond, the Paul Mellon Collection.

St. Louis a decade later—reveals that he was
telling tales with similar themes. Whether he
responded to fiction or to social mores and
economic conditions in New York City, to the
history of his adopted home in the West, or to
the lives of those he encountered there, Deas
imbued his paintings with fears that defined
the decade. He exhibited his first pictures in
the wake of the Panic of 1837, when capitalist
speculation went awry, drove the banks to de-
fault, and put the American economy into a tail-
spin. His personal and artistic decisions were

founded on these conditions, and he recast the
deep-seated competitive impulses of a sputter-
ing market economy into stories that metaphor-
ically dramatized conflicts embedded in the na-
tion's political, social, and cultural life.

Although Deas was especially tuned to the
pitch of his time, he was not the newcomer that
the *Mirror*'s critic intimated he was. In 1844, he
had resumed exhibiting his art in New York City
after a hiatus of four years. The critics might
have forgotten the works Deas showed at the
National Academy of Design between 1838 and

1840, but those pictures already articulated many of the same ideas that would capture the attention of critics and collectors starting in 1844 with *Long Jakes.* A look at the four extant paintings from Deas's "early" period does more than set the stage for his narratives of the American West: with their themes of competition and escape, these early pictures cross the permeable border between East and West.

The first picture Deas exhibited at the National Academy of Design, in 1838, was *Turkey Shooting* (fig. 3.1). Deas may have calculated that this subject—a scene from *The Pioneers* (1823), one of James Fenimore Cooper's "Leatherstocking Tales"—would bring him the greatest rewards from an elite audience. How else to explain his inclusion of a sly detail that only close readers of Cooper's text would catch? By painting the initials "E. E." on the brim of the kneeling contestant's hat, which the black man holds, Deas revealed the identity of Edward Effingham at a point in the story at which Cooper had not yet done so.[2] If this was a wink to his literate viewers, Deas also nodded to the artistically alert by likening the dead turkey in the foreground to the bird his fellow Philadelphian Charles Willson Peale had shown drooped over the taxidermist tools in *The Artist in His Museum* (fig. 3.2). But Deas treated his subject in a way that would appeal to a wider audience. His main characters followed those of Cooper's story, but he staffed the scene with caricatures more humorous than Cooper's. Critics in the 1830s regarded *Turkey Shooting* as comic, but we now see that Deas had established a theme he would pursue, namely, the deadly serious business of economic competition.

Cooper's fictional African American, Abraham Freeborn, is at the center of the composition, conducting the Christmas shooting match organized for his personal profit. Deas marked the free black man, called Brom, as an outsider by dressing him in tattered, ill-fitting hand-me-down clothes and adorning him with an exotic gold earring (fig. 3.3). Yet he also linked Brom visually to the group of whites by repeating the stripes of his gloves and shirt in

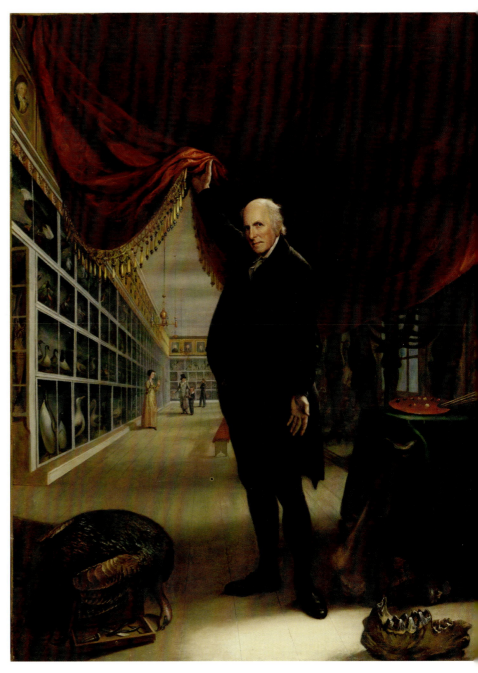

3.2. Charles Willson Peale (American, 1741–1827), *The Artist in His Museum,* 1822. Oil on canvas, 103¾ × 79⅞ in. Courtesy of the Pennsylvania Academy of the Fine Arts, Philadelphia, gift of Mrs. Sarah Harrison (The Joseph Harrison, Jr., Collection).

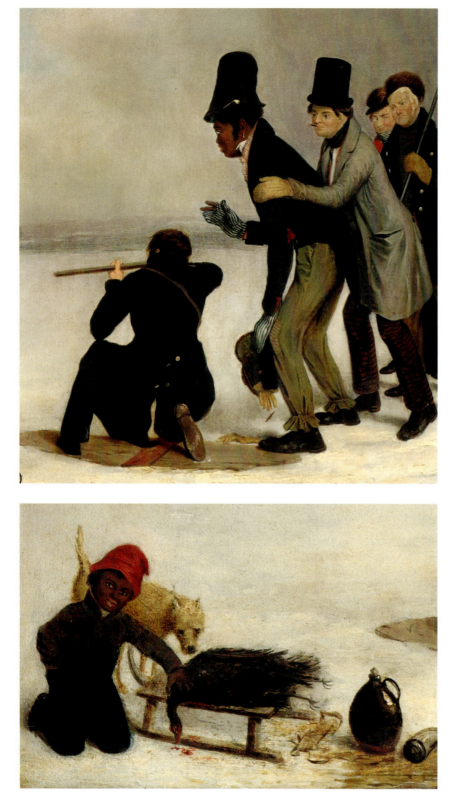

3.3. Detail of fig. 3.1, Deas, *Turkey Shooting.*

3.4. Detail of fig. 3.1, Deas, *Turkey Shooting.*

the striped attire of the other men and boys. These men form a motley crew that may have spent too much time at the tavern on the snowy bluff above: one is a buffoon who peers down the barrel of his rifle as he prepares to stomp on his own hat, showing frustration at a bad shot; another points to coins in the palm of a fellow observer, alluding perhaps to a bet on the contest; and another winks at us as knowing observers. The only other figure to engage our attention directly is the black child at the lower left, who focuses us on the dead turkey by holding it by the neck for our inspection (fig. 3.4). In contrast to the white children in the right foreground corner, who concentrate on the man taking aim, this boy, perhaps Brom's son, participates in the commercial side of his father's business by advertising the quality of the bird.[3] The stakes are high: Brom fears he will lose money because the shooters are bending the rules. Deas chose to paint the moment in Cooper's story when a white contestant restrains Brom from interfering with the marksman, to which Brom cries out: "Gib a nigger fair play."[4] Deas's contemporaries probably judged Brom to be the racial stereotype of fear and greed that author and artist portrayed him to be, but Deas positioned him where Cooper did not—at the heart of the story. His image, then, summons up new thoughts. Just what did fair play mean in the artist's own competitive world—a world increasingly, and uneasily, defined by race?

Two of the pictures Deas submitted to the next National Academy of Design annual exhibition, in 1839, affirmed his interest in painting stories that entwined race and economic competition. One of them, *The Devil and Tom Walker* (fig. 3.5), was a literary subject. Washington Irving included the story of Tom Walker's pact with the devil in his 1824 collection, *Tales of a Traveller.* Irving set his tale in 1727 Boston, but his account of the economic conditions that the fictional Tom Walker exploited describe the boom and bust cycles of the early-nineteenth-century American economy, making it an understandable choice of subject for Deas in the year following the Panic of 1837: "In a word, the great

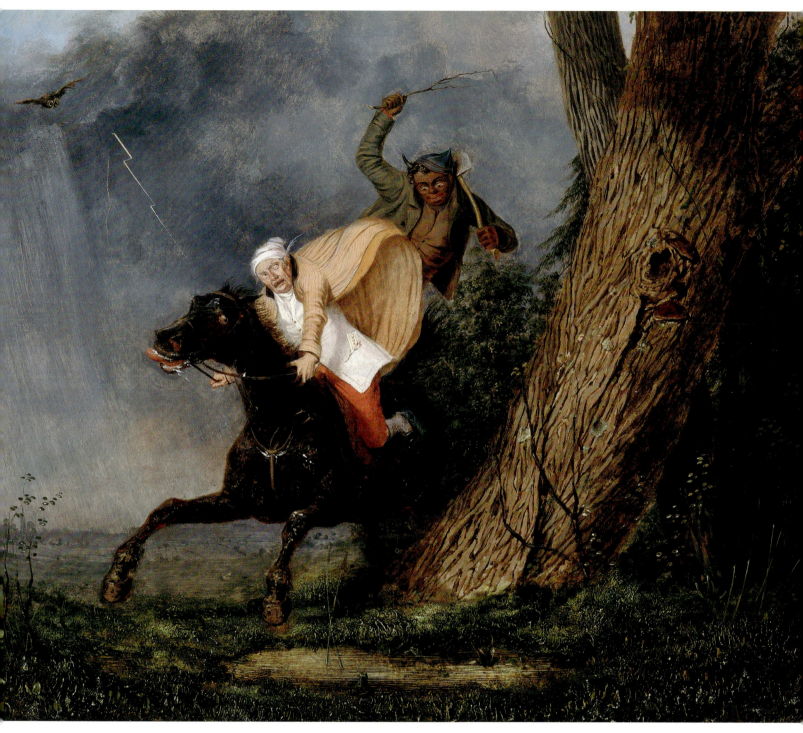

3.5. Charles Deas, *The Devil and Tom Walker*, 1838. Oil on canvas, 17½ × 21 in. Collection of Richard P. W. Williams.

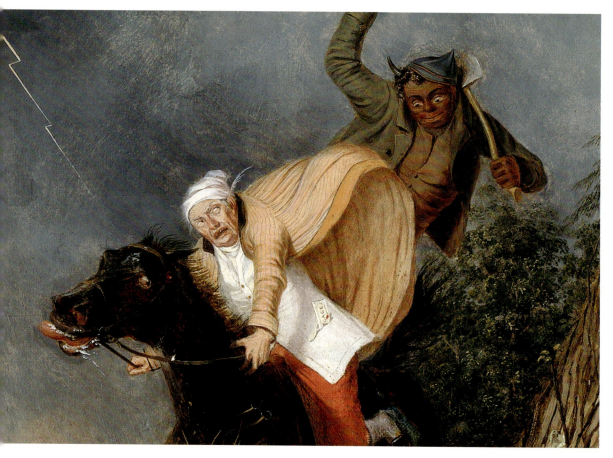

3.6. Detail of fig. 3.5, Deas, *The Devil and Tom Walker.*

speculating fever which breaks out every now and then in the country, had raged to an alarming degree, and everybody was dreaming of making sudden fortunes from nothing. As usual the fever had subsided; the dream had gone off, and the imaginary fortunes with it; the patients were left in doleful plight, and the whole country resounded with the consequent cry of 'hard times.'" Irving concluded that "at this propitious time of public distress Tom Walker set himself up as a usurer in Boston."

Tom owed his "success" to a pact he had made with the devil: in exchange for a pirate's treasure, he promised to "extort bonds, foreclose mortgages, drive the merchant to bankruptcy." Tom conducts his business as he promised, but when faced with his own mortality he calls on the devil as witness of his "fair" practice: "'The devil take me,' said he, 'if I have made a farthing!'" The devil then arrives to collect Tom Walker's mortgaged soul. Yet the devil is not the only personification of evil in Irving's story or in Deas's painting. Tom's weak character may have made him easy prey, but he elicits no pity. He is despicable because he exploited and ruined others. The cruel usurer is getting his rightful comeuppance in the hell predicted by the gap-toothed grimace and bug-eyed stare given to him by Deas.[5]

Selling one's soul to the devil was a familiar theme in American popular literature of the 1830s. In one unsigned story published early in the same year that Deas painted *The Devil and Tom Walker,* the seller is an artist who accepts a magic pencil from the devil and promises to pursue his art to attain "wealth, and fame, and honours." Although this fictional character saves his soul by abandoning painting,[6] Tom Walker pays the price of his Faustian bargain.

The Devil and Tom Walker seeded Deas's imag-

ination, but by telling Irving's story in a new way he made the scene his own. He created an earthly hell by his extraordinary treatment of the landscape: a storm has broken on a summer afternoon, evidenced by a corner of blue; rain falls in sheets; background clouds billow to the ground and glow an eerie purple; the lone tree trunk, like a deciduous actor, rears back as the horse and riders pass by. Deas also mined the story for significant details. For example, the two creatures he chose from the many with which Irving populated the "old Indian swamp" had symbolic meaning that his contemporaries would have recognized: the owl heralded death, and the bullfrog inhabited the underworld.[7] By so excerpting and focusing on elements of the story, Deas distilled its horror.

Deas also surpassed illustration by deviating from Irving's text. He conflated the devil's two appearances by staging Tom's last ride in the "old Indian swamp," the first place the two met. Although Deas presented the devil in the guise Irving gave him at the beginning of the story— that of a woodsman with an ax over his shoulder—the artist specified the devil's race. Deas's devil is not Irving's "great black man . . . neither negro nor Indian . . . his face . . . neither black nor copper colored, but swarthy and dingy"; he is a man with the stereotypical features of an African American from whose curly-haired head sprout the devil's horns.[8] Deas set his painting in a moment that Irving left to the reader's imagination—the devil literally riding Tom Walker to his death (fig. 3.6). Deas condemned Tom's business practices with a symbolic detail—a mortgage juts from Tom's pocket—but he pronounced his verdict on the usurer just as effectively by painting the physical horror on Tom's face and in the expression of the horse. The artist devoted his greatest effort to the animal: its tongue hangs out, white foam flies from its mouth, and its eyes show as much terror as Tom's do.

Deas's contemporaries categorized *The Devil and Tom Walker* as a humorous painting, but it also corresponds to the mode of contemporary melodramatic theatrical comedy that critiqued the excess of speculators and the hardship imposed by the Panic of 1837.[9] By compressing the story into one scene, by specifying the devil's race, and especially by portraying the horror that Irving implied, Deas turned his narrative into an exquisite, almost painful crescendo of the fears of his time. In *Turkey Shooting,* Deas caught Cooper's sense of economic competition, but Brom is less a threat than a character to laugh at. We may laugh, too, at the fate of the moneylender Tom, but it is the devil, transformed by Deas into an unmistakably African American man, who haunts the picture and colors its many possible meanings.

An African American man appears in the background of *Walking the Chalk* (fig. 3.7), which hung with *The Devil and Tom Walker* at the National Academy of Design's exhibition in 1839. This man plays a new role in Deas's art. He is not an agent of the action, like Brom or the devil. He is instead a knowing observer of the moral and economic failings of white men. For this reason alone, he is central to the painting's drama.

The ostensible subject of *Walking the Chalk* is the sport of wagering on a drunk's ability to walk a line chalked on the floor of a tavern. While at first we may smile at the various barroom antics of men as inebriated as the "walker," a closer look reveals that something more than betting is going on. The three men at the left appear to be conspiring. Both the figure straddling a Windsor chair and the man lighting his pipe seem unsurprised that the object of the bet is walking a straight line. The third member of this trio looks out at us while he thumbs his nose, a signal of disrespect for rules and a gesture that lets us in on the swindle (fig. 3.8).

These barflies have tricked the straw-haired youth seated at the right side of the composition. We understand this by observing several things about him. He is the only one in the bar who is surprised that the contestant can walk a straight line. The young man signals his surprise by staring in open-mouthed disbelief and by leaning so far forward for a better look that he spills his drink and has to be steadied by his

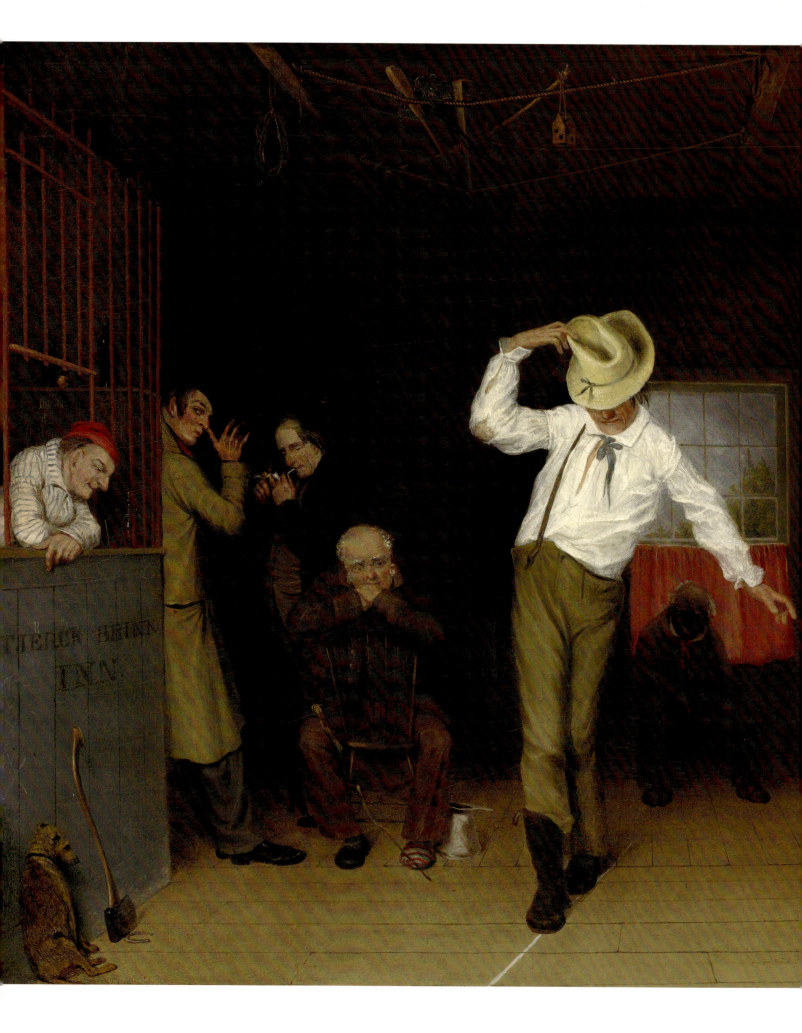

3.7. Charles Deas, *Walking the Chalk,* 1838. Oil on canvas, 17⅜ × 21⅜ in. The Museum of Fine Arts, Houston. Museum purchase with funds provided by the Agnes Cullen Arnold Endowment Fund.

3.8. Detail of fig. 3.7, Deas, *Walking the Chalk.*

3.9. Detail of fig. 3.7, Deas, *Walking the Chalk.*

companion (fig. 3.9). A more sober observer might see that the walker, despite his disheveled appearance and apparently drunken demeanor, balances firmly on the line. This "drunk" strikes a stylish pose—he curls his right arm up and holds on to his hat while he extends his left arm to gesture toward the youth. His dance is a parody of the efforts of a drunk to maintain his balance. The hustling walker does so for a purpose: he feigns drunkenness to stimulate the youth's thirst for an easy buck. But the horseshoe resting beneath an ax against the bar tells us that the youth's luck has run out.[10]

Deas filled his picture with cues that signified drunkenness. The nautical gear slung from the ceiling refers to the painting's title: to "walk chalk" was a shipboard sobriety test for sailors. Among the visual puns in the painting are the anthropomorphized, slumping dog ("drunk as a dog"); the crow perched atop the bar ("canned to the crow's nest"); the "Dutch courage" hinted in the nationality of the inn's owner, whose name, Tjerk Brink, is stenciled on the bar; the slippered foot of the man seated backward in a chair ("has lost a shoe"); the rope hanging over the conspirators to the left ("gallows" drunk); and the man with bandaged eye at right middle ground ("half blind"). The black man in the background may be a "slave to drink."[11]

On the "cage," or frame, bar to the left of the inn's name is a curious image drawn in chalk—a crude caricature of an old man in profile whose nose is featured prominently over his toothless mouth. What is its meaning in the midst of all the cues Deas planted for his viewers to see and interpret? A dozen years later, Richard Caton Woodville included a similar caricature chalked on a slate board hanging in front of a frame bar in *Waiting for the Stage* (1851; figs. 3.10 and 3.11). Could these caricatures have been warnings put there by the barkeep against the type of gambling that went on in his establishment? A chalked image is ephemeral: Deas might be commenting on the transience of art, implying that images are easily erased or forgotten, or, by extension, on the transience of life—this man is old, and he looks away from the game.[12]

3.10. Richard Caton Woodville (American, 1825–1855), *Waiting for the Stage,* 1851. Oil on canvas, 15 × 18½ in. In the Collection of the Corcoran Gallery of Art, Washington, D.C., Museum Purchase, Gallery Fund, William A. Clark Fund, and through gifts of Mr. and Mrs. Lansdell K. Christie and Orme Wilson.

3.11. Detail of fig. 3.10, Woodville, *Waiting for the Stage.*

Deas showed contemporary evils in his picture: the young man's first mistake was to enter the bar, an error he compounded by drinking too much and gambling. Alcohol consumption was dropping dramatically in the 1830s, indicating new attitudes toward sobriety. Drinking was

3.12. David Gilmour Blythe (American, 1815–1865), *Boy at the Pump*, 1858–1859. Oil on canvas, 14 × 12⅛ in. Philadelphia Museum of Art, the W. P. Wilstach Collection, bequest of Anna H. Wilstach, 1893.

increasingly condemned as a habit that would make a young man less reliable as a laborer in the competitive market of the late 1830s. But gambling was an even greater danger to individual success in a society that valued production over consumption. Gambling was a mid-nineteenth-century obsession: Americans gambled on everything "from a horse race to the number of peas in a pod," as social historian Carl Bode put it.[13] But in the mid-nineteenth century, most Americans feared that gambling would undermine youth. Reverend Rufus Clark thundered

his judgment in a book of advice to young men: he would rather see his son "struggling with death—his eyes sinking, his breast heaving, his heart throbbing" than "mingle with gambling fiends . . . to imbibe their horrible principles."[14]

The development of integrity and self-reliance in American youth was often described in navigational metaphors.[15] Deas's contemporaries, then, would have appreciated his adaptation of the naval practice of "walking chalk" and his inclusion of nautical accoutrements in *Walking the Chalk.* One false step on the narrow line chalked between success and failure could alter the course of any man's life. The nineteen-year-old Deas put his own reputation at risk by showing a painting on the theme of drinking at the National Academy of Design. "It is enough to know that such scenes are passing around us, without having them placed before us on canvas," wrote the critic for the *Commercial Advertiser* about *Walking the Chalk.*[16] The *New York Literary Gazette* admonished the artist, "We would remind this promising young painter, that the degradation of human nature is not a pleasing subject for contemplation, and consequently not a fit subject for art; unless it be so represented as to convey a moral lesson, or excite moral sympathies, as in the tales, not more humorous than pathetic, of Dickens, or in those great pictures of Hogarth, where the ludicrous and the affecting are perceived as one."[17]

Why did Deas's critics not detect a moral lesson in *Walking the Chalk?* Were they offended by the display of drunkenness? Or did they recognize the unfolding scam and believe that the picture showed all too vividly that trust was a commodity in short supply? Did they think the artist was mocking temperance or, more pointedly, the temperance movement? The man thumbing his nose alerts viewers, as I have suggested, that one set of rules—for betting on a drunk's steadiness—has been broken. But his gesture had other implications. David Gilmour Blythe later employed this gesture in *Boy at the Pump* (1858–59; fig. 3.12), in which a ragged boy thumbs his nose at a water pump, while his pocket is weighed down with the bottle that

contains his chosen thirst quencher. Blythe was direct and obvious: this boy is thumbing his nose at temperance.[18] Deas's inspiration for *Walking the Chalk* may have been William Sidney Mount's *Bar-room Scene* (1835; fig. 3.13), which features a tipsy drunk dancing before an appreciative audience of three men and a boy.[19] No one, least of all the dancer, looks at the broadside posted on the back wall to advertise a temperance meeting. Mount's "gesture"—advertising temperance in a bar—was surely ironic. But unlike Deas's later chalk walker, Mount's dancer is pathetic: his clothes are tattered, and he is reduced to dancing for a drink. Unlike Deas, Mount gave his viewers no signals that his dancer is an itinerant hustler faking inebriation: no one winks or thumbs a nose. Mount's dancer, unlike Deas's walker, does not balance on a white line.

Yet race structures both pictures: each features a black man set apart from whites. Mount's black character is a racist stereotype. He grins and looks on from the shadows near the door at the whites in the central group, none of whom acknowledges his presence. Deas's black man is also invisible to the white bar patrons, but the artist gave him a kind of prominence by positioning him beneath and behind the walker's outstretched arm and against the brightest spot in the composition—the window's red café curtain (fig. 3.14). He may be poorly dressed with one bare foot wrapped in a rag, but he plants the other directly on the chalked line. Mount's black man looks at the action within the composition; Deas's black man looks outward and smiles slightly at us. Like the man thumbing his nose, he informs us of the disruption in *Walking*

the Chalk's ostensible subject. But the foul play he signals goes beyond the drunken gambling scam. We know that the black man's fate was "on the line" in this period, subject to the control of white men's laws. Because "walking the chalk" was American slang for following the straight and narrow moral path, Deas's image warns us not to trust all that we see.[20] However

his initial audience saw this black man's role, to us he is at the painting's moral center.

Deas set *Walking the Chalk* in the bar of a country inn, but the scene shows the urban temptations for young men who at the time poured into New York City from American farms and rural villages as well as from abroad. The popular writings of Asa Greene in the 1830s exposed their experiences to a wide audience. In his humorous novel *The Perils of Pearl Street* (1834) and his guidebook *A Glance at New York* (1837), Greene itemized the pitfalls of urban

3.13. William Sidney Mount (American, 1807–1868), *Bar-room Scene*, 1835. Oil on canvas, 22⅝ × 27⁷⁄₁₆ in. William Owen and Erna Sawyer Goodman Collection (1939.392); reproduction, The Art Institute of Chicago.

life, chief among them scamming rogues and conniving tavern owners. Perhaps influenced by the poor reception this painting received, Deas ended his production of such scenes of social life with *Walking the Chalk.* In the last of the four pictures that survive from his early career, he

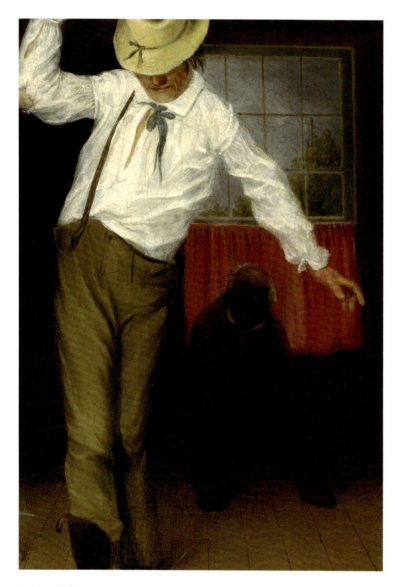

3.14. Detail of fig. 3.7, Deas, *Walking the Chalk.*

took up a new subject that pointed to a change in his life.

Deas's new focus was on violent military action. He may have called on his boyhood fantasies to imagine these cavalrymen fighting in a brooding, turbulent landscape, but he looked to an earlier work, *The Devil and Tom Walker,* to

recast as a military mount the black horse (minus the lolling tongue) that carried Walker to his death. The two horses in *The Trooper* (fig. 3.15) (admittedly an odd title for a picture with two soldiers) convey the painting's emotional energy and lead us to the bloody combat taking place on their backs. The dénouement seems sure: the man on the left fires his pistol directly at the chest of his opponent, who reels backward and throws his sword arm into the air. Yet the shooter has been wounded, too, for the sword has found its mark and blood pours down his forehead. Deas's painting of military action, fantastically realized, is thrillingly escapist. It points to a traditional test of manhood—survival in military combat—that Deas did not take. But it also directs us to the place where he and many of his contemporaries tested their skills—the West.

Although Deas's western subjects were new, his themes—of self-testing and competition for economic survival—were not. To see how these western paintings expressed the issues Deas began to explore in New York City, I turn first to *Long Jakes* and *The Death Struggle,* paintings that he sent to New York after living in the West for about five years. By favoring him with their patronage, the managers of the American Art-Union recognized Deas as a painter of subjects of national concern.

Reinvigorated and with a new name that expressed its national ambitions, the American Art-Union was established in 1843 to provide fresh opportunities for American artists. It was both a public exhibition space and an organization of members paying an annual fee of five dollars. Members were solicited from throughout the United States, although most came from the New York region. The Art-Union's management encouraged artists to exhibit in their rooms for several reasons, the main being to attract the press and new viewers, some of whom might join. As the Art-Union's coffers filled with annual fees, the managers purchased paintings that would be distributed at a Christmastime lottery. Each member had one chance to win one of the purchases. Among the

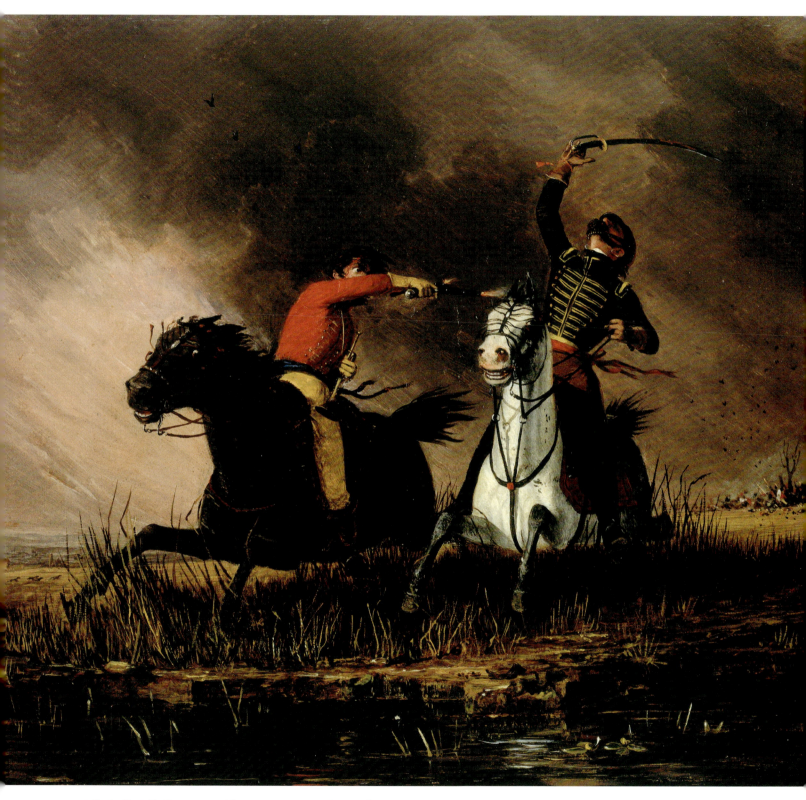

3.15. Charles Deas, *The Trooper*, 1840. Oil on canvas, 12¼ × 14 in. Private collection.

results of this cultural phenomenon were publicity for American art and growing ownership of American pictures by a wider public. It was also an arena for the managers, members of a rising professional class, to exercise their cultural as well as their political and economic influence.

The managers sought subjects of national interest to attract a new public. They found what they were looking for in *Long Jakes* (fig. 3.16). The artist was academically trained and particularly skilled in creating clearly readable forms; the subject was fresh and represented a part of the continent that was of intense interest to the public; and the canvas was the right size (about 30×25 inches) to hang in a parlor. *Long Jakes* could, therefore, tap into contemporary interests and stoke a potential member's fantasy of owning an important work of art; it might also encourage the prompt payment of dues. If Deas had targeted the new organization for his picture, his calculations paid off: the managers purchased it for the substantial sum of five hundred dollars.[21]

Why was *Long Jakes* so appealing? The painting represents a single, mounted figure seen from below and silhouetted against a blue sky. What at first may appear to be a static composition at closer look is animated by the rider's twist in his saddle, which is mirrored by the turn of his horse's head as if it is straining to see what has distracted the rider. The artist paid great attention to details of the figure's gear, including his rifle (its wooden ramrod carried firmly in the barrel), powderhorn, and knife; a bedroll behind the saddle's cantle; and a length of rope tied around its pommel. The rider wears fringed leggings and puckered-vamp moccasins, of Indian manufacture and typical of the dress of Rocky Mountain trappers. Deas made a bold color choice that balanced this proliferation of details: he contrasted the trapper's bright red shirt with the green blanket wrapped around the saddle and draped down over a blue saddle blanket edged in red ribbon. Man and horse dominate the composition and are set off by clusters of foliage in the foreground and by a rocky butte in the background. This butte

and the picture's subtitle at the Art-Union—*the Rocky Mountain Man*—specify its setting in the West's distant and by then famous mountain ranges. Deas humanized this lone trapper: he is hard worn but still strong, apparently independent but connected by similar poses to a companion, his dignified horse. In other words, he evokes our interest as an exotic character from the West, but he also elicits our sympathy as a weary working man.

By endorsing *Long Jakes,* the Art-Union managers recognized western subjects as the most effective beacons of American culture. Joel T. Headley, soon to be known for his popular biography of George Washington, proclaimed in an address at the organization's 1845 annual meeting that only the West could represent the nation because "our Atlantic coast has such an intimate connection with Europe, that I have sometimes thought we never should have much that was national till the West should give shape and character to the country."[22] Elite discourse such as this influenced the reception of *Long Jakes,* but the possibility of individual freedom and adventure that this fur trapper projected had an even broader appeal for city dwellers of all classes. The Art-Union's president, William Cullen Bryant, believed that the managers could "appeal to the growing taste and patriotic pride of their fellow citizens" by "placing meritorious works of art within the reach of the smallest means."[23] One of the Art-Union's goals was to cultivate a sense of national over regional identity by fostering cultural expressions that an audience expanded by class and region might share. Free exhibitions with evening hours in luxurious settings were parts of a strategy to lure new viewers. An upstate New York newspaper critic listed the range of visitors from "the portly merchant to the poor seamstress," optimistically concluding that "all social distinction is lost in admiration of Art—all are happy." Perhaps it was so. Another strategy was to make a spectacle of art patronage enacted at the annual distribution of paintings. Describing the "popularity contest" the lottery fostered, the *Broadway Journal* reported that *Long Jakes* was

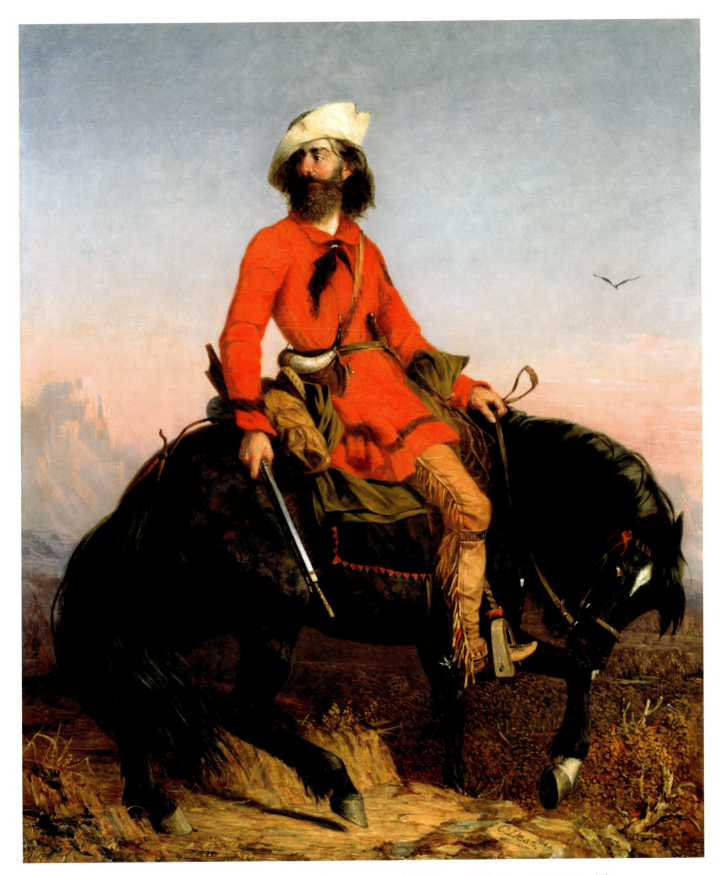

3.16. Charles Deas, *Long Jakes, "the Rocky Mountain Man,"* 1844. Oil on canvas, 30 × 25 in. Jointly owned by the Denver Art Museum and The Anschutz Collection; purchased in memory of Bob Magness with funds from 1999 Collectors' Choice, Sharon Magness, Mr. and Mrs. William D. Hewit, Carl and Lisa Williams, Estelle Rae Wolf-Flowe Foundation, and the T. Edward and Tullah Hanley Collection by exchange (1998.241).

3.17. Matthew Brady (American, 1823–1896), *Marshall O. Roberts,* ca. 1860–1865. Photograph (glass negative contact print). Brady-Handy Photo Collection, Library of Congress, Prints and Photographs Division (LC-DIG-CWPBH-03462).

one of "the two great favorites with the public . . . judging from the sensation among the audience when the numbers were drawn" at the distribution in 1844.[24]

Deas submitted three more western pictures to the Art-Union in 1845. Critics who saw one of these paintings, *The Death Struggle,* thrilled to the story, which they elaborated from the singular moment Deas depicted. Like *Long Jakes,* this picture bore evidence of the "far west," or "Indian country," where, as one critic wrote, "numbers of these [trappers] have perished while ranging its wilderness."[25] Although the public had a chance to see what the excitement was about, *The Death Struggle* was not destined for the lottery. The acquisitive patron and auctioneer George Washington Austen purchased

it directly from Deas while it was on view at the Art-Union in the fall of 1845. Like Marshall O. Roberts (fig. 3.17), who later acquired *Long Jakes,* Austen joined the management of the Art-Union in 1846—Austen as treasurer—and each served until 1851, when the institution, facing a legal challenge of its lottery, began to quickly decline. Although not among the wealthiest of the managers, Austen amassed a significant art collection. Roberts thrived financially and became an enormously wealthy businessman whose investments in railroads and steamships fueled development in the West. Roberts shared the outlook of his fellow managers who purchased pictures for themselves and for the Art-Union that promoted national unity through their subjects of western expansion. These managers effectively brought their business interests and worldview to bear on their cultural patronage. During the Civil War, Roberts reaped unconscionable profits from the sale of ships to the government, while at the same time he polished his image as a selfless supporter of the Union cause by lending works of art, among them *Long Jakes,* to New York's Metropolitan Sanitary Fair in 1864, held to benefit Union troops. *Long Jakes* perfectly suited Roberts's vision of the West as a place of opportunity for the rugged entrepreneur, or at least for the investment capital of a rugged New York entrepreneur.[26]

While the Art-Union offered Deas institutional and private patronage and put his paintings before the public, the *New York Illustrated Magazine of Literature and Art* gave his images a new audience and a new context. While they were on view at the Art-Union, *Long Jakes* and *The Death Struggle* apparently caught the eye of Lawrence Labree, the magazine's culturally ambitious editor. Labree, like the managers of the Art-Union, wanted to give what he called "national character" to his business. One of his strategies was to include reproductive images of American subjects in his new publication. As a result, the first engraving in the July 1846 issue of the *New York Illustrated Magazine* was of an American westerner with the Anglicized French name "Long Jakes" (fig. 3.18). Labree

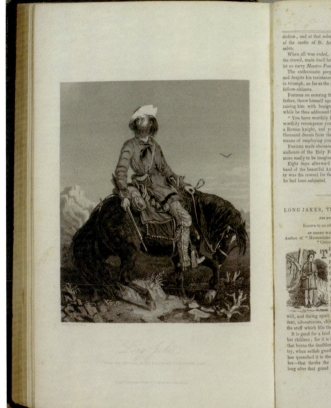

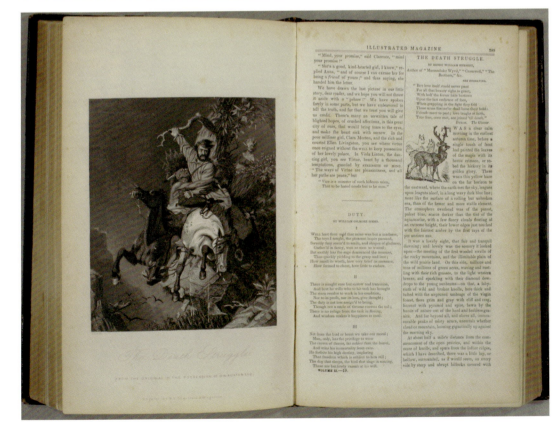

3.18. *New York Illustrated Magazine of Literature and Art* 2 (July 1846). Spread of title page for Henry William Herbert, "Long Jakes, the Prairie Man," and steel engraving *Long Jakes* (after Charles Deas), by William G. Jackman. Newberry Library, Chicago (A5.6575).

3.19. *New York Illustrated Magazine of Literature and Art* 2 (September 1846). Spread of title page for Henry William Herbert, "The Death Struggle," and steel engraving *The Death Struggle* (after Charles Deas), by William G. Jackman. Courtesy of American Antiquarian Society, Worcester, Massachusetts.

[Frontispiece.]

3.20. *Portrait of Henry William Herbert.* 7¾ × 4⅞ in. Frontispiece to David W. Judd, *Life and Works of Frank Forester* (Henry William Herbert) (London: Frederick Warne, 1882). Courtesy of Amherst College Library, Amherst, Massachusetts.

fixed the image within a particular set of ideas by commissioning the popular sporting writer Henry William Herbert (1807–1858) to compose a short piece in response to Deas's picture. In September 1846, he teamed up Deas and Herbert again for a linked image and story called *The Death Struggle* (fig. 3.19). Thus, as the United States pursued an expansionist war with Mexico, images and words carried ideas about the West's new role in national life to readers facing the prospect of sudden and dramatic westward expansion.[27]

While Labree tapped into Deas's rising popularity at the Art-Union, he relied on more-established talent by selecting Herbert (fig. 3.20) to provide the narrative and William G. Jackman to engrave the images. Herbert, an English immigrant to New York City in 1831, longed for success as an author of historical fiction but settled for selling pieces on sport hunting under the pseudonym "Frank Forester." Herbert also supported himself by publishing melodramatic stories. Although they may have been hackwork, the tales he wrote to accompany Deas's images expressed his most important themes—contemporary life's brutal competition and the enervated condition of American manhood. He extolled new masculine opportunities in an Anglo-Saxon hunting tradition that he believed could be renewed only in the American West.[28]

The year 1846, when Deas's two pictures appeared as prints, was an extraordinary time in the history of the nation's expansion. The war with Mexico, which began in May, ended two years later with the cession of over half a million square miles of territory comprising present-day New Mexico, Nevada, Arizona, Utah, and California, as well as part of Colorado. In June, the United States–Great Britain Boundary Treaty brought land consisting of the present-day states of Oregon, Washington, and Idaho. James K. Polk added more land to the United States than any president except Thomas Jefferson, and like Jefferson he instigated a dramatic change in Americans' view of the territorial ambitions of their nation. Deas was among the first to make visible the cultural implications of the nation's future in the West.

In September 1844, while New York toasted *Long Jakes,* Deas was with a military expedition in the West. These simultaneous events were emblematic of the artist's dual authority as a rugged westerner and as a painter who exhibited in the nation's art capital. He had, in fact, changed himself dramatically since moving West. A description of Deas on the Wharton expedition tells how the Philadelphia-born, New York–trained artist shown in his 1840 *Self-Portrait* (see fig. 1.1) became a westerner—be-

came in fact the living counterpart of his imaginary fur trapper Long Jakes. The soldiers called Deas by the nickname "Rocky Mountains," and his appearance on the expedition shows how he had appropriated the trappings of the wilderness. A description, published in the sporting journal *Spirit of the Times* in November 1844, reported that he "had a broad white hat—a loose dress, and sundry 'traps and truck' hanging about his saddle, like a fur hunter. Besides, he had a Rocky Mountain way of getting along; for, being under no military restraint, he could go where he pleased, and come back when he had a mind to."[29]

It is small wonder that, in the heady atmosphere of westward expansion, Deas's contemporaries understood the character of *Long Jakes* as mirroring the changing geography of the nation in the mid-1840s. Long Jakes expressed more than a generalized expansionist ideology: the painting's character spoke directly to the specific context of the war with Mexico. The *Broadway Journal*'s critic dubbed him a "Santa Fe trader,"[30] assuming that he plied the trail leading directly into territory that the U.S. government would soon fight to annex. The *New York Illustrated Magazine* targeted and presumably attracted an educated, art-aware audience that might have associated the trapper's pose with earlier images of conquering heroes on horseback and thus connected this westerner with national power or even with the contemporary conquest of Mexican lands. Herbert directed his story at men, who might have been interested in the prominently displayed two-piece wood stirrup and the unusual, even exotic, high cantle that identified the trapper's saddle as "Mexican" or "Spanish" style. Deas's art and Herbert's essay positioned the western trapper as a symbol of the nation's territorial ambitions. Long Jakes represented the region's past, which was being claimed as national heritage. If his contemporary audience was uncomfortable with the identity of the soaring bird whose dihedral wingspread more closely resembles a turkey vulture than a symbolic American bald eagle, no one expressed it. How, then, can we re-cover the signals that *Long Jakes* sent to contemporary viewers?[31]

Henry Tuckerman provides some help. In the biographical sketch of Deas published in 1846, he made the artist the hero of a broader story about the prospects for the only "true" American art distinctive enough to attract European attention. Tuckerman would have used the adverb "exclusively" in qualifying Ralph Waldo Emerson's 1837 advice to young American men to cease listening to "the courtly muses of Europe,"[32] for Tuckerman believed that most American art derived "naturally" from the country's English past. The nation's cultural future, however, lay in novel subjects: "Tales of frontier and Indian life—philosophic views of our institutions—the adventures of the hunter and the emigrant—correct pictures of what is truly remarkable in our scenery, awaken instant attention in Europe. If our artists or authors, therefore, wish to earn trophies abroad, let them seize upon themes essentially American." Tuckerman admired Deas for devoting himself to subjects drawn from this distinctively American region. What made the region distinctive, Tuckerman argued, was "the interesting spectacle afforded by primeval nature, and the juxtaposition of civilized and savage life."[33] We now see Tuckerman's romantic embrace of the savage as negatively charged with mid-nineteenth-century racial and cultural prejudices, but his pairing of savagery and civilization represents a polarity embodied in *Long Jakes,* a polarity or ambiguity we need to understand.

Charles Lanman, a landscape painter and author who visited Deas's studio in St. Louis in 1846, asserted that Long Jakes looked "like an untamed hawk."[34] Yet Deas's trapper struck the critic of the *Broadway Journal* as tamer, or at least formerly tame: "'Long Jake[s]' was not always a Santa Fe trader—there are traits of former gentleness and refinement in his countenance, and he sits upon his horse as though he were fully conscious of his picturesque appearance."[35] The *Broadway Journal*'s interpretation of *Long Jakes* suited the goal of its editor, Charles F. Briggs (later an Art-Union manager),

to foster a national literature in the face of increasing sectionalism. For these readers, Long Jakes was like Deas himself, an easterner turned westerner whose image assured them that the nation's newest territory would develop as a "civilization" without losing the empowering elements of its "savagery."

To many, including Washington Irving, the fur trade represented the spirit of western enterprise: one of "the pioneers and precursors of civilization."[36] The entrepreneurial fur trapper was a hero to contemporary merchants such as St. Louis railroad builder and financier Thomas Allen. In a speech at the founding of the city's Mercantile Library in December 1846, Allen claimed the fur trader as an ancestor because the commerce that he brought to the West led to civilization. Happily mixing genders, Allen pronounced commerce to be "in some sense king, as she is in another, the great apostle of civilization and refiner of humanity."[37] The fur trade was in the vanguard of this mercantile movement, and the entrepreneurial fur trapper—dubbed by historian William Goetzmann an "expectant capitalist"—was the forerunner of the civilizing merchant.[38]

Deas's imaginary fur-trapping mountain man arrived in New York bearing St. Louis baggage and a national reputation.[39] The artist intended his character to be of French extraction: he painted *Long Jakes* in St. Louis and may have had the history of the region in mind. The Art-Union registered the painting as "Jaques" and "Long Jaques," which implies that Deas submitted this title and wanted his character to retain his French heritage. The peculiar moniker "Jakes" makes sense only in its extraction from the French. That this name change appeared in the Art-Union's catalogue indicates that that institution's managers were the ones who morphed him into an Anglo for his ride in New York City. In their eagerness to foster nationalism, they may have wanted to distance this heroic figure on horseback from the history of French occupation of Louisiana Territory and thus identify the West as a place still being conquered by Anglo-Americans.

Whether of French (to some) or Anglo (to others) extraction, Long Jakes, like Deas, had also taken on Native ways: his fringed leggings are Indian-made and embellished with quillwork, as are his moccasins. Although he has a knife tucked into his waist sash, he is more prominently armed with a rifle, symbolizing European American technological superiority. Long Jakes's "national" status, heralded by the *New York Illustrated Magazine* when announcing the engraving, revealed the complex hybridity of a man fully adapted to his western environment. At once French, Anglo, Indian, both "civilized" and "savage," independent yet linked to a vast international trade in furs, Deas's figure was updated into a new type of American man with a national reach: the westerner.

Deas silhouetted Long Jakes against a blue sky, high on a bluff and literally at bird's-eye viewing level. But the lone rider is about to surrender the summit: he turns in his saddle to take what appears to be a last look back, and his horse has begun to descend the trail. To Deas's contemporaries, the trapper was an ancestor, a character who relinquished the wilderness to others promoting expansion and bringing mercantile interests into the West. The trapper's sober expression and weary demeanor intimate that even he is aware that his era is over. Deas reinforced his presentation of Long Jakes as a character of the past by illuminating the horizon with the glow of a setting sun.

Long Jakes's counterpart in the developing mythology of the West was, of course, the Indian. Although Natives were subjects of Deas's portraits and genre scenes, in only one of his paintings did he treat the figure of a Native as he did Long Jakes—alone in a wilderness setting. Deas presented each of these isolated figures—the trapper in *Long Jakes* and the Native in his 1847 painting *A Solitary Indian, Seated on the Edge of a Bold Precipice* (fig. 3.21)—on a high point with a vast landscape beneath and behind him. The Indian is perched on a bluff above a lake. He is silhouetted, as is Long Jakes, against the sky. But the purple storm clouds in the Native's landscape convey a darker mood

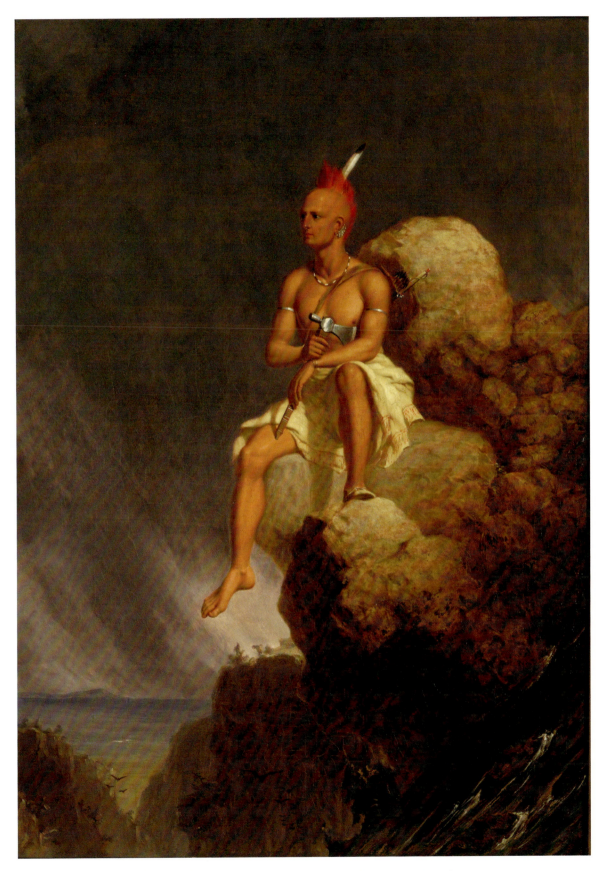

3.21. Charles Deas, *A Solitary Indian, Seated on the Edge of a Bold Precipice*, 1847. Oil on canvas, 36¼ × 26 in.
Courtesy of the Museum of the American West, Autry National Center (93.173.1).

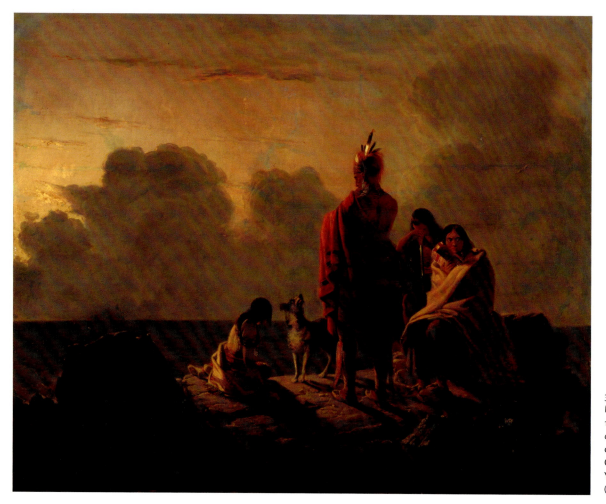

3.22. Tompkins H. Matteson (American, 1813–1884), *The Last of the Race*, 1847. Oil on canvas, 39¾ × 50 in. Collection of the New-York Historical Society (Neg. #6311c; acc. #1931.1).

than do the blue sky and rosy horizon behind the trapper. Like the Natives who are backed up against the Pacific Ocean in Tompkins H. Matteson's painting of the same year (fig. 3.22), Deas's solitary Indian is on the edge, at the end of the proverbial trail. A St. Louis critic described the Indian as being on a "perilous perch,"[40] but to my eye he appears in control of his destiny. Unlike Long Jakes, he is an ideal specimen of physical prowess: his bare chest, arms, and legs are as firm as the rocks on which he sits, and he is ritually tattooed, adorned, and armed. Curiously, he wears just one moccasin, on the foot that rests on solid rock (fig. 3.24). This detail leaves the viewer with the impression that, in preparation to return to the wilderness beneath him, he has emancipated one foot.

To Deas's contemporaries, the Indian and the trapper were characters from the past that represented the new role of the West in the construction of a national identity. But the two characters also represented the romance of escape. The *Broadway Journal*'s critic linked *Long Jakes* to such contemporary ideas: "[W]ith his rifle in hand, his blazing red shirt, his slouched hat, long beard and coal black steed, [he] looks as wild and romantic as any of the characters in Froissart's pages, or Salvator Rosa's pictures. . . . The purple hills and the brown furze harmonize finely in the picture, and give it a very romantic aspect."[41] While this critic may have evoked the works of Jean Froissart and Salvator Rosa as shorthand for the romantic, their curious pairing tells us that *Long Jakes* conjured

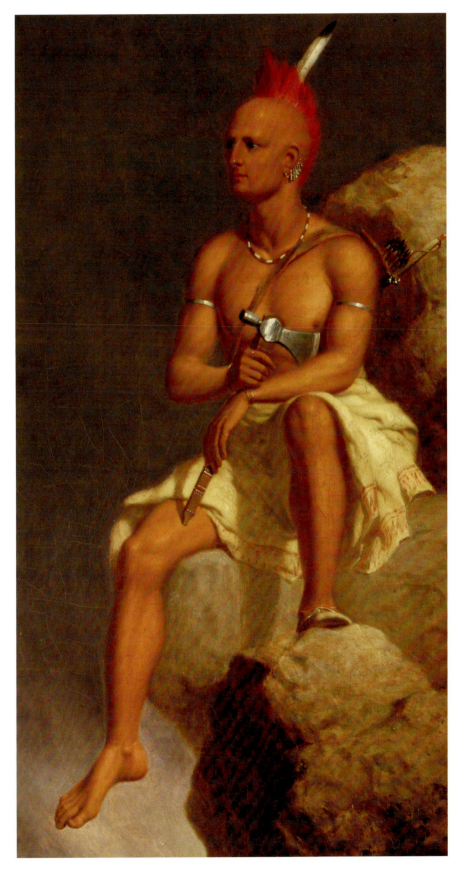

3.23. Detail of fig. 3.21, Deas, *A Solitary Indian*.

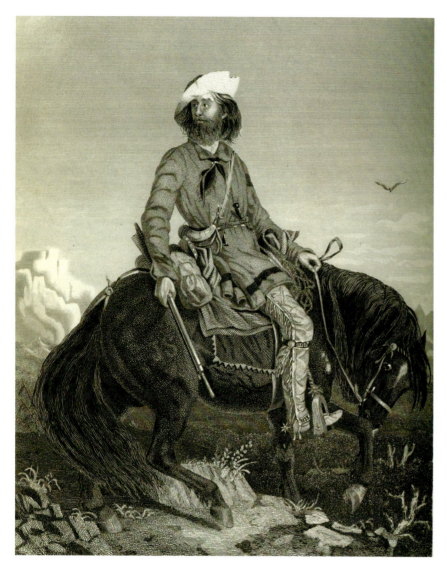

3.24. William G. Jackman (active ca. 1841–1860s), *Long Jakes* (after Charles Deas). Steel engraving, 5¾ × 4¾ in., bound into the *New York Illustrated Magazine of Literature and Art* 2 (July 1846). Newberry Library, Chicago (A5.6575).

Herbert summoned "the olden legends of knight-errantry and strange chivalric valor" and called Long Jakes "chivalric" in the story he wrote for the *New York Illustrated Magazine* (fig. 3.24). He subsumed Deas's imaginary character into his own obsession with the loss of masculinity in contemporary urban society, a loss he blamed on the "merchant princes." If Thomas Allen in his 1846 speech adopted the fur trapper as an ancestor of the contemporary merchant, Herbert saw the trapper differently. In his story, he made Long Jakes a figure for the present and future by positing him not as a mercantile ancestor but as an antidote to what Herbert called the "tyranny of trade." Unlike those merchants at the heart of "the soul-enslaving thought-destroying empire of majorities and masses," Long Jakes was "a man emphatically, and peculiarly; a man at an epoch when manhood is on the decay throughout the world. . . . A man of energy, and iron will, and daring spirit, tameless, enthusiastic, ardent, adventurous, chivalric, free—a man made of the stuff which fills the mould of heroes." Herbert proposed that America's only salvation from what he perceived as her two greatest threats—mercantile greed and democratic excess—was to develop "a race peculiar to America, her own appropriate and independent sons, known to no other land— the men of the prairies." His views were consistently racist and male-focused: he believed that only by tapping the heritage of northern Europe could contemporary man save himself.

In 1846, Anglo-Saxons were asserting their racial superiority in the war with Mexico. It was the first American war pursued on foreign territory and the first covered by newspaper correspondents. Obviously aware of reports of early battles, Herbert brought the conflict into his story of Long Jakes. He did so to proclaim his belief that warfare, terrible as it might be, was an opportunity for America to cleanse itself of materialism: "[T]here are many even of the best and most religious who would . . . welcome war with all its havoc, all its horrors, as the sole thing . . . which can lead them to suppose that men have higher capabilities than that of hoarding

simultaneously noble and terrifying interpretations—a wild man suited to Rosa's dark seventeenth-century landscapes but with the core of urbane chivalry of Froissart's fourteenth-century knights. Deas's contemporaries, in fact, used the adjectives "chivalric" and "wild" to characterize fur trappers and mountain men. As Francis Parkman wrote in 1847 in "The Oregon Trail," one of his *Knickerbocker* series, "I defy the annals of chivalry to furnish the record of a life more wild and perilous than that of a Rocky Mountain trapper."[42] Chivalry was a complicated, international notion, and to many Americans the war with Mexico was "the Crusade of the Nineteenth Century."[43]

money . . . that there are such things, in a word, as truth, and honor; as patriotism and glory; and that the whole aim and intention of man's life, and the world's existence[,] is not, as the merchants would have us to believe, mere selfishness and mammon." The Mexican War's successful conclusion, which Herbert and others anticipated, would add new western lands to the nation—the space necessary for American men to reclaim their power.

Herbert explained why he found Long Jakes to be the ideal American male—"a specimen, the very picture and model of a man." He asked his readers to "look on that sinewy and nervous frame. . . . Look on that bold frank sun-burned face. . . . Look on the graceful ease of hand and leg." He described Long Jakes's attire as "real, useful," yet "showy" and "more than romantic." But Herbert reserved his greatest admiration for the horse. Repeating the mantra "Look at him!" Herbert called his readers' attention to the image, describing a horse no less handsome and well built than its rider. He never mentioned that the trapper made his living as part of the vast fur trade; instead, he explained that Long Jakes supported himself more romantically by capturing and selling wild horses. Herbert concluded by touching on the heroic feats that Long Jakes's noble steed made possible. Readers would conclude that hope for American civilization was in western lands, where "natural" men could enjoy true liberty.

To Herbert, Long Jakes was a hero who was "nobler, stronger, braver, and more faithful, than the pale offspring of society." Yet a close look at Deas's painting reveals chinks in the trapper's armor. What Herbert called his "bold sun-burned face" might be interpreted as features reddened by exposure to drink rather than the elements. Herbert's "broad brimmed sombrero, well suited to guard the eyes alike from the overpowering splendor of the level sunbeams . . . and from the driving hail or sleet of winter," has a distinctive "bite" taken out of its cocked brim. I find these details telling and believe that they carry with them the possibility of drunken moments in Long Jakes's past.

While his overall affect is that of a capable, independent man, Long Jakes's "bitten" hat and ruddy nose recall earlier American depictions of the trapper's life as dissolute. What strikes us as odd, even funny, today, Deas's contemporaries probably viewed as fleeting references to an older conception of the Rocky Mountain trapper.[44]

Was Deas, in fact, a humorist? Some critics of his early genre pictures certainly thought so. They also considered humor, when properly employed, to be an artistic virtue. The *New-York Mirror* characterized *Turkey Shooting, Walking the Chalk,* and *The Devil and Tom Walker* as "humorous pictures," further noting that Deas had "much of the humour of Hogarth, without any of his grossness." Even when faulting his artistic skills, another critic judged his early work to have "much merit and humor." Yet another believed that he had "wit and mind" and praised his genre pictures as "laughable, good, admirable."[45] But did Deas carry this proclivity for humorous subjects into the West? We know that he employed amusing antics to put Indian sitters at ease, because Lieutenant J. Henry Carleton described this incident on the Wharton expedition in the summer of 1844: "Mr. Deas seemed to possess the whole secret of winning the good graces of the Indians. . . . As he said he was sure they did not understand English, he always gave his salutations in French and with a tone and gestures *so irresistibly comic that, generally, the whole lodge would burst into a roar of laughter,* though not a shadow of a smile could be seen on his face" (emphasis in the original). To such comic speech, Deas added dances and mock bows "that would put even an Ottoman in ecstasies."[46] Although Carleton revealed only some of Deas's attitudes toward Natives (and showed his own stereotyping in speaking of an "Ottoman"), he intended to amuse readers of his journal with this description of Indians as childlike, easily distracted, even duped into posing. We see only the European American side of this encounter, which tells us that Carleton encouraged his readers to find humor in Deas's approach to

3.25. Charles Deas, *The Death Struggle*, 1845. Oil on canvas, 30 × 25 in. Shelburne Museum, Shelburne, Vermont.

Indians; to discover what the Natives thought of Deas's behavior probably did not occur to Carleton. Although *Long Jakes*'s contemporary professional critics appear to have taken the trapper very seriously, other viewers may have brought the various published characterizations of Deas as a humorist to their encounters with *Long Jakes.*

Humor and manliness were, in fact, compatible qualities in the mid-1840s. An essay on American humor, published in 1845, allows us to see how Long Jakes could be both manly and funny at the same time. Defending American writers and painters as sufficiently humorous, this essayist believed that because Americans are "nearer to the English than any other people, the offspring and descendants of the great Anglo-Saxon race, we surely must inherit their constitutional tendency, the turn for humor, that lurks in the blood of every true Englishman." This "turn for humor" was deeply masculine as well: "Humor is the characteristic of the English mind, founded on a deep, manly, thoughtful character, and so far from being incompatible with seriousness or even deep gloom, that it springs a rich plant out of that fruitful and strong soil." This author believed, as did Herbert, that Anglo-Saxon racial characteristics would flourish in America. Although Herbert found nothing humorous in Long Jakes, he might have agreed that, like other Anglo-Saxon characteristics, "humor is a manly quality, and requires the pure air of freedom to expand in."[47]

A set of popular stories of the West shows how Deas's contemporaries could see a character like Long Jakes as both serious and comic. In the summer of 1844, while Deas was painting *Long Jakes,* Matthew Field's "Prairie and Mountain Life" appeared in the *St. Louis Weekly Reveille.* Field based the writings on his experiences with Sir William Drummond Stewart's excursion to the Rockies in 1843, and he intended his sketches to "weave in jocose or serious anecdotes . . . as hunter's stories, travelling, or round the camp fire."[48] As such, they are western tall tales, wild exaggerations that spring (sometimes far) from experience to give voice to the denizens of a new American region.

Field spun several stories around Joe Poirier, an experienced boatman and hunter of French ancestry who was on the Stewart expedition. According to Field, Joe was "a kind and gentle-hearted man, in spite of a long career in this half-savage way of life."[49] He was, in other words, a western character who reconciled polarities that Tuckerman called "civilization" and "savagery." But unlike Herbert's one-dimensional, heroic Long Jakes, Joe was funny. He was the target of jokes about Frenchmen because, as Field reported, "he chats most amusingly in broken English." A celebrated hunter, Joe could also make mistakes. One such incident occurred when he took members of Stewart's party to hunt buffalo, which he assured them he could spot as tiny specks on the horizon. All were surprised, when, according to Field, "The living things were rising in the air! Heads, horns and hump, side-ribs, marrow-bones, fleeces, tail pieces, tongue, hump ribs, sweet bread—all were soaring high 'into thin air.'"[50] The "flying buffalos" turned out to be a flock of crows. Field milked the story for all its humor, ribbing Joe and the greenhorns he tricked.

Field's stories offer a framework for imagining the way Deas's contemporaries encountered *Long Jakes.* He was more than a member of a group that Field classed as "the men of the mountains and the white wanderers of the wilderness."[51] To those who saw him in the mid-1840s, Long Jakes might have been a complicated character, for like Joe Poirier, he could be simultaneously an experienced hunter, a vulnerable man, and a fool.

In 1844, Deas suggested that Long Jakes was vulnerable. The following year, he crafted a picture that cast a trapper into a full-blown crisis. How do we account for the change? To begin with, *The Death Struggle* (fig. 3.25) is a hallucinatory image. Its nightmarish quality raises the question of Deas's mental state. When Dr. Pliny Earle admitted him to the Bloomingdale Asylum for the Insane in 1848, he reported that sometime between 1844 and 1847 Deas

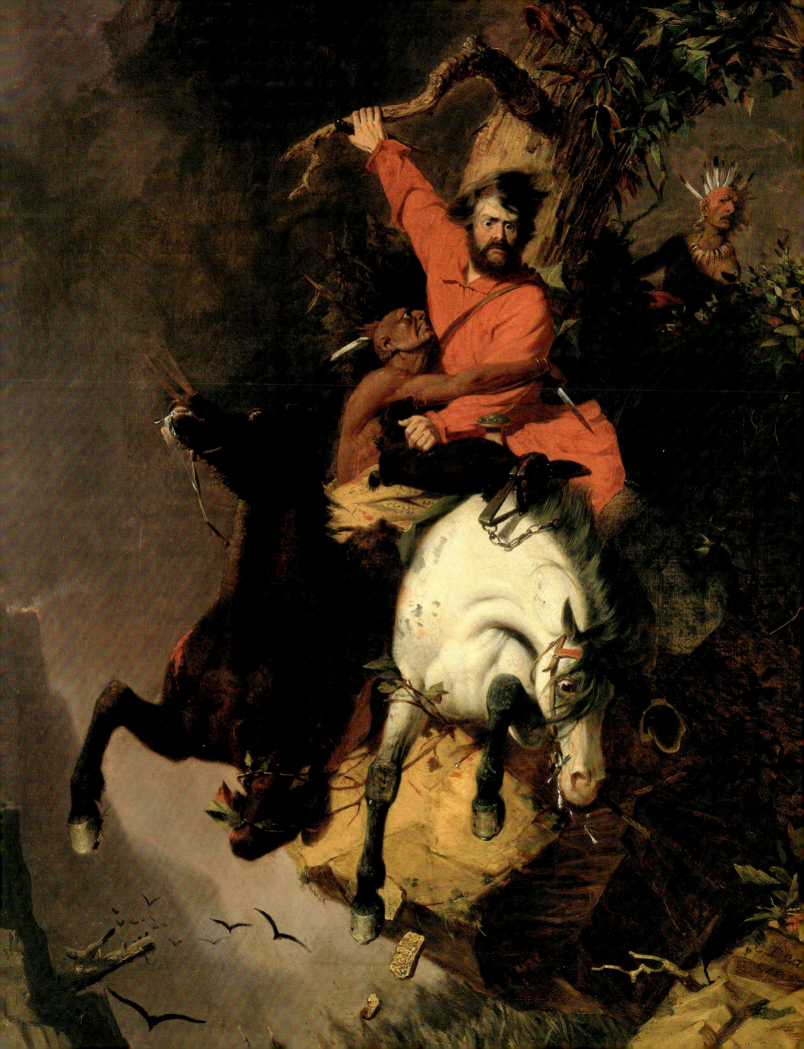

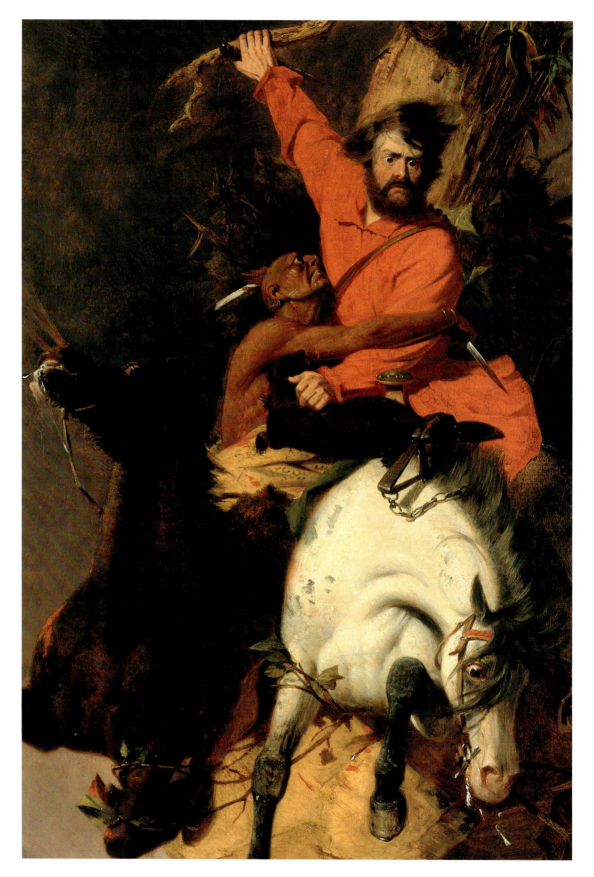

3.26. Detail of fig. 3.22, Deas, The Death Struggle.

had become "monomaniacal on the subject of mesmerism."[52] Could the dreamlike *Death Struggle* have originated in a séance, under a mesmerist's care? Does our interpretation change when we know that Deas painted it while suffering from mental illness? And was that illness the source of his most intensely creative period? A look back at *The Devil and Tom Walker* (1838) and *The Trooper* (1840) confirms that Deas had been attracted to terrifying encounters on horseback early in his career. This attraction was fully expressed in *The Death Struggle.* Distinctly different from the toxic mix of monsters and writhing human sufferers depicted in (the now lost) *A Vision,* which Deas painted in the throes of his illness circa 1849,[53] *The Death Struggle* nonetheless exhibits the terror of an increasingly troubled mental state.

As was his practice, the artist carefully observed and sharply delineated the dress and accoutrements of his subject: the buffalo robe decorated with pictographs that the Native combatant wears, the large bear-claw necklace on the background spectator, and the saddle, the bridle, and the beaver trap at the center of the composition. But he subordinated these elements to the blood-spilling, eye-popping horror of the unfolding catastrophe: in fighting on horseback over the possession of a beaver still in its trap, an Indian and a white man plunge over a cliff. The bodies of the two men and the live beaver entwine in a series of expressive gestures: the white man grasps the beaver's neck with one hand and clutches at a branch behind them with the other; the beaver bites the Indian; and the Indian flings his arm across his adversary's body (fig. 3.26).

The white man's large frame, his red shirt, the open expression of his face, and his white horse all mark him as the picture's focus. But even if Deas put the Indian in a more vulnerable position and showed him to suffer a greater number of grievous wounds, he intertwined their fates. The Indian grimaces in pain and looks up at the white man, whose wide-eyed stare implies that he cannot look down. Neither is in control. Instead, it is the horses that, according to the

3.27. Charles Deas, *Indian Brave*, 1847. Oil on cardstock, 7¹³⁄₁₆ × 6⅛ in. Gilcrease Museum, Tulsa, Oklahoma.

Broadway Journal's critic, "break from the control of their riders, and rush headlong towards a frightful precipice." Racial prejudice prevailed in the way Deas registered on each man's face awareness of his destiny. The critic saw that "the face of the Indian exhibits no other expression than that of tiger-like ferocity" but that the white trapper wears "an expression of horror at his appalling situation."[54] Two years later, in 1847, Deas painted two portraits of western types that reinforce similar stereotypes (figs. 3.27 and 3.28). In this pair of works, the fury conveyed

3.28. Charles Deas, *River Man*, 1847. Oil on cardstock, 6¾ × 5⅜ in. Gilcrease Museum, Tulsa, Oklahoma.

Carson" and his Indian "Mato-tope." In 1846, Máh-to-tóh-pa was among the most famous Indians in American history, second chief of the Mandans and a fierce warrior against his people's Native enemies. He had welcomed white trappers, traders, and explorers to his home on the upper Missouri but then denounced all whites when his family—indeed, almost the entire Mandan tribe—was wiped out in 1837 by smallpox carried to them by whites. Máh-to-tóh-pa died of the disease. Karl Bodmer painted him, and George Catlin depicted and devoted several chapters to the chief in *Letters and Notes on the Manners, Customs, and Conditions of the North American Indians* (1841). Herbert likely knew of this book, widely available in America.

"Mike Carson" conjoins the names of two famous western characters: Mike Fink and Christopher "Kit" Carson. The exploits of Ohio and Mississippi boatman Mike Fink, exaggerated and fictionalized as tall tales, appeared in popular literature, and Kit Carson was celebrated as John C. Frémont's guide in the explorer's reports of the western surveys. To appreciate Herbert's story, we need to know that Mike Fink and Kit Carson were judged to be both heroes and reckless murderers.[55] Mike Carson, protagonist of Herbert's "Death Struggle," is one of a group of four trappers the author described as "chivalric rovers of the western wilderness . . . the offspring of perfect freedom and perfect self-reliance," yet a character flaw condemns him. According to Herbert, he has "filled his prejudiced mind with false conclusions, and convinced himself of the truth of a lie." His racial prejudice blinds him to the evidence, and he mistakenly concludes that Mato-tope has stolen a beaver from his trap.

On his way to seek revenge, Carson comes upon the Indian's trap and attempts to steal the beaver still struggling for its life, but Mato-tope confronts him, and the fierce fight depicted by Deas ensues. As their horses pitch them all into a ravine, Carson "clutches in desperation a limb above his head protruding from the stem of the last tree, but it cracks—it yields, impotent to save." Deas's picture leaves us literally hanging

by the Indian's glare, his open mouth, and his wind-swept hair is set off by the voyageur's solemn, world-weary expression. Whatever advantage his dominant position and superior awareness might have given the white man in *The Death Struggle,* it ultimately does him no good. Whatever competitive spirit led him to raid an Indian's trapping ground, he is doomed to fail.

Herbert, in his 1846 story, gave full voice to the trapper's moral failure hinted at by the *Broadway Journal*'s critic. Herbert also chose names for his protagonists (fig. 3.29) that he hoped would resonate with his readers: he called his Anglo-American trapper "Mike

from an intact branch. Herbert's story does not. He fleshed out the horrific consequences of the two men's plunge, which no doubt encouraged viewers of the engraving to do the same. Herbert concluded his story with one of Carson's men "gazing at the crag's foot on a pile of blood and mutilated flesh and bones crushed and almost indistinguishable. Two horses, and *one* human carcase [*sic*]." The Indian's comrades, according to Herbert, discovered the two bodies so hopelessly entangled that they cut off the white trapper's hands to retrieve the body of their fellow Indian. They then scalped the white man and left his mutilated body to rot. I think Herbert wanted his readers to consider the evil of a cycle of revenge, which could taint even a "splendid specimen" such as Mike Carson. In this competitive world, no one could afford any moral weakness.

Elizabeth Johns has proposed that Deas's audiences reacted to the fact that this trapper "endured to the death in a contest that requires the utmost courage," which affirmed for eastern men that "male power" was "attained through violence."[56] My analysis focuses more on the fact that the trapper does not prevail, that his supposed superior racial power failed him. While *The Death Struggle* affirmed contemporary beliefs about racial superiority and the value of competition, it also undercut them. The trapper's competitive spirit, which viewers in the 1840s might admire, is undermined by the trapper's theft from the Indian and his failure to "win" the beaver or even to live to tell the tale. To explore how Deas's contemporaries perceived this work, I have considered other ways in which they might have encountered the phrase "death struggle" in popular writings of the mid-1840s. A different tale, also titled "The Death Struggle," appeared in two publications, the *St. Louis Weekly Reveille* and New York's *Spirit of the Times,* in the summer of 1845, just before Deas's *Death Struggle* went on view in New York. Both magazines circulated nationally, and no journal published more important works of southern and western literary humor than did *Spirit of the Times.* John S. Robb, writing under the pseud-

3.29. William G. Jackman, *The Death Struggle* (after Charles Deas). Steel engraving, 5¾ × 4¾ in., bound into the *New York Illustrated Magazine of Literature and Art* 2 (September 1846). Courtesy of American Antiquarian Society, Worcester, Massachusetts.

onym "Solitaire," told a tale about two characters named, generically enough, Smith and Jones, who were shoemakers in a frontier town. The competition to advertise their businesses with elaborate signs ends with Jones attempting the ultimate in self-promotion. He rigs himself up with boots and suspenders to a flagpole in front of his shop. As he hangs there overnight, he slowly strangles: "Morning broke—astonishment and horror!—terrible Jones!—triumphing in death!"[57] With black humor, Robb satirized contemporary commercial competition.

I imagine that Deas's audience would not have missed the connections. "Death struggle"

was a figure of speech commonly used in the 1830s and 1840s to characterize fierce political contests.[58] Robb and Deas deployed the phrase for commercial battles (whether over shoes or animal pelts) that were ruthless and sometimes fatal. Robb had a reason to make shoemakers the protagonists of his story. Shoemakers, like many other frontier craftsmen, were being ruined by eastern merchant capitalists who controlled the production of goods and shipped them to new markets in the West, where they undersold the locals.[59] Seen against these changes in the frontier economy, Smith and Jones might be funny because they were anachronisms. They desperately competed against one another when their true enemy was the economic reality of mass production. Smith survived this competition with Robb, but he, too, would eventually succumb to forces beyond his control. Deas thus set his competition between a white trapper and an Indian in a past that resonated with eastern audiences in 1846. *The Death Struggle* entwined races and cultures in a contest for western resources, symbolized by an old commodity, the beaver, which the buffalo had by that point surpassed as the target of the fur trade. By summarizing a western past, the picture projected, as did the tale of two frontier shoemakers, a moment of deep disquiet about the future control of the continent.

Another story by Robb extends the commercial context for Deas's *Death Struggle* in a different direction. "In at the Death: A Rocky Mountain Sketch," published in 1846, hinges on a trapper's encounter with a large bull buffalo, the market hunter's prey, which he tracks across the plain and succeeds in wounding but not killing. The enraged buffalo attacks the trapper, who finds himself literally on the edge of a cliff and with just one option. He takes refuge on a shallow ledge, only to see that the buffalo, in the throes of death, is "totter[ing] over the verge" and certainly will crush him. The trapper, "frantically grasping his shaggy mane . . . was hurled with him to the bottom of the ravine." Horror then turns to humor. The trapper discovers that he has landed on top of the beast: the buffalo

had "broken the force of my plunge into the ravine." The story concluded with the trapper cutting himself "a few steaks as proof of my being 'in at the death'" and leaving the buffalo's "carcass to the wolves, well satisfied with my share of *that game.*"[60]

Robb's story "In at the Death" suggests two things to me about Deas's *Death Struggle.* The first is that the buffalo and the Indian might be interchangeable in these narratives, such that Deas's contemporaries considered the Indian to be both as wild as the animal and as dispensable. The determined expression and upright posture of Deas's trapper mark him as a being that his contemporaries considered to be superior to the Indian, whose face is contorted and who appears to slip away despite his desperate hold on the trapper. Another implication is that viewers probably saw Deas's pictures in the context of other stories of exaggerated plights. Readers laughed at the more obvious tall tale, although some viewers may have winced at the obvious theatricality of Deas's melodrama.

Reactions to Deas's paintings varied. That one viewer (in St. Louis) called "spirited and striking" a picture that another (in New York City) mocked as excessively melodramatic reveals the different ways in which Deas's contemporaries classified his work.[61] What, specifically, about *The Last Shot,* which Deas showed in St. Louis in 1846 and at the Art-Union in 1847, thrilled the St. Louis critic and discomfited the one in New York? The picture's subject, known today only from contemporary descriptions, was a violent encounter between an American "hero" and a Mexican "villain" during the battle of Resaca de la Palma. War gave rise to heightened racism, and Deas's picture appears to demonstrate that Mexicans joined Indians and African Americans as objects of white fear. In 1848, Francis Parkman summed up this attitude in "The Oregon Trail," one of his *Knickerbocker* series: "The human race in this part of the world is separated into three divisions, arranged in the order of their merits: white men, Indians, and Mexicans; to the latter of whom the honorable title of 'whites' is by no means conceded."[62]

Some Americans, perhaps to imagine a suitable enemy, went against the grain of racist attitudes and judged Mexican officers as "worthy of the days of chivalry."[63] But most commentators on the war saw Mexicans not merely as racially inferior but as inferior precisely because of the racial mixture—Spanish, American Indian, and African—attributed to them. The "embedded" American war correspondent Thomas Bangs Thorpe, for example, expressed such prejudices when he claimed that the "private soldier of the Mexican army" was a mixture of different races in which "the evil qualities of each particular one is alone retained."[64]

To wartime American eyes, the most hated Mexicans were the guerrillas called rancheros. In *The Last Shot,* Deas pitted a ranchero against the former Texas Ranger Samuel H. Walker, a captain in General Zachary Taylor's army. A critic for the press in St. Louis described the way in which Walker, "prostrate upon the ground" because the ranchero had shot his horse, bravely kills his "treacherous enemy." The critic played off the ranchero's "look of mingled surprise and agony" against Walker's "firm, determined countenance."[65] The Mexican was no match for the all-American Sam Walker, who became a national hero well before his death in battle in October 1847.

Although we can know little more without seeing *The Last Shot,* the St. Louis critic's account of the picture suggests that Deas's image of Walker matched contemporary views of Americans as fighting for the Anglo-Saxon "race" destined to populate the North American continent. John L. O'Sullivan, who coined the phrase "Manifest Destiny," declared in 1845 that "the Anglo-Saxon foot is already on [California's] borders.... [T]he advance guard of the irresistible army of Anglo-Saxon emigration has begun to pour down upon it."[66] Men such as Walker pressed forward the cause.

Could the New York critic who wrote that "contemplation" of "the hideous aspect of the dying 'ranchero' ... at breakfast-time would destroy ... the appetite, and ... peace of mind" of its owner "forever" have mocked a subject

as ostensibly serious as Walker's fight and the cause it represented? Was he making fun of Deas's sensationalized treatment of the subject or of the falsely refined sensibilities of art collectors? The critic quoted a line from Chaucer's Prologue to *The Canterbury Tales,* which may have displayed his own literary pretensions.[67] Comprehending the perspective of anyone who saw Deas's work more than 160 years ago requires imagination and risks a false reconstruction. Where was the line dividing paintings that appealed to "higher" sensibilities from those that milked the sensational? Had Deas stepped over the line, as he had when he showed *Walking the Chalk* a decade before *The Last Shot?*

There is little doubt that audiences of the mid-1840s grasped the racial assumptions of Deas's depictions of death struggles, whether between a white soldier and a ranchero or a white trapper and an Indian. The Indians Deas painted in compositions without whites, however, elicited responses from the press that were more complex than those called up by the Native in *The Death Struggle.* For example, when the *Broadway Journal*'s critic saw *The Indian Guide* (now lost) at the Art-Union in the spring of 1845, he viewed the guide in Deas's painting to be superior to a "pure savage." This distinction was critical because, as he wrote,

> Pictures of pure savage life, like those by Mr. Catlin, cannot excite our sympathies as strongly as do the representations of beings who belong to our own race. The Indian stands at an impassable remove from civilization, but the half-breed forms a connecting link between the white and red races; we feel a sympathy for the Indian Guide that we never could for the painted savage, for we see that he has a tincture of our own blood, and his trappings show that he has taken one step towards refinement and civilized life.[68]

Characters such as those Deas painted in *The Indian Guide* and *Long Jakes* were markers along a western continuum that Tuckerman polarized as "savagery" and "civilization" in

his biographical sketch of Deas. Reaction to Deas's pictures shows that his audiences wanted their wild white men, like Long Jakes, to retain vestiges of their former civilized ways, while they valued Indians who had shaken off some of their wildness in a move toward civilization. The balance between wildness that affirmed masculinity and civilization that kept such wildness in check was a delicate one.

Is the *Broadway Journal*'s phrase "tincture of our own blood" only a trope to assert the superiority of "white" blood? Or does the phrase point specifically to miscegenation? This critic saw Deas's Indian guide as "a connecting link between the white and red races" that would move Indians "towards refinement and civilized life." Did Deas intend the subject of *The Indian Guide* to be of mixed race? There is no evidence other than this critic's response, which aligns him with some contemporary "scientific" theories of racial hierarchy that existed in a complex mix of ambiguous attitudes toward "mixed-bloods."[69] One such theory illuminates the *Broadway Journal* critic's attitude. George Combe, a Scottish lawyer whose prolific writings on phrenology attracted the attention of American artists, ranked a child of Indian and European American parents to be "decidedly superior in mental qualities to the native, while they are still inferior to the European parent."[70] Combe was just one authority upon whom European Americans relied in their efforts to rationalize the destruction of Native lifeways and the annexation of Native land by claiming racial superiority. But that Combe's justification seems to value those of mixed race, which many others despised, suggests how tortured these efforts were.

Deas, in fact, put a racially mixed family at the center of another of his 1845 paintings.[71] In *The Voyageurs* (fig. 3.30), a family of six—a French trapper, his Indian wife, and their four children—navigate upriver in a dugout canoe.[72] Deas divided members of this family into their respective areas of responsibility. The gray-bearded patriarch, assisted by a daughter who paddles in front of him, controls his family's passage from the stern (fig. 3.31). The eldest child, a son, stands in the bow and holds the spear with which he has caught fish (fig. 3.32). The wife and mother is at the center of the canoe, with her two youngest children gathered around her. She props the baby atop the covered cargo, to which are strapped the family's possessions, including a battered

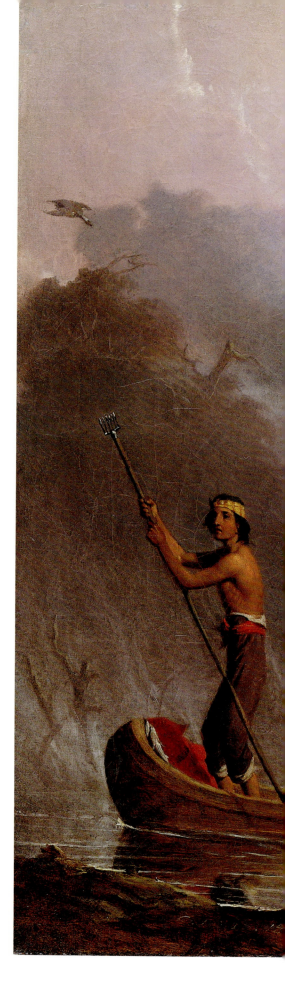

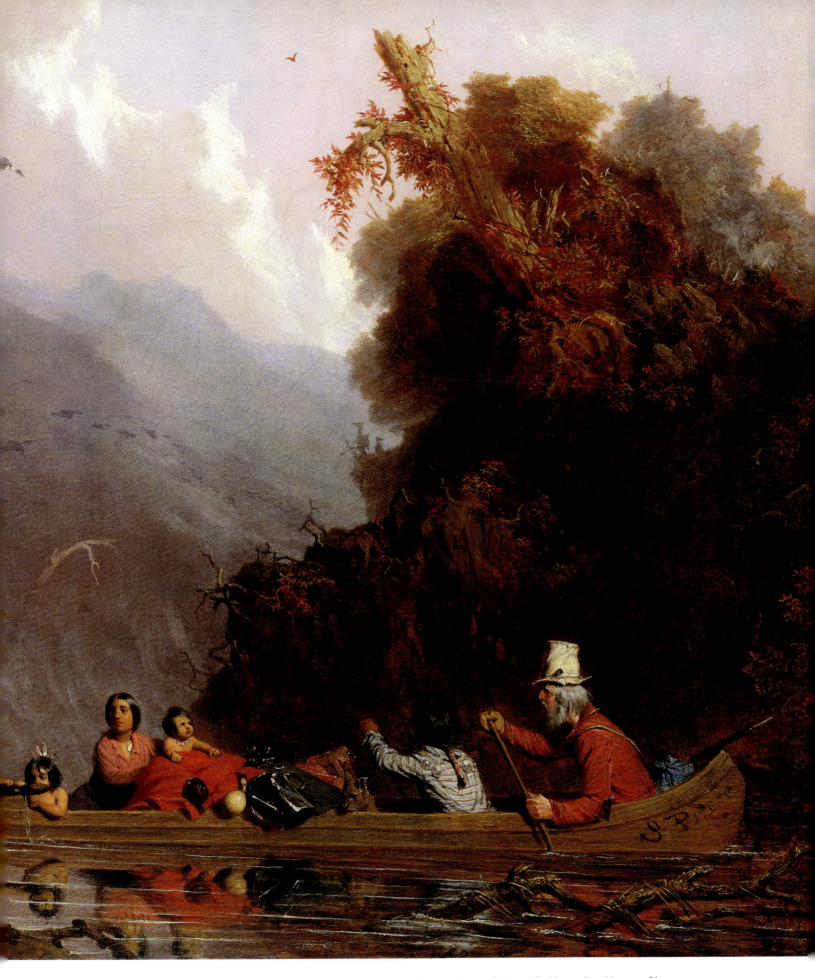

3.30. Charles Deas, *The Voyageurs*, 1845. Oil on canvas, 31½ × 36 ½ in. The Rokeby Collection; photograph © 2002 The Metropolitan Museum of Art.

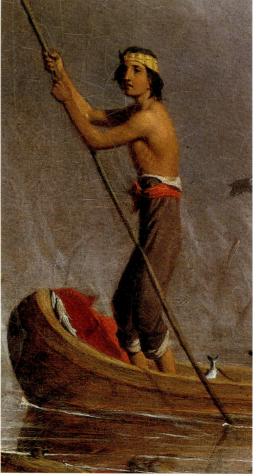

3.31. Detail of fig. 3.30, Deas, *The Voyageurs.*

3.32. Detail of fig. 3.30, Deas, *The Voyageurs.*

3.33. Detail of fig. 3.30, Deas, *The Voyageurs.*

metal coffeepot (fig. 3.33). Deas meticulously painted these still-life elements, as he did the headgear and dress that differentiate the races: the man sports a European-style high beaver hat, and one of the small children wears a feathered headband.

Deas embodied in his art the sexually and socially driven alliances between European Americans and Native Americans in the West. His knowledge of the racially mixed West was surely personal, something he saw in his day-to-day life, but it was also professional and official. In July 1841, during his first year traveling in the Upper Mississippi River valley, he witnessed signatures of "mixed-bloods" for the Doty Treaty. In fact, one of the signatories designated "mixed-blood Dakota Sioux" was Emilie Hooe, whose husband, Captain Thornton Alexander Seymour Hooe, signed on behalf

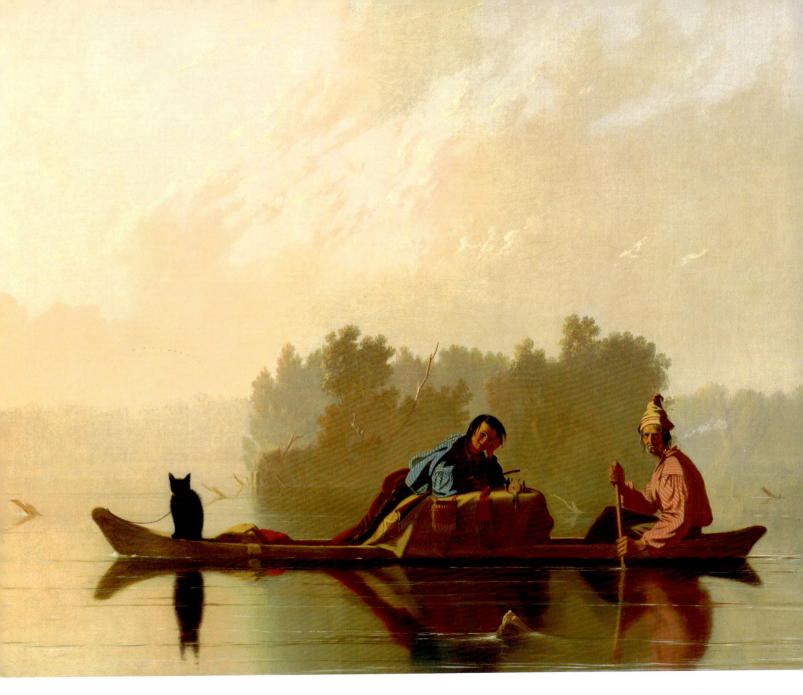

of his wife. Deas knew Captain Hooe at Fort Crawford and had painted his portrait there in 1840 (see fig. 1.10). Perhaps he learned then or on the Doty mission that Captain Hooe was a great-grandson of George Mason IV of Gunston Hall in Virginia and that Hooe's wife was a great-niece of the Sioux chief Wabasha. The West that Deas experienced was racially more fluid than the East where he had grown up. We do not know how his contemporaries reacted to *The Voyageurs*. Perhaps it was a private commission and perhaps Deas exhibited it, but no record has

surfaced, and no critic is known to have commented on it.

If Deas did not send his painting of a fur trader's family on a western river to New York City, another Missouri artist submitted a picture of this subject: in 1845, the American Art-Union acquired a painting by George Caleb Bingham for distribution but changed its title from the one Bingham offered, *French Trader—Halfbreed Son*, to *Fur Traders Descending the Missouri* (fig. 3.34).[73] By doing so, the Art-Union managers erased the picture's ethnic and racial

3.34. George Caleb Bingham (American, 1811–1879), *Fur Traders Descending the Missouri*, 1845. Oil on canvas, 29 × 36½ in. (73.7 × 92.7 cm). The Metropolitan Museum of Art, Morris K. Jesup Fund, 1933 (33.61); image © The Metropolitan Museum of Art.

3.35. Charles Deas, *Indians Coming down a Defile,* 1847. Oil on canvas, 14 × 20 in. Stark Museum of Art, Orange, Texas.

associations, which changed its relationship not only to history but also to contemporary life in the West. Deas's and Bingham's pictures share a basic organization (figures traveling on a river presented parallel to the picture plane) and have the same undercurrent (western commerce). Otherwise they differ dramatically. Bingham's all-male pair balances in a harmonious, pyramidal composition. Looking out to engage us, the men appear relaxed in a calm riverscape simplified to its essentials: a clump of bushes anchors them from behind, and a single snag slightly agitates the water in the foreground.

Bingham's father and son are heading down-stream, to market their pelts (in other words, to-ward "civilization"), while Deas's family travels upstream, back into a "wilderness" darkened by a storm.[74] Deas's skill as a landscape painter is on display here in lessons he must have learned from looking at the work of Thomas Cole. One tree trunk, barely anchored to a river bluff, an-gles high above the boat. After 1845, Deas ap-pears to have devoted more effort to pure land-scapes with narratives more natural than arti-ficial. By ordering the compositions of two of these landscapes (figs. 3.35 and 3.36) around a single bare tree trunk, he continued to pay hom-age to Cole. Skies carry an emotional charge in

3.36. Charles Deas, *Western Scenery,* 1848. Oil on canvas, 13½ × 17 in. Private collection; courtesy of Kodner Gallery, St. Louis, Missouri.

Deas's independent landscapes as they do in *The Voyageurs,* in which the family travels into a storm manifested by dark, billowing clouds.

A voyageur (who traded for pelts) and a trapper such as Long Jakes had different roles in the historical and contemporary western dramas of the 1840s. In Lanman's prose, penned during the summer of 1846, the voyageur was "the shipping merchant of the wilderness."[75] The passage of Deas's hardy family through this forbidding landscape implies, as we have come to expect, the difficulties of contemporary commercial life. The Art-Union's decision to buy Bingham's *Fur Traders Descending the Missouri* affirmed a

view of smoothly flowing western commerce that suited eastern interests. Deas's river is more ambiguous. It is abundant and pure in itself: the fish flapping in the bow are evidence of the eldest son's successful catch, and one child dips into the river to drink from it. But Deas's imagined river is also one element of a natural environment that is perilous to the transportation of goods. Nature both endangers and sustains the survival of this racially mixed family.

Western rivers, especially the Missouri and the Mississippi (which join just north of Deas's adopted home, St. Louis), were essential to the local, regional, and national

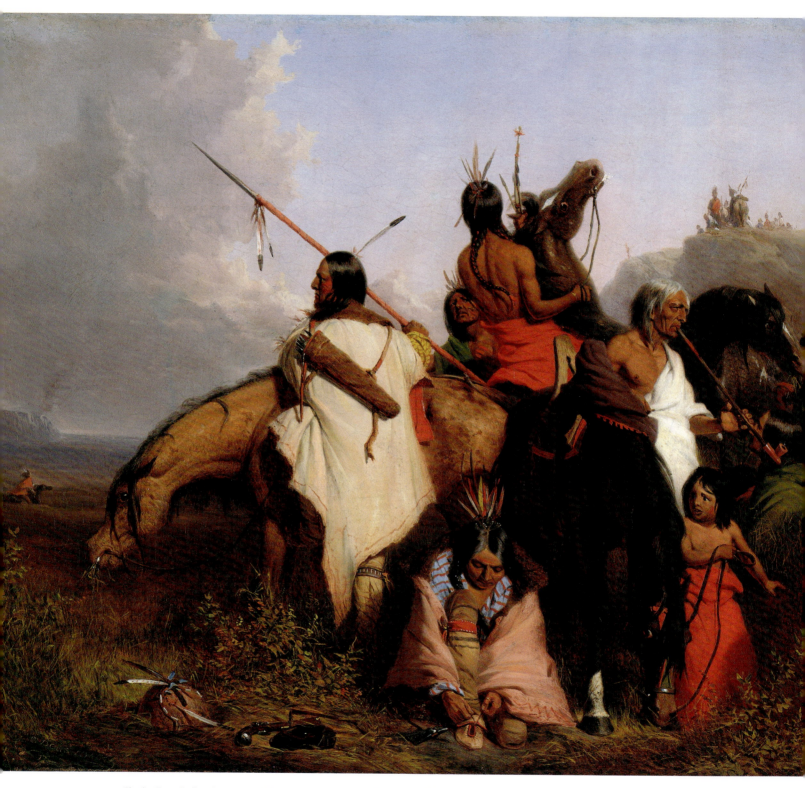

3.37. Charles Deas, *Indian Group,* 1845. Oil on canvas, 14⅛ × 16½ in. Amon Carter Museum, Fort Worth, Texas (1980.42).

economies, but they also threatened commerce and life. Despite the efforts of government and business to keep the Mississippi and the Missouri navigable, steamboats frequently ran aground—and sometimes sank with the loss of human life as well as cargo. The rivers menaced more than transportation and commerce. Cities were at risk for floods, which were among the most feared events in river towns. In 1844, when Deas lived in St. Louis, the valley experienced a devastating flood. It was one of many, but the worst in fifty years. Navigable (sometimes barely) and abundant (but also rife with danger), the river in *The Voyageurs* symbolically conveys essential contradictions of the West's simultaneous economic power and vulnerability.

Deas also incorporated family life in a painting that, like *The Voyageurs,* is dated 1845. Yet the differences between these two pictures are telling. Although determining the narrative of *Indian Group* (fig. 3.37) is difficult, it is surely a story posing a threat more immediate than the one the voyageurs face. The theme of danger may have been new to Deas's treatment of family life, but he had previously worked on other ideas about Indian family life that he developed in *Indian Group.* One example of this appears in a pair of watercolors signed and dated 1843— *Sioux Awaiting the Return of Friends* (fig. 3.38) and *Winnebagoes* (fig. 3.39)—in which he addressed acts of communication and poignant moments of returning home.

In *Indian Group,* Deas established the tension that underlies the threat to such idyllically constituted family life by tightly clustering figures in the right foreground and then, while eliminating a middle ground, shifting the action abruptly into the background on the left. He had employed a shift like this before, in *Turkey Shooting* (see fig. 3.1), but in *Indian*

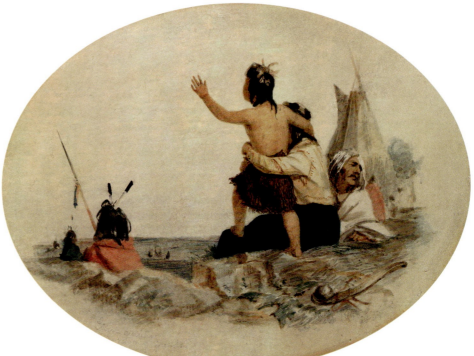

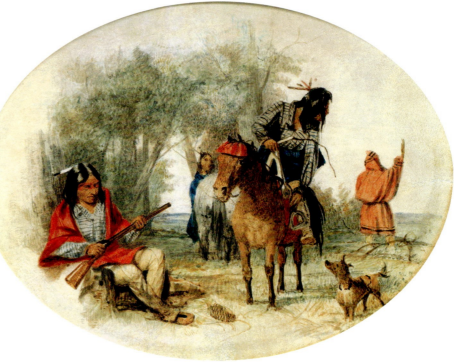

3.38. Charles Deas, *Sioux Awaiting the Return of Friends,* 1843. Watercolor on paper, 7½ × 9½ in. Collection of Thomas A. and Jane Petrie.

3.39. Charles Deas, *Winnebagoes,* 1843. Watercolor on paper, 7 × 9¼ in. Courtesy of private collection.

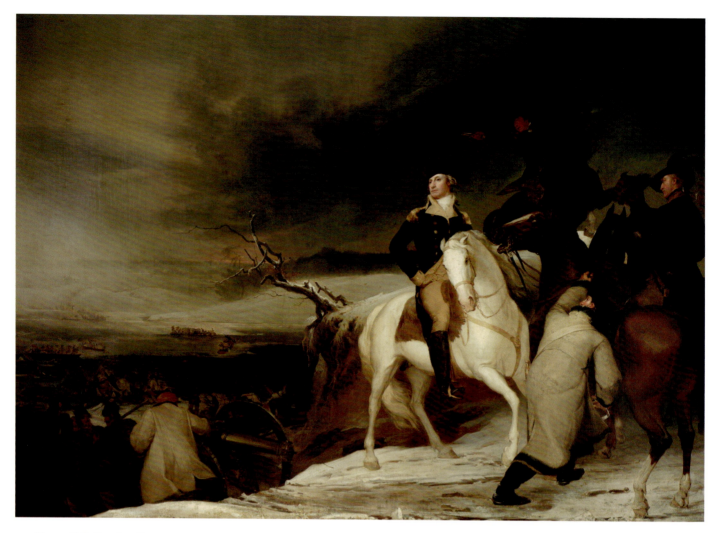

3.40. Thomas Sully (American [b. England], 1783–1872), *The Passage of the Delaware,* 1819. Oil on canvas, 146½ × 207 in. Museum of Fine Arts, Boston, gift of the owners of the Old Boston Museum (03.1079).

Group he more compactly arranged the figures in a circle that relates to the mounted figures in the foreground of Thomas Sully's immense painting *The Passage of the Delaware* (fig. 3.40), which Deas likely knew. He also kept the viewer's attention moving within the composition by varying the positions of the figures in *Indian Group:* preparing to mount, reining in a rearing horse, standing, sitting, kneeling.

The directions of their gazes also vary, which leads our own (and also our thoughts) in different directions. Two of the men carry our attention into deep space; whether it is to the source of a signal or the source of a threat is not entirely clear. The dark clouds Deas piled up in this corner, which cast the background action into deep shadow, convey a sense of foreboding echoed in the tense poses of some of the figures.[76] One of

these figures is already mounted; the other, seen from behind and clad in a buffalo robe, slips his foot into a stirrup and holds his saddle in preparation to mount (fig. 3.41). That this figure also clasps a lance indicates that he is prepared to attack his enemies or to defend his own group. Deas countered this centrifugal movement with the centripetal force of the family. At the far right, he composed a quartet of an old man, a young mother who carries an infant close to her breast, and an older child (fig. 3.42). This group is not, however, disengaged from the action. The older child, who holds the reins of one of the horses, turns away from the old man and the woman with an expression of anxiety, even of terror. This child, then, connects the two narratives: one of warfare, the other of family.

How exactly are we to interpret these two

3.41. Detail of fig. 3.37, Deas, *Indian Group*.

3.42. Detail of fig. 3.37, Deas, *Indian Group*.

narratives? Did Deas's contemporaries see the Indians, embattled and encircled, as threatening, or did they empathize with his evocation of family ties? And whatever their attitudes toward the Indians might have been, did his viewers believe the painting to be set in a mythical past or a place so far away that they could comfortably romanticize fighting Indians? Perhaps they did so relegate its subject, but the picture's various stories also resonated in the present. There is no evidence that Deas exhibited this picture and no record of his contemporaries' response to it. But because the painting belonged to Philip Kearny, who was with Deas on the Wharton expedition in the summer of 1844, it may be related to the intertribal conflict that Major Clifton Wharton was ordered to investigate. In Wharton's words, the expedition was organized both to "impress upon such Indian tribes as we may meet the importance of their friendly treatment of all white persons in their country . . . and to endeavour to effect a reconciliation between the Pawnees and the Sioux between whom a most ferocious war has been carried on for many years."[77] The *Reveille* reported Indian conflicts such as these to its St. Louis readers.[78]

Closer to the homes that European Americans were building in the West came newspaper reports of ongoing Indian aggression against settlers. A writer for the *Reveille* railed

against what he judged to be "the Indian hordes who are now daily committing murder, outrage and robbery on the plains."[79] Another reporter expressed hope that the federal government would forcefully intervene to "use some other

3.43. Detail of fig. 3.37, Deas, *Indian Group*.

measures with the Indians than making them presents, and smoking with them the pipe of peace."[80] A few writers in the St. Louis press sympathized with the plight of displaced Natives, however: "Amid the cry of execration which is raised against Indian outrages, etc., we are now and then compelled to remember that the red man, also has his complaint to make."[81]

The action in *Indian Group* expresses this range of attitudes. The Indians in Deas's painting are armed and dangerous, potentially a

threat, but they also appear threatened. Fundamentally, family life is at stake here. The decade of the 1840s was filled with pressures pushing families apart. Federal law enforced terrible life disruptions on two groups. The enslavement of African Americans and the forced removal of Indians had obvious, devastating effects on all aspects of their lives. But even white Americans were subject to economic pressures that uprooted them. Deas was no exception: he left his family's New York circle and moved west. Affected by his restlessness and relocation, Deas perhaps saw this uneasy world every place he looked.

One character in *Indian Group* prepares for warfare in a way quite different from that of his fellows. The others look outward or at each other; this man looks down, engrossed in the mundane activity of tying his moccasin (fig. 3.43). This calm, deliberate action gives our eye a place to rest and momentarily relieves the narrative's tension. Because it is an intimate, absorptive moment, it also offers us the chance to reflect on Indian life outside the bounds of white observation.

The most intimate of Deas's pictures is *Winnebagos Playing Checkers* (fig. 3.44). His inscription on the painting's verso—"from nature"—implies that he had seen such a game, yet the scene itself conveys something quite different. The game takes place inside a Ho-Chunk (Winnebago) bark lodge, the enclosed recesses of which appear to be private, out of the sight of European Americans. In this way, it differs from the open-air setting of Seth Eastman's *Chippewa Indians Playing Checkers* (fig. 3.45), which, according to his wife, Mary Eastman, shows two Ojibwa (Chippewa) captives held at Fort Snelling.[82] A closer look at Deas's picture reveals a tension absent from Eastman's languorous game and offers a context in which to understand one meaning of Indians playing checkers in the 1840s.

Checkers was immensely popular with mid-nineteenth-century Americans, who considered it more respectable than playing cards, which left too much to chance and cheats.[83]

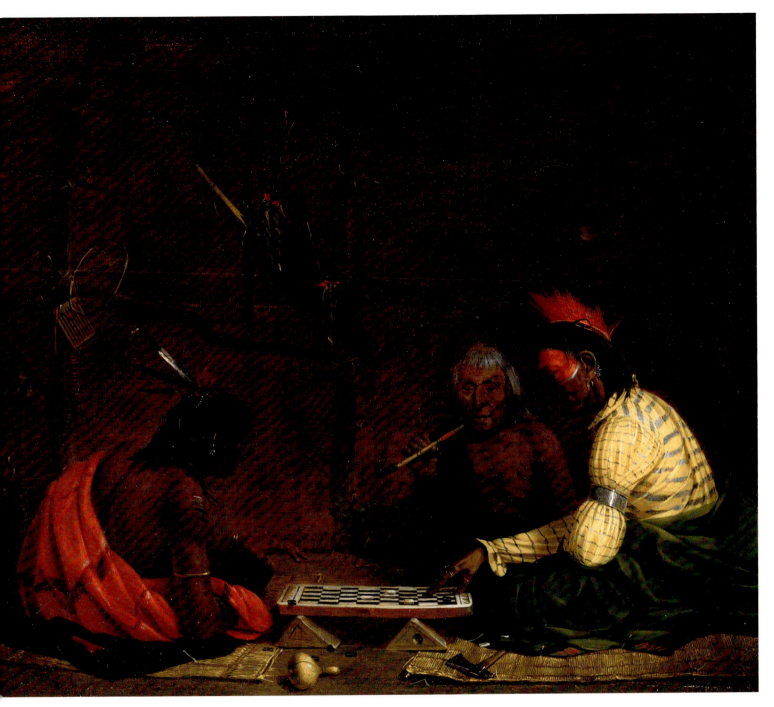

3.44. Charles Deas, *Winnebagos Playing Checkers,* 1842. Oil on canvas, 12½ × 14½ in. Private collection, New York.

3.45. Seth Eastman (American, 1808–1875), *Chippewa Indians Playing Checkers,* 1848. Oil on canvas, 30 × 25 in. Courtesy of The Anschutz Collection.

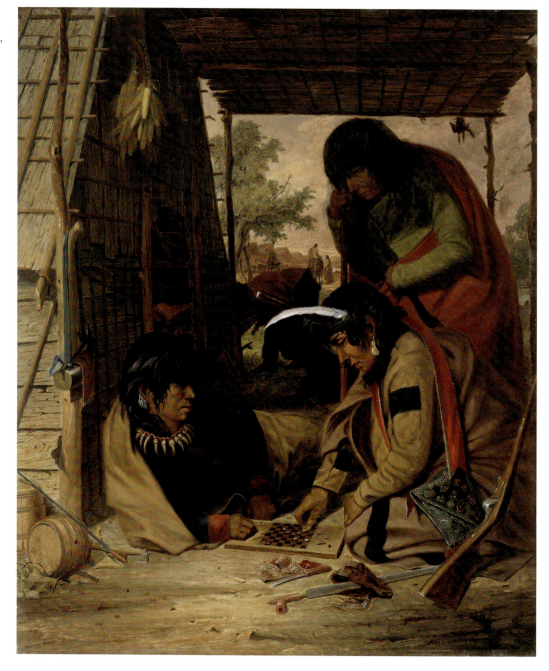

The contest that Deas set up is more vigorous than the games of checkers played by Natives that his contemporaries, such as the Eastmans, depicted and described. Mary Eastman wrote that the Sioux she observed at villages near Fort Snelling slept or played checkers all day and, in her words, "seemed to forget that they were the greatest warriors and hunters in the world."[84] Deas's men appear not to have forgotten their roles. He dressed his players in ceremonial attire: they wear headdresses and metal rings, earrings, and armbands, and their faces and bodies are painted. Play is competitive, and the game is close: the man on the left may be ahead, but we see that his back is tensed because he has just raised his head and hand in surprise at his opponent's move. He glances toward the spectator, who registers his own surprise by taking

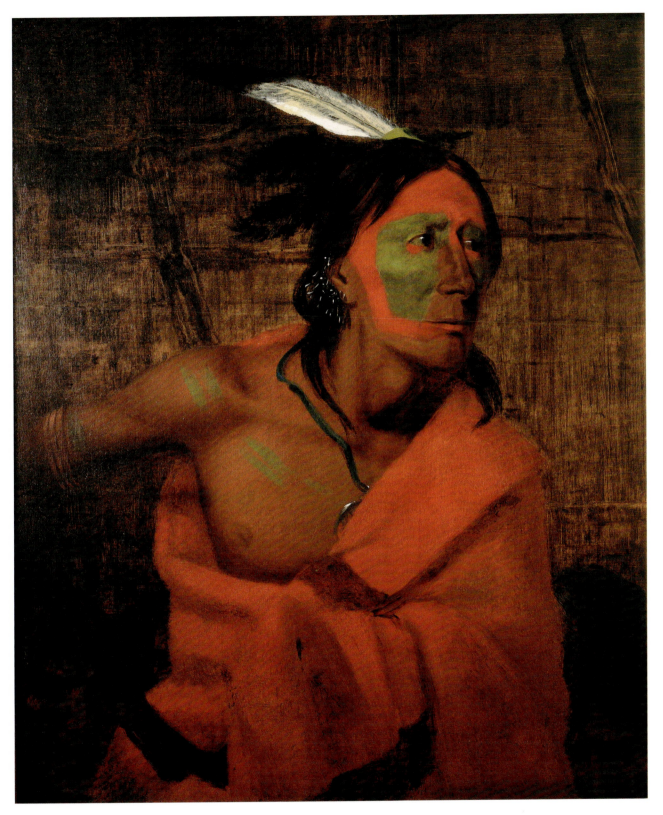

3.46. Charles Deas, *Winnebago (Wa-kon-cha-hi-re-ga) in a Bark Lodge,* by 1842. Oil on canvas, 36 × 30 in.
From the collections of the St. Louis Mercantile Library at the University of Missouri–St. Louis.

the pipe from his mouth and opening his lips to speak. The spectator's eyes are riveted on the yellow-shirted player's long, elegant fingers touching the piece he is about to move.

The still-life elements Deas arrayed around the lodge may be just beautiful objects meant to enliven the composition and to demonstrate his knowledge of Indian life, but the quiver and in particular the hatchet may have more-sinister implications: they adumbrate violence underlying this board game played in a dark interior. All games hone practical skills, but checkers requires calculation and anticipation as part of a successful strategy to control the board and capture an opponent's pieces. Understood this way, Deas's game of checkers is a metaphor for skills that Indians might use against whites—to retain land and secure better provisions in negotiations. There are no known contemporary reviews of this picture, which Deas probably showed at the St. Louis mechanics' fair in 1842, but its context of ongoing treaty negotiations with Natives in the upper Mississippi River valley allows us to take the competition in *Winnebagos Playing Checkers* beyond the game board.[85]

The interior wall of a bark lodge much like the one in *Winnebagos Playing Checkers* forms the backdrop of an extraordinary portrait that Deas painted at approximately the same time. The setting and the action of Deas's figure in *Winnebago (Wa-kon-cha-hi-re-ga) in a Bark Lodge* (fig. 3.46) extend the metaphor of strategy deduced from the checkers players into a darker world of conspiracy.

This portrait is one of a group of four that came into the collection of the St. Louis Mercantile Library in 1869. Its subject, Wa-kon-cha-hi-re-ga, is the only identified sitter in the group. We know who he is because Deas inscribed his name on a small portrait sketch perhaps painted from life (fig. 3.47).[86] Wa-kon-cha-hi-re-ga, whom whites called "Roaring Thunder" or "Dandy," was a famed Winnebago leader who had led opposition to the federal government's efforts in 1837 to move his people farther west. The government considered him

dangerous.[87] In the large-scale portrait, Deas showed Wa-kon-cha-hi-re-ga wearing the same face paint and eagle-feather-and-tail headdress as in the sketch. The two portraits are otherwise strikingly different in ornament, accompanying objects, and pose. The Native did not commission his portrait, of course, and Deas controlled the changes that he made. Yet all portraiture is collaborative to some extent, and Wa-kon-cha-hi-re-ga's demeanor and the knowledge of his history gleaned during their interactions likely guided Deas's presentation of him.

Among the changes Deas made as he worked from sketch to large-scale portrait were shifting the setting from the outdoors to the interior of a bark lodge and animating his subject's body so that the man appears to have leapt up from a sitting position. One effect of this action is that the peace medal he wears—a symbol not only of tribal status but also of cooperation with white government—swings into the blanket's folds and out of sight. Two eerie faces emerge from the picture's shadowy corners to tell us that the man is not alone. Deas's portrait, then, becomes one scene in a narrative taking place within the bark lodge. Tension fills this moment: Wa-kon-cha-hi-re-ga's anxious sidelong glare and the fierce expressions on the faces below lure us into imagining a story of Native conspiracy unfolding in the dark, private spaces of the lodge. We do not have to be reminded of Wa-kon-cha-hi-re-ga's acts of defiance to understand this portrait within the context of Deas's work and of the 1840s.

The tense anticipation that Deas built up in *Winnebagos Playing Checkers* and *Winnebago (Wa-kon-cha-hi-re-ga) in a Bark Lodge* breaks into full physical confrontation in *Sioux Playing Ball* (fig. 3.48). The Indian ball game was a popular attraction for travelers in the upper Mississippi region and a favorite subject of artists. Deas certainly could have seen one of the games played by Dakota Sioux encamped near Fort Snelling. Lanman, describing a game he saw there in the summer of 1846, admired the physical beauty of the "supple and athletic forms of the best-built people in the world." He likened the players

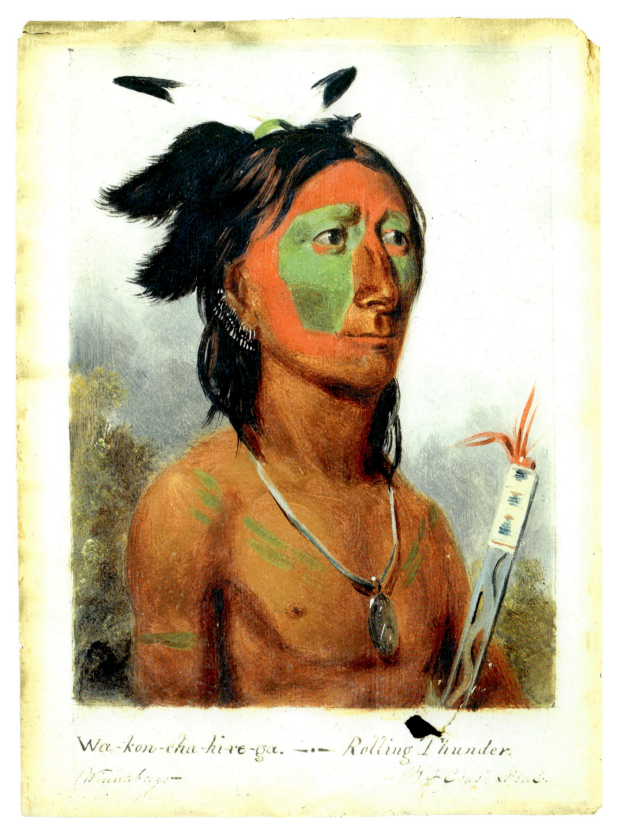

Wa-kon-cha-hi-re-ga. ··— *Rolling Thunder.*

3.47. Charles Deas, *Wa-kon-cha-hi-re-ga / Rolling Thunder,* by 1841. Oil on paper, 8¼ × 6¼ in. Courtesy
of The Lunder Collection, Colby College Museum of Art, Waterville, Maine.

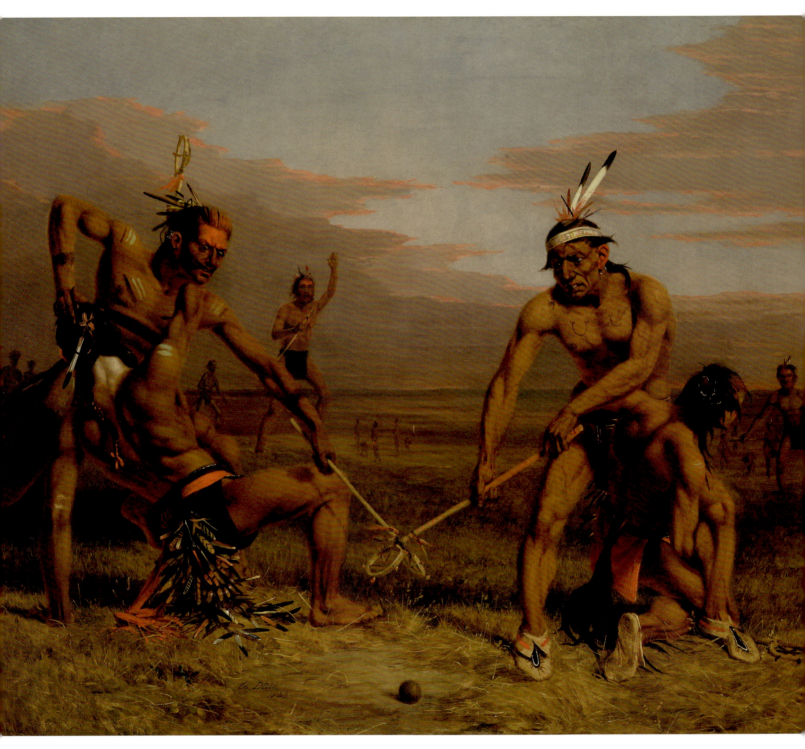

3.48. Charles Deas, *Sioux Playing Ball*, 1843. Oil on canvas, 29 × 37 in. Gilcrease Museum, Tulsa, Oklahoma.

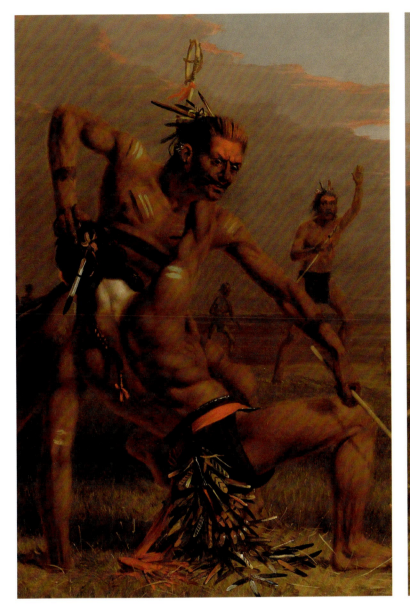

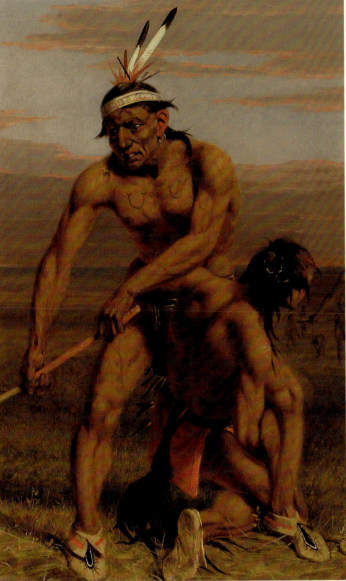

3.49. Detail of fig. 3.48,
Deas, *Sioux Playing Ball.*

3.50. Detail of fig. 3.48,
Deas, *Sioux Playing Ball.*

to antique sculpture and noted that "the only drawback connected with [the ball game] is the danger of getting your legs broken, or the breath knocked out of your body, which are calamities that frequently happen."[88]

In his painting, Deas exceeded even the dangerously competitive play that Lanman called "the only drawback." Against an open plain populated by players running to join the action, Deas staged a tense moment in a game of uncertain outcome. The standing player on the left reaches forward in an effort to scoop the ball off the ground just as his opponent on the right aggressively blocks it with his stick. Simultaneously, each of the two standing players is entwined in the arms of an opposing player who tries to bring him down (figs. 3.49 and 3.50). We focus on the bustles, headdresses, moccasins, and body paint that Deas detailed. Yet most riveting are the fierce facial expressions and the powerful physicality of ritually painted and scarified, highly muscled, and almost nude bodies. Deas, like other visitors who saw competitive ball games, was surely not

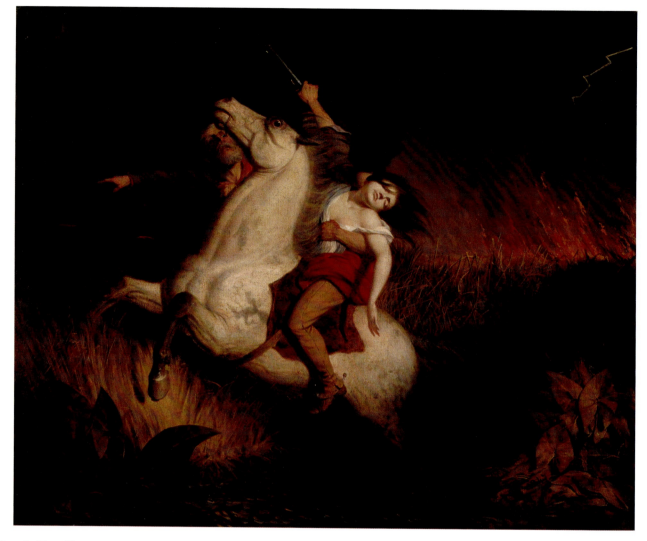

3.51. Charles Deas, *Prairie on Fire*,
1847. Oil on canvas, 28¾ × 35¹⁵⁄₁₆ in.
Gift of Mr. and Mrs. Alastair Bradley
Martin, the Guennol Collection,
Brooklyn Museum (48.195).

afraid, yet the players he reimagined in paint
are terrifying to behold. Many tribes regarded
this game as "the little brother of war" because
it kept a warrior's skills sharp.[89] That Deas's pic-
ture projects competitors' willingness to fight
ferociously tells us that Indian games told tales
with meanings that transcended the field of
play.

Prairie on Fire (fig. 3.51) is one of Deas's imagi-
nary tales that, like *Sioux Playing Ball,* reaches
for a meaning beyond its subject. He chose a
prairie fire as both the setting for and the force
that generates his story. Autumn fires, common
occurrences on the great western prairies, were
popular subjects for artists and authors in the

1830s and 1840s. These fires were dramatic, but
they were also intriguing because their origins
varied: ignited by lightning, they were signs of
nature's power; ignited by Indians to flush out
game or an enemy, they signaled the association
of Indians with that power.

Deas's picture, shown at the St. Louis me-
chanics' fair in 1847, suited the most theatrical
of contemporary tastes. The picture's thrilling
landscape setting is matched by the story un-
folding within it. *Prairie on Fire,* like *The Death
Struggle,* is an image of desperate riders barely
controlling their terrified mounts. But Deas in-
troduced to *Prairie on Fire* a theme distinctly
absent from *The Death Struggle*—the theme of

rescue. A young man on a rearing white horse holds the limp body of a woman in front of him. We see only the back of his head because he is turning to look at the raging fire. Tucked tightly next to them is an older, gray-bearded man on a black horse. The situation looks to be dire: the woman is unconscious; the young man raises a rifle; the old man anxiously tries to direct a possible escape; and the white horse's rearing stance and glaring eye register terror (fig. 3.52).

The source of this story may have been close at hand. While Deas must have known the many written descriptions, fictional accounts, and pictorial images of prairie fires that abounded in the 1830s and 1840s, he certainly read the story that Herbert spun around Long Jakes. Herbert concluded his story with an encomium to the trapper's horse (and a nod to Sir Walter Scott):

> Many times has he saved [Long Jakes's] life, by his sagacity and speed; many times has he won the first honors of the chase; many times has he borne him to the rescue of human life, and once of female honor.
>
> The prairie has roared behind him, one furnace of devouring flame, yet he has still outstripped the lightning speed of that destroying element; a host of savages, with bow and spear and rifle, have barred his rider's passage, yet through that host he has borne him unwounded.
>
> Hurrah! then for the prairie horse; Hurrah! for the Prairie Rider! both children of the wilderness! both nobler, stronger, braver, and more faithful, than the pale offspring of society! both
>
> > Are America's peculiar sons,
> > Known to no other land![90]

Like Herbert, Deas used the prairie fire as an opportunity to showcase heroic action.

What Herbert would have written after seeing *Prairie on Fire* we can only imagine, but the picture did inspire at least one narrative. A "correspondent" writing from St. Louis in April 1847

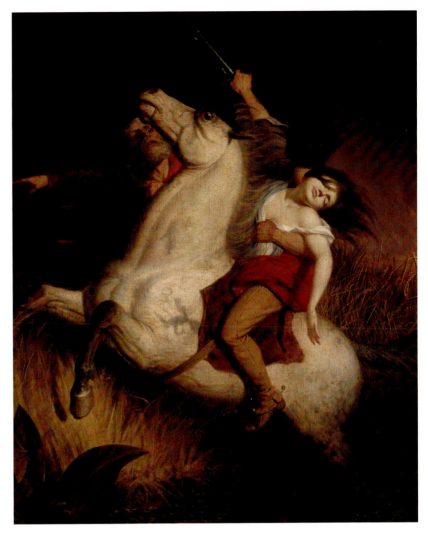

3.52. Detail of fig. 3.51, Deas, *Prairie on Fire*.

described a visit he had made to Deas's studio, which "suggested" to him "these few remarks." They are worth quoting at length:

> The subject is a group escaping from the fearful peril of a prairie on fire. The figures represent an old hunter on his horse, whose face, and grey beard, and hair, tell the tale of many a hardy adventure through which he has passed. Riding by his side and seated on a noble animal is another figure, the most prominent in the picture, clasping in his arms a young girl, to whom he is betrothed, and supposed to be the daughter of the old hunter. She rests apparently exhausted in the arms of her lover, her hair disheveled and streaming in the wind.[91]

The correspondent may have created this family saga to give a sensuous picture the cloak of respectability. Familial relationships might explain, or excuse, the presentation of a woman "exhausted in the arms of her lover." Even this lover, whose virile arm surrounds her breasts, looks away from the woman, her eyes closed in her lolling head, her hair loosened in streams behind her, and her chemise sliding off her shoulder. Were readers not assured of their relationship and reassured by her father's presence, this rescue might appear to be rape. Moreover, the picture of a man with straight black hair carrying off a white woman might also recall contemporary stories and images of Indians abducting white women. The picture, then, could evoke many and varied terrors.

So could the landscape, described by the correspondent for the *Literary World:* "Behind them furiously rages the burning prairie; and one can almost imagine that he hears the crackling of the dry grass beneath the resistless flames. They have just reached a small stream, and are supposed to have gained a place of safety." The correspondent's choice of the verb "suppose" expresses what we, too, strain to see in Deas's picture. If the artist meant to convey the idea of deliverance, he did not succeed: the creek these riders have reached offers sorry haven from the raging fire. The artist set his narrative in an appropriately dark landscape eerily lit by a flash of lightning as well as by the fire. Deas had some difficulty fitting three figures and two horses into his illusionistic space, but he effectively appealed to senses other than visual. Like the correspondent, we "hear the crackling of the dry grass." We also feel the heat of the fire ignited by lightning, a bolt of which pierces the sky. Terrifying atmospheric conditions were part of Deas's repertoire from as early as 1838, when the devil rode Tom Walker through sheets of rain. But if the stormy landscape in *The Devil and Tom Walker* conveys Tom's hellish fate, the fiery landscape of *Prairie on Fire,* with its exaggerated broad-leafed plants in the corners of the foreground, projects a different nightmare. This landscape is more terrifying than Tom Walker's hell because it was nurtured by the psychic anxiety from which Deas was increasingly suffering in the mid-1840s. The phrase "prairie fire," referring to a fad or popular obsession, was, like "death struggle," a common figure of speech in the 1840s. One St. Louis critic, for example, described animal magnetism, or mesmerism, as a "prairie fire" that "sweeps over the country" every few years.[92] Mesmerism was, of course, the "prairie fire" that consumed Deas: by 1847, according to Earle's history of the artist's mental illness, Deas had become "a monomaniac" on the subject.[93]

Prairie on Fire did not merely expose Deas's inner terror, however. European Americans used the expression to describe the destruction of Native populations by white invasions. In a passage from *Letters and Notes on the Manners, Customs, and Conditions of the North American Indians,* George Catlin decried the way the "vices and dissipations introduced by the immoral part of *civilized* society" had contaminated Indian life: "From the first settlements of our Atlantic coast to the present day, the bane of this *blasting frontier* has regularly crowded upon them . . . and, like the fire in a prairie, which destroys everything where it passes, it has blasted and sunk them, and all but their names, into oblivion, wherever it has travelled."[94] In contrast to Catlin's stern seriousness, the comic author (and Indian agent) Richard S. Elliot, writing as "John Brown" in a piece for the *Reveille* in 1845, credited the "prairie fire" metaphor to a Native speaker. Brown "recounted" a chief's oration with the purpose of humorously mocking Indian greed, but the figure of speech he quoted implies its currency: "When war broke out among the tribes, it was like the blowing of the south wind; the grass waved back and forth, but the roots remained firm in the ground. But when the white man came, the red men were consumed before him as the fire spreads over the prairie in autumn."[95] Deas's painting is thus more than a story of fire and family. We can see various ways in which it might have resonated in

a time and a place where changes were brewing and people turned to mesmerists for answers. *Prairie on Fire* registers the terror, both personal and social, that these changes provoked.

Stories are at the center of all Deas's art. He re-created moments from literature, mined the implied narratives of scenes inspired by his own experiences, and made up tales. In turn, Deas's paintings prompted writers to spin stories about them. Although the stories differ, their themes are consistent. Three of his surviving early narratives depict competitive moments that hinge on a black man's action or observation. By moving west, Deas freed his imagination from divisions of black and white, yet he built on his early ideas and kept the focus of his art on race and competition. Working from St. Louis, Deas produced western "goods" in a national art competition critical to his own survival. The nation's future, as well as the artist's career, was playing out in the West. That in the end Deas succumbed to his own demons does not diminish the national resonance of his pictures, which gave substance to the region that was shaping the idea of America. Tales of competition, underpinned by racism, reached beyond the wall of the art gallery and the pages of popular journals to expose fears about the outcome of the explosive expansion of the nation's borders.

NOTES

The chapter epigraph is from the *New Mirror* 3, no. 24 (September 14, 1844): 384. Emphasis in the original.

1. "The Art Union Pictures," *Broadway Journal* 1, no. 1 (January 4, 1845): 13.

2. Ellwood Parry first noted Deas's reference to Effingham in *The Image of the Indian and the Black Man in American Art, 1590–1900* (New York: George Braziller, 1974), 80.

3. Deas's conjunction of a turkey and a jug may be an early use of the bird's association with drunkenness. If this is so, then the black child calls our attention to the loutish behavior of several of the white shooters. For an 1846 and an 1853 reference, see Mitford M. Matthews, ed., *Dictionary of Americanisms on Historical Principles,*

vol. 2 (Chicago: University of Chicago Press, 1951), 1779. Nancy Rash discussed the possible meaning of the penned turkey in George Caleb Bingham's *Jolly Flatboatmen* in *The Paintings and Politics of George Caleb Bingham* (New Haven, Conn.: Yale University Press, 1991), 75.

4. James Fenimore Cooper, *The Pioneers* (1823; reprint, Albany: State University of New York Press, 1980), 195.

5. Washington Irving, "The Devil and Tom Walker," *Tales of a Traveller* (1824; reprint, Boston, Mass.: Twayne, 1987), 217–26.

6. "The Fiend and the Artist; or, the Old Gentleman's Pencil," *New-York Mirror* 15, no. 3 (February 10, 1838): 257. Neil Harris mentioned this story in *The Artist in American Society: The Formative Years, 1790–1860* (New York: George Braziller, 1966), 223.

7. Iona Opie and Moira Tatem, eds., *Dictionary of Superstitions* (London: Oxford University Press, 1996).

8. Guy C. McElroy brought attention to Deas's racially stereotyped devil in *Facing History: The Black Image in American Art, 1710–1940* (San Francisco: Bedford Arts; Washington, D.C.: Corcoran Gallery of Art, 1990), 25. Sarah Burns mentioned Deas's *Devil and Tom Walker* in her consideration of John Quidor's paintings as metaphors for the fear of blackness in *Painting the Dark Side: Art and the Gothic Imagination in Nineteenth-Century America* (Berkeley and Los Angeles: University of California Press, 2004), chap. 4, "The Deepest Dark."

9. *Walking the Chalk* is characterized as a humorous picture in *New-York Mirror* 17, no. 20 (November 9, 1839): 159; see also David Grimsted, *Melodrama Unveiled: American Theater and Culture, 1800–1850* (Chicago: University of Chicago Press, 1968), chap. 8, "The Melodramatic Structure."

10. My guides though the fascinating world of nineteenth-century American cheats have been Karen Halttunen, *Confidence Men and Painted Women: A Study of Middle-Class Culture in America, 1830–1870* (New Haven, Conn.: Yale University Press, 1982); Ann Fabian, *Card Sharps, Dream Books, and Bucket Shops: Gambling in 19th-Century America* (Ithaca, N.Y.: Cornell University Press, 1990); and T. J. Jackson Lears, *Something for Nothing: Luck in America* (New York: Viking, 2003). (I am indebted to James Maroney, Debra Force, Guy Jordan, Kevin Sweeney, and Kenneth Ames for enlightening conversations about this picture.)

11. See Mathews, *Dictionary of Americanisms.*

12. Justin Wolff connected the caricature in Woodville's painting to, among other things, the corrupt card game nearby; see Wolff, *Richard Caton Woodville: American Painter, Artful Dodger* (Princeton,

N.J.: Princeton University Press, 2002), 153. Bryan J. Wolf proposed Woodville's chalked image as part of "the imagery of dislocation," one of many "signs of transience" in *Waiting for the Stage;* see Wolf, "History as Ideology or, What You Don't See Can't Hurt You, Mr. Bingham," in *Redefining American History Painting,* ed. Patricia M. Burnham and Lucretia Hoover Giese (Cambridge: Cambridge University Press, 1995), 258–59.

13. Carl Bode, *The Anatomy of American Popular Culture, 1840–1861* (Berkeley and Los Angeles: University of California Press, 1959), 62. See also Ian R. Tyrrell, "Temperance and Economic Change in the Antebellum North," in *Alcohol, Reform and Society: The Liquor Issue in Social Context,* ed. Jack S. Blocker, Jr., 45–67 (Westport, Conn.: Greenwood Press, 1979).

14. Rev. Rufus W. Clark, *Lectures on the Formation of Character, Temptations and Mission of Young Men* (Boston: John P. Jewett, 1853), 225, quoted in Halttunen, *Confidence Men and Painted Women,* 17.

15. Halttunen, *Confidence Men and Painted Women,* 26.

16. "National Academy of Design: No. IV." *New-York Commercial Advertiser,* June 17, 1839, 4.

17. "Exhibition of the National Academy—No. II. Pictures of Incident and Character," *New-York Literary Gazette* 1, no. 15 (May 11, 1839): 118, reviewing *The Devil and Tom Walker* and *Walking the Chalk.*

18. Sarah Burns made this observation about Blythe in *Painting the Dark Side,* chap. 2, "The Underground Man."

19. Two recent studies of *Bar-room Scene* are Deborah J. Johnson, "William Sidney Mount: Painter of American Life," in *William Sidney Mount: Painter of American Life,* by Deborah J. Johnson, with essays by Elizabeth Johns, Franklin Kelly, and Bernard F. Reilly, Jr. (New York: American Federation of Arts, 1998), 33, 36; and Judith A. Barter, Kimberly Rhodes, and Seth Thayer, with contributions by Andrew Walker, *American Arts at the Art Institute of Chicago: From Colonial Times to World War I* (Chicago: Art Institute of Chicago, 1998), 152–53.

20. John S. Farmer and W. E. Henley, *Slang and Its Analogues, Past and Present* (privately printed, 1896), 7:286.

21. Elizabeth Johns detailed some of these reasons for *Long Jakes's* appeal at the Art-Union in *American Genre Painting: The Politics of Everyday Life* (New Haven, Conn.: Yale University Press, 1991), 76. The Art-Union managers purchased the painting on September 9, 1844 (Minutes of the Committee of Management, American Art-Union Papers, New-York Historical Society).

22. Headley's address was published in *Transactions of the American Art-Union for the Year 1845* (New York: privately printed, [1846]), 13.

23. William Cullen Bryant, *American Art-Union Circular* (January 1845).

24. The upstate New York newspaper is the *Oswego Commercial Times,* December 1, 1848, quoted in Rachel N. Klein, "Art and Authority in Antebellum New York City: The Rise and Fall of the American Art-Union," *Journal of American History* 81, no. 4 (March 1995): 1548. On the ideology of the Art-Union, see also Patricia Hills, "The American Art-Union as Patron for Expansionist Ideology in the 1840s," in *Art in Bourgeois Society, 1790–1850,* ed. Andrew Hemingway and William Vaughan, 314–39 (Cambridge: Cambridge University Press, 1998). Alan Wallach placed the organization within the context of antebellum American art institutions in "Long-Term Visions, Short-Term Failures: Art Institutions in the United States, 1800–1860," in *Art and Bourgeois Society,* 297–313. The popularity of *Long Jakes* at the 1844 distribution is covered in "The Art Union Pictures," *Broadway Journal* 1, no. 1 (January 4, 1845): 13. Exempted from this popularity contest was *The Passing Storm,* which the well-established Asher B. Durand had sold to the Art-Union at a low price to show his support for the organization.

25. "Pictures by Mr. Deas, at the Art-Union," *Anglo American* 5, no. 20 (September 6, 1845): 474.

26. Gilbert F. Everson, a New York importer and purveyor of shoe and boot findings, received *Long Jakes* at the Art-Union's December 1844 distribution and was listed as the picture's owner when the reproductive engraving was published in July 1846. Marshall O. Roberts acquired the painting sometime (I believe a long time) before 1864, when he lent it to New York's Metropolitan Sanitary Fair (*Catalogue of the Art Exhibition at the Metropolitan Fair, in Aid of the U.S. Sanitary Commission* [New York, 1864, cat. no. 10]). Tuckerman included *Long Jakes* in a list of Roberts's collection in Tuckerman, *Book of the Artists: American Artist-Life* (New York: G. P. Putnam, 1867), 626. See Roberts's obituary in the *New York Times,* September 12, 1880, 5, and his entry in the *National Cyclopaedia of American Biography,* vol. 3 (New York: James T. White, 1893), 350, and in the *Dictionary of American Biography,* vol. 16 (New York: Charles Scribner's Sons, 1935), 11–12. J. Gray Sweeney, in "'Endued with Rare Genius': Frederic Edwin Church's *To the Memory of Cole,*" *Smithsonian Studies in American Art* 2, no. 1 (Winter 1988): 69n2, proposed that Austen was forced to sell his collection when he suffered financial losses with the Art-Union's collapse.

27. Volume 2 of the *New York Illustrated Magazine of Literature and Art* announced the initiative as "Great Improvement Ahead!" in the Editor's Notes (June 1846): 128; see also Henry William Herbert, "Long Jakes: The Prairie Man" (July 1846): 169–74; Herbert, "The Death Struggle" (September 1846): 289–94.

28. On Herbert's career, see David W. Judd, ed., *Life and Writings of Frank Forester (Henry William Herbert),* 2 vols. in 1 (London: Frederick Warne, 1882); and Luke White, Jr., *Henry William Herbert and the American Publishing Scene, 1831–1858* (Newark, N.J.: Carteret Book Club, 1943). Daniel Justin Herman, in *Hunting and the American Imagination* (Washington, D.C.: Smithsonian Institution Press, 2001), assessed Herbert's contributions and summarized ideas about contemporary manhood expressed in "Long Jakes."

29. [J. Henry Carleton], journal entry dated August 16, 1844, "Occidental Reminiscences: Prairie Log Book; or, Rough Notes of a Dragoon Campaign to the Pawnee Villages in '44," *Spirit of the Times* 14, no. 40 (November 30, 1844): 475.

30. "The Art Union Pictures," *Broadway Journal* 1, no. 1 (January 4, 1845): 13.

31. Dawn Glanz, who did groundbreaking work on Deas and other western genre painters, proposed a connection to Jacques-Louis David's *Napoleon Crossing the Alps* (as well as copies and reproductions of it), all widely known in the United States, to support her proposal that *Long Jakes* was understood as a national hero; see Glanz, *How the West Was Drawn: American Art and the Settling of the Frontier* (Ann Arbor, Mich.: UMI Research Press, 1982), 44–45. Studies of the cultural response to the Mexican War include Robert W. Johannsen, *To the Halls of the Montezumas: The Mexican War in the American Imagination* (New York: Oxford University Press, 1985); and Martha A. Sandweiss, Rick Stewart, and Ben W. Huseman, *Eyewitness to War: Prints and Daguerreotypes of the Mexican War, 1846–1848* (Washington, D.C.: Smithsonian Institution Press for the Amon Carter Museum, 1989). (I am indebted to Byron Price for information on the Mexican saddle.)

32. Ralph Waldo Emerson, "The American Scholar," August 31, 1837, address to Harvard's Phi Beta Kappa Society, published the next month as *An Oration Delivered before the Phi Beta Kappa Society* (Boston: James Monroe, 1837).

33. [Henry T. Tuckerman,] "Our Artists—No. V: Deas," *Godey's Magazine and Lady's Book* 33 (December 1846):250–53.

34. Charles Lanman, *A Summer in the Wilderness: Embracing a Canoe Voyage up the Mississippi and around Lake Superior* (New York: D. Appleton, 1847), 16.

35. *Broadway Journal* 1, no. 1 (January 4, 1845): 13.

36. Washington Irving, *Astoria* (1836), 3, cited in Glanz, *How the West Was Drawn,* 28.

37. Thomas Allen, "Fur Trade of Missouri," *St. Louis Weekly Reveille,* December 28, 1846, 115. I am grateful to John Hoover for this reference and the stimulating conversation that clarified my ideas about Long Jakes's role as symbolic entrepreneurial hero. Nancy Rash also mentions Allen's speech in connection with Bingham's similar views in *The Paintings and Politics of George Caleb Bingham* (New Haven, Conn.: Yale University Press, 1991), 53.

38. William H. Goetzmann extended Richard Hofstadter's list of "expectant capitalists" to include the trapper. See Goetzmann, "The Mountain Man as Jacksonian Man," *American Quarterly* 15, no. 2 (Autumn 1963): 405.

39. Glanz, in *How the West Was Drawn,* summarized these national sources and discussed the many ways they presented trappers to mid-nineteenth-century audiences. She relied, as we all do, on the work of William H. Goetzmann, especially *Exploration and Empire: The Explorer and the Scientist in the Winning of the American West* (New York: Alfred A. Knopf, 1966), and she cited the different conclusions reached by Goetzmann in "Mountain Man as Jacksonian Man" and Harvey L. Carter and Marcia C. Spencer in "Stereotypes of the Mountain Man," *Western Historical Quarterly* 6, no. 1 (January 1975): 17–32.

40. "A New Painting, by Deas," *St. Louis Weekly Reveille,* November 1, 1847, 468.

41. "The Art Union Pictures," *Broadway Journal* 1, no. 1 (January 4, 1845): 13. An 1808 English translation of Froissart was still in print at least thirty years later, information for which I thank Howell Chickering. On Salvator Rosa and the nineteenth century, see Richard W. Wallace, *Salvator Rosa in America* (Wellesley, Mass.: Wellesley College Museum, 1979).

42. Francis Parkman, Jr., "The Oregon Trail: Scenes at the Camp," *Knickerbocker* 30, no. 6 (December 1847): 475. Parkman gathered material he published serially in *Knickerbocker* (February 1847–February 1849) into a book, *The Oregon Trail* (1872; reprint, New York: Viking Press, Literary Classics of the United States, 1991).

43. George Lippard, *Legends of Mexico: The Battles of Taylor* (Philadelphia, 1847), quoted in Johannsen, *To the Halls of the Montezumas,* 72. Scholars of Miller's work have focused on his patron William Drummond Stewart's aristocratic background: see Ron Tyler, "Alfred Jacob Miller and Sir William Drummond Stewart," in *Alfred Jacob Miller: Artist on the Oregon Trail,* ed. Ron Tyler, 19–45 (Ft. Worth, Texas: Amon Carter Museum, 1982); and Joan Carpenter Troccoli, *Alfred Jacob Miller: Watercolors of the American West* (Tulsa, Okla.: Thomas Gilcrease Museum, 1990). Lisa Strong extended these generalized ideas of chivalry into the specifics of patronage in the influence of Stewart over the artist's choice of subjects for paintings of the western rendezvous a decade before Deas's trapper arrived in New York; see Lisa Strong, "Images of Indigenous Aristocracy in Alfred Jacob Miller," *American Art* 13, no. 1 (Spring 1999): 62–83.

44. I proposed considering Long Jakes as a humorous figure in *American Paintings from the Manoogian Collection* (Washington, D.C.: National Gallery of Art; Detroit: Detroit Institute of Arts, 1989), 86–89. Johns wrote about these traits as revealing his "questionable social status" (*American Genre Painting,* 66–67). The Herbert quotations in this section are from his "Long Jakes, the Prairie Man," *New York Illustrated Magazine of Literature and Art* 2 (July 1846): 169–74.

45. The first review appeared in the *New-York Mirror* 17, no. 20 (November 9, 1839): 159; the second in the *New York Morning Herald,* June 25, 1840, 2; and the third in the *New-York Mirror* 18, no. 15 (October 3, 1840): 119.

46. [J. Henry Carleton], journal entry dated August 31, 1844, "Occidental Reminiscences: Prairie Log Book; or, Rough Notes of a Dragoon Campaign to the Pawnee Villages in '44," *Spirit of the Times* 14, no. 51 (February 15, 1845): 608.

47. "American Humor," *United States Magazine and Democratic Review* 17, no. 87 (September 1845): 212–19. The author of this essay cited Deas, William Sidney Mount, and Francis William Edmonds as "comic artists" and "genuine humorists."

48. Matthew C. Field, "Diary, July 9–11, 1843," in Field, *Prairie and Mountain Sketches,* collected by Clyde and Mae Reed Porter, ed. Kate L. Gregg and John Francis McDermott (Norman: University of Oklahoma Press, 1957), 88. Field was a poet and a travel writer as well as a humorist. He served as an assistant editor of the *New Orleans Picayune* and cofounded the *St. Louis Reveille.*

49. [Matthew C. Field,] "Prairie and Mountain Life: Joe Pourier and the Bear," *New Orleans Daily Picayune,* January 12, 1844, reprinted in Field, *Prairie and Mountain Sketches,* 102. Pourier's name was also spelled "Poirier."

50. [Matthew C. Field,] "Prairie and Mountain Life: Approaching . . . Flying Buffalo!" *St. Louis Weekly Reveille,* August 26, 1844, reprinted in Field, *Prairie and Mountain Sketches,* 97–100.

51. [Matthew C. Field,] "Prairie and Mountain Life," *St. Louis Weekly Reveille,* September 9, 1844, 65, reprinted in Field, *Prairie and Mountain Sketches,* 186–90.

52. Pliny Earle Papers, American Antiquarian Society, Lists of Patients and Notes on Cases, box 5, folder 3. See also the Records of the Bloomingdale Asylum, Medical Center Archives of New York–Presbyterian/Weill Cornell.

53. One description of *A Vision* is in Editor's Table, "National Academy of Design," *Knickerbocker* 33, no. 5 (May 1849): 468–70.

54. "The Paintings at the American Art-Union," *Broadway Journal* 2, no. 9 (September 13, 1845): 154–55. Julie Schimmel proposed a reading of this picture as "boding disaster for each side of Indian-white strife";

see Schimmel, "Inventing 'the Indian,'" in *The West as America: Reinterpreting Images of the Frontier, 1820–1920,* ed. William H. Truettner (Washington, D.C.: Smithsonian Institution Press), 165.

55. See "Death of Mike Fink," *Spirit of the Times* 14, no. 37 (November 9, 1844): 437. Most contemporary views of Carson followed Frémont's accolades for his guide and scout in his official *Report of the Exploring Expedition to the Rocky Mountains in the Year 1842 and to Oregon and North California in the Years 1843–44* (Washington, D.C.: Blair and Rives, for U.S. House of Representatives, 1845), but some—such as Charles Preuss, who was on the 1843 expedition and kept private diaries—were disgusted by what they saw as Carson's brutal treatment of Indians. See Thomas Dunlay, *Kit Carson and the Indians* (Lincoln: University of Nebraska Press, 2000). On the various attitudes of fur traders toward Indians, see Lewis O. Saum, *The Fur Trader and the Indian* (Seattle: University of Washington Press, 1965).

56. Elizabeth Johns focused chapter 3, entitled "From the Outer Verge of Our Civilization," on *Long Jakes;* see Johns, *American Genre Painting.* This quotation is on p. 78.

57. "Solitaire" [John S. Robb], "The Death Struggle," *St. Louis Weekly Reveille,* June 23, 1845, 393, and *Spirit of the Times* 15, no. 22 (July 26, 1845): 257. The story is collected in John S. Robb, *Streaks of Squatter Life, and Far-West Scenes* (Philadelphia: Carey and Hart, 1847), facsimile reproduction, ed. John Francis McDermott (Gainesville, Fla.: Scholars' Facsimiles and Reprints, 1962), 180–83. See Fritz Oehlschlaeger's introduction to *Old Southwest Humor from the* St. Louis Reveille, *1844–1850,* ed. Oehlschlaeger (Columbia: University of Missouri Press, 1990).

58. William A. Craigie, *A Dictionary of American English on Historical Principles* (Chicago: University of Chicago Press, 1938–44), 2:734.

59. John R. Commons, "American Shoemakers, 1648–1895," *Quarterly Journal of Economics* 24 (1909): 39–84. Stuart Blumin discussed Commons's conclusions in "Mobility and Change in Ante-Bellum Philadelphia," in *Nineteenth-Century Cities: Essays in the New Urban History,* ed. Stephan Thernstrom and Richard Sennett, 200–202 (New Haven, Conn.: Yale University Press, 1969).

60. Solitaire [John S. Robb], "'In at the Death': A Rocky Mountain Sketch," *St. Louis Weekly Reveille,* August 17, 1846, 963. Emphasis in the original.

61. The first quotation is from "A New Picture by Deas," *St. Louis Weekly Reveille,* August 31, 1846, 980; the second is from "The Fine Arts: The Art Union Pictures (Continued)," *Literary World* 2, no. 39 (October 30, 1847): 303.

62. Francis Parkman, Jr., "The Oregon Trail: The Pueblo and Bent's Fort," *Knickerbocker* 32, no. 2 (August 1848): 95, cited in David Leverenz, *Manhood and the American Renaissance* (Ithaca, N.Y.: Cornell University Press, 1989), 229. See also Kim Townsend, "Francis Parkman and the Male Tradition," *American Quarterly* 38, no. 1 (1986): 97–113.

63. Philip Young, *History of Mexico . . . From the Period of the Spanish Conquest, 1520, to the Present Time, 1847* (Cincinnati: J. A. and U. P. James; New York: J. S. Redfield, 1847), quoted in Johannsen, *To the Halls of the Montezumas,* 23.

64. T[homas] B[angs] Thorpe, *Our American Army at Monterey* (Philadelphia: Carey and Hart, 1847), 96, quoted in Johannsen, *To the Halls of the Montezumas,* 22.

65. "A New Picture by Deas," *St. Louis Weekly Reveille,* August 31, 1846, 980.

66. See discussion of rancheros in Johannsen, *To the Halls of the Montezumas,* 23–25, and in Richard Slotkin, *The Fatal Environment: The Myth of the Frontier in the Age of Industrialization, 1800–1890* (New York: Atheneum, 1985), 192–93. See also John L. Sullivan, "Annexation," *United States Magazine and Democratic Review* 17, no. 85 (July–August 1845): 5–10, quoted in Reginald Horsman, *Race and Manifest Destiny: The Origins of American Racial Anglo-Saxonism* (Cambridge, Mass.: Harvard University Press, 1981), 219.

67. "The Fine Arts: The Art Union Pictures (Continued)," *Literary World* 2, no. 39 (October 30, 1847): 303.

68. "The Fine Arts," *Broadway Journal* 1, no. 16 (April 19, 1845): 254.

69. On mixed marriages and the offspring born in such unions in the world of the fur trader, see Saum, *Fur Trader and the Indian,* chap. 4, "The Frenchman, the Englishman, and the Indian"; and Susan Prendergast Schoelwer, "The Absent Other: Women in the Land and Art of Mountain Men," in *Discovered Lands, Invented Pasts: Transforming Visions of the American West,* by Jules David Prown, Nancy K. Anderson, William Cronon, Brian W. Dippie, Martha A. Sandweiss, Susan Prendergast Schoelwer, and Howard R. Lamar, 135–65 (New Haven, Conn.: Yale University Press, 1992).

70. George Combe, *The Constitution of Man Considered in Relation to External Objects* (Boston: William D. Ticknor, 1841), 158. On the popularity of Combe's book, first published in America in 1829, see Charles Colbert, *A Measure of Perfection: Phrenology and the Fine Arts in America* (Chapel Hill: University of North Carolina Press, 1997), 20–22. On scientific racism and Catlin's paintings, see Bridgit Goodbody, "George Catlin's Indian Gallery: Art, Science, and Power in the Nineteenth Century," Ph.D. dissertation, Columbia University, 1996. More generally on the fictional presentation of "mixed-bloods," see William J. Scheick, *The Half-Blood: A Cultural Symbol in 19th Century American Fiction* (Lexington: University Press of Kentucky, 1979); and Harry J. Brown, *Injun Joe's Ghost: The Indian Mixed-Blood in American Writing* (Columbia: University of Missouri Press, 2004).

71. I first raised the issue of the racially mixed family in "Charles Deas," in *American Frontier Life: Early Western Painting and Prints,* by Ron Tyler et al., 51–77 (Ft. Worth, Texas: Amon Carter Museum; New York: Abbeville Press, 1987). Julie Schimmel (in "Inventing 'the Indian,'") and Susan Schoelwer (in "The Absent Other") carried the discussion further.

72. His appearance and distinction from the rest of his family suggest that the patriarch is white. By so identifying him, Deas did not follow one construction of the voyageur as being of mixed French and Indian heritage as, for example, Charles Lanman did in 1846: "By birth he is half French, and half Indian, but in habits, manners, and education, a full-blooded Indian. . . . He belongs to a race which is entirely distinct from all others on the globe" (*A Summer in the Wilderness,* 141, 146).

73. Deas's picture may have inspired Bingham's. Charles D. Collins, who seems not to have known of Deas's 1845 *The Voyageurs* oil, proposed Deas's related, undated watercolor, *The Trapper and His Family* (collection of the Museum of Fine Arts, Boston) as a source for Bingham's picture; see Collins, "A Source for Bingham's *Fur Traders Descending the Missouri,*" *Art Bulletin* 66, no. 4 (December 1984): 678–81. I have found no contemporary reviews of either Deas's or Bingham's picture. *Fur Traders Descending the Missouri* remained in the family of the Art-Union member to whom it was distributed in December 1845 (and out of the public or scholarly eye) until it was acquired by the Metropolitan Museum of Art in 1933. There is no evidence that Deas exhibited his 1845 *The Voyageurs*, which was acquired soon after the Civil War by the family in whose hands it remains.

74. Angela Miller argued that Bingham "located the western fragment as part of a national whole, translating exotic tongues into a familiar formal and expressive language" in "The Mechanisms of the Market and the Invention of Western Regionalism: The Example of George Caleb Bingham," in *American Iconology: New Approaches to Nineteenth-Century Art and Literature*, ed. David C. Miller (New Haven, Conn.: Yale University Press, 1993), 120. Rash also discussed the relationship of Bingham's picture to contemporary commerce in *Paintings and Politics,* 53–54.

75. Lanman, *Summer in the Wilderness,* 141.

76. Tuckerman reported that in his youth Deas had spent time in Sully's Philadelphia studio (Tuckerman,

"Our Artists—No. V: Deas," 251), and *The Passage of the Delaware* was on view in Boston from the 1840s, known in a reproductive print published in the *New-York Mirror* in 1842, and often copied by Deas's contemporaries. See Philipp P. Fehl, "Thomas Sully's *Washington's Passage of the Delaware:* The History of a Commission," *Art Bulletin* 55, no. 4 (December 1973): 584–99. For discussion of the meaning of the long view and precipitous shifts from foreground to background in painting of this period, see Roger B. Stein, "Charles Willson Peale's Expressive Design: *The Artist in His Museum*," *Prospects: An Annual of American Cultural Studies* 6 (1981): 139–85. Alexander Nemerov carries this idea into the distant "space of danger" of Sully's picture in *The Body of Raphaelle Peale: Still Life and Selfhood, 1812–1824* (Berkeley: University of California Press, 2001), 176–82.

77. "The Expedition of Major Clifton Wharton in 1844," *Collections of the Kansas State Historical Society* 16 (1923–1925): 273. (I am grateful to Herman Viola, who first suggested to me that this picture might be about intertribal conflict.)

78. See, for example, "An Indian Feud: The Sioux and the Chippewa," *St. Louis Weekly Reveille*, September 29, 1845, 505; and "From the Indian Country," *St. Louis Weekly Reveille*, July 13, 1846, 924.

79. "Indian Depredations," *St. Louis Weekly Reveille*, July 26, 1847, 357.

80. *St. Louis Weekly Reveille*, July 20, 1846, 933. On the role of newspapers in conveying attitudes toward Indians see John M. Coward, *The Newspaper Indian: Native American Identity in the Press, 1820–90* (Urbana: University of Illinois Press, 1999).

81. "Indian Hardships," *St. Louis Weekly Reveille*, July 12, 1847, 343.

82. Mary Eastman to Colonel Andrew Warner, American Art-Union, June 27, 1849, quoted in John Francis McDermott, *Seth Eastman: Pictorial Historian of the Indian* (Norman: University of Oklahoma Press, 1961), 58.

83. Elizabeth Johns wrote about the difference between card and checker playing in Bingham's work and proposed that his *Checker Players* of 1850 (in the collection of the Detroit Institute of Arts) may not have found favor with the Art-Union managers because it was "too mannerly." She cited an 1852 handbook of etiquette for checkers players; see Johns, "The 'Missouri Artist' as Artist," in *George Caleb Bingham*, by Michael Edward Shapiro, Barbara Groseclose, Elizabeth Johns, Paul C. Nagel, and John Wilmerding (St. Louis: Saint Louis Art Museum; New York: Harry N. Abrams, 1990), 128–30. Kathryn Sweeney Hight discussed connections between images of Indian card playing and white male fantasy in the context of the 1840s debate over gambling

in "The Frontier Indian in White Art, 1820–1876: The Development of a Myth," Ph.D. dissertation, University of California, Los Angeles, 1987, 256–58.

84. Mary Eastman, *Dahcotah; or, Life and Legends of the Sioux around Fort Snelling* (New York: John Wiley, 1849), 179.

85. My thanks to David Penney, who might not agree with the conclusions I reached when I went down the path he suggested to think about *Winnebagos Playing Checkers*.

86. Following John Hoover's ideas about these portraits, I published them as works by Deas. See Carol Clark, "Four Oil Paintings of Indian Chiefs: Charles Deas and the St. Louis Mercantile Library," in *St. Louis and the Art of the Frontier*, ed. John Neal Hoover, 15–31 (St. Louis: St. Louis Mercantile Library at the University of Missouri, St. Louis, 2000).

87. Deas's inscription appears to be phonetic, and the translation of the name he heard is more likely "Roaring Thunder" than the "Rolling Thunder" he wrote beneath the Ho-chunk name. (I am grateful to anthropologist Nancy Lurie for this identification and for her guidance through Winnebago history.)

88. Lanman, *Summer in the Wilderness*, 58.

89. Thomas Vennum, Jr., argued that although most of the evidence that lacrosse was a surrogate for war comes from the Cherokees, tribes in the Great Lakes region likely considered it this way as well. He discussed levels of violence and deaths in the game in *American Indian Lacrosse: Little Brother of War* (Washington, D.C.: Smithsonian Institution Press, 1994). (I am grateful to him for conversations about lacrosse; he identified for me the particular technique for retrieving a ground ball that Deas painted, which is now known as the "Indian scoop" [personal communication, March 20, 2006].)

90. Herbert, "Long Jakes: The Prairie Man," 174. Herbert opened and closed this story with a quotation from Walter Scott's *Halidon Hill* (1822), act 2, scene 2.

91. "Mr. Deas," *Literary World* 1, no. 12 (April 24, 1847): 280. The "St. Louis correspondent" is not identified, but his introductory statements about Deas's role as a western painter are similar to those expressed by both Charles Lanman and Henry Tuckerman. Lanman spent time in St. Louis in these years and had visited Deas's studio. Although I do not know whether Tuckerman ever traveled west, he wrote at least some of the art criticism for the *Literary World*. On the last point, see David B. Dearinger, "Annual Exhibitions and the Birth of American Art Criticism to 1865," in *Rave Reviews: American Art and Its Critics, 1826–1925,* ed. David B. Dearinger (New York: National Academy of Design, 2000), 76.

92. *St. Louis New Era*, November 19, 1841, quoting the "Phil. American."

93. Records of the Bloomingdale Asylum, Medical Center Archives of New York–Presbyterian/ Weill Cornell; and Pliny Earle Papers, American Antiquarian Society, Lists of Patients and Notes on Cases, box 5, folder 3.

94. George Catlin, *Letters and Notes on the Manners, Customs, and Conditions of the North American Indians* (London: privately printed, 1841; reprint, New York: Dover, 1973), 1:60. Emphasis in the original.

95. John Brown [Richard S. Elliot], "A Specimen of Indian Eloquence," *St. Louis Weekly Reveille*, May 12, 1845. Richard Smith Elliott worked for the government as an Indian agent among the Potawatomies at Council Bluffs, Iowa. On Brown, see Nicholas Joost, "Reveille in the West: Western Travelers in the *St. Louis Weekly Reveille,* 1844–1850," in *Travelers on the Western Frontier,* ed. John F. McDermott, 203–40 (Urbana: University of Illinois Press, 1970).

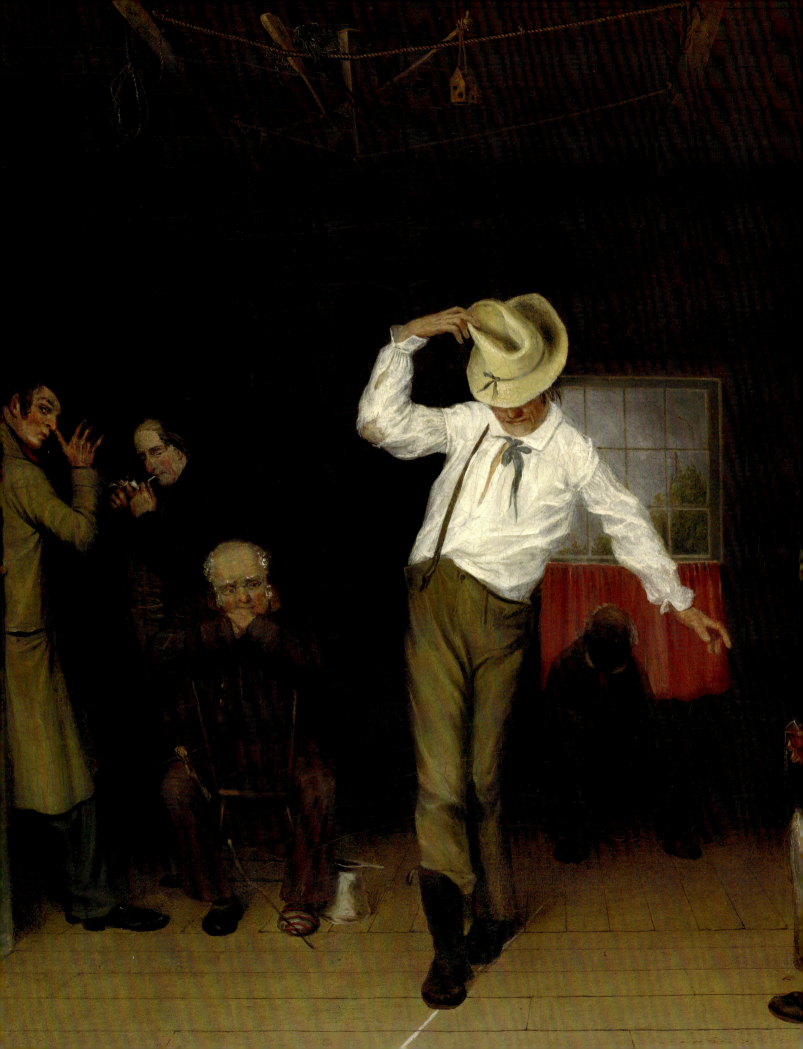

4

WALKING THE CHALK

Taverns, Alcohol, and Ambiguity

Guy Jordan

Some "walk the crack" to make a show,
Some roll upon the floor;
Some pay the bill they know not how,
And straight they see no more.
"A Parody," 1836

Walking the Chalk (1838; fig. 4.1), a recently rediscovered painting by Charles Deas, depicts a man in the midst of a sobriety test.[1] The title of the picture alludes to a drinking game, the goal of which is to consume as many drinks as possible while retaining the ability to walk along a straight line of chalk drawn on the floor. Like present-day roadside sobriety tests, in which suspected drunk drivers are made to "walk the line," such methods were employed in the nineteenth century to determine fitness for duty on board navy and merchant vessels. But the object in *Walking the Chalk* appears to be to fail (rather than to pass) or, more precisely, to stave off failure as long as possible before what will no doubt be a catastrophic—and amusing—collapse. The contest at the core of Deas's painting involves its tipsy participant in a carefully calibrated experiment to determine (the hard way) how much, exactly, is *too* much. In this and other paintings, Deas articulates boundaries that mark inexorable transformations from moderation to excess.[2] Moreover, the re-emergence of this fascinating painting offers an opportunity to consider its place among

4.1. Detail of fig. 3.7, Deas, *Walking the Chalk.*

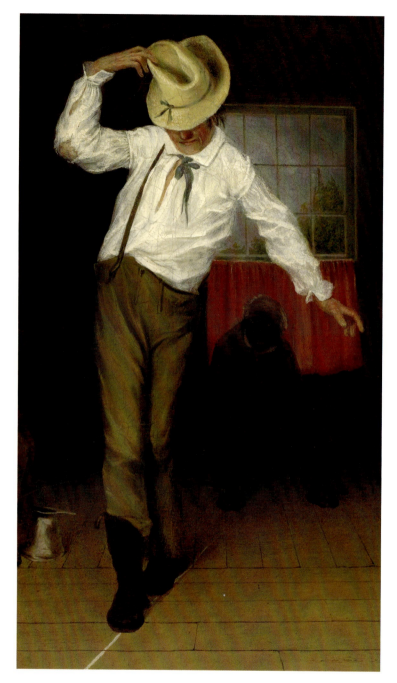

4.2. Detail of fig. 3.7, Deas, *Walking the Chalk.*

cern—much less follow—the straight and narrow path. A short story published in 1846 considered the practice of "walking the chalk" in a similar way: "Larry was a hard working, and, occasionally hard drinking, Dutch-built little man, with a fiddle head and a round stern; a steady-going straight-forward fellow, barring when he carried too much whiskey, which, it must be confessed, might occasionally prevent his walking the chalk with perfect philomathical accuracy."[4] The ability to adhere to a straight and narrow lifestyle, in other words, depends on sobriety. Its absence impairs the otherwise "steady-going" and "straight-forward" Larry's ability to see correctly. Thus, "walking the chalk" tests sobriety by testing the ability to see straight. When the contestant falls off the line, however, failure is recorded as a loss of balance. One period reference to the practice of "walking the chalk" aligns intemperance with a general sense of incoordination.

> The genius of a wag, Fitzgerald, of the "City Item," has made a most important discovery, whereby the nation will be able to save a great deal of money. The discovery is nothing less than a new plan for moderate and immoderate dram drinkers to get tipsy-turvy, without smelling either London Porter or Ferintosh [an Irish whisky]. The plan is a very simple one, only to spin round rapidly on the heel of one foot as many times as may conduce to give the performer, according to his moderate or immoderate desires, that beautiful street attitude, denominated "walking the chalk with a bric' [*sic*] in your hat."[5]

To appear as a drunkard who unsuccessfully and humorously attempts to walk a straight line, then, one need not drink but may simply spin oneself dizzy. The inability to maintain balance serves as a surrogate for intoxication. Imbalance registers here, as it does in Deas's *Walking the Chalk,* as a coordination disorder—an inability to spatially and socially relate oneself to the world.

The composition of *Walking the Chalk* is or-

similarly themed works that depict the interiors of taverns, thereby shedding light on conflicting attitudes toward the consumption of alcohol in antebellum America.[3] Such tavern pictures reveal the Janus-faced role of alcohol as both a facilitator and an inhibitor of social cohesion.

Walking the Chalk relates the plight of the drunkard as one who is no longer able to dis-

ganized around a tall, thin, enervated man, positioned at the center of the canvas, who strides toward the picture plane along a chalk line, carefully placing his right foot in front of his left (fig. 4.2). He sports a bright white shirt, worn through at the right elbow and highlighted by a sloppily fastened tie that dangles precipitously from the collar. A suspender strap runs over his right shoulder and strains to support a pair of heavy trousers. Wobbling along in calf-high boots with his left arm extended to keep his balance and his right hand curled above his head to steady his straw hat, the man assumes the shape of an off-kilter teakettle. Captured, it would seem, on the verge of discombobulation, he appears only a step or two away from his boiling point, as viewers within and in front of the painting anticipate the critical stumble. Everything about him appears to be about to come apart at the seams. Whether the response will be lighthearted laughter, pity, scorn, or a combination thereof, this much is certain: the chalk walker is about to become the object of it. Upon his inevitable forfeiture of self-control and self-governance, he will be transformed into a vulgar object of caricature and take his place in the gallery of stereotyped visages that inhabit the "Tjerck Brink Inn," the name carved on the gray wooden planks of the bar.[6]

He will tumble into (and likely onto) the sorry cast of characters observing his shenanigans. We might read the inebriated man sitting on the bench and steadied by his companion at the lower right as the first man to play the game, and it is now up to the current contestant to best his mark (fig. 4.4). On the left, the bartender records their "scores" on the wall, drink by drink (fig. 4.3). Behind the bar, a man in a top hat gazes out at the viewer and thumbs his nose in a period gesture that expresses either his disapproval of the scene or perhaps the presence of some sort of con game, one in which we are evidently invited to take part. Next to him, in front of a portly pipe smoker, sits an elderly man with a swollen foot, a telltale symptom of gout. His gaze, like that of the bartender's, is fixed on the central figure's increasingly wobbly steps. In the

4.3. Detail of fig. 3.7, Deas, *Walking the Chalk.*

back of the room, an elderly black man sits aloof from the rest of the group, sporting a wry, knowing smile as he looks on at the proceedings. At the back right is a man who has sustained an eye injury, perhaps the result of a recent brawl.

Set against this motley crew of ragged, spent, and worn-down characters, most of whom exhibit evidence of a long history of unhealthy

spectacle" in which everyone stares at the feet of the man, callously waiting for him to "fall." Once he does, he will officially fail the sobriety test and will be determined to be unquestionably drunk.

By obscuring the eyes and concealing the identity of the chalk walker, Deas renders him an "everyman," one whose identity, while stereotyped, is not as securely fixed as those of the other individuals in the room. The figure can be read as a yeoman farmer, the kind of character who made frequent appearances in the genre paintings of William Sidney Mount. His apparent age places him somewhere between the older, more prosperous farmer pictured in Mount's *Long Island Farmer Husking Corn* (fig. 4.5) and the innocent youth who plays the fiddle in *Dancing on the Barn Floor* (fig. 4.6). Deas's *Walking the Chalk* was almost certainly painted in response to Mount's similarly themed work, *Bar-room Scene* (fig. 4.7). This painting, which has been known by several alternative titles, is, like Deas's picture, organized around a central figure whose face is obscured and whose alcohol-driven actions are the focus of attention for everyone else in the room.[7] The supporting casts of both *Walking the Chalk* and *Bar-room Scene* are exclusively male and cut across a broad spectrum of age groups and ethnic, racial, and economic backgrounds.

With disheveled hair, tattered clothing, and his back to the picture plane, the man in Mount's *Bar-room Scene* dances to a beat kept by the clapping hands of a rustic but apparently well-to-do gentleman on the left.[8] Although Mount may have intended to juxtapose the excessive intoxication of the central dancer with the relative sobriety of the other patrons of the tavern, the man in the top hat seated on the right—with his flushed complexion, bleary eyes, and hands on knees that support the weight of his upper body like a pair of crutches—is nevertheless unmistakably drunk.[9] There can be no doubt that this group of onlookers is anything but innocent; they are, rather, entirely complicit in the indecorous goings-on. Yet with its warm tones and brightly lit interior, *Bar-room Scene*

living and improper conduct, the tipsy antihero of *Walking the Chalk* conveys an overwhelming sense of latent, impending transgression, of sobriety doomed to be—but not quite yet—lost. This sense of anxiety—indicating that something sinister is about to happen—is embodied in the tense attitude of the dog that leans next to the ax against the wall in front of the bar. Seven pairs of eyes in the painting (including those of the dog) converge on the line of chalk, intent on seeing the precise moment when the central character loses his balance. The viewer is invited to play along with the characters in the painting, who observe what is, in effect, a "diagnostic

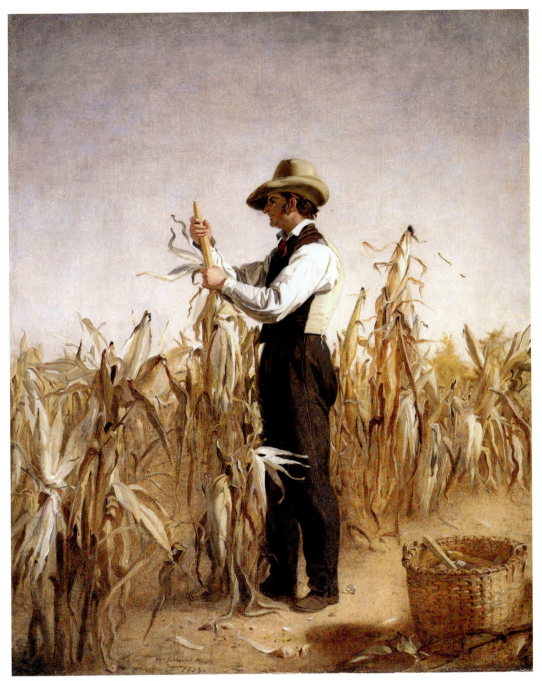

4.5. William Sidney Mount (American, 1807–1868), *Long Island Farmer Husking Corn,* 1834. Oil on panel, 27 × 17 in. The Long Island Museum of American Art, History & Carriages, gift of Mr. and Mrs. Ward Melville, 1975.

presents an ambience of levity, conviviality, and ironic humor (the merrymaking takes place next to an advertisement for temperance meetings) that stands in subtle contrast to the more somber atmosphere of *Walking the Chalk.* Unlike Mount's picture, in which everyone seems to be enjoying himself (and we as viewers are invited to observe the amusing antics of the dancing fig-

ure along with those within the fictive space of the painting), *Walking the Chalk*—which lacks any figure that could be mistaken for an innocent observer with whom the viewer might identify—draws its audience deep into the confines of the inn to join the cast of characters who leer at the chalk walker's feet.

According to David S. Reynolds, a scholar of

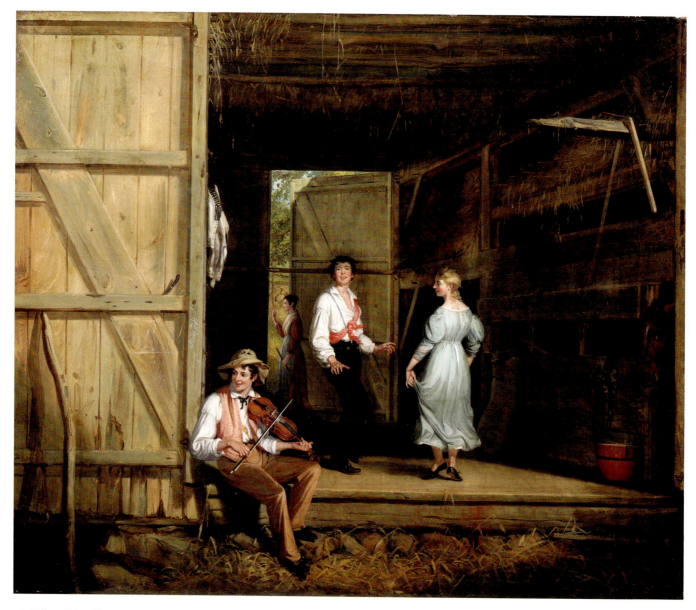

4.6. William Sidney Mount, *Dancing on the Barn Floor*, 1831. Oil on canvas, 25 × 30 in. The Long Island Museum of American Art, History and Carriages, gift of Mr. and Mrs. Ward Melville, 1955.

American literature, during the early 1830s temperance narratives assumed a more pessimistic tone, one with "a note of doom, as more writers stressed alcoholism's ravages rather than its remedies."[10] While the irony of Mount's *Barroom Scene* makes light of the hypocrisy that plagued many would-be reformers, *Walking the Chalk* appears by comparison to indulge in the foibles of its characters, and this led one reviewer of the picture to caution Deas "that the degradation of human nature is not a pleasing subject for contemplation, and consequently

not a fit subject for art; unless it be so represented as to convey a moral lesson, or excite moral sympathies, as in the tales, not more humorous than pathetic, of Dickens, or in those great pictures of Hogarth, where the ludicrous and affecting are perceived as one."[11] The reviewer was unable to discern any moral compass in *Walking the Chalk* that could have taught him a useful lesson or provided a cautionary tale. He saw it instead as nothing more than a coarse celebration of bad behavior without repercussions, one that existed merely for amusement, disen-

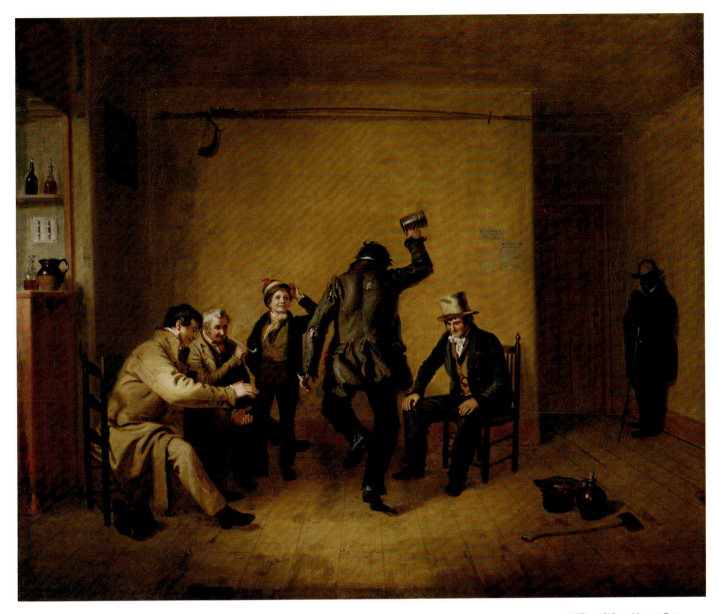

4.7. William Sidney Mount, *Barroom Scene*, 1835. Oil on canvas, 22⅝ × 27¹⁄₁₆ in. The William Owen and Erna Sawyer Goodman Collection, The Art Institute of Chicago; photograph © The Art Institute of Chicago (1939.392).

gaged from the reforming purpose that usually accompanied such narratives.

The pessimism of *Walking the Chalk,* in which the inhabitants of the bar take a decidedly twisted delight in witnessing the moral and physical downfall of the central character, stands in contrast to earlier attitudes toward drinking. Such sentiments at least acknowledged the synthetic potential of taverns in early America to generate a sense of community by providing a space that brought together a diverse set of individuals under one roof. During the American Revolution, as one scholar recently summarized, "taverns and coffeehouses provided one of the central spaces where political opinion and nation building originated."[12] Taverns, inns, alehouses, and oyster houses provided a convivial setting where sometimes-fractious factions could work through their differences. Although many taverns catered to an exclusively upper- or lower-class clientele, an increasing number of establishments at the dawn of the nineteenth century came to be frequented by a mixed array of bourgeois, middle-

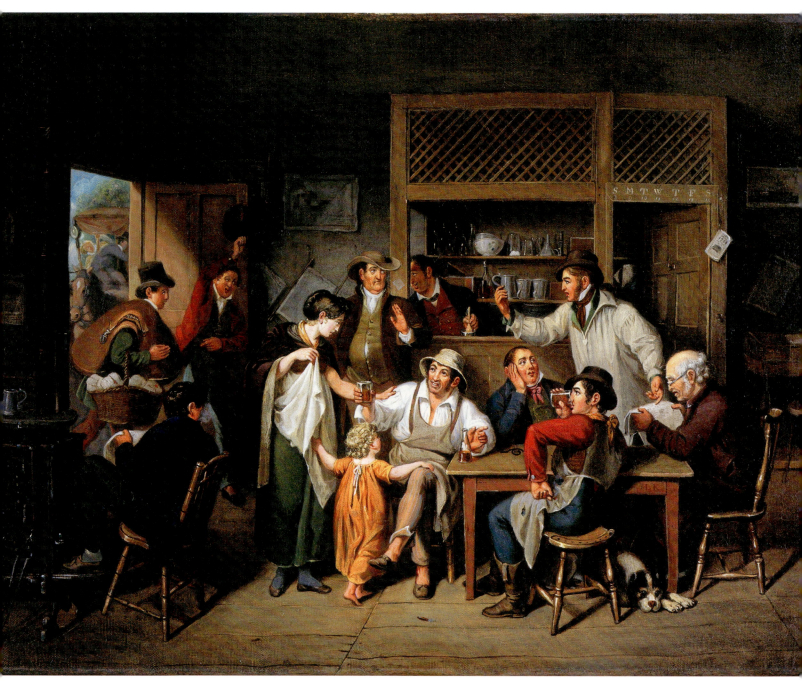

4.8. John Lewis Krimmel (American [b. Germany], 1786–1821), *Village Tavern*, 1813–14. Oil on canvas, 16⅞ × 22½ in. Toledo Museum of Art, purchased with funds from the Florence Scott Libbey Bequest in Memory of Her Father, Maurice A. Scott (1954.13).

income, and working-class customers.[13] Taverns and inns frequently doubled as post offices and newsstands and provided a setting where travelers mingled and conversed with local citizens. Offering opportunities for mediation between individuals and communities, taverns appealed to genre painters such as John Lewis Krimmel, who sought to capture in his painting *Village*

Tavern (fig. 4.8) something of the social and cultural dynamism of the new nation.[14]

Village Tavern is a whirl of activity, with twelve characters (plus one dog) densely packed into a small space. Just inside the doorway on the left, a young man rushes in and waves his hat to alert the barkeep to the arrival of a stagecoach. Entering along with him is a man selling yarn

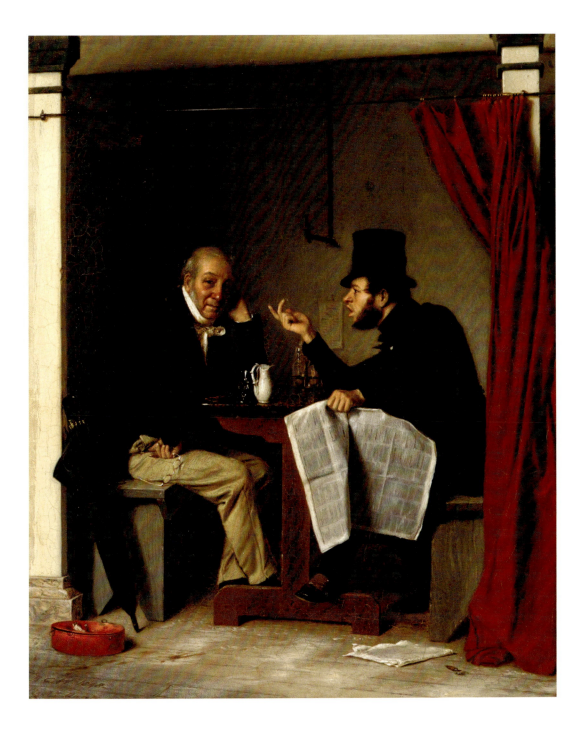

and varieties of fabric. In the bottom left corner, a traveler warms his feet by a stove as he gazes toward the table in front of the bar. To the right, a father's attention has been diverted from a debate—perhaps a nascent dispute—that is under way between a corpulent Quaker (identified by his hat), whose girth visibly strains the buttons on his vest, and a man standing to the right, who sports a derby and a thick, coarse coat. The Quaker appears to dismiss the animated, aggressive, and likely alcohol-emboldened gesture of his adversary, who speaks while he points to a newspaper being read by an elderly man seated nearby. A refined youth, perhaps a student, listens to the gesturing man's tirade with his hand on his cheek. He sits across from an older

4.9. Richard Caton Woodville (American, 1825–1855), *Politics in an Oyster House,* 1848. Oil on fabric, 16 × 13 in. The Walters Art Museum, Baltimore (37.1994).

man in an apron (a butcher or blacksmith?), who takes a drink while watching the wife and daughter vainly beseech the farmer to abandon his glass. All the while, the large dog, which has apparently witnessed this sort of raucous commotion many times before, nestles under the table as relaxed and serene as if nothing were out of the ordinary.

Krimmel's painting celebrates the tavern as a nexus of exchange, where old and young, rich and poor, and men from a variety of trades and occupations sit down and talk to one another.[15] The conviviality in the picture depends on the social lubricant of alcohol. Divisions between generations and classes are bridged because the consumption of alcohol encourages individuals to speak freely. Through a process of productive obfuscation, alcoholic beverages blurred the sharp divisions that frequently kept people apart. For instance, in a long and wide-ranging essay entitled "Something about Wine," American art critic Henry Tuckerman noted in 1858 that the titular beverage could "[s]often us; to make us kinder than our reason, and more admissive than our candor, and to enable us to begin larger sympathies and associations from a state in which the feelings are warm and plastic."[16] Beer, Tuckerman argued, "by its properties, destroys fine distinctions," and it, along with pipe smoking, "obfuscated the modern German brain; yet the parsons meet in the public gardens, and without conscious wrong, empty their frugal glasses and send abroad lusty whiffs, with a quiet zest that disarms theological strife."[17] In moderate amounts, alcohol reduces friction by softening hard facts and amplifying sympathies. For example, the two men in *Politics in an Oyster House* (fig. 4.9), by Richard Caton Woodville, may not literally or figuratively see eye to eye, yet they apparently are able to sit down with one another in open discourse, thanks in large part to the carafe and half-empty glass of beer between them on the tabletop. Drink meliorates and diffuses the tense and potentially eruptive debate between the brash young man, who (like the derby-wearing disputant in Krimmel's *Village Tavern*) gestures ag-

gressively across the table, and the elderly veteran, whose bright red nose and flushed cheeks indicate his inebriation.[18] The composition of *Politics in an Oyster House* highlights a dichotomy between the mellow indirectness of the older man, who has clearly been sipping the beer in his glass, and the grating churlishness of his youthful—and ostensibly sober—companion. Even though this young man is visibly irritated and the old man appears less than receptive to his companion's ideas, beer operates here as a potable ombudsman and smoothes the tenor of the conversation.[19]

Like Woodville's *Politics in an Oyster House,* Krimmel's *Village Tavern* shows how alcohol might encourage communication; but despite all its excitement and vitality, it also speaks to the disruptive capacity of taverns to foster intemperance and idleness.[20] In Krimmel's painting, the younger, more aggressive man—with his blank stare and loose-lipped countenance that convey cantankerousness and slurred speech—is the one who has clearly been drinking. He offers the tankard in his right hand to the Quaker, who politely but sternly raises his left hand to indicate his refusal (fig. 4.10). Bright sunshine falls at a sharp angle through the doorway and onto the floor, an indication that it is the middle of the day. Many of the tavern's patrons are dressed for work, yet they are not working. The wife of the farmer, who appears to have been crying, lifts a section of her simple and unembellished dress toward her face to wipe away tears as she grasps her husband's right arm, imploring him to leave the tavern. Their daughter plaintively and wistfully gazes up at her tippling father while placing one hand on each parent in an attempt to defuse the impending conflict. The two female figures appear as aliens in an all-male world, one that resists the moralizing effect of virtuous women and thus threatens the social, emotional, and economic integrity of the family and, by extension, the viability of the young nation that Krimmel's generic *Village Tavern* serves to symbolize. The seven days of the week, inscribed over the doorway and on an almanac for the year 1814, stand as testaments

to the dilatory passing of time. While acknowledging the potential of taverns to enhance sociability, free speech, and democratic sympathies, Krimmel's picture ultimately captures the group in *Village Tavern* on the cusp of antagonism, at the moment when tempers begin to flare, productivity begins to suffer, and families begin to break apart. The level of intensity is here about to cross a threshold beyond which the consumption of alcohol exacerbates rather than smoothes over society's lines and cracks.

Like Krimmel's painting, Mount's *Bar-room Scene* at least acknowledges the sense of community that taverns encourage; Deas's *Walking the Chalk* dispenses with it altogether. Unlike Mount's mirthful characters, who work together to maintain an upbeat musical rhythm, the denizens of Deas's picture hardly interact with one another, much less engage in any sort of profitable communication. The focus in Deas's narrative is not on the light-hearted festivities that alcohol helps bring about, such as those

portrayed in Mount's *Bar-room Scene,* but on a state of affairs that appears disquieting and, at best, morally ambiguous. *Walking the Chalk* concentrates the attention of its characters—and by extension, that of the audience—on a scene that requires its protagonist to drink as much as he possibly can until he is as drunk as a doornail. Deas's seedy spectacle of drinking for its own sake presents a dark vision of over-indulgence disengaged from any moralizing influence. The unthinking and compulsive consumption depicted in the scene is counterproductive and elicits a reciprocal response from the viewer, who is free to indulge his or her fascination with the seedy underbelly of society that Deas's *Walking the Chalk* so alluringly reveals. Something about the painting clearly disturbed its critics, who expressed their uneasiness with what one reviewer deemed not to be "a fit subject for the pencil. It is enough to know that such scenes are passing around us, without having them placed before us upon canvas."[21] That is to say, Charles Deas's peculiar little painting about drinking for the sake of drinking was potentially dangerous and threatened to knock its viewers—like Deas's chalk walker—off balance. Although the artist may have intended his picture to be charming, perhaps even funny, its humor was, in the eyes of its critics, overwhelmed by its vivid portrayal of an unhealthy and unseemly group of tavern-goers that was too intense to be palatable to contemporary eyes. Unlike the tavern scenes painted by Krimmel, Mount, and Woodville, Deas's *Walking the Chalk* does not offer even a suggestion of the positive benefits that derive from the drinking it depicts. Instead, it conveys a decidedly dim view of the practice, in which the characters in the painting appear trapped in a dreary existence, teetering precariously on the edge of society.

NOTES

The chapter epigraph is from Anonymous, "A Parody," *The Every Body's Album: A Humorous Collection of Tales, Quips, Quirks . . .* (December 1, 1836): 89.

1. I thank Eleanor Jones Harvey, Franklin Kelly, and William Truettner for bringing this painting to my attention, and Carol Clark for sharing with me her expertise on Charles Deas. The staff of Debra Force Fine Art kindly provided me the opportunity to view the painting and shared a file full of useful information. Special thanks are owed to the Museum of Fine Arts, Houston, whose recent purchase of Charles Deas's *Walking the Chalk* ensures that this important and delightful painting will be accessible to the public. Finally, I thank Steven Baker at the University of Oklahoma Press and freelance editor Sally Bennett for their assistance with the preparation of this chapter.

2. For a discussion of the role that race and gender play in this process in this and other Deas paintings, see chapter 1 of Guy Jordan, "The Aesthetics of Intoxication in Antebellum American Art and Culture," Ph.D. dissertation, University of Maryland, 2007; for an analysis of the meaning of the African American figure in *Walking the Chalk,* see Guy Jordan, "Race in Transit: Intoxication and Slavery in the Art of Charles Deas," *Visual Resources* 24, no. 3 (September 2008): 253–72.

3. For an excellent discussion of temperance-themed genre paintings produced during the antebellum period, see Nora C. Kilbane, "A Tug from the Jug: Drinking and Temperance in American Genre Painting, 1830–1860," Ph.D. dissertation, Ohio State University, 2006.

4. Anonymous, "The Good Woman," *New York Illustrated Magazine of Literature and Art* 1 (January 1846): 15.

5. Anonymous, "Great Discovery," *Scientific American* 5, no. 25 (March 9, 1850): 194; emphasis in original.

6. I have been unable to locate a literary source for the name or any period narratives that approximate the goings-on in Deas's picture, but the painting may relate to one of the many hundreds of temperance tales published during the 1830s. *Walking the Chalk* may depict an invented scene from an actual drinking establishment in or around Kingston and Ulster County, New York, where Deas spent much of his childhood. There were many inhabitants of the area at that time with the last name "Brink." See Theodore B. Meyers, "Lineage of the Christian Meyer Family," *Olde Ulster Magazine,* 10, no. 8 (August 1914): 243–47.

7. For more information about Mount's *Bar-room Scene,* see Deborah J. Johnson, "William Sidney

Mount: Painter of American Life," in *William Sidney Mount: Painter of American Life,* by Deborah J. Johnson, Elizabeth Johns, Franklin Kelly, and Bernard F. Reilly, Jr. (New York: American Federation of Arts, 1998), 33, 36; and Judith A. Barter, Kimberly Rhodes, and Seth A. Thayer, with contributions by Andrew Walker, *American Arts at the Art Institute of Chicago: From Colonial Times to World War I* (Chicago: Art Institute of Chicago, 1998), 152–53.

8. The man is described in a period review as a "rustic, beating time." See The Fine Arts, *Knickerbocker* 5, no. 6 (June 1835): 555. On the racial implications of the dance in Mount's painting, see Barter et al., *American Arts;* and Kevin Scott, "Rituals of Race: Mount, Melville, and Antebellum America," Ph.D. dissertation, Purdue University, 2004, esp. chaps. 1 and 2.

9. Johnson suggests that only the central character has been drinking. See Johnson, *William Sidney Mount,* 33.

10. David S. Reynolds, *Beneath the American Renaissance: The Subversive Imagination in the Age of Emerson and Melville* (Cambridge, Mass.: Harvard University Press, 1988), 66. See also Reynolds, "Black Cats and Delirium Tremens: Temperance and the American Renaissance," in *The Serpent and the Cup: Temperance in American Literature,* ed. David S. Reynolds and Debra J. Rosenthal, 22–59 (Amherst: University of Massachusetts Press, 1997).

11. "Exhibition at the National Academy—No. 11," *New York Literary Gazette* 1, no. 15 (May 11, 1839): 118.

12. Bruce Dorsey, *Reforming Men and Women: Gender in the Antebellum City* (Ithaca, N.Y.: Cornell University Press, 2002), 98. Dorsey and other scholars have also noted the role that taverns played in reifying male hegemony; women were infrequent visitors to such "smoke-filled rooms" where political opinions and alliances were formed. See, for instance, Sharon V. Salinger, *Taverns and Drinking in Early America* (Baltimore, Md.: Johns Hopkins University Press, 2002), esp. 220–26. Women, even when present in taverns, "did not, like their male counterparts, participate in the sociability of the house. They were there to serve and not to be seen or heard" (Salinger, *Taverns and Drinking,* 226).

13. Salinger, *Taverns and Drinking,* 243.

14. For an excellent study of the impact of the temperance movement on Krimmel and his art, see Janet Marstine, "America's First Painter of Temperance Themes: John Lewis Krimmel," *Rutgers Art Review* 9–10 (1988–89): 111–34. My reading of this painting follows closely that of Annelise Harding in her *John Lewis Krimmel: Genre Painter of the Early Republic* (Winterthur,

Del.: Winterthur Publications, 1994), 59, 65. See also Kym Rice, *Early American Taverns: For the Entertainment of Friends and Strangers* (Chicago: Regnery Gateway, 1983), 83. Rice includes Krimmel's picture in her useful analysis of the visual and material culture of taverns.

15. As alcoholic beverages became cheaper to produce, tavern culture became accessible to a broader cross section of Americans. For an argument that emphasizes the fundamental importance of taverns as a force for democratization and the encouragement of free speech, see David W. Conroy, *In Public Houses: Drink and the Revolution of Authority in Colonial Massachusetts* (Chapel Hill: University of North Carolina Press, 1995).

16. H. T. Tuckerman, "Something about Wine," *Knickerbocker* 52, no. 2 (August 1858): 154.

17. Tuckerman, "Something about Wine," 149, 153.

18. For a reading of this painting that takes into account the widespread cultural uproar over immoderate alcohol consumption, see Justin Wolff, *Richard Caton Woodville: American Painter, Artful Dodger* (Princeton, N.J.: Princeton University Press, 2002), 69–83. Wolff also reads the ruddy complexion and bemused smile of the older man in *Politics in an Oyster House* as signs of intoxication (*Richard Caton Woodville,* 75).

19. That the substance is beer, rather than a stronger beverage, is important to my reading. The physician Benjamin Rush, for instance, used political language to elaborate on this dichotomy between healthy and unhealthy alcoholic beverages. Beer and cider were "invaluable FEDERAL liquors," vital "companions of those virtues that can alone render our country free and respectable," while hard liquors were "*[a]nti-federal . . .* the companions of all those vices, that are calculated to dishonor and enslave our country" (emphasis in original). Benjamin Rush, "An Oration on the Effects of Spirituous Liquors on the Human Body," *American Museum* 4 (1788): 325–27.

20. For an analysis of anti-tavern crusades in the colonial period, see David S. Shields, "The Demonization of the Tavern," in Reynolds and Rosenthal, *Serpent and the Cup,* 10–21. Shields concludes that "[t]he tavern was a gaping maw that consumed men's savings and gnawed at their credit in the eyes of the public" ("Demonization," 18). The historian William Rorabaugh notes that Benjamin Franklin called taverns "a Pest to society" in the March 29, 1764, issue of the *Pennsylvania Gazette;* see Rorabaugh, *The Alcoholic Republic: An American Tradition* (Oxford: Oxford University Press, 1979), 34.

21. "National Academy of Design: No. IV," *New-York Spectator,* June 17, 1839.

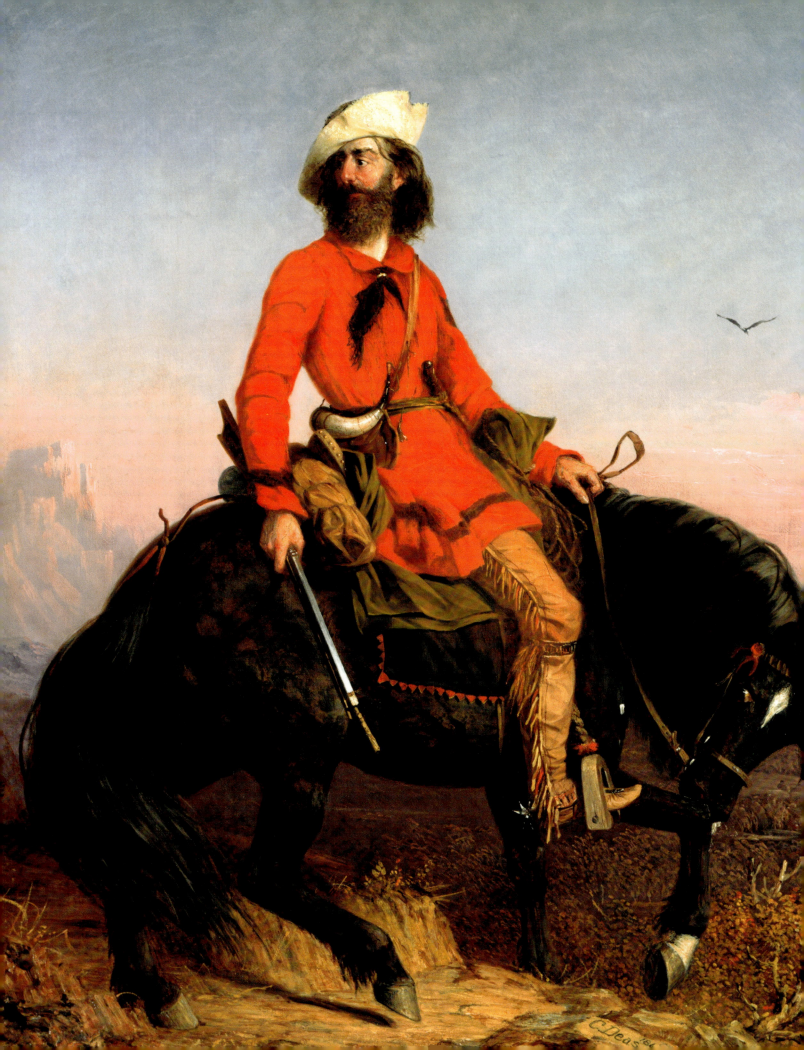

5

LONG JAKES
Some Currents in the Mountain Air

Joan Carpenter Troccoli

As Carol Clark discusses elsewhere in this volume (see chapter 1), the exhibition and sale to the American Art-Union of Charles Deas's *Long Jakes, "the Rocky Mountain Man"* (fig. 5.1) in the fall of 1844 marked Deas's reentry into the New York art world after an absence of four years.[1] During most of that time, Deas lived in St. Louis, which had served as regional headquarters for American commercial and government enterprises in the Far West since the purchase of Louisiana Territory from France in 1803. Deas called his mountain man "Jaques" and "Long Jaques" in recognition of the prominent role played by men of French ancestry in the city's fur trade,[2] which, though on the wane in the mid-1840s, was still a major industry and source of wealth for its most prominent citizens. The American Art-Union anglicized the subject's name to "Long Jakes" after it bought the picture from Deas in September 1844; the Art-Union also appended the qualifier "the Rocky Mountain Man" to the painting's title.[3] New York journalists described the subject of *Long Jakes* variously as "the *red-shirt hunter on his horse in the prairie*"; a "Santa Fe trader" who "comes to us from the outer verge of our civilization"; the embodiment of "a mountain hunter"; and a "Prairie Man" and "Prairie Rider" who makes his living hunting wild horses.[4]

5.1. Detail of fig. 3.16, Deas, *Long Jakes*.

Deas's iconic image is simple enough in form and sufficiently rich in detail to sustain all these characterizations. In this chapter, I focus on two seemingly minor elements of *Long Jakes*—the dusty mountainscape in the background and the brand on the horse—that may allude to past history and current events of special interest to an artist resident in St. Louis in 1844. These details suggest that in *Long Jakes* Deas may have intended to pay tribute to the role in western American exploration and expansion played by a certain class of fur hunter, the free trapper. This is a group with which Deas wished to identify, if his dress and behavior in the late summer of 1844 (shortly after he completed *Long Jakes*) are any indication. From August 12 to September 21, 1844, Deas traveled across Nebraska with an expedition led by Major Clifton Wharton. One of Wharton's junior officers, Lieutenant J. Henry Carleton, kept a diary of the expedition that was published serially in the New York journal *Spirit of the Times* from November 9, 1844, to April 12, 1845. In one of these dispatches, Carleton reported that Deas dressed and equipped himself like a fur trapper. As Lieutenant Carleton phrased it, the artist also came and went as he pleased, in "a Rocky Mountain way," referring to the free trappers who worked for fur companies on short-term contracts or were in business for themselves.[5]

Since the time of Lewis and Clark, fur trappers (who acquired extensive geographical knowledge from Indians, as well as from their own practical experience) had rotated in and out of government service as guides for army exploring expeditions. Well before the American West was mapped—before, in fact, much of it was even "American"—it had been thoroughly surveyed by fur hunters. Washington Irving noted this in *The Adventures of Captain Bonneville U.S.A., in the Rocky Mountains and the Far West* (1837), his history of a French-born army officer who reconnoitered the Rockies in the early 1830s in the guise of a fur trader: "The Rocky Mountains and the ulterior regions, from the Russian possessions . . . down to the Spanish settlements of California, have been traversed and ransacked in every direction by bands of hunters and Indian traders; so that there is scarcely a mountain pass, or defile, that is not known and threaded in their restless migrations, nor a nameless stream that is not haunted by the lonely trapper."[6] The patriotic partnership of fur trappers and army explorers in the cause of American expansion was in the news when Charles Deas painted *Long Jakes* in 1844. The headliner of the early 1840s was the charismatic but highly fallible John Charles Frémont, who embarked in the spring of 1842 on his first expeditionary command, a survey of the Oregon Trail from Westport, Missouri, to South Pass in present-day Wyoming.

Frémont's association with Christopher "Kit" Carson, the most famous of the many mountain men who assisted him, began with the 1842 expedition. It is tempting, therefore, to identify Carson as the "famous trapper and hunter of the great Western Prairies and Rocky Mountains" that the *New York Illustrated Magazine of Literature and Art* proclaimed as the subject of *Long Jakes* in June 1846.[7] Carson's star was on the rise when Deas painted *Long Jakes,* but he was far from the celebrity that he would become by the 1850s. The principal guide for Frémont's 1842 expedition was the voyageur Basil Lajeunesse. Moreover, unlike Frémont, whose national fame dated to the publication of his first expedition report in the spring of 1843 and who was fêted by all of St. Louis on his return from his second expedition in July 1844, Carson did not revisit the city where Deas maintained his studio until 1847.[8]

The weathered Long Jakes bears no resemblance to Frémont, who was a twenty-nine-year-old second lieutenant in the U.S. Army's Corps of Topographical Engineers when he departed for South Pass from St. Louis in 1842.[9] A portrait by the American artist George P. A. Healy (fig. 5.2)—which, its title notwithstanding, depicts Frémont wearing the uniform of a second lieutenant (a rank he would retain until appointed by President Tyler to the double brevet of first lieutenant and captain on July 31, 1844)[10]—records his youthful, fresh-faced appearance,

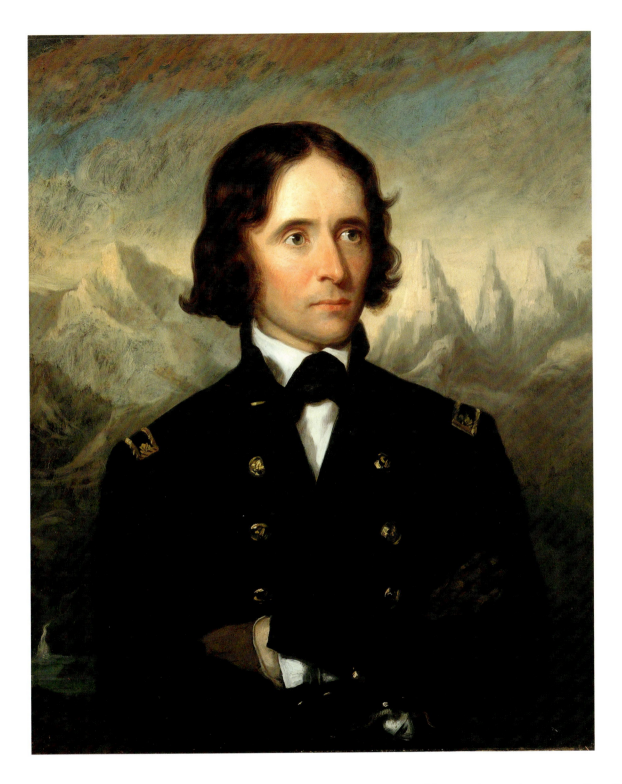

upon which the privations of his later expedi-
tions would soon exact a visible toll (fig. 5.3).
However, it is not the figure in *Long Jakes* that
evokes Frémont, but the range of mountains on
the distant horizon.

Frémont's first expedition was the creation
of his father-in-law, Missouri Senator Thomas
Hart Benton, an outspoken advocate of western
expansion. Operating in sub-rosa defiance of
President Tyler's policy of respecting the bor-

5.2. George Peter Alexander Healy
(American, 1813–1894), *General
John C. Frémont,* n.d. Oil on can-
vas, 30 × 25¼ in. Union League
Club of Chicago.

5.3. Matthew Brady Studio (unknown photographer), *Untitled (Portrait of John Charles Frémont)*, ca. 1854. Daguerreotype. Collection of the Oakland Museum of California.

of Engineers, ordered Lieutenant Frémont to "explore and report upon the country between the frontiers of Missouri and the South Pass in the Rocky mountains."[11] By this time, Benton's passing remark in 1825 that the Rocky Mountains should form the "Terminus" to American territorial ambitions in the West was ancient history. He had long since concluded that the United States needed to occupy the full extent of the North American continent and that the only sure way of laying claim to the Oregon country and California was to flood them with U.S. citizens. Benton saw to it that Frémont's survey was enlarged to include all of South Pass, the least challenging wagon route over the Continental Divide in the central Rockies. By 1842, South Pass had been traversed by American trappers and early Oregon pioneers for nearly twenty years; Frémont's expanded commission had far more to do with publicizing the Oregon Trail than with serving a pressing cartographic need.[12]

The gentle topography of South Pass (fig. 5.4) disappointed Frémont. In his expedition report, the lieutenant lamented that South Pass possessed "nothing of the gorge-like character and winding ascents of the Allegheny passes in America; nothing of the Great St. Bernard and Simplon passes in Europe," although Frémont had less authority on this second point because he had never been to Europe. Frémont reported that the gradual elevation at South Pass was quite like "the ascent of the Capitol hill from the avenue, at Washington."[13] Of course, demonstrating the ease with which emigrant wagon trains could cross the Continental Divide at South Pass was the whole point of his expedition. But the mapping of South Pass, a place already well known and well used, was not the stuff of which legendary explorations—and legendary explorers—were made.

Fortunately, more-exciting scenery was at hand. Frémont pushed his party beyond South Pass and into the Wind River Range, "a grand

ders of Mexico and maintaining the joint occupation of Oregon by the United States and Great Britain, Benton and like-minded legislators used the congressional power of the purse to fund a survey of the Oregon Trail by the Army Corps of Topographical Engineers, which supervised official explorations of the West from 1838 to 1863. In the early months of 1842, Colonel John James Abert, the head of the Corps

5.4. James F. Wilkins (American, 1808–1888), *Pacific Springs* [South Pass], 1849. Pencil sketch, 21½ × 8½ in. The James F. Wilkins Overland Trail Drawings, 1849, Wisconsin Historical Society (31696).

bed of snow-capped mountains . . . pile upon pile, glowing in the bright light of an August day." From his motley team of trappers, packers, and voyageurs, Frémont selected fifteen men to accompany him even farther, to the top of what he called "Snow peak," which he believed (incorrectly) to be the tallest of all the Rocky Mountains.[14] On his comprehensive map of 1845, based on this and his next expedition (1843–44), which extended his survey from the Rockies to Fort Vancouver on the Columbia River in Oregon,[15] Frémont modestly affixed his name to what he recalled as Snow Peak, although there is some doubt as to whether what is now called Frémont Peak is actually the mountain he climbed in 1842.[16]

Frémont's vaguely stated purpose in exceeding his orders—to survey the sources of the Colorado, Columbia, Missouri, and Platte rivers—sounds reasonable, but historians agree that in scaling Snow Peak, he was really looking to generate publicity for himself as well as to further the expansionist objectives of his father-in-law.[17] Frémont engineered the final assault on the mountain to ensure that he would be the first to reach the top.[18] Once there, he and

his men paused to determine their altitude and then, in the explorer's words, "fixing a ramrod in a crevice, unfurled the national flag to wave in the breeze where never flag [of any country, and in saying this, Frémont meant in particular the ensigns of Spain, Mexico, and Great Britain] waved before." The "national flag," specially designed for the expedition, was a variation on the stars and stripes that featured an aggressive-looking eagle. It turned Frémont's extracurricular alpine excursion into a dramatic assertion of the intention, as well as the right, of the United States to assume control over western territories that were owned by Mexico or uneasily shared with Great Britain.[19] Of all the accomplishments associated with his first expedition, it was Frémont's conquest of "the highest peak of the Rocky mountains" that made him a national hero (fig. 5.5).[20]

In raising his eagle flag on the summit of Snow Peak, Frémont created an image—albeit a mental one—that galvanized an entire generation of prospective westerners,[21] and he lost no time in disseminating it. Following his return to Washington on October 29, 1842, Frémont dictated his expedition report to his

5.5. *Frémont Plants the American Flag on the Highest Peak of the Rocky Mountains.* Wood engraving, from John Bigelow, *Memoir of the Life and Public Services of John Charles Frémont* (New York: Derby and Jackson, 1856). Western History Art Collection, Denver Public Library.

been one of the first great photo opportunities in American history. Among the instruments with which Frémont equipped his expedition was a daguerreotype camera that the modern-minded explorer proposed to operate himself, much to the amusement of the expedition's German cartographer, Charles Preuss, who delighted in recording Frémont's various short-comings and failures, of which there would be enough over the course of their relationship to sate the most devoted aficionado of schaden-freude. Daguerreotypes are difficult to make under controlled conditions indoors, and the process proved completely intractable in the wilderness. No photographs were made, and the camera was lost when another newfangled piece of technology deployed by Frémont, an inflat-able India-rubber boat, capsized in the Platte.[23]

Although, like so much else associated with Frémont's expeditions, the daguerreotype experiment was a disaster, the image of his conquest of the Rockies would endure in both intangible and concrete form. Frémont devoted nine of the seventy-nine pages in his expedition report to the ascent, spinning out the difficulties (including ice, altitude sickness, cold, hunger, and risk of bodily injury) that he and his men encountered in the dangerous and deceptive terrain of the Wind River Range. Frémont, of course, plays the starring role in the drama, appearing as America's first celebrity rock climber.[24] The flag raising on Snow Peak was illustrated in the biography published in conjunction with Frémont's run for president in 1856 and pictured in other campaign materials; in a demonstration of its long-running mythic power, the scene was reproduced on a postage stamp in 1898.[25]

Lacking the hoped-for photographic docu-mentation of the expedition, Frémont turned to Preuss to make the sketches of Great Plains and Rocky Mountain scenery that were reproduced in his report.[26] Preuss's *Central Chain of the Wind River Mountains* (fig. 5.6), "gleaming like silver," as Frémont described them,[27] form the back-drop of Healy's portrait of the handsome young explorer, which forever blends Frémont's image

wife, Jessie, a talented editor. Despite its tedious title—*Report on an Exploration of the Country Lying between the Missouri River and the Rocky Mountains on the Line of the Kansas and Great Platte Rivers*—Frémont's account, like the expedition itself, was designed to appeal to a mass audience. It was in print and circulating briskly by the end of March 1843.[22]

Frémont recognized early on the power of grand gestures and their representation to ad-vance his career, and had all gone according to plan, his conquest of Snow Peak might have

Central Chain of the Wind River Mountains

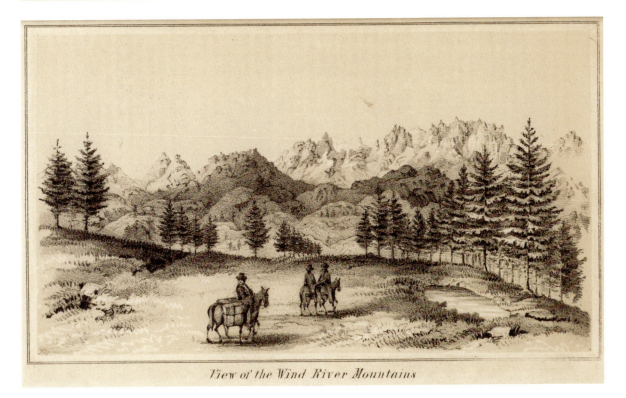

View of the Wind River Mountains

5.6. Edward Weber after Charles Preuss, *Central Chain of the Wind River Mountains,* in Lieut. J. C. Frémont, *Report on an Exploration of the Country Lying between the Missouri River and the Rocky Mountains on the Line of the Kansas and Great Platte Rivers,* 27th Cong., 3rd sess., ser. 416, Senate Doc. 243. Washington, D.C., 1843. Western History Art Collection, Denver Public Library.

5.7. Edward Weber after Charles Preuss, *View of the Wind River Mountains,* in Lieut. J. C. Frémont, *Report on an Exploration of the Country Lying between the Missouri River and the Rocky Mountains on the Line of the Kansas and Great Platte Rivers,* 27th Cong., 3rd sess., ser. 416., Senate Doc. 243. Washington, D.C., 1843. Western History Art Collection, Denver Public Library.

with the site of his first and most unalloyed expeditionary success. In constructing *Long Jakes,* Charles Deas may also have referred to the illustrations in Frémont's expedition report (fig. 5.7). As in Healy's portrait, Deas's adaptation of illustrations from the explorer's report had less to do with Preuss's rather pedestrian views than with associating *Long Jakes* with Frémont's much-hyped achievement.

For the most part, Deas composed his landscapes along the lines established by Thomas Cole, master of the Hudson River school. In *Long Jakes,* the rocky ledge in the foreground, the blasted tree (a Cole hallmark) at lower right, the precipitous drop in elevation, the distant watercourse at the landscape's lowest point, and the passages of intricate brushwork in the middle ground recall devices employed by Cole in many of his paintings of the 1820s and 1830s. The most majestic of these is *View of Schroon Mountain, Essex, New York, after a Storm* (fig. 5.8), which was shown at the National Academy of Design in 1838 and in the galleries of the Apollo Association in 1839, where Deas also exhibited a picture that year.[28] But the distant range of mountains in *Long Jakes* belongs to a different topographical family than Cole's Catskills, Adirondacks, and White Mountains. Deas's rocky mountain is grayer, bleaker, and more forbidding, in a way reminiscent of Frémont's description of the Wind River Mountains in the vicinity of Snow Peak as "a nearly perpendicular wall of granite, terminating 2,000 to 3,000 feet above our heads in a serrated line of broken, jagged cones" and "a savage sublimity of naked rock" unmitigated by vegetation.[29]

The angular peaks in *Long Jakes* can be interpreted as a symbol of America's conquest of the Rockies by Frémont and his crew of fur trappers and hunters. Nine months before Deas completed *Long Jakes,* Frémont's second expedition had reached the Columbia River and accomplished its objective of joining Frémont's surveys to that of the United States Exploring Expedition, which had mapped the Northwest Coast, "thus presenting a connected exploration from the Mississippi to the Pacific."[30] The

American trail to Oregon had been fully surveyed by November 1844; Frémont's emigrant-friendly map of the trail would be published the following year; and Great Britain would cede all claims to its northwestern American terri-

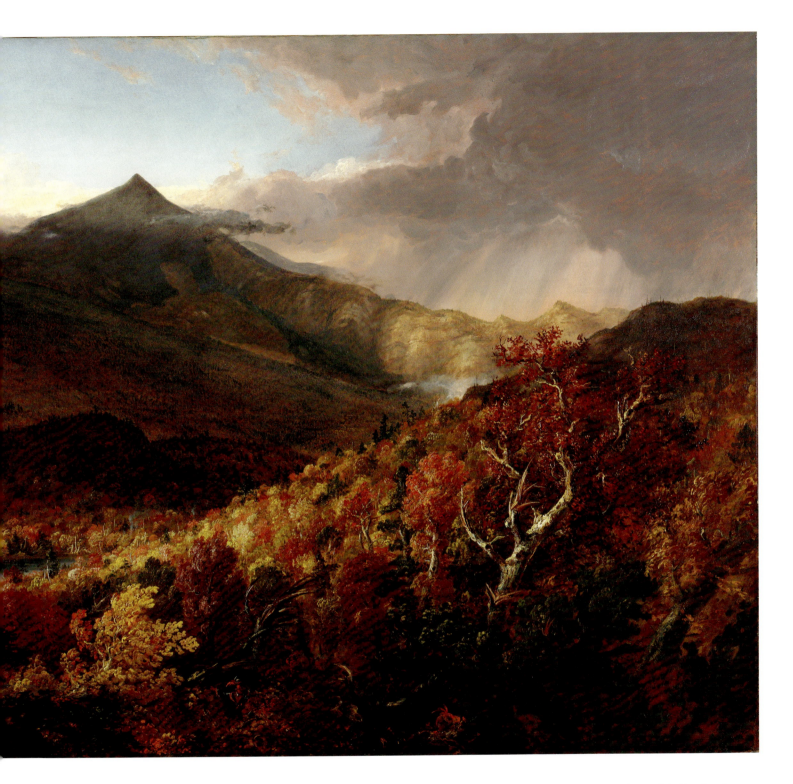

tories south of the forty-ninth parallel in June 1846. Frémont would have been the first to concede that without his valiant troop of mountain men, his contributions to this sequence of events could not have been made with such stunning speed. In *Long Jakes,* Deas may have acknowledged the role of the Rocky Mountain fur trapper in achieving America's dominion in the West by branding the rump of the figure's handsome, spirited horse with the initials "J. S."

5.8. Thomas Cole (American [b. England], 1801–1848), *View of Schroon Mountain, Essex County, New York, after a Storm,* 1838. Oil on canvas, 39⅜ × 63 in. The Cleveland Museum of Art, the Hinman B. Hurlburt Collection.

(fig. 5.9). Nearly twenty years before Frémont captured the spotlight, much of the country he surveyed had been traversed by Jedediah Smith, who in his short life was a fur trapper, mountain hunter, and Santa Fe trader, as well as one of America's greatest explorers.[31]

5.9. Detail of fig. 5.1, Deas, *Long Jakes*.

In 1822, Smith signed on with William Ashley, cofounder of what would become known as the Rocky Mountain Fur Company. Ashley's predecessors and contemporaries among American fur executives treated trappers like indentured servants, chaining them to the company by keeping them in perpetual debt. Ashley, by contrast, signed his men to short-term contracts (thus making them "free") and allowed them to keep a greater share of the profits. Rather than relying on trade with Indian hunters, Ashley sent his trappers directly into the wilderness. They assembled once a year in a mountain valley to exchange their furs for supplies brought from St. Louis by wagon. To these rendezvous, Ashley's men carried not only their annual catch but also reports on promising new locations in which to hunt. In the long run, the geographical information Ashley's men collected was far more valuable than the tons of fur they hauled to their annual meetings. The Rocky Mountain rendezvous was a veritable convocation of trapper-explorers, and its most prolific participant was Jedediah Smith.[32]

Like the United States was said to be, Ashley's fur company was a meritocracy, opening the path to riches to any man willing to risk the dangers of the wilderness. Smith was a quick study and a precocious leader. Ashley made him a field captain at twenty-four and a partner in the firm two years later. In 1826, Smith and two junior partners, David Jackson and William Sublette, bought out the rest of Ashley's interest in the fur company.[33]

Smith's rapid advancement must be understood in the context of a Rocky Mountain trapper's life expectancy, which was often painfully short. Smith's career could easily have ended in 1823, when he was nearly decapitated by a grizzly bear in present-day South Dakota. But thanks to some impromptu wilderness surgery performed by fellow trapper James Clyman at Smith's direction, he recovered and went on to explore, traverse, and open to fur hunters vast areas of the transmontane West, including the Great Salt Lake and Great Basin; remote regions of the Colorado Plateau; and California, Oregon, and the Sierra Nevada. Prominent among Smith's achievements was his discovery of the eastern entrance to South Pass, which he and fellow trapper Thomas Fitzpatrick found with the help of Crow Indians in March 1824.[34]

Although Smith's crossing of South Pass from east to west was not as intensively publicized as Frémont's passage eighteen years later, the press certainly took notice. The *St. Louis Enquirer* reported that "we learn that [some of Ashley's men] have discovered a passage by which loaded wagons can . . . reach the navigable waters of the Columbia River. This route lies South of the one explored by Lewis and Clarke [*sic*], and is inhabited by Indians friendly to us." By early December 1824, the momentous news had appeared in the nationally distributed *Niles' Weekly Register*.[35]

In the 1820s, South Pass was most prized as the gateway to the Green River country and its abundant beaver population, but Smith and his partners foresaw its potential for America's continental future. In October 1830, they wrote to the U.S. secretary of war, urging the government to move aggressively to contain British

territorial ambitions in Oregon and encourage Americans to immigrate there via South Pass. To demonstrate its feasibility for wagon trains, they outlined the route of their supply caravan to the rendezvous of 1830 on Wind River. With a party of eighty-one men mounted on mules, as well as "ten wagons, drawn by five mules each, and two dearborns, drawn by one mule each," not to mention "twelve head of cattle, [and] a milk cow," they traveled overland from St. Louis to "what is called the *Southern Pass.*" "All the high points of the mountains then in view were white with snow," the partners reported, "but the passes and valleys and all the level country, were green with grass," which, they implied, could supply forage for horses and cattle. "This," the partners averred, "is the first time that wagons ever went to the Rocky mountains; and the ease and safety with which it was done prove the facility of communicating over land with the Pacific ocean."[36]

The letter was published by the U.S. Senate and widely reprinted in American newspapers, once again bringing Smith, his partners, and South Pass to national attention. Their achievement was trumpeted by the *St. Louis Beacon,* which commented acerbically that the "ease with which [the caravan of Smith, Jackson, and Sublette reached South Pass], and could have gone on to the mouth of the Columbia, shows the folly and nonsense of those *'scientific'* characters who talk of the Rocky Mountains as the barrier which is to stop the westward march of the American people."[37]

His enthusiasm for South Pass notwithstanding, Smith's days in the Rocky Mountains were over. At the rendezvous of 1830, Smith and his partners (Jackson and Sublette) sold their fur company to five other veterans of Ashley's firm. They returned to St. Louis, where, in hopes of securing their retirement with the kinds of profits they had become accustomed to in the fur business, they established themselves in the Santa Fe trade.[38]

American merchants had opened the Santa Fe Trail, which connected the northern Mexican provincial capital to Independence, Missouri, in 1821. As was the case in the Rocky Mountain beaver country, commerce preceded conquest in the American Southwest. General Stephen Watts Kearny would lead his Army of the West down the Santa Fe Trail en route to seizing the capital in August 1846.

Like free trapping, freighting on the Santa Fe Trail was lucrative but hazardous. The steeper portions of the trail, especially Raton Pass, which straddles the borders of present-day Colorado and New Mexico, were tough going for wagons heavily laden with merchandise. When Smith entered the trade, however, the mountains could be bypassed via the so-called Cimarron Route, although this detour presented its own problems, including long dry stretches and exposure to Comanche and Kiowa warriors intent on preserving their buffalo range.[39]

Like Smith, Josiah Gregg, trader and author of *Commerce of the Prairies,* made his first journey on the Santa Fe Trail in 1831. Gregg's widely read book included a description of the tragic misfortunes that befell Smith on the trail.

> Capt. Smith and his companions were new beginners in the Santa Fé trade, but being veteran pioneers of the Rocky Mountains, they concluded [that] they could go anywhere; and imprudently set out without a single person in their company at all competent to guide them on the route. . . . There being a plain track to the Arkansas river, they did very well thus far; but from thence to the Cimarron [River], not a single trail was to be found, save the innumerable buffalo paths . . . which are exceedingly perplexing to the bewildered prairie traveler.
>
> When Capt. Sublette's party entered this arid plain, it was parched with drought; and they were doomed to wander about for several days, with all the horrors of a death from thirst staring them continually in the face. In this perilous situation, Capt. Smith resolved at last to pursue one of these seductive buffalo paths, in hopes [that] it might lead to the margin of some stream or pond. He set out alone; for besides the temerity which desperation

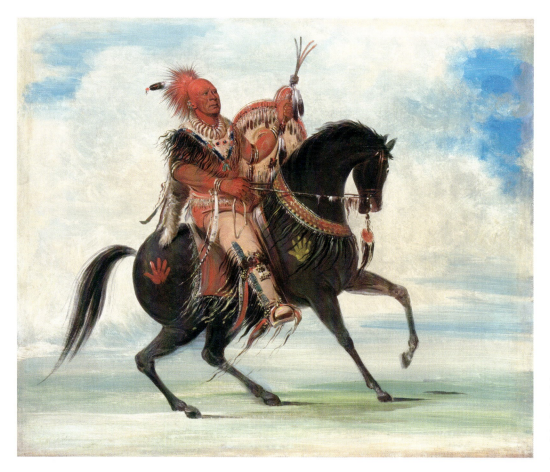

5.10. George Catlin (American, 1796–1872), *Kee-o-kúk, the Watchful Fox, Chief of the Tribe*, 1835. Oil on canvas, 24 × 29 in. Smithsonian American Art Museum, Washington, D.C., gift of Mrs. Joseph Harrison, Jr. (1985.66.1a).

always inspires, he had ever been a stranger to fear; indeed, he was one of the most undaunted spirits that had ever traversed the Rocky Mountains; and if but one-half of what has been told of him be true,—of his bold enterprises—his perilous wanderings—his skirmishings with the savages—his hair-breadth escapes, etc.—he would surely be entitled to one of the most exalted seats in the Olympus of Prairie mythology. But, alas! unfortunate Captain Smith! after having so often dodged the arrow and eluded the snare of the wily Mountain Indian, little could he have thought, while jogging along under a scorching sun, that his bones were destined to bleach upon those arid sands!

Gregg went on to describe Smith's murder by "a gang of Comanches, who were lying in wait for him," when he finally reached the Cimarron.[40]

Commerce of the Prairies was published in July 1844[41]—in time for Gregg's account of Smith's achievements and demise to have prompted Deas to memorialize the legendary trapper in a detail of *Long Jakes*. In *Commerce of the Prairies*, Gregg describes Smith as "a celebrated veteran mountain adventurer," and there can be no doubt that Smith survived in the memories of his former colleagues in St. Louis thirteen years after his death.[42] Thomas Hart Benton knew Smith personally and was aware, of course, of Smith's discovery of South Pass in 1824.[43] Thomas Fitzpatrick, who was among the last of Smith's friends to see him alive on the Santa Fe Trail, was "chief guide" on Frémont's second expedition and thus was in an excellent position to pass on some of Smith's geographical knowledge to the younger explorer.[44]

As a leading painter in St. Louis, Charles Deas may well have numbered some of Smith's as-

sociates among his acquaintances and perhaps among his patrons as well. Deas's membership in the St. Louis Mercantile Library exposed him to many of Smith's peers in the fur trade, the dominant industry of what was, in 1844, a fairly small city of about 34,000 residents.[45]

In the short term, Smith's achievements were not forgotten, especially by the people who shared in and profited from them. But because his plans to publish his journals and a "master map of the whole West" based on his explorations had died with him in 1831, the extent and utility of his discoveries would remain unappreciated until the late nineteenth century, when scholars began to piece together his surviving papers and maps.[46] A handful of place-names, such as Smith's Fork and Horse Creek in the Green River valley, where Smith and Fitzpatrick lost their horses to Shoshones, and mid-nineteenth-century American and European maps commemorate Smith's adventures, but his geographical expertise was largely lost until Frémont surveyed much of the same ground in the 1840s.[47]

Whether or not Deas intended to refer to the considerable accomplishments of Jedediah Smith in *Long Jakes,* his painting is consonant with Smith's short but magnificent career in its elevation of the humble trapper to iconic status. (Smith let his hair grow long to cover some of the scars from his encounter with the grizzly bear in 1823, but he never wore a beard; Deas could not have intended *Long Jakes* to be a literal portrait of him.)[48] With *Long Jakes,* Deas initiated a series of heroic depictions of working-class westerners that culminated in Frederic Remington's and Charles Marion Russell's paintings of anonymous cowboys half a century later.

Long Jakes belongs to a European tradition of equestrian portraiture of kings and military heroes that had been employed by Deas's most notable American artistic predecessors in the West—George Catlin and Alfred Jacob Miller—in the 1830s. However, *Long Jakes* constitutes a departure from their use of the form. Catlin and Miller reserved it for the nobility:

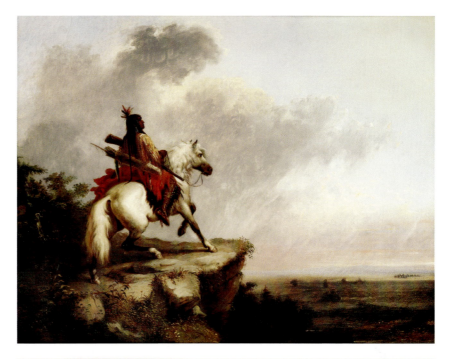

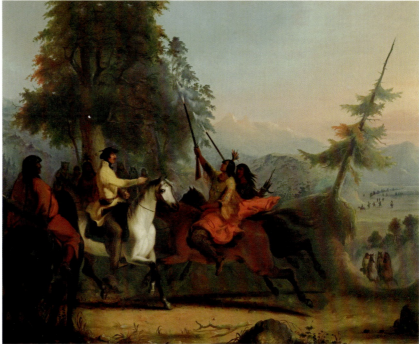

5.11. Alfred Jacob Miller (American, 1810–1874), *Indian Scout,* 1851. Oil on canvas, 18 × 24 in. Western History Art Collection, Denver Public Library.

5.12. Alfred Jacob Miller, *Sir William Drummond Stewart Meeting Indian Chief,* ca. 1837. Oil on canvas, 33 × 42½ in. Gilcrease Museum, Tulsa, Oklahoma (0126.738).

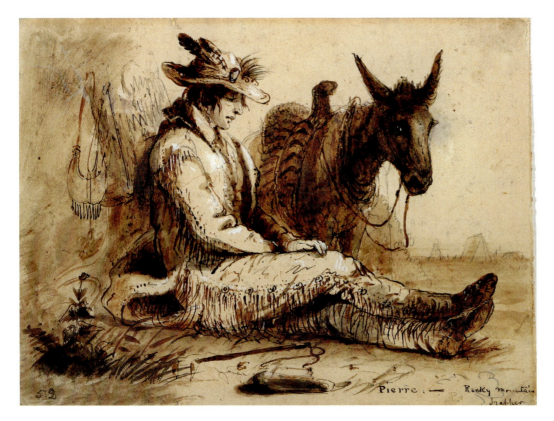

5.13. Alfred Jacob Miller, *Pierre, A Rocky Mountain Trapper,* late 1850s. Sepia-toned watercolor, gouache, pen and ink, and graphite on paper, 6¾ × 9½ in. Gilcrease Museum, Tulsa, Oklahoma (0236.1060).

either the "noble savage," as in Catlin's 1835 portrait of the Sauk and Fox chief Keokuk (fig. 5.10) and Miller's *Indian Scout* (fig. 5.11); or the European aristocracy, as in Miller's *Sir William Drummond Stewart Meeting Indian Chief* (fig. 5.12).

Catlin adopted some items of "western" dress to enhance his exotic image and occasionally donned Indian clothing from his collection of artifacts to enliven his public appearances, but to dress like a trapper, as Deas did on the Wharton expedition, would have been inconceivable to him. In his book *Letters and Notes on the Manners, Customs, and Conditions of the North American Indians* (1841), Catlin portrays French Canadian voyageurs (who are not to be confused with the courtly francophone executives who ran the American Fur Company) as rustic bumpkins who speak a comic *franglais*.[49] Similarly, Miller's French Canadian trappers look like shaggy North American peasants (fig. 5.13). Deas seems not to have shared the blanket prejudice against French trappers held by

Catlin and Miller, although allusions to some of the stereotypical weaknesses attributed to voyageurs, such as the overfondness for alcohol signified by his red nose, may appear in *Long Jakes,* as Carol Clark points out in her discussion of this picture (chapter 3).

In the early 1840s, however, French Canadians and their American counterparts had a genuine hero in Frémont, whose father came from Québec; his mentor, the master cartographer and French emigrant Joseph N. Nicollet, instilled in him a sense of pride in his French heritage (although he had been born out of wedlock). When he returned to Washington, D.C., in 1840 after assisting Nicollet in St. Louis and Minnesota, the young explorer changed the spelling of his anglicized surname "Fremon" to Frémont—the exact reverse of what happened to Deas's *Jaques* when it was sent east to New York, where the French community was hardly as dominant or respected as it was in Missouri. Frémont consorted with the French upper crust in St. Louis,[50] and he staffed his first expedition

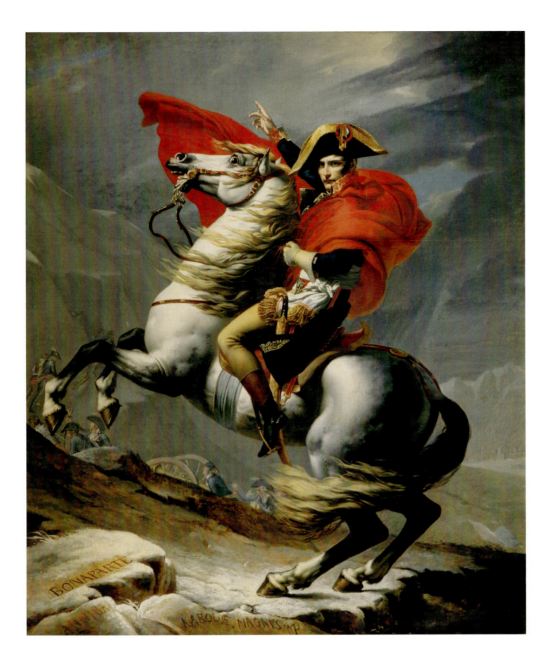

almost exclusively with men who had French given names or surnames, the only exceptions being Carson and Preuss.[51] At numerous points in his 1842 report, Frémont rather ostentatiously quotes himself speaking French to his men as well as to Indians, whose associations with French traders long predated their dealings with Americans.

Deas, too, spoke fluent French, with which he addressed Pawnees encountered on the Wharton expedition.[52] Deas had also mastered some of the formal lessons found in well-known works of early-nineteenth-century French art. The structure of *Long Jakes* has been likened to that of Jacques-Louis David's *Napoleon Crossing Mont Saint Bernard, May 20, 1800* (fig. 5.14),[53] although the central figure group in David's composition is actually closer to that of Deas's *Prairie on Fire* (fig. 5.15). In terms of emotional charge, however, *Long Jakes* begs comparison with the work of Théodore Géricault, a member of the generation of French painters that

5.14. Jacques-Louis David (French, 1748–1825), *Napoleon Crossing Mont Saint Bernard,* May 20, 1800, 1801. Oil on canvas, 107 × 95 in. Château de Versailles et de Trianon, Versailles. Photograph courtesy of Réunion des Musées Nationaux/Art Resource, New York.

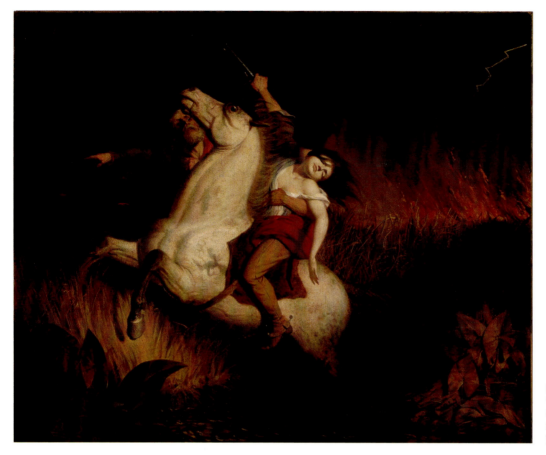

5.15. Charles Deas, *Prairie on Fire*, 1847. Oil on canvas, 28¾ × 25¹⁵⁄₁₆ . Gift of Mr. and Mrs. Alastair Bradley Martin, the Guennol Collection, Brooklyn Museum (48.195).

succeeded the Neoclassicist David. Géricault, like his Romantic contemporaries, explored the full spectrum of human and equine sensibility, providing models for the distracted Long Jakes and his apprehensive horse in, for example, *Le Cuirassier blessé, quittant le feu* (*The Wounded Soldier Leaving the Battle,* known also as *The Wounded Cuirassier*) (fig. 5.16). This painting, familiar to American artists through a lithographed reproduction,[54] depicts a French cavalryman in anguished flight from the chaos of battle.[55] In contrast to Géricault's soldier, who is exiting the field, Deas's hero is still firmly in the saddle. Like the real-life characters who inspired it, *Long Jakes* has an aggressive aspect: despite the figure's wary glance backward, he "goes ahead" to assert American ownership of a vast terrain, just as American fur trappers and traders nursed a sense of entitlement to California, Oregon, and the Rocky Mountain

West even as they tangled with Spanish authorities and the British Hudson's Bay Company.[56]

Charles Deas's genius in *Long Jakes* was to subsume its many associations and allusions in an image of brilliant clarity and force. The density of possible references contained in Deas's striking image contributes as much energy to his picture as does the richness of painterly incident in the figure and the landscape below. But despite the picturesque detail that fills much of the canvas, *Long Jakes* has an unforgettable graphic simplicity. For all the power of Deas's characterization of his subject, in the final analysis, *Long Jakes* is more than a portrait of a western "type" or a genre scene—it is a history painting. In *Long Jakes,* Deas compressed twenty years of western events and personalities into a composition of supreme formal and narrative economy.

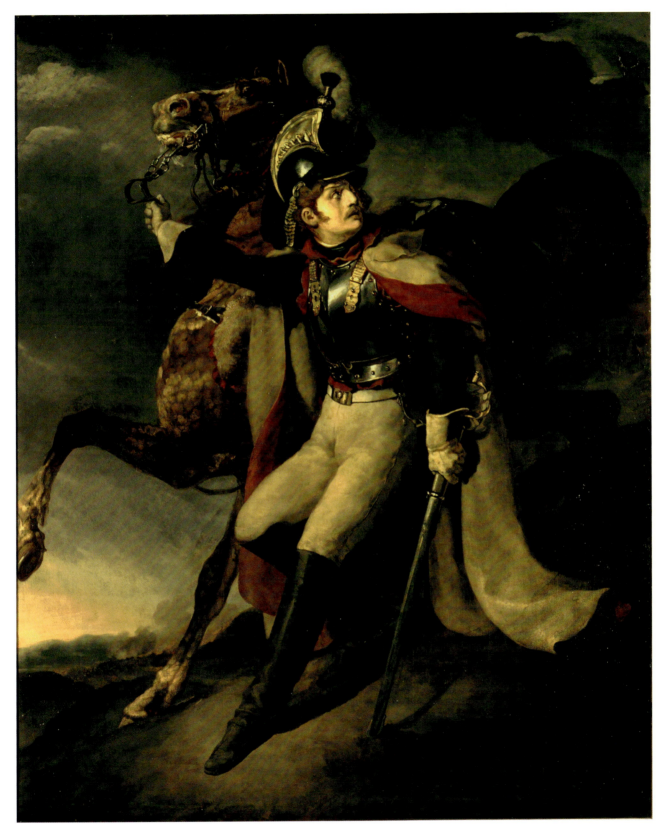

5.16. Théodore Géricault (French, 1791–1824), *Le Cuirassier blessé, quittant le feu (The Wounded Soldier Leaving the Battle)*, Salon of 1814.
Oil on canvas, 115 × 89⅜ in. Musée du Louvre, Paris. Photograph courtesy of Réunion des Musées Nationaux/Art Resource, New York.

Notes

1. I thank Carol Clark, Peter H. Hassrick, Brian W. Dippie, Tom Petrie, John Hoover, Rick Stewart, Joan Holt, and Chuck Rankin for their advice and encouragement during my long course of researching and writing this chapter.

2. See chapter 3, this volume.

3. For the acquisition of *Long Jakes* by the Art-Union, see chapter 3 and catalogue no. 55, this volume. The addition of "the Rocky Mountain Man" to the picture's title was published in *Transactions of the American Art-Union for the Year 1844* (New York, 1845).

4. *The New Mirror* 3, no. 24 (September 14, 1844): 384 (emphasis in the original); "The Art Union Pictures," The Fine Arts, *Broadway Journal* 1, no. 1 (January 4, 1845): 13; [Henry T. Tuckerman], "Our Artists—No. V: Deas," *Godey's Magazine and Lady's Book* 33 (December 1846): 253; Henry William Herbert, "Long Jakes, the Prairie Man," *New York Illustrated Magazine of Literature and Art* 2 (July 1846): 169, 174. (I thank Carol Clark for giving me copies of the original publications cited above.)

5. For the dates of the Wharton expedition and the serial publication of Carleton's journal, see J. Henry Carleton, *The Prairie Logbooks: Dragoon Campaigns to the Pawnee Villages in 1844, and to the Rocky Mountains in 1845* (Chicago: Caxton Club, 1943; reprint, edited and with an introduction by Louis Pelzer, Lincoln: University of Nebraska Press, 1983), xiv, 5, 149, 287n12. Carleton's description of Deas appeared in his journal entry of August 16, 1844, published in *Spirit of the Times* on November 30, 1844 (p. 475). See also *The Prairie Logbooks,* 28 and 28n.

6. Washington Irving, *The Adventures of Captain Bonneville, U.S.A., in the Rocky Mountains and the Far West,* ed. Edgeley Todd (Norman: University of Oklahoma Press, 1961; reprint, Norman: University of Oklahoma Press, 1986), 8. *The Adventures of Captain Bonneville* was first published in 1837 under the title *The Rocky Mountains.*

7. "Great Improvement Ahead!" Editor's Notes, *New York Illustrated Magazine of Literature and Art* 2 (June 1846): 128.

8. For Frémont's return to St. Louis in 1844, see Tom Chaffin, *Pathfinder: John Charles Frémont and the Course of American Empire* (New York: Hill and Wang, 2002), 209, 211; Ferol Egan, *Frémont: Explorer for a Restless Nation,* rev. ed. (Reno: University of Nevada Press, 1985), 266; and John Charles Frémont, *Memoirs of My Life* (1887; reprint, with new introduction by Charles M. Robinson III, New York: Cooper Square Press, 2001),

412. Carson's five-year absence from St. Louis is documented in *Kit Carson's Autobiography,* ed. Milo Milton Quaife (Chicago: Lakeside Press, R. R. Donnelley and Sons, 1935; reprint, Lincoln: University of Nebraska Press, 1966), 119; and Hampton Sides, *Blood and Thunder: An Epic of the American West* (New York: Doubleday, 2006), 185.

9. Marianne Richter to Peter H. Hassrick, personal communication, August 9, 2006. (I am grateful to Peter Hassrick for drawing Healy's portrait to my attention.)

10. The portrait is not dated, but if Healy took Frémont's likeness from life, he almost certainly did so in the early months of 1843, around the time Frémont's report of his first expedition was published and the young explorer became a celebrity. According to his memoir, *Reminiscences of a Portrait Painter* (Chicago: A. C. McClurg, 1894), Healy was on the East Coast of the United States in 1843; he painted a portrait of William Hickling Prescott, author of *History of the Conquest of Mexico* (1843), in Boston that year (Healy, *Reminiscences,* 208–10). If he also painted Frémont in 1843, Healy would have had to work fast, because the explorer departed from Washington in the early spring of 1843 to carry out the second half of his survey of the Oregon Trail; Frémont reached the confluence of the Kansas and Missouri rivers near present-day Kansas City, well out of Healy's reach, on May 17 (Frémont, *Memoirs,* 165, 167). Frémont's time in Washington in 1843 may have been short, but the prolific Healy had learned "the discipline of completing a work, from sketch to final composition, in a limited time" in the Paris studios in which he had trained; see Lois Marie Fink, *American Art at the Nineteenth-Century Paris Salons* (Washington, D.C.: National Museum of American Art, Smithsonian Institution, 1990), 45–46. Healy could have painted Frémont's head and shoulders in a brief sitting or two and subsequently added the portrait's background—an unusual one for Healy, who normally depicted his subjects in nearly featureless interiors—by referring to Charles Preuss's sketches of the Wind River Mountains or the reproductions of them published in Frémont's first report.

11. John C. Frémont, *The Exploring Expedition to the Rocky Mountains* (1842), ed. Herman Viola and Ralph E. Ehrenberg (Washington, D.C.: Smithsonian Institution Press, 1988), 9. Frémont's report of his 1842 expedition was published in March 1843 by the U.S. Senate as *A Report on an Exploration of the Country Lying between the Missouri River and the Rocky Mountains on the Line of the Kansas and Great Platte Rivers* (Senate Document 243, 27th Cong., 3rd sess.). In 1845, Frémont's 1842 report was reissued, together with his account of his second expedition, *A Report of the Exploring Expedition to Oregon*

and North California in the Years 1843–'44 (Washington, D.C.: Gales and Seaton), under the collective title *Report of the Exploring Expedition to the Rocky Mountains in the Year 1842, and to Oregon and North California in the Years 1843–'44 by Brevet Capt. J. C. Frémont, of the Topographical Engineers, Under the Orders of Col. J. J. Abert, Chief of the Topographical Bureau.* My references in this essay to Frémont's reports are to the reprint of the 1845 volume published by the Smithsonian Institution Press in 1988. In documenting my quotations from Frémont's reports of 1842 and 1843, I distinguish between the two by citing the year of the expedition to which I refer in parentheses.

12. Frémont, *Exploring Expedition to the Rocky Mountains* (1842), 9; Chaffin, *Pathfinder,* 97–100, 82; Frémont, *Memoirs,* 164, 59–60.

13. Frémont, *Exploring Expedition to the Rocky Mountains* (1842), 60.

14. Ibid., 61, 64, 68, 70, x; Chaffin, *Pathfinder,* 117.

15. Frémont, "Notice to the Reader," and Viola and Ehrenberg, "Introduction," in Frémont, *Exploring Expedition to the Rocky Mountains,* 3–4 and xi; see also Chaffin, *Pathfinder,* 184.

16. Chaffin, *Pathfinder,* 127: "Historians and mountaineers can't agree" whether it was Frémont Peak, Gannett Peak, or Woodrow Wilson Peak.

17. Frémont, *Exploring Expedition to the Rocky Mountains* (1842), 63, 70; Chaffin, *Pathfinder,* 121, 137.

18. David Roberts, *A Newer World: Kit Carson, John C. Frémont, and the Claiming of the American West* (New York: Simon and Schuster, 2001), 38–49; Chaffin, *Pathfinder,* 127.

19. Frémont, *Exploring Expedition to the Rocky Mountains* (1842), 69; Chaffin, *Pathfinder,* 128; William H. Goetzmann, *Exploration and Empire: The Explorer and the Scientist in the Winning of the American West* (New York: Alfred A. Knopf, 1966; reprint, New York: W. W. Norton, 1978), 243–44.

20. Frémont, *Exploring Expedition to the Rocky Mountains* (1842), 70.

21. Goetzmann, *Exploration and Empire,* 249–50. As Peter Hassrick has observed (personal communication of February 13, 2007), Frémont's gesture had the popular impact of Joe Rosenthal's iconic photograph of U.S. Marines raising the stars and stripes on Iwo Jima in 1945. Chaffin compares it to another triumphant moment in American exploration, Neil Armstrong's planting of a weightless, star-spangled—and seemingly heavily starched—banner on the moon in 1969 (*Pathfinder,* 145).

22. Frémont, *Memoirs,* 162–63; Chaffin, *Pathfinder,* 139.

23. Roberts, *Newer World,* 36–37; Chaffin, *Pathfinder,*

131–32; Viola and Ehrenberg, "Introduction," in Frémont, *Exploring Expedition to the Rocky Mountains,* x–xi. See also Robert Shlaer, *Sights Once Seen: Daguerreotyping Frémont's Last Expedition through the Rockies* (Santa Fe: Museum of New Mexico Press), 15–19.

24. Frémont, *Exploring Expedition to the Rocky Mountains* (1842), 62–70.

25. Viola and Ehrenberg, "Introduction," in Frémont, *Exploring Expedition to the Rocky Mountains,* xi; Chaffin, *Pathfinder,* gallery section after p. 224.

26. Ron Tyler, *Prints of the West* (Golden, Colo.: Fulcrum, 1994), 72–74.

27. Frémont, *Exploring Expedition to the Rocky Mountains* (1842), 61.

28. See Oswaldo Rodriguez Roque, "*Schroon Mountain, Adirondacks, 1838,*" in *American Paradise: The World of the Hudson River School,* ed. John K. Howat (New York: Metropolitan Museum of Art, 1987), 134. Regarding the exhibition at the Apollo Galleries in 1839 of Deas's picture, a scene from *Hamlet,* see cat. no. 13, this volume.

29. Frémont, *Exploring Expedition to the Rocky Mountains* (1842), 68, 66.

30. Frémont, *Exploring Expedition to the Rocky Mountains* (1843–44), 188; Chaffin, *Pathfinder,* 184–85.

31. Goetzmann, *Exploration and Empire,* 112. The standard reference for Jedediah Smith is Dale Morgan, *Jedediah Smith and the Opening of the West* (Lincoln: University of Nebraska Press, 1953; reprint, Lincoln: University of Nebraska Press, 1964). See also Harvey L. Carter, "Jedediah Smith," in *Mountain Men and Fur Trappers of the Far West,* ed. LeRoy R. Hafen, 91–108 (Glendale, Calif.: Arthur H. Clark, 1965; reprint, with an introduction by Harvey L. Carter, Lincoln: University of Nebraska Press, 1982). To compare Smith's explorations to those of Frémont, see Warren A. Beck and Ynez D. Haase, *Historical Atlas of the American West* (Norman: University of Oklahoma Press, 1989), maps 28 and 36.

32. Morgan, *Jedediah Smith,* 28–29; "The Mountain Men," in Goetzmann, *Exploration and Empire,* 105–45; David Lavender, *The Rockies* (New York: Harper and Row, 1968; reprint, with an introduction by Duane A. Smith, Lincoln: University of Nebraska Press, 2003), 79, 83–86. As Morgan (*Jedediah Smith,* 117–20) and Lavender (*Rockies,* 78–79) acknowledge, Ashley's way of doing business had been pioneered by Donald Mackenzie of the British North-West Company in the late 1810s and early 1820s.

33. Carter, "Jedediah Smith," 94; Goetzmann, *Exploration and Empire,* 112; Morgan, *Jedediah Smith,* 172–73, 189–90.

34. Morgan, *Jedediah Smith,* 84–85, 89–92, 176, and map, 14–15; Goetzmann, *Exploration and Empire,*

113–15, 120–36, 144–45; Carter, "Jedediah Smith," 91; William H. Goetzmann, *New Lands, New Men: America and the Second Great Age of Discovery* (New York: Viking, 1986), 139–46; Beck and Haase, *Historical Atlas of the American West,* map 28. The first known crossing of South Pass by white Americans was made by employees of the American Fur Company traveling east from its post at Astoria, Oregon. See Goetzmann, *Exploration and Empire,* 34, 116–17.

35. Morgan, *Jedediah Smith,* 155, 404n3.

36. Ibid., 93, 313, 315–16, 321, 343, 346. The entire letter is reprinted on 343–48; emphasis in the original. See also Goetzmann, *Exploration and Empire,* 138–40; Goetzmann, *New Lands, New Men,* 144–45. Captain Benjamin L. E. de Bonneville was the first to actually cross South Pass with wagons, in 1832.

37. Quoted in Morgan, *Jedediah Smith,* 322–23; emphasis in the original.

38. Ibid., 316, 320, 325–28.

39. Stephen G. Hyslop, *Bound for Santa Fe: The Road to New Mexico and the American Conquest, 1806–1848* (Norman: University of Oklahoma Press, 2002), 165; Goetzmann, *New Lands, New Men,* 136; Josiah Gregg, *Commerce of the Prairies* (1844), edited and with an introduction by Max L. Moorhead (Norman: University of Oklahoma Press, 1990), 66.

40. Gregg, *Commerce of the Prairies,* 64–65.

41. Moorhead, "Introduction," in Gregg, *Commerce of the Prairies,* xxii; Gregg's preface to the original edition is datelined "New York, June 12, 1844."

42. Gregg, *Commerce of the Prairies,* 64.

43. Morgan, *Jedediah Smith,* 325; Sides, *Blood and Thunder,* 187–88; David Dary, *The Santa Fe Trail: Its History, Legends, and Lore* (New York: Alfred A. Knopf, 2001), 90.

44. Morgan, *Jedediah Smith,* 329; Chaffin, *Pathfinder,* 149.

45. Regarding the population of St. Louis in 1844, see *Green's Saint Louis City Directory for 1845* (St. Louis: James Green, 1844). (I thank Carol Clark for sharing this information with me.) Leading fur traders such as Pierre Chouteau, Jr., and government officials including William Clark and Benjamin O'Fallon were generous in their assistance to and patronage of the artists who passed through the city. See John Neal Hoover, ed., *St. Louis and the Art of the Frontier (Proceedings of a Symposium, St. Louis: Cradle of Western American Art, 1830–1900)* (St. Louis: St. Louis Mercantile Library at the University of Missouri–St. Louis, 2000). The establishment of a connection between Charles Deas and Jedediah Smith's family and associates demands further research. (I thank John Hoover, director of the St. Louis Mercantile Library at the University of Missouri, St. Louis, for suggesting avenues to pursue in this endeavor.)

46. Goetzmann, *Exploration and Empire,* 141. In *Jedediah Smith,* 10, Morgan writes that "J. J. Warner and Joe Meek . . . kept Jedediah Smith's memory alive during the first two generations after his death." Goetzmann cites Francis Fuller Victor's *River of the West* (Hartford, Conn.: R. W. Bliss, 1870) and William Fayel's unpublished manuscript of 1886, "A Narrative of Colonel Robert Campbell's Experiences in the Rocky Mountain Fur Trade from 1825–1835," at the Bancroft Library of the University of California, Berkeley, as early sources on Smith (see Goetzmann, *Exploration and Empire,* 140n7 and 130n8). The first major publication on Smith, according to Morgan (*Jedediah Smith,* 10) and Carter ("Jedediah Smith," 91n1) was Harrison C. Dale's *Ashley-Smith Explorations and the Discovery of a Central Route to the Pacific,* published in 1918. As early as 1906, however, Smith's reputation had revived to the point where he rated an appearance in Frederic Remington's series of illustrations of great explorers published in *Collier's Weekly* in 1906–1907. Remington's *Great Explorers: X—Jedediah Smith,* based on a painting of about 1905, appeared in *Collier's* on July 14, 1906. (Remington destroyed the painting in 1908.) See Peter H. Hassrick and Melissa J. Webster, *Frederic Remington: A Catalogue Raisonné of Paintings, Watercolors and Drawings* (Cody, Wyo.: Buffalo Bill Historical Center; Seattle: University of Washington Press, 1996), 2:806, cat. no. 2786. See also Ben Merchant Vorpahl, *Frederic Remington and the West: With the Eye of the Mind* (Austin: University of Texas Press, 1978), 281n36; and Peggy Samuels and Harold Samuels, *Frederic Remington* (Austin: University of Texas Press, 1982), 361. (I thank John Hull and Brian W. Dippie for bringing Remington's picture to my attention.)

47. Irving, *Adventures of Captain Bonneville,* 167; Morgan, *Jedediah Smith,* 94, 210–11, 371–72; Goetzmann, *Exploration and Empire,* 141–45; Goetzmann, *New Lands, New Men,* 146. The most complete chart of Smith's explorations is the Gibbs-Smith map, a copy of Frémont's map of 1845 annotated with Smith's travels that was discovered in 1953; see Goetzmann, *Exploration and Empire,* 142–43.

48. Morgan, *Jedediah Smith,* 312.

49. See, for example, George Catlin, *Letters and Notes on the Manners, Customs, and Conditions of the North American Indians* (London: privately printed, 1841; reprint, New York: Dover, 1973), 1:63–65.

50. Andrew Rolle, *John Charles Frémont: Character as Destiny* (Norman: University of Oklahoma Press, 1991),

2; Chaffin, *Pathfinder*, 45–46, 76–77. On Frémont's relationship with Nicollet, see Edmund C. Bray and Martha Coleman Bray, eds. and trans., *Joseph N. Nicollet on the Plains and Prairies* (St. Paul: Minnesota State Historical Society Press, 1993), 8–41.

51. Frémont, *Memoirs,* 75; Egan, *Frémont,* 60.

52. See chapter 1, this volume; Carleton, *Prairie Logbooks,* 100–101.

53. Dawn Glanz, *How the West Was Drawn: American Art and the Settling of the Frontier* (Ann Arbor, Mich.: UMI Research Press, 1982), 45.

54. Peter H. Hassrick, "The Wounded Trapper," in *Forging an American Identity: The Art of William Ranney,* by Linda Bantel and Peter H. Hassrick, with essays by Sarah E. Boehme and Mark F. Bockrath, ed. Kathleen Luhrs (Cody, Wyo.: Buffalo Bill Historical Center, 2006), 110–11.

55. Frederick J. Cummings et al., *French Painting, 1774–1830: The Age of Revolution* (Detroit: Detroit Institute of Arts; New York: Metropolitan Museum of Art, 1975), 447–48.

56. Goetzmann, *Exploration and Empire,* 139, 155; Lavender, *Rockies,* 83–84; Morgan, *Jedediah Smith,* 115.

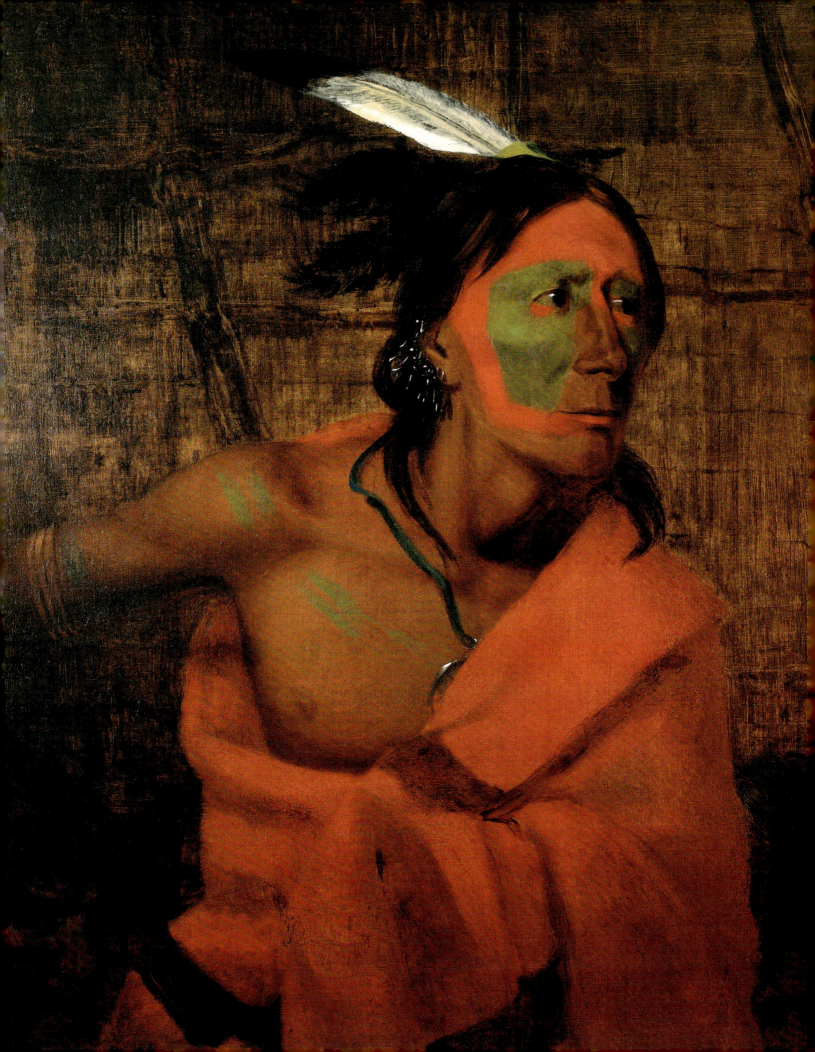

Charles Deas

A CATALOGUE OF WORKS

Carol Clark

With the assistance of Anne Monahan and Scott Lannon Wands

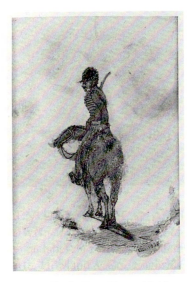

Cat. no. 4. Charles Deas, *Mounted Soldier*.
Photograph courtesy of Sloan's Auctioneers.

The following catalogue is a record of all known paintings, watercolors, and drawings by Deas and of prints after his work. Entries for works that are now lost, which number about half of all those recorded, include transcriptions of contemporary descriptions of these works to aid in their future rediscovery. Titles of paintings are those given by the artist or as first exhibited or published. References are cited by author's last name and date of publication; full citations are listed by year in the list of references that follows this catalogue. The citation of references adheres to the following conventions:

1. Publications during Deas's lifetime are as complete as possible; scholarship after Deas's death in 1867 is cited if it offers new information or new insight or if it provides notable context.
2. Catalogues of exhibitions in which Deas's work appeared are distinguished by an asterisk.

1. *The Milkman,* 1833
Pen, ink, watercolor, and collage on paper, 5¾ × 5½ in.
Inscribed, lower right: C. Deas 1833
 "Man with a covered pail standing in the cut-out doorway of a house, the door is pasted open to the right, the decorated foyer is in the foreground."
2. *Feeding the Pigs*
Oil on board, 9½ × 7½ in.
 "Negro woman with red bucket at right, feeding two pigs at left outside of a building."
3. *Negroes Sawing*
Oil on board, 9½ × 7½ in.
 "Standing man in red shirt at left, sawing a log beside a seated man, buildings in the background; landscape on verso."

Present collection: Private collections
Provenance: By descent in the family of Deas's brother Fitz Allen Deas to the present collections

Detail of fig. 1.18, Deas, Winnebago (Wa-kon-cha-hi-re-ga) in a Bark Lodge.

Reference: McDermott 1950, p. 294

At least three of Deas's youthful works remain in the hands of descendants of his brother Fitz Allen Deas. Their existence is recorded in two places. John Francis McDermott corresponded with Anne Lamb Horton, a descendent of Fitz Allen Deas, on March 9, 1948 (John Francis McDermott Papers, Lovejoy Library, Southern Illinois University, Edwardsville), about paintings in her collection. I believe that these three are the works McDermott published in 1950 as "plantation scenes," without further information. In 1987, art dealer Robert Mayo appraised and described them as above; he also assigned an approximate date of circa 1835 to the two unsigned and undated oil paintings, but he provided no basis for that date (appraisal dated March 5, 1987, Richmond, Virginia; Fitz Allen Deas Family Papers, Virginia). I have not gained permission to see them.

4. *Mounted Soldier,* 1834
Graphite, pen and ink (?), and wash on paper, 4⅝ × 3⅜ in. (sight)
Inscribed, lower right: CD. 1834.
Present collection: Unknown
Provenance: Antique Art Galleries, Kensington, Md., 1990; to Sloan's sale (Washington, D.C., February 3, 1991, lot no. 2593)

The year after the sixteen-year-old Deas initialed and dated this drawing, his family tried unsuccessfully to secure his appointment to the United States Military Academy at West Point, New York. This youthful work testifies to his fascination with the military and especially with the mounted figure.

 A note handwritten and attached to the back of the frame reads as follows: "Drawn by Charles Deas when he was 16 years old. He was the youngest son of Wm. Allen and Anne Izard Deas and brother of my grandfather Col. George Deas, U.S.A. His paintings have now become fashionable. One called 'The Duel' owned by the Watts family, slave scenes owned by [illeg.] and his best known painting 'The Last Shot' owned by [illeg.] in the Middle West."

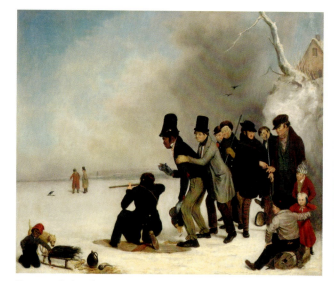

Cat. no. 5. *Turkey Shooting.*

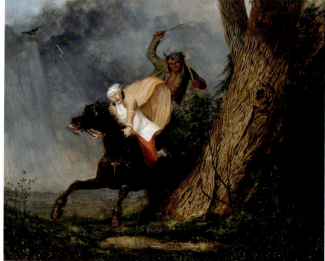

Cat. no. 7. *The Devil and Tom Walker.*

This drawing disappeared in 1991 after it was sold at Sloan's, and I have only seen a reproduction of it.

5. *Turkey Shooting,* by 1838
Oil on canvas, 24¼ × 29½ in.
Inscribed, lower right: C Deas 18[illeg.]
Present collection: Virginia Museum of Fine Arts, Richmond, the
 Paul Mellon Collection
Provenance: Peter Gerard Stuyvesant, 1838; by descent in his fam-
 ily to the Rutherfurd-Stuyvesant Collection and to Princess
 Alexandre de Caraman-Chimay, Allamuchy, N.J.; to Alan R.
 Stuyvesant; to Wildenstein and Company, 1953; to Paul Mellon,
 1953; to the present collection, 1985
*Alternative titles: Shooting on the Ice; Shooting for a Turkey; The Turkey
 Shoot*
References: *NAD 1838, cat. no. 313; NY Commercial Advertiser
 1838; NY Mirror 1838; NY Morning Herald 1838; *Stuyvesant
 Institute 1838, cat. no. 110; NY Literary Gazette 1839; NY Mirror
 1839; Tuckerman 1846, p. 251; *Metropolitan Museum 1937, cat.
 no. 36; *Metropolitan Museum 1939, cat. no. 125; *MFA Boston
 1944, cat. no. 21; Baur 1947, p. 281; McDermott 1950, p. 294;
 Bloch 1967, p. 120; Parry 1974, pp. 77–81; *McElroy 1990, p. 25

Turkey Shooting was Deas's first publicly exhibited picture, and it received generally favorable reviews. Listed for sale at the National Academy of Design 1838 exhibition, it was acquired by Peter Gerard Stuyvesant, who lent it later that year to an exhibition at the institute that bore his name. The Stuyvesant Institute's catalogue specified that Deas's inspiration was James Fenimore Cooper's 1823 novel *The Pioneers.* Following chapter 17, Deas centered this composition on Abraham Freeborn (called Brom), the African American man who organized Cooper's fictional "shoot." Deas chose, however, to dress his characters anachronistically in the striped pants and square-toed shoes of the early nineteenth century rather than the costume of the novel's eighteenth-century setting.

Deas appears to have relied on fellow Philadelphian Charles Willson Peale's monumental self-portrait, *The Artist in His Museum* (1822; see fig. 3.2), for the ornithological specimen of a dead tur-key and for the dramatic compositional shift from foreground to background, exemplifying a structure Deas continued to employ. (On Peale's painting, see Roger B. Stein, "Charles Willson Peale's Expressive Design: The Artist in His Museum," *Prospects* 6 [1981]: 139–85.) In 1967, Maurice Bloch noted the compositional similar-ity of this picture to George Caleb Bingham's *Shooting for the Beef* (1850, Brooklyn Museum) and suggested that Bingham, who visited New York City in 1838, may have seen Deas's painting on view at the National Academy of Design.

Turkey Shooting was included in a trio of exhibitions around the time of World War II that celebrated daily life and sport in America. The catalogues for all three exhibitions interpret the painting as an unmediated view of an early American masculine pastime without mention of Deas's literary source or of the presence of a black man. Although the 1937 Metropolitan Museum of Art catalogue mentions "a widely popular print" after this painting, I have found neither the print nor a contemporary reference to it.

NOTE: *I am grateful to Edward Maeder for his help in identifying by period and type the clothing Deas chose for his characters.*

6. *Negro Boy,* ca. 1838
Oil [on canvas?]
Present collection: Unknown

This work is known only by an invoice recording that art deal-ers Victor Spark and James Graham purchased an "Oil painting of Negro Boy by 'Deas'" from Bernard Black, another New York City dealer, in 1957 (Victor Spark Papers, Clients and Colleagues Files, James Graham and Sons folder #4, Archives of American Art, Smithsonian Institution). If this work is indeed by Deas, it may be related to *Turkey Shooting* (cat. no. 5), Deas's only known painting to include an image of an African American child. I therefore group it with that picture.

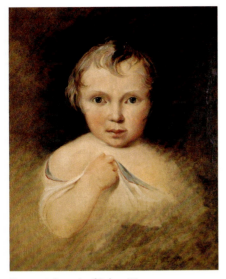

Inscription and stencil mark on verso of *Portrait of Robert Watts*. Photograph from William H. Bender Papers, Archives of American Art, Smithsonian Institution, Washington, D.C.

Cat. no. 8. *Portrait of Robert Watts*.

7. *The Devil and Tom Walker,* 1838
Oil on canvas, 17½ × 21 in.
Inscribed, lower right: CD 1838
Present collection: Collection of Richard P. W. Williams
Provenance: Hermann Warner Williams, Jr., by 1941; bequeathed to his son, 1974
References: *NAD 1839, cat. no. 261; NY Commercial Advertiser 1839a; NY Commercial Advertiser 1839b; NY Evening Post 1839a; NY Literary Gazette 1839; NY Mirror 1839; Baur 1947, p. 281; McDermott 1950, p. 294; *Hoopes and Moure 1974, cat. no. 51; *McElroy 1990, p. 26

The entry for this painting in the catalogue for the National Academy of Design's 1839 exhibition indicated that it was for sale and pointed out what Deas's literate viewers undoubtedly knew, that his source was Washington Irving's *Tales of a Traveller* (1824).

Hermann Warner Williams, Jr. (1908–1974), who later became director of the Corcoran Gallery of Art in Washington, D.C., acquired this work between about 1935 and 1941, when he lived in New York City and worked as a curator first at the Brooklyn Museum and then at the Metropolitan Museum of Art. Family history records that Williams purchased the picture at auction. A label on the verso reveals it was sold as a work by John Quidor. The painting was cleaned, which uncovered Deas's signature and the date.

8. *Portrait of Robert Watts,* 1838
Oil on canvas, 17 × 14 in.
Inscribed on verso (covered by a relining in 1960): Robert Watts, Jr. Jr. / Painted by Chas. Deas / at Chesnut Lodge / [Nov.?] 1838
Present collection: From the collections of the St. Louis Mercantile Library at the University of Missouri–St. Louis
Provenance: Estate sale, Winegarden Auction Rooms, New York City, 1961; to Victor Spark and James Graham, New York City, 1961; to Parke-Bernet (PB84) sale (New York City, February 26, 1969, lot no. 196); to Peter Vogt, Lakeview, N.Y., 1969; to William H.

Bender, Jr., Bronxville, N.Y., 1970; to Estate of William H. Bender, Jr.; to Sotheby Parke Bernet sale (New York City, January 24–26, 1974, lot. no. 539); to private collection; to The Art Collection, Inc., New York City, by 2000; to the present collection, 2001
Reference: Clark 2001, pp. 8–10

Deas's young nephew was the subject of his first known portrait. The inscription on the back of the canvas reveals that he painted it at Chesnut Lodge, the home of his mother, Anne Izard Deas, in Ulster, New York (before and later known as Saugerties). Deas's only sister, Charlotte (1809–1869), had married physician Robert Watts, Jr. (1812–1867), there two years before, on July 7, 1836 (*New-York American*, July 11, 1836).

The Watts's first child was born in 1837 in Vermont and subsequently lived with his parents in New York City. Like his father, for whom he was named, young Robert became a physician. In 1872, Robert Watts responded to historian Lyman Draper's request for information about the location of his uncle Charles Deas's paintings and papers, about which Watts professed little knowledge (Draper Papers, State Historical Society of Wisconsin). Watts died in 1917 in New York City.

In this, as in his other portraits of children, Deas shows his stylistic debt to prominent Philadelphia artist Thomas Sully, whose work, according to Henry Tuckerman, he knew from his childhood there. Both artists presented children as idealized, cherubic incarnations of innocence.

The portrait appeared on the market in a 1961 estate sale with *The Trooper* (cat. no. 26).

An inscription on the stretcher records that John Venuti relined the canvas in 1960. Covered in that relining is a stencil mark, PREPARED BY / EDWARD DECHAUX / NEW YORK, which identifies the canvas maker; the Dechaux company used this format from about 1834 until the 1840s (Alexander W. Katlan, *American Artists' Materials Suppliers Directory, Nineteenth Century* [Park Ridge, N.J.: Noyes Press, 1987], vol. 1, p. 18). The Dechaux company's stencil also appears on the verso of pictures Deas painted in St. Louis

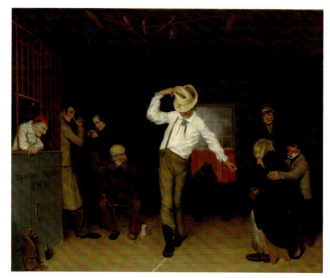

Cat. no. 9. *Walking the Chalk.*

Cat. no. 10. *Drawing from Cast of the Apollo Belvedere.*

almost a decade later: *Indians Coming down a Defile* (cat. no. 77) and *A Solitary Indian, Seated on the Edge of a Bold Precipice* (cat. no. 81).

9. *Walking the Chalk,* 1838
Oil on canvas, 17⅜ × 21⅜ in.
Inscribed, lower right: C. Deas. 1838.
Present collection: The Museum of Fine Arts, Houston. Museum purchase with funds provided by the Agnes Cullen Arnold Endowment Fund
Provenance: Private Canadian collections from at least 1926 until 2007; to the present collection, 2007
References: *NAD 1839, cat. no. 268; NY Commercial Advertiser 1839a; NY Commercial Advertiser 1839b; NY Literary Gazette 1839; NY Mirror 1839; NY Morning Herald 1839a; NY Morning Herald 1839b; Tuckerman 1846, p. 251; Cowdrey and Williams 1944, p. 35

Walking the Chalk caught the attention of several New York City critics when it was listed for sale at the 1839 National Academy of Design's exhibition. Some found it amusing, but others, such as the critic for the *New York Literary Gazette,* believed that it was not "a fit subject for art," because it did not "convey a moral lesson."

The painting disappeared from public view after the National Academy's exhibition, but it made its way to Canada sometime before 1926. In 1944, long before it returned to public view, Bartlett Cowdrey and Hermann Warner Williams sorted out the confusion of this painting with another bar scene by William Sidney Mount.

10. *Drawing from Cast of the Apollo Belvedere,* ca. 1838
Charcoal, brown chalk, and white chalk highlights on buff wove paper, 23 × 17¹³⁄₁₆ in.
Inscribed, lower center, in graphite and chalk: <u>Chas. Deas.</u>
Present collection: National Academy Museum, New York (1981.87)

According to the May 2, 1838, report of Samuel F. B. Morse, president of the National Academy of Design, Deas submitted this drawing in competition for the Large Silver Palette, awarded that year for the best large drawing (no smaller than eighteen inches high) in black and white chalks of the *Apollo Belvedere.* Deas's drawing was probably based on the National Academy's plaster cast, which was made after the Roman marble copy of the original Greek bronze sculpture. Deas did not win the competition.

NOTE: *I am grateful to John Davis for the reference to Morse's report. On the Silver Palette competition, see Thomas S. Cummings,* Historic Annals of the National Academy of Design *(Philadelphia: George W. Childs, 1865; reprint, New York: Kennedy Galleries, 1969), 150.*

11. *Head of a Dog,* by 1839
Present collection: Unknown
References: *NAD 1839, cat. no. 295; *Artists' Fund Society 1840, cat. no. 219

Deas listed this painting for sale at the Philadelphia Artists' Fund Society exhibition in 1840, after which it disappeared from public view.

12. *Hudibras,* by 1839
Present collection: Unknown
Alternative title: Hudibras Engaging the Bear-Baiters
References: *NAD 1839, cat. no. 114; Tuckerman 1846, p. 251

Deas listed *Hudibras* for sale at the 1839 exhibition of the National Academy of Design, and Tuckerman later augmented the title to *Hudibras Engaging the Bear-Baiters.* The subject is based on English satirical poet Samuel Butler's (1612–1680) most famous burlesque work, *Hudibras,* published between 1662 and 1678. Butler used his title character, a colonel in Oliver Cromwell's army, and the popular seventeenth-century entertainment of bearbaiting (in which dogs attacked a chained bear) to ridicule the hypocrisies and pretensions

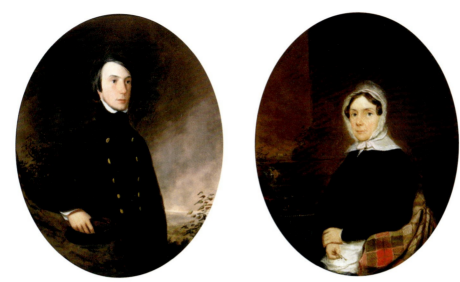

Cat. no. 15. *Portrait of a Man.* Cat. no. 16. *Portrait of a Woman.*

that Butler saw in Puritanism. *Hudibras* was probably familiar to Deas through frequent references in contemporary American literature, such as James Fenimore Cooper's *Pioneers* (1823), chapter 35. Deas also may have known William Hogarth's set of twelve large-format prints (1726) illustrating the poem.

13. *Scene from Shakspeare* [*sic*]—*Hamlet and Polonius, "Very Like a Whale,"* by 1839
Present collection: Unknown
Reference: *Apollo 1839, cat. no. 32

Deas invoked the moment in *Hamlet* when the prince delays action with tactics consonant with his madness, real or feigned. Hamlet toys with Polonius, calling on him to agree with the prince's changeable readings of clouds—they are like camels, weasels, then whales. Polonius obsequiously concedes, "Very like a whale" (act 3, scene 2). What would this scene from a play broadly familiar in Deas's time have meant to his audience? Might the image of conjuring creatures from clouds have been taken as confirmation of the artist's genius, his prerogative to work from his mind and transform nature into art? Did Deas actually show the formations or leave to his viewers' imagination the visual conversion of cloud into creature in Hamlet's mind's eye? All is conjectural. This is the only image I know of this scene in nineteenth-century American art, and no contemporary description has survived of the painting, listed for sale in the Apollo Association catalogue.

> NOTE: *I am grateful to Donald Adam and to Peter Berek for enlightenment about this scene.*

14. *Shoeing a Horse by Lamplight,* by 1839
Present collection: Unknown
Reference: Tuckerman 1846, p. 251

Tuckerman included this title among works Deas exhibited in 1839,

which he characterized as "a variety of cabinet pictures, drawn chiefly from familiar life, which met with more or less success."

15. *Portrait of a Man,* 1839
Oil on canvas, 12⅛ × 10⅛ in.
Inscribed, lower right: C. Deas. / 1839
16. *Portrait of a Woman,* 1840
Oil on paperboard attached to wood panel, 12⅛ × 9¾ in.
Inscribed, lower right: C. Deas / 1840

Present collection: From the collections of the St. Louis Mercantile Library at the University of Missouri–St. Louis
Provenance: Private collection, Conn.; to Berry-Hill Galleries, New York City, 1984; to the present collection, 2001
Alternative titles: Man of the Atwater Family; Woman of the Atwater Family
References: Berry-Hill Galleries 1985, p. 8; Clark 2001, pp. 10–13

These two portraits came on the market in 1984 from a family that believed the portraits might be images of their own "Atwater branch," about which there was no further information. Although the two pictures, painted before Deas left New York City, are not exactly the same size, of the same date, or on the same kind of support, their close relationship suggests that they might be portraits of members of the same family. They seem to be pendants: the artist placed each sitter within the same oval trompe l'oeil stone frame embellished with similar foliage, and he signed each picture in the same way and place.

In contrast to the style of Deas's portraits of children (*Portrait of Robert Watts*, cat. no. 8; *Portrait of Gratz A. Moses*, cat. no. 44; and *Portrait of Three Children*, cat. no. 22), this pair is Neoclassically restrained and may have been inspired by the work of Charles Fraser and Samuel F. B. Morse.

> NOTE: *I am indebted to the research of Bruce Chambers and of Bob Gibson as I sorted through the possible identity of these sitters.*

17. *Evening,* by 1840
Present collection: Unknown
Provenance: J. Mason, by 1840
References: *NAD 1840, cat. no. 297; NY Morning Herald 1840b

After seeing *Evening* at the National Academy of Design, the critic for the *Morning Herald* reported that "the effect is rather rich, but the figures are not well drawn; the whole is too dark." The painting was exhibited by its owner, "J. Mason, Esq.," who may be the John L. Mason listed as an attorney at 20 Nassau Street in the 1840–41 *Longworth's Almanac for New York.*

18. *Fare Thee Well,* by 1840
Present collection: Unknown
Alternative title: Farewell
References: *NAD 1840, cat. no. 296; NY Morning Herald 1840b

The critic for the *Morning Herald* who reviewed the 1840 National Academy of Design's exhibition found fault with *Fare Thee Well:* "The horse looks as if it was painted from a wooden hobbyhorse. It is impossible for a horse to stand on the tip of his hind feet as this one stands. The coloring is very dry, but the air of the picture is good." The painting was listed for sale in the exhibition.

19. *Fisherman Making a Haul,* by 1840
Present collection: Unknown
Alternative title: Making a Haul
Provenance: Apollo Association; distributed to James E. Heath, Richmond, Va., 1840, no. 9
References: *Apollo 1840, cat. no. 92; NY Mirror 1840; Apollo Transactions 1841, no. 9

The critic for the *New-York Mirror* found *Fisherman Making a Haul,* on view and for sale at the Apollo Association's 1840 exhibition, to be "laughable, good, admirable" but cautioned that "this young art-

ist must not paint so fast; more care will make him very eminent. He has wit and mind." The Apollo Association acquired it for $40 (under the title *Making a Haul*) and distributed it to James E. Heath of Richmond, Va. (Minutes of the Committee of Management, Apollo Association, December 28, 1840, Records of the American Art-Union, New-York Historical Society Library). This was likely James Ewell Heath (1792–1862), a state legislator, recording secretary of the Historical and Philosophical Society of Virginia, the first editor of the *Southern Literary Messenger,* and the author of *Edge Hill; or, the Family of the Fitzroyals: A Novel* (1828).

NOTE: *My thanks to Susan Tracy for information on Heath.*

20. *Fourth of July in the Country,* by 1840
Present collection: Unknown
References: Knickerbocker 1840, p. 82; *NAD 1840, cat. no. 199; NY Commercial Advertiser 1840; NY Morning Herald 1840a; *Artists' and Amateurs' Association 1841, cat. no. 202

This work was listed for sale at both the National Academy of Design exhibition in 1840 and the Artists' and Amateurs' Association exhibition in 1841. The critic for the *Morning Herald* offered this opinion, from which may be gleaned a vague idea of what the picture looked like:

It might as well be called a "Tin pedlar halting," or a "Militia training." The stuff intended for earth and the leaden sky are bad. There is much merit and humor in the figures, but they would be much better if less scattered, so as not to produce such a spotty effect. A mass of light ought to have been thrown upon the principal group, and the rest should have been kept down in middle tint and shadow. This picture shows this artist to have a great deal of what painters call "smeddum" in him, but he is very deficient in a true knowledge of the art. It wants aerial perspective and generalizing; every object is too distinctly made out. There are a great many defects in the drawing; the shoulders of most of the figures are drawn

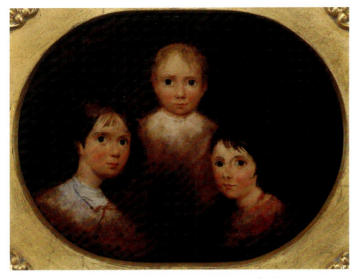

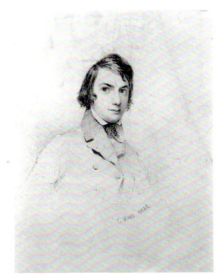

Cat. no. 22. *Portrait of Three Children.* Photograph courtesy of Robert Mayo.

Cat. no. 25. *Self-Portrait.*

up. The general character and the expression is pretty good; but every thing is too sharply made out, and too much pinched up.

NOTE: *Thanks to David Dearinger and to Marc Simpson, I understand that the Morning Herald's critic meant "energy" or "spirit" when he invoked the painters' use of the word "smeddum."*

21. *North River Fisherman,* by 1840
Present collection: Unknown
Reference: *Artists' Fund Society 1840, cat. no. 221

The only notice of this picture is its appearance at the Artists' Fund Society exhibition in 1840, where it was listed for sale.

22. *Portrait of Three Children,* by 1840
Oil on panel, 9 × 13 in.
Present collection: Private collection, Virginia
Provenance: By descent in the family of Deas's brother Fitz Allen to the present collection

This group portrait shows three of the four children of Deas's brother Fitz Allen and his wife, Lavinia Heth Randolph Deas. Ann Heth Deas (b. February 15, 1835) is at the left, William Allen Deas (b. August 11, 1838) is in the middle, and Lavinia Randolph Deas (b. February 15, 1836) is at the right. Deas was a witness at the christening of William on June 9, 1839, at Trinity Episcopal Church in Ulster (before and later known as Saugerties), New York. He must have painted this portrait before he left for the West in the spring of 1840. The portrait passed down through the family of the Deases' fourth child, Mary Carter Deas, who was born in 1846.

23. *Sketch on the North River,* by 1840
Present collection: Unknown
Reference: *NAD 1840, cat. no. 149
Deas exhibited this painting and listed it for sale at the National Academy of Design in 1840.

24. *A Writ of Foreclosure,* by 1840
Present collection: Unknown
References: *NAD 1840, cat. no. 200; NY Morning Herald 1840a

A Writ of Foreclosure was listed for sale at the National Academy of Design's exhibition. The critic for the *Morning Herald* described it as follows:

The horse is tolerably natural, but out of drawing; everything is too sharp and hard. The stack of hay might have been painted with half the work, and yet made to look more natural. The idea of the horse kicking away the raven as "not ready yet," is barely expressed, and though there is plenty of minutia, yet it does not tell; Mordant would have done five times as much in a few broad touches. The whole wants breadth of expression.

NOTE: *The identity of "Mordant" remains a mystery despite the efforts of colleagues Carrie Rebora Barratt, John Davis, David Dearinger, William Gerdts, and Marc Simpson, to all of whom I am grateful.*

25. *Self-Portrait,* 1840
Graphite on buff wove paper, 9½ × 6¹¹⁄₁₆ in.
Inscribed, lower right center: C. Deas 1840.
Present collection: National Academy Museum, New York (1981.86)
Provenance: to the present collection, 1840

Deas submitted this drawing to fulfill his obligation to present a portrait of himself to the National Academy of Design within one year of his election as an associate (May 8, 1839). He is dressed in a double-breasted coat buttoned up to a black silk cravat tied in a bow, which secures a high white shirt collar turned back at the neck; and he sports a contemporary, youthful hairstyle.

NOTE: *I am grateful to Edward Maeder for his help in identifying Deas's attire.*

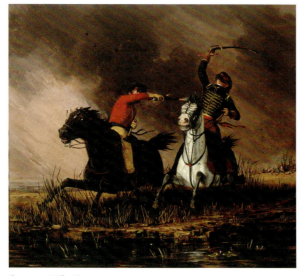

Cat. no. 26. *The Trooper.*

Cat. no. 27. *Portrait of Thornton Alexander Seymour Hooe.*

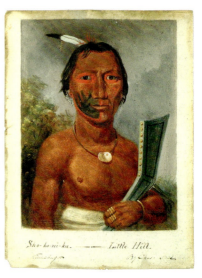

Cat. no. 30. *Sho-ko-ni-ka / Little Hill.*

26. *The Trooper,* 1840
Oil on canvas, 12¼ × 14 in.
Inscribed, lower right: C. Deas 1840
Present collection: Private collection
Provenance: Estate sale, Winegarden Auction Rooms, New York
City, 1961; to Herbert Roman, Inc., New York City; to Kennedy
Galleries, New York City, 1961; to Mr. and Mrs. Norman
Woolworth, Maine and New York City, 1961; to Hirschl and Adler
Galleries, New York City, 1966; to Maude B. Feld and Samuel B.
Feld, New York City, 1969; to their estates, 1995; to Sotheby's sale
(New York City, November 28, 2001, lot no. 177); to the present
collection, 2001
Alternative title: The Encounter
References: *NAD 1840, cat. no. 291; NY Morning Herald 1840b

The critic for the *Morning Herald* briefly commented on *The Trooper,*
which Deas exhibited and offered for sale at the National Academy
of Design: "The man is dying before he is shot; or else he is so ac-
commodating as to throw his sword arm up in order to give his an-
tagonist a fair mark. The whole is painted too hard and opaque;
it wants generalizing and juciness [*sic*]." Although the *Morning
Herald*'s description makes clear that this is the painting Deas ex-
hibited at the National Academy, *The Trooper* is an odd title for a
picture that includes more than one mounted soldier. The picture
dropped from sight in 1840; it reappeared on the market in a 1961
estate sale with *Portrait of Robert Watts* (cat. no. 8). A note at-
tached to the back of the frame of the watercolor *Mounted Soldier* (cat. no.
4) states that the Watts family owned a work called *The Duel,* which
may be another title for *The Trooper.*

The subject appears to be part of a narrative, perhaps from a writ-
ten source unrecognized by the *Morning Herald*'s critic, perhaps
constructed from Deas's fascination with military action.

27. *Portrait of Thornton Alexander Seymour Hooe,* 1840
Oil on canvas, 35 × 27½ in.
Inscribed, lower left: C. DEAS / 1840
Present collection: Board of Regents, Gunston Hall Plantation,
Mason Neck, Virginia, gift of Paula Chase Fielding
Provenance: Commissioned in 1840; by descent through the Hooe
family; gift to the present collection, 1974
Reference: Clark 2000, p. 23

Deas's first known commission in the West was for a portrait of
one of his brother George's fellow U.S. Army officers stationed with
the Fifth Infantry at Fort Crawford, Prairie du Chien, Wisconsin
Territory. A great-grandson of George Mason IV of Gunston Hall,
Captain Hooe (1806–1847) lost his right arm in the battle of Palo
Alto in 1846 and for his bravery was brevetted to major the year be-
fore he died in Baton Rouge, Louisiana. Hooe family history relates
that his widow, Emilie Rolette Hooe, who was a grand-niece of the
Sioux chief Wabasha, took the portrait with her from Prairie du
Chien when she moved to Washington, D.C., about 1869.

28. *Portraits of Several Indians,* by 1841
Present collection: Unknown
References: St. Louis Missouri Republican 1841; Tuckerman 1846,
p. 252

The *Daily Missouri Republican* listed a group of works Deas showed
at the St. Louis Mechanics' Institute Fair as no. 12, "Portraits of
several Indians, taken from life." These may include the works
Tuckerman described as having been completed when Deas was
near Fort Snelling in the summer of 1841:

The ensuing summer [1841] he made a tour to Fort Snelling and
the upper Mississippi—painted a view of St. Anthony's Falls and
several of the fine-looking Sioux in the vicinity. The latter enter-
prise was attended with some difficulty. The Indians, believing that

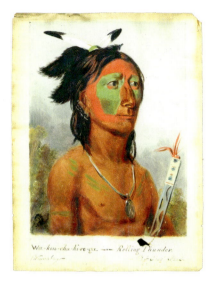

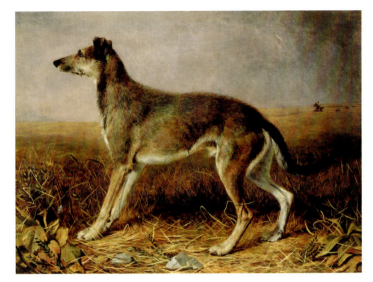

Cat. no. 31. *Wa-kon-cha-hi-re-ga / Rolling Thunder.* Cat. no. 32. *Lion.*

the governor had sent a "medicine man" to carry away a portion of their visible bodies with a view to the utter destruction of the tribe, refused to sit. Tommah, a great conjurer, was at last induced to submit to the ordeal after much persuasion, and the others soon followed his example.

29. *Several Portraits,* by 1841
Present collection: Unknown
Reference: St. Louis Missouri Republican 1841

The *Daily Missouri Republican* distinguished between two groups of portraits Deas showed at the 1841 Mechanics' Institute Fair. Because entry no. 12 was "Portraits of several Indians," the pictures included in entry no. 20, "Several portraits," were likely to have been depictions of European Americans, possibly some of the commissioned portraits Deas is known to have undertaken at Fort Snelling and in St. Louis.

30. *Sho-ko-ni-ka / Little Hill,* by 1841
Oil on paper, 8¼ × 6¼ in.
Inscribed beneath image: Sho-ko-ni-ka. Little Hill. / Winnebago. By Chas. Deas.
31. *Wa-kon-cha-hi-re-ga / Rolling Thunder, by 1841*
Oil on paper, 8¼ × 6¼ in.
Inscribed beneath image: Wa-kon-cha-hi-re-ga. Rolling Thunder. / Winnebago. By Chas. Deas.

Present collection: The Lunder Collection, Colby College Museum of Art, Waterville, Maine
Provenance: Private collection, Binghamton, N.Y.; to Christie's sale (New York City, March 16, 1990, lots no. 43 and 44); to Alexander Gallery, New York City, 1990; to Thomas Colville Fine Art, New Haven, Conn., 1995; to the Lunder Collection, 1996; to present collection, 2009
Reference: Clark 2000, pp. 19–20

It seems likely that Deas painted this pair of portraits on his first and only recorded voyage through the interior of Wisconsin Territory in the winter and spring of 1840–41. We know from Tuckerman that Deas "paint[ed] the likenesses of the prominent members of the tribe" at Fort Winnebago (1846, p. 252).

Sho-ko-ni-ka, or Little Hill, signed every Winnebago treaty between 1829 and 1865. His distinctive features appear in many group photographs of Winnebago delegations in the East. Deas shows his face painted with the mark of the bear clan and wearing a shell ornament secured with brass pins to a leather necklace, brass or copper rings and bracelets, nickel or "German silver" earrings, and a roach of deer hair dyed red surmounted by an eagle feather. He holds a spiked gunstock club painted blue, with a metal spike and brass furniture tacks attached to it.

Wa-kon-cha-hi-re-ga (whose name translates more likely as Roaring Thunder, not Rolling Thunder) wears the same kind of earrings as Sho-ko-ni-ka. His headdress is of eagle feathers and fur (possibly fox tail), and he carries a flat openwork puzzle pipe stem painted blue and decorated with porcupine quillwork and feathers at the tip. Deas painted him again (cat. no. 41) in the same face and body paint, earrings, and eagle feather and fur-tail headdress, but in the larger portrait Deas situated him in a narrative structure.

NOTE: *For their help in identifying the dress and accoutrements in these two portraits I am grateful to Nancy Lurie, Evan Maurer, David Penney, and William Sturtevant.*

32. *Lion,* 1841
Oil on canvas, 49½ × 67½ in.
Inscribed, lower center: C. Deas / 1841.
Present collection: Art Collection of the Minnesota Historical Society
Provenance: Commissioned by Henry H. Sibley, Mendota, Minnesota Territory, 1841; bequeathed to his son Alfred Brush Sibley, Helena, Mont., 1891; to the present collection, 1928
References: Frémont 1887, pp. 32–33; Coen 1976, p. 14; Clark 2000, p. 23

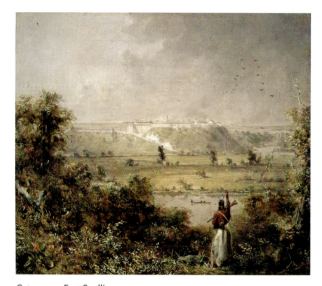

Cat. no. 33. *Fort Snelling.*

Cat. no. 34. *Portrait of Lieutenant Henry Whiting.*

Deas's largest canvas features a famous dog called Lion, an Irish wolfhound–Scottish deerhound mix that belonged to Henry Hastings Sibley (1811–1891). In 1841, when he met Deas, Sibley headed a post of the American Fur Company's operations at Mendota, across the river from Fort Snelling. Sibley was instrumental in organizing Minnesota Territory and was elected the state's first governor in 1858. The Sibley House Historic Site includes his spacious stone house, where Deas's portrait of Lion now hangs, as it did during Sibley's residence there. Sibley's devotion to his dog is evident in the epitaph he penned for Lion: "My noble Lion! Fleet, staunch, brave, and powerful! Your master will never look upon your like again. Old age and hard service have done their work upon you, and the hunting grounds which knew you shall know you no more" ("Hunting in the Western Prairies," *Spirit of the Times* 17, no. 8 [April 17, 1847]: 87).

33. *Fort Snelling,* ca. 1841
Oil on canvas, 12¼ × 14¼ in.
Present collection: Harvard University, Peabody Museum
Provenance: David Ives Bushnell, Jr., after 1931; bequeathed to Mrs.
 Belle Johnston Bushnell, his mother, 1941; bequeathed to the
 present collection, 1946
References: McDermott 1950, p. 298; Clark 1987, p. 55

The inspiration for Deas's only known view of Fort Snelling appears to have been Seth Eastman's *Fort Snelling on the Upper Missouri* [*sic*] (see fig. 1.14), shown at the National Academy of Design's annual exhibition of 1838, where Deas likely saw it. It is Eastman's only image of the fort to show an Indian with his back to the viewer (Sarah Boehme, "Seth Eastman: Illustrating the Indian Condition," Ph.D. dissertation, Bryn Mawr College, 1994, p. 85). Although the Indian is Deas's most specific borrowing, Deas more generally followed Eastman's vantage point from the valley's south bluff above Mendota, clearly showing the fort's commanding position at the confluence of the Minnesota and Mississippi rivers. Because Deas's

picture is undated, he may have painted it before he saw the fort for himself, but more likely he carried the image of Eastman's painting in his mind's eye and painted this view after he had seen the fort, perhaps on his first and only recorded stay in the summer of 1841.

The painting was acquired by David Ives Bushnell, Jr., probably after 1931, for it does not appear in the unpublished 1931 catalogue of Bushnell's collection (Peabody Museum, Harvard University). How Bushnell attributed the unsigned and undated picture to Deas is a mystery; there were few examples of the artist's work to which he could have compared this picture in the 1930s. Perhaps he acquired it through connections in St. Louis, where he was born and where his father had been a distinguished member of the historical and archaeological community. Wherever Bushnell acquired the painting, his source probably told him who had painted it.

34. *Portrait of Lieutenant Henry Whiting,* ca. 1841
Oil on canvas, 14 × 10½ in.
Present collection: Private collection
Provenance: By descent in the sitter's family to the present collection

Deas is recorded as witnessing the Doty Treaty at Traverse des Sioux (Oeyoowarha, which is probably a phonetical translation of "Oiyuwege," the Dakota name for Traverse des Sioux) on the Minnesota River in Iowa Territory on July 31, 1841, in the company of Lieutenant Henry Whiting. Deas probably painted Whiting's portrait that summer at Fort Snelling. Whiting was born in New York State in 1818 and graduated from the United States Military Academy at West Point in 1840. He served in Texas in 1845 and 1846, after which he returned to civilian life. He regained his commission during the Civil War and was promoted to the rank of colonel. After the war, Whiting became a teacher and a merchant in St. Clair, Michigan, and he was a regent of the University of Michigan from 1858 to 1863. He died in 1887.

NOTE: *My thanks to Carol Walker Aten for bringing to my attention this portrait, which she astutely attributed.*

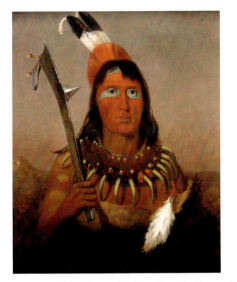

Cat. no. 40. *Winnebago with Bear-Claw Necklace and Spiked Club.*

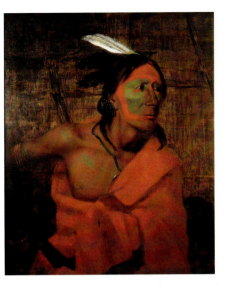

Cat. no. 41. *Winnebago (Wa-kon-cha-hi-re-ga) in a Bark Lodge.*

35. *View of St. Anthony's Falls,* ca. 1841
Present collection: Unknown
Reference: Tuckerman 1846, p. 252

The only reference to this work is contained in Tuckerman's description: "The ensuing summer [1841] he made a tour to Fort Snelling and the upper Mississippi—painted a view of St. Anthony's Falls." This singular, picturesque waterfall on the upper Mississippi River was sacred to the area's Indians and became a popular site for European American visitors, especially after the completion of nearby Fort Snelling in 1825.

36. *Illinois Troops Crossing Cedar Creek,* by 1842
Present collection: Unknown
References: St. Louis Missouri Republican 1842; McDermott 1950,
 pp. 300–301

This painting is known only from its listing in the *Daily Missouri Republican*'s review of the 1842 Mechanics' Institute Fair. Recent research has complicated the picture's subject: Illinois troops had not been mobilized since the Black Hawk War of 1832, thus Deas could not have seen them in action. Research has not revealed whether this might be an image of a historical event or which of the many Cedar Creeks in the region Deas included in this picture.

 NOTE: *My thanks to Paul Rosewitz and to James B. McCabe for information on Illinois troops.*

37. *Interior of a Winnebago Winter Lodge,* by 1842
Present collection: Unknown
References: St. Louis Missouri Republican 1842; McDermott 1950,
 pp. 300–301

This painting is known only by its inclusion among Deas's works listed in the *Daily Missouri Republican*'s review of the St. Louis Mechanics' Institute Fair in 1842.

38. *Landscape Paintings,* by 1842
Present collections: Unknown
References: St. Louis Missouri Republican 1842; St. Louis New Era
 1842b; McDermott 1950, p. 300

The *Daily Missouri Republican* and the *New Era* reported that "landscape paintings" were among the works Deas showed at the St. Louis Mechanics' Institute Fair in 1842.

39. *Sesseton Sioux Playing at Ball,* by 1842
Present collection: Unknown
References: St. Louis Missouri Republican 1842; McDermott 1950,
 pp. 300–301

The *Daily Missouri Republican* listed *Sesseton Sioux Playing at Ball* among Deas's entries to the St. Louis Mechanics' Institute Fair in 1842. This may be "A representation of Sioux Indians by Deas," mentioned in the *New Era*'s review of the fair on November 4, 1842.

40. *Winnebago with Bear-Claw Necklace and Spiked Club,* by 1842
41. *Winnebago (Wa-kon-cha-hi-re-ga) in a Bark Lodge,* by 1842
42. *Winnebago with Bear-Claw Necklace and Spear,* by 1842
43. *Winnebago with Peace Medal and Pipe,* by 1842
Each: Oil on canvas, laid down on masonite, 36 × 30 in.
Present collection: From the collections of the St. Louis Mercantile
 Library at the University of Missouri–St. Louis
Provenance: Possibly David D. Mitchell, St. Louis; John How, St.
 Louis, by 1869; to the present collection, 1869
References: Miller 1950; Clark 2000

It is likely, although not certain, that these four portraits were among "a number of portraits of Indian chiefs, landscape paintings etc, etc" that the *Daily Missouri Republican* (November 7, 1842) reported Deas had on view at the St. Louis Mechanics' Institute Fair. They also may have been included in the less specific listing—

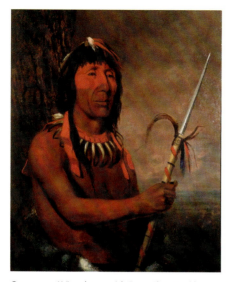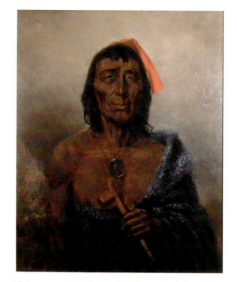

Cat. no. 42. *Winnebago with Bear-Claw Necklace and Spear.* Cat. no. 43. *Winnebago with Peace Medal and Pipe.*

"Portraits and Landscapes from the pencils of C. Bowes, and C. Deas"—that the *New Era* (November 3, 1842) reported to have been shown at the fair.

In 1869, John How, a former mayor of St. Louis and an art collector, deposited "for safe keeping" at the Mercantile Library a group of objects. Among them were listed "four oil paintings of Indian Chiefs" without mention of the artist who painted them (St. Louis Mercantile Library, Board of Direction Minutes Record Book, August 3, 1869, p. 8). John How may have been the owner of the portraits, but according to descendants of David D. Mitchell, who served as superintendent of Indian affairs in St. Louis several times between 1841 and 1852, Mitchell had commissioned them. To add to the mystery, Clarence Miller, the Mercantile Library's director from 1942 until 1958, passed along undocumented information that the portraits had been at one point in the collection of Indian agent Benjamin O'Fallon (1793–1842), a nephew of William Clark and the owner of more than forty paintings by George Catlin (teleconference with Elizabeth Kirchner, former Mercantile librarian, June 15, 1994).

These four portraits were thought to be by Catlin for many years before 1950, when Clarence Miller published the attribution. That attribution was questioned by scholars and librarians as early as 1965. In 1996, Mercantile Library director John Hoover and I proposed that Deas painted the four portraits, something that former library board member Frank Dunnagan had suspected in 1973 (June 3, 1973, letter to Buffalo Bill Historical Center director Harold McCracken, St. Louis Mercantile Library Archives).

These four may be the only survivors of a larger group. But even isolated as they are today, they form a coherent group of subjects that represent the four ages of man. Each of Deas's sitters displays a distinctly different age and attitude.

Winnebago with Bear-Claw Necklace and Spiked Club has suffered damage and has been more extensively in-painted and retouched during conservation treatments than the other three portraits, notably around the face. The sitter for this portrait, the youngest of the

group, wears a headdress composed of dyed-red deer hair and eagle feathers. His otter-skin necklace has attachments of grizzly bear claws, unusually large brass buttons, and a single "breath feather," from the underside of an eagle's tail, which falls over his skin robe. Face painted, he holds a trade gun-stock club with steel-blade spike.

Winnebago (Wa-kon-cha-hi-re-ga) in Bark Lodge is the man Deas had sketched (cat. no. 31) wearing the same face and body paint, earrings, and headdress. The peace medal prominently displayed in the sketch here swings on its ribbon into the folds of his brown-striped, red trade blanket. In the prime of life, he is the only one of the four sitters who is shown in action, rising inside the hut from a group that is represented by two eerie faces visible at lower left and right.

Winnebago with Bear-Claw Necklace and Spear has the most specific outdoor setting in this group. A body of water in the background evokes the lakes just west of Lake Michigan or perhaps that Great Lake itself behind this clearly aged man, who leans against a tree and holds a wooden pole. The pole is wound with ribbon and has a long bayonet blade attached to it with ribbon and hair. A blue trade blanket striped in red and darker blue is wrapped around the subject's waist, and he wears a neckpiece consisting of grizzly bear claws attached to red stroud ties (from cloth woven in the mills of England's Stroud district and used in trade with Indians) that hang over his shoulders.

Winnebago with Peace Medal and Pipe depicts the oldest of the four subjects. He is wrapped in a blue robe draped across one shoulder, and his hair is ornamented with a single salmon-colored ribbon. Deas marked his status in two ways: with a prominently displayed peace medal, possibly of President John Tyler, and with a red pipe-stone (also called catlinite, after George Catlin) pipe.

NOTE: *My thanks to John Hoover for bringing these portraits to my attention and for collaborating on their attribution. For their help in identifying the dress and accoutrements in these four portraits I am grateful to Emma Hansen, Nancy Lurie, Evan Maurer, David Penney, and William Sturtevant.*

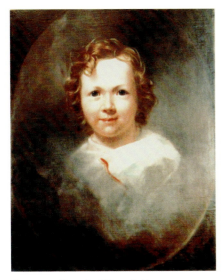

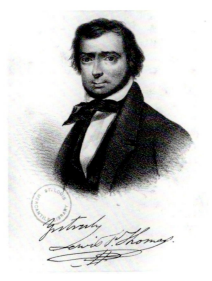

Cat. no. 44. *Portrait of Gratz A. Moses.*

Cat. no. 46. John Caspar Wild, after Deas, *Portrait of Lewis Foulk Thomas.*

44. *Portrait of Gratz A. Moses,* 1842
Oil on canvas, 19 × 15 in. (sight)
Inscribed, lower right: C DEAS / 1842
Present collection: Collection of Edna Moses
Provenance: Given by the artist to the sitter's mother, Mary Porter
 Ashe Moses, St. Louis, 1842; by descent to the sitter and then
 to his youngest son, Asheleigh Strudwick Moses (1878–1978),
 Montrose, Ala.; bequeathed to his widow, the present owner, 1978

According to family history, this is a portrait of Gratz Ashe Moses
(1838–1901), the firstborn son of physician Simon Gratz Moses
(1813–1897), painted in St. Louis when the boy was 3½ years old.
Deas is thought to have signed it on the boy's fourth birthday,
November 24, 1842, when he presented it and a companion portrait
of a Pawnee child (cat. no. 45) to Mrs. Moses in appreciation of the
family's many kindnesses.

 S. Gratz Moses, a member of a distinguished Philadelphia Jewish
family, was private physician to Joseph Bonaparte in Bordentown,
N.J., when his son Gratz was born. In 1841, the family moved from
Philadelphia to St. Louis, where Dr. Moses became a civic leader:
he was prominent in the medical treatment of women; he estab-
lished a free public health dispensary in 1842; and he was one of
the founders of the city's first synagogue. His son Gratz A. Moses,
the subject of this portrait, was raised in St. Louis and served in the
Confederate Army. He returned to St. Louis after the war and, like
his father, was an eminent women's physician in that city, where he
died on July 7, 1901.

 Like *Portrait of Robert Watts* (cat. no. 8) and *Portrait of Three
Children* (cat. no. 22), this image owes a stylistic debt to Thomas
Sully. Painted four years later than *Robert Watts,* it shows greater as-
surance of handling of illusionistic volume and atmosphere, uni-
fied within an oval format.

 NOTE: *I am grateful to Edna Moses, who recounted the oral history of her hus-
 band's family in an interview on March 3, 2001.*

45. *Portrait of a Pawnee Child,* 1842
Present collection: Unknown
Provenance: Gift of the artist to Mary Porter Ashe Moses, 1842

According to Moses family history, when Deas painted Gratz A.
Moses (cat. no. 44), he also painted a portrait of the Pawnee child
who was young Moses's playmate. The family reported that Deas
gave both portraits to Mrs. Moses and that the pictures were sent to
Canada for safekeeping before the Civil War. The portrait of Gratz A.
Moses was returned to the family; this portrait was lost in Canada.

 NOTE: *I am grateful to Mrs. Edna Moses, who recounted the oral history of her
 husband's family in an interview on March 3, 2001.*

46. John Caspar Wild (American [b. Switzerland], 1804–1846),
 Portrait of Lewis Foulk Thomas, 1842
 After Charles Deas, *Portrait of Lewis Foulk Thomas*
Lithograph, 7 × 4½ in., bound into a volume
Present collection: From the collections of the St. Louis Mercantile
 Library at the University of Missouri–St. Louis
References: St. Louis New Era 1842a; Thomas 1842; McDermott
 1950, p. 300; Clark 2000, p. 23

This print is the frontispiece for Lewis Foulk Thomas's *Inda: A
Legend of the Lakes, with Other Poems* (1842), which was purport-
edly the first volume of poetry published west of the Mississippi.
Vespasian Ellis, the book's publisher, wrote in the prefatory
"Advertisement" that John Caspar Wild created the lithographic
portrait of the author from a "splendid painting by C. Deas." That
painted portrait is not known to survive.

 At least one critic found fault with the two illustrations. "S. D.
T.," reviewing the volume for the *New Era,* wrote, "The engravings
of this volume—being a portrait of the author, and an illustration
of a scene in Inda—are miserably executed, a disgrace to St. Louis.
It is to be regretted that they obtained admission into such good
company." The critic mistakenly called the lithographed portrait an

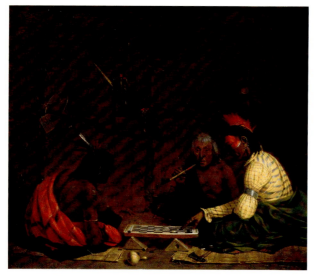

Cat. no. 47. *Winnebagos Playing Checkers.*

Inscription on verso of *Winnebagos Playing Checkers.* Photograph courtesy of James Maroney, Inc.

"engraving," and his reference to "execution" suggests that he may have been attacking the quality of the reproductions rather than the images from which they were taken. It is not clear what this critic meant by "such good company," but the Swiss-born Wild was St. Louis's leading printmaker in the early 1840s.

47. *Winnebagos Playing Checkers,* 1842
Oil on canvas, 12½ × 14½ in.
Inscribed on verso (covered by a relining): Winnebagos / playing
 Checkers. / Chas Deas. / St. Louis / 1842. / from / nature
Present collection: Private collection, New York
Provenance: Rollin Sanford, Brooklyn; to Leeds sale (Sanford collec-
 tion, New York City, 1859, lot no. 29); private collection, Calif.; to
 Spanierman Gallery, New York City, 1983 (with James Maroney,
 Inc., New York City); to Thyssen-Bornemisza Foundation,
 Lugano, 1984; to Phillips, de Pury and Luxembourg sale (New
 York City, December 3, 2002, lot no. 41); to the present collection,
 2002
Alternative titles: Game of Checkers or Drafts; Indians Playing Games
References: St. Louis Missouri Republican 1842; Crayon 1859, p. 381;
 Leeds Sale 1859; *Clark 1987, pp. 56–57; Clark 2000, pp. 20–21

Winnebagos Playing Checkers takes its title from the artist's in-
scription on the back of the canvas. The picture came to light in
California in 1983, with no indication of its prior history. Quite
likely, it is the painting that belonged to Brooklyn merchant Rollin
Sanford (1806–1879) and was sold (for $27.50) in 1859 from his
collection. Both the size (14 × 12 in.) and the title, *Indians Playing
Games,* of the Sanford picture fit *Winnebagos Playing Checkers.* The
Sanford catalogue cited an accolade that I cannot confirm: that the
picture had "gained the first prize in Cincinnati, in the early days
of the Artist." If accurate, this probably refers to the short-lived an-
nual exhibition program of the Section of Fine Arts of the Society for
the Promotion of Useful Knowledge (sometimes called the Society
for the Diffusion of Useful Knowledge) in Cincinnati. The group

mounted its second and final annual exhibition in 1842. (On this
group, see Kenneth R. Trapp, "The Growth of Fine Arts Institutions
In Cincinnati, 1838–54," paper delivered at the Ohio-Indiana
American Studies Association Spring Meeting, April 21, 1978.)

This painting may be the "Game of Checkers or Drafts" that the
Missouri Republican reported on November 7, 1842, as being among
the pictures Deas had on view at the St. Louis Mechanics' Institute
Fair.

Deas set the checkers match inside a bark wigwam. On the walls
hangs a quiver with a bow and arrows, its strap ornamented with
red ribbon that joins pieces of braided fabric or hair. To the left is
a bead heddle, or small hand loom, complete with woven bead-
work suspended from it, and what appears to be a hoop for a ball
game. The object directly beneath the quiver, perhaps a satchel
with a leafy branch protruding from it, establishes the depth of the
room, as does the foreshortened checkerboard set up on triangular
blocks. Between the satchel and the board is an observer who holds
a lighted pipe with a dark stone bowl. Two other still-life objects
draw our attention: a gourd (probably a rattle) and a hatchet (possi-
bly a pipe-tomahawk) mark a foreground that is further elaborated
by scattered black and white checkers and the woven rush mats on
which the players sit. Deas lavished painterly attention on these ob-
jects, which he may have observed in use by Indians when they gath-
ered for trade and military negotiations at Great Lakes forts he vis-
ited or in collections he could have consulted in St. Louis.

Deas presented the two players in elaborate face paint and wear-
ing headdresses: one of eagle feathers, dyed hair, and beads; the
other a roach made of deer hair dyed red. He painted the glint of
metal earrings, rings, and armbands, none more brilliant than the
nickel silver band around the sleeve of the striped, yellow trade-
cloth shirt worn by the player on the right.

NOTE: *For their help in identifying the dress and accoutrements in this pic-
ture I am grateful to Nancy Lurie, Evan Maurer, David Penney, and William
Sturtevant.*

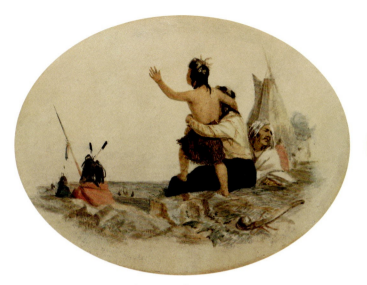

Cat. no. 49. *Sioux Awaiting the Return of Friends.*

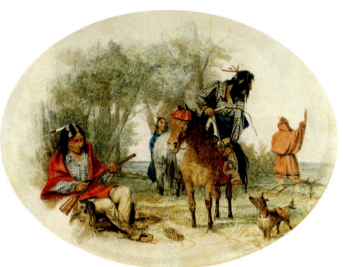

Cat. no. 50. *Winnebagoes.*

48. *View on the Upper Mississippi, One Mile below Fort Snelling,*
by 1843
Present collection: Unknown
Provenance: John Rosenerants by 1843
Reference: *PAFA 1843, cat. no. 65

This painting is known only from its listing in the catalogue for the
Pennsylvania Academy of the Fine Arts' 1843 exhibition. The ex-
hibition catalogue more fully described the subject of this picture
as "Some Sioux Chiefs, on horseback, are escorting their flag to a
Council meeting." John Rosenerants is listed as the work's owner,
but I suspect a typographical error because Philadelphia direc-
tories record no such family. McElroy's Philadelphia directory of
1844 does include a John Rosencrants, merchant; in later years,
Rosencrants is described in directories as a carpet manufacturer.

49. *Sioux Awaiting the Return of Friends,* 1843
Watercolor on paper, 7½ × 9½ in.
Inscribed, lower left: Sioux awaiting / the return of friends; lower right:
C Deas 1843
Present collection: Collection of Thomas A. and Jane Petrie, Denver
Provenance: Selkirk Galleries sale (St. Louis, May 10–15, 1982, lot
no. 506); private collection, Los Angeles, by 1983; to Goldfield
Galleries, Los Angeles, 1983; to Gerald P. Peters Gallery, Santa
Fe, 1984; to John Eulich, Dallas, 1984; to Sotheby's sale (New York
City, December 3, 1998, lot no. 175); to the present collection,
1998
Alternative title: Friends
References: Stewart 1986, p. 30; Clark 1987, pp. 56–57

50. *Winnebagoes,* 1843
Watercolor on paper, 7 × 9¼ in.
Inscribed, lower left: Winnebagoes; lower right: C. Deas 1843 / C. Deas
1843
Present collection: Private collection

Provenance: Selkirk Galleries sale (St. Louis, May 10–15, 1982, lot
no. 506); private collection, Los Angeles, by 1983; to Goldfield
Galleries, Los Angeles, by 1983; to Gerald P. Peters Gallery, Santa
Fe, 1984; to the present collection, 1990.
References: Clark 1987, pp. 56–57; *Schimmel 1988, pp. 24, 85

These two watercolors are clearly a pair and may have been part of a
larger group. Each was once mounted on a decagonally shaped pa-
perboard support, and in an unusual practice Deas incised his sig-
nature into the paperboard of each one.

In *Sioux Awaiting the Return of Friends,* Deas focused on a child
standing on a high bluff within a family group and near a Sioux tipi.
The child, held protectively by his mother, raises his arm to wave
and draws our attention to the figures below the bluff. A ball-headed
club made from a single burl, or tree knot, terminates the fore-
ground at the lower right.

Deas also structured *Winnebagoes* around acts of communica-
tion. A man in a capote made from a striped Hudson's Bay blanket,
his back to the party in the foreground, raises his arm to greet those
below and in the far distance. The men, their horses, and a dog are
all in a clearing framed by lush foliage. The two men closest to the
picture plane wear deerskin leggings and moccasins, striped shirts
of blue trade cloth, and blankets. The figure seated at left holds
and inspects a rifle that has a burled wood gunstock. The mounted
figure turns in his saddle and looks at what has attracted the atten-
tion of the man waving. He grasps a quirt in his right hand, which
rests on the high pommel of what appears to be a woman's saddle.
Sporting a cap, his horse exchanges glances with the alert dog in the
foreground.

That these two watercolors are of similar format suggests they
were a pair or perhaps two works from a larger group of scenes of
Indian life.

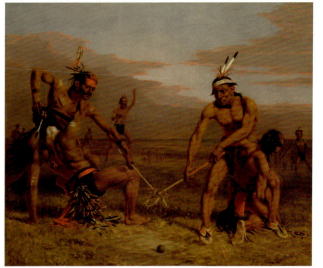

Inscription on verso of *Sioux Playing Ball*. Photograph from Victor Spark Papers, Archives of American Art, Smithsonian Institution, Washington, D.C.

Cat. no. 51. *Sioux Playing Ball.*

51. *Sioux Playing Ball,* 1843
Oil on canvas, 29 × 37 in.
Inscribed, lower left: C. Deas. / 1843.
Inscribed, verso (covered by a relining): Sioux's playing ball. / by C. Deas / St Louis / Missouri
Present collection: Gilcrease Museum, Tulsa, Oklahoma
Provenance: American Art-Union; distributed to Mrs. E. M. Anderson, Palmyra, N.Y.; by descent through the family to Mrs. Edison W. Anderson, Palmyra, N.Y.; to Victor D. Spark, New York City, 1956; to Thomas Gilcrease, Tulsa, Okla., 1957; to Thomas Gilcrease Foundation, Tulsa, Okla., 1962; to the present collection, 1963
Alternative titles: Group of Indians Playing Ball; Sioux—Ball Playing
References: *NAD 1844, cat. no. 228; NY Morning Herald 1844; Broadway Journal 1845c; AAU Transactions 1849, no. 218; McDermott 1950, pp. 302–303, 310; Clark 1987, pp. 57, 59

Sioux Playing Ball is probably the same picture that Deas showed at the National Academy of Design in 1844 (*Group of Indians Playing Ball*) and the one described as "a party of Indians at play" that the *Broadway Journal* (June 21, 1845) reported Deas had on view at the American Art-Union. If this supposition is correct, the picture did not find a buyer at either venue, for Deas submitted *Sioux Playing Ball* to the Art-Union in 1848. The managers purchased it and two other pictures from Deas for a total of $250 (Minutes of the Committee of Management, October 5, 1848, Records of the American Art-Union, New-York Historical Society Library). The American Art-Union label, with the artist's name and the handwritten title *Sioux—Ball Playing,* was removed from the verso and is retained in the Gilcrease Foundation Archives. An old photograph shows that the label was attached to the frame, indicating that this frame is original to the picture. Its current title derives from the inscription on the verso of the canvas (modified for clarity).

Deas included many details of the dress and equipment of these

Eastern Dakota (or Santee Sioux). Their sticks, made of bent wood and rawhide, are decorated with quills and red metal cone tinklers. All four figures in the foreground wear headdresses; the ears of the two facing us are adorned with silver earrings or cuffs. Ritually painted and scarified, they are clad only in breechcloths. The bustles of two of the players are well delineated; one is made of feathers and the other fashioned from horsehair. Although it was unusual in Indian ball games, which early French settlers called lacrosse, for some players to be barefoot and others to wear moccasins in the same match, Deas shod only two of his four players. The artist seemed especially interested in the moccasins of the figures at right: they are soft and puckered, painted with red stripes at the edge, and inlayed, possibly with quillwork, at the vamp. The same moccasins appear in *Indian Group* (cat. no. 61) and similar tattooing on the figure in *A Solitary Indian, Seated on the Edge of a Bold Precipice* (cat. no. 81). Using a technique now called the "Indian scoop," the standing player on the left goes for the ball; his effort is blocked by the player on the right.

NOTE: *For their help in identifying the dress and accoutrements in this picture I am grateful to Evan Maurer, David Penney, William Sturtevant, and Thomas Vennum, who also shared his deep knowledge of the Indian ball game.*

52. *An Interior,* by 1844
Present collection: Unknown
Provenance: C. N. Robinson by 1844
Reference: *Artists' Fund Society 1844, cat. no. 111

The Artists' Fund Society catalogue lists the owner of this painting as C. N. Robinson, who appears in Philadelphia directories of the time as a dealer in looking glasses, frames, prints, and paintings.

53. *Drawings from the Wharton Expedition,* 1844
Present collection: Unknown

In his account of Major Clifton Wharton's expedition from Fort
 Leavenworth to the Pawnee Villages in 1844, J. Henry Carleton re-
 corded these sketches by Deas.
Two Sketches at Camp
Reference: Carleton 1844–45, vol. 14, no. 38 (November 16, 1844):
 451

In his diary entry of August 13, 1844, Carleton reported, "We en-
camped at three o'clock this afternoon on the northern bank of this
creek, the spot selected is a very desirable one, having wood and
water upon three sides of it, and one of those fortress hills upon
the fourth. It is a little prairie of itself, and is just large enough for a
magnificent encampment. Mr. Deas made two very fine sketches of
this spot after the tents were pitched and the fires lighted."

Drawing of the Lodge of Charachoreesh, Chief of the Grand Pawnees
Reference: Carleton 1844–45, vol. 14, no. 46 (January 11, 1845): 543

In his diary entry of August 29, Carleton devoted several pages to
describing the "old chief's lodge" and noted that Deas made a draw-
ing of it. Carleton described Charachoreesh as an "old man . . . sit-
ting upon a mat with his guests upon each hand—in a circle, and
numbering in all say about twenty." He reported that the lodge was
"lighted through a hole in the top which is about three feet in diam-
eter" and described every lodge in the Pawnee village as having "on
the opposite side of the circle from the entrance and facing towards
it . . . a buffalo skull with the horns on." He wrote that "Mr. Deas
said it was the most glorious light for a painter he had ever seen. As
he was making a drawing of the old chief's lodge and myself writ-
ing this description of it, one of the Indians thinking it was too
dark where we sat for us to see conveniently—went and took down
a white shield made of buffalo-bulls scalp, and held it just in the

sunlight that came streaming through from above; in a moment the
lodge was as bright as day from the reflected rays."

Sketch of Stede-le-we-it (Called Big Greasy), a Tepage (Pawnee) Chief
Reference: Carleton 1844–45, vol. 14, no. 50 (February 8, 1845): 596

In his diary, Carleton recounted the events of August 30, 1844:

 A Tepage chief, named Stede-le-we-it came forward and shook
 hands preparatory to making a speech. He was the drollest looking
 old chap we ever saw, being nothing but a great ball of animated
 fat; and besides, he had the smallest legs that ever before had the
 temerity to attempt to support such an unwieldy globe of flesh, as
 the one that rested upon them. Some of the officers named him
 "Big Greasy" for short. . . . While Big Greasy was attending the
 council just described, some mischievous Indian had turned his
 horse loose. The animal finding himself at liberty, deliberately trot-
 ted off for his own village. . . . Fortunately, the teams had not gone
 when Big Greasy ascertained these facts, and he was enabled to
 persuade a driver to haul his saddle and bridle on one of the wag-
 ons, though not one of them could be induced to do as much for
 the old man himself. He was too fat for that. However, they told
 him . . . that one of the officers . . . had gone on ahead in a light
 Jersey wagon, and if he hurried he might overtake him and get a
 ride the rest of the way in that. The idea of his running with his ton
 of fat was not exactly obsolete, for no sooner said, than off the old
 man started, at a rapid pace, to overtake the carriage alluded to. .
 . . He [the driver] knew at once who it was [chasing after him] . . .
 and was determined to try the old fellow's bottom, by keeping him
 at his speed as long as he could hold out. . . . Mr. Deas made a very
 spirited sketch of the old fellow's race, in which, at a glance, a bet-
 ter description of his appearance and character is conveyed, than
 could possibly be given by words.

Hunseker's Ferry on the Nishnebottona
Reference: Carleton 1844–45, vol. 15, no. 6 (April 5, 1845): 64

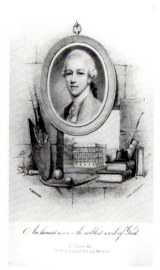

Cat. no. 54. Francis D'Avignon, after Deas,
Emblematic Portrait of Ralph Izard.

Cat. no. 55. *Long Jakes, "the Rocky Mountain Man."*

On September 13, 1844, Carleton wrote in his diary that Deas made a "splendid drawing" after dark of their encampment upon the Nishnebottona at Hunseker's Ferry and described the scene: "This night our squadrons were all encamped in one line along the river, which at this point made a beautiful bend, giving the row of tents the form of a crescent. After dark, and when the fires were all lighted, the effect of this scene was magnificent. The fires, and tents, and men, and horses, were all reflected in the water: while [in] back were the deep woods and the obscurity."

54. Francis D'Avignon (American [b. France?], ca. 1813–after
 1865), *Emblematic Portrait of Ralph Izard,* 1844
 After Charles Deas, *Emblematic Portrait of Ralph Izard*
Lithograph on paper, 7⅜ × 4½ in., bound into volume
Inscribed in plate: F. Davignon / Lith. of Endicott. / An honest man's the
 noblest work of God. / C. Deas del. / From a miniature by Meyer.
Present collection: Amherst College Library, Amherst, Massachusetts
References: Izard 1844; Mack and Savage 1999, pp. 31, 236

Deas designed this image to serve as the frontispiece to the collection of his late grandfather's letters that his mother, Anne Izard Deas, edited and published in 1844. In his design, Deas added emblems of learning and agriculture to a reproduction of a now-lost miniature portrait of Ralph Izard (1742–1804) painted in 1774 by Jeremiah Meyer (1735–1789) when Izard was living in England. The building seen through an opening in the illusionistic stone wall is a curiosity unrelated to any of the known images or descriptions of Izard's homes.

Ralph Izard was a close advisor to George Washington during the American Revolution and served as senator from the new state of South Carolina from 1789 to 1795. He retired from political life in 1795 and suffered a debilitating stroke two years later. From then until his death in 1804, Izard dedicated himself to literature. He derived his personal motto, "An honest man's the noblest work of God," from Alexander Pope's *Essay on Man,* epistle iv (1732–34);

Deas used this motto as the print's title. The print was executed by Francis D'Avignon, who was especially skilled at reproducing daguerreotypes as lithographs, and was published by the brothers George and William Endicott of New York City.

55. *Long Jakes, "the Rocky Mountain Man,"* 1844
Oil on canvas, 30 × 25 in.
Inscribed, lower right: C. Deas. 1844
Present collection: Jointly owned by the Denver Art Museum and
 The Anschutz Collection; purchased in memory of Bob Magness
 with funds from 1999 Collectors' Choice, Sharon Magness, Mr.
 and Mrs. William D. Hewit, Carl and Lisa Williams, Estelle Rae
 Wolf-Flowe Foundation, and the T. Edward and Tullah Hanley
 Collection by exchange (1998.241)
Provenance: American Art-Union; distributed to G. F. Everson, New
 York City, 1844, and in his collection until at least 1846; Marshall
 O. Roberts, New York City, by 1864; to his widow, 1880; to Fifth
 Avenue Art Galleries sale (Roberts collection, New York City, 1897,
 lot no. 23); private collection, New York City, by 1945; private col-
 lection, Minneapolis, by 1954; to private collection, Minneapolis,
 1972; to Vose Galleries, Boston, 1985; to Richard Manoogian,
 Detroit, 1986; to Vance Jordan Fine Art, New York City, 1992; to
 private collection, Jackson Hole, Wyo., 1992; to Vance Jordan
 Fine Art, 1998; to the Denver Art Museum, 1998; jointly owned
 by the Denver Art Museum and The Anschutz Collection, 2008
Alternative titles: Jaques; Long Jaques; Long Jake
References: New Mirror 1844; AAU Transactions 1845, no. 49;
 Broadway Journal 1845a; Broadway Journal 1845b; Herbert
 1846a; NY Illustrated Magazine 1846; Spirit of the Times 1846;
 Tuckerman 1846, p. 253; Lanman 1847, p. 16; NY Illustrated
 Magazine 1847, p. 48; NY Evening Post 1848a; *Washington
 Exhibition 1853, cat. no. 96; NY Times 1853; Historical Magazine
 1860; *Metropolitan Sanitary Fair 1864, cat. no. 10; Tuckerman
 1867, p. 626; Fifth Avenue Art Galleries Sale 1897; McDermott

Cat. no. 55A. William G. Jackman, after Deas, *Long Jakes.*

1950, pp. 301–303; Glanz 1982, pp. 44–45; *Clark 1987, pp. 59–62; *Clark 1989; Johns 1991, pp. 66–78; Schoelwer 1992, pp. 160–64

The *New Mirror* reported on September 14, 1844, that Deas's image of a trapper was on view at the gallery of William A. Colman. The American Art-Union had already accepted Deas's picture and insured it for the substantial sum of $500 (Minutes of the Committee of Management, September 9, 1844, Records of the American Art-Union, New-York Historical Society Library). In December 1844, the picture was distributed to Gilbert F. Everson, a New York City importer and purveyor of shoe and boot findings. Marshall O. Roberts (1814–1880), the enormously wealthy rail and steamship entrepreneur who became an Art-Union manager in 1846, acquired it sometime before 1864, when he lent it to the sanitary fair in New York City. (Roberts was a major lender to the 1853 Washington Exhibition, to which he may have lent *Long Jakes.* The catalogue for that exhibition, however, does not list an owner for the picture.) The painting disappeared from record after it was auctioned in the 1897 Roberts sale to an unknown bidder for $70. It resurfaced in the basement of a house in Minneapolis in 1985 (information courtesy of Vose Galleries, Boston) and has been a focus of Deas scholarship ever since.

Before *Long Jakes* was distributed in the Art-Union's December lottery, the Art-Union's Committee of Management voted to make a daguerreotype of the painting. Although their minutes of December 9, 1844, and January 13, 1845 (AAU Records), indicate that they hired Isaiah R. Clark to do the job for $10, they do not reveal the purpose of the project. Clark may have made this daguerreotype to aid in designing a reproduction of *Long Jakes* that the Art-Union managers envisioned but never completed. Clark, also known as James R. Clark, was listed in the city directory of 1844 as a daguerrein at 247 Broadway in New York City, where he was affiliated with the firm of Anthony, Edwards and Co. (which operated under various names) as well as with the National Miniature Gallery.

This picture has had several titles. It is "Jaques" and "Long Jaques" in the Art-Union's handwritten records but "Long Jakes, 'the Rocky Mountain Man'" in the organization's published lists. The *Broadway Journal* called the picture "Long Jake," and Tuckerman, Lanman, and some others followed this lead. I return to the picture's first published title.

NOTE: *I am grateful to Carol Walker Aten for sharing her research on Deas, undertaken at Vose Galleries when the painting came onto the market in 1985.*

55A. William G. Jackman (active 1841–1860s), *Long Jakes,* 1846
 After Charles Deas, *Long Jakes, "the Rocky Mountain Man"*
Steel engraving, 5¾ × 4¾ in., bound into volume
Inscribed in plate: Painted by C. Deas; Engd. By W. G. Jackman / Long Jakes / From the Original in the Possession of C. F. Everson, ESQ. / Engd. Especially for the N.Y. Illustrated Magazine
Present collection: Newberry Library, Chicago
References: Herbert 1846a; NY Illustrated Magazine 1846; Spirit of the Times 1846; NY Illustrated Magazine 1847; Historical Magazine 1860; McDermott 1950, p. 303; Glanz 1982, p. 44; Reilly 1987, p. 184; Johns 1991, p. 70

Deas's painting *Long Jakes* inspired Lawrence Labree, editor of the *New York Illustrated Magazine of Literature and Art,* to commission William G. Jackman to make a fine, reproductive print after the painting. Labree also hired Henry William Herbert (1807–1858) to write an essay, "Long Jakes, the Prairie Man," to publish alongside Jackman's print in the July 1846 issue.

In 1847, the *New York Illustrated Magazine* published William Cullen Bryant's poem "The Hunter of the Prairies," proclaiming that it "fits so admirably one of our plates in the first volume—'Long Jakes,' from a painting by Deas." Bryant, who was president of the Art-Union when *Long Jakes* made its appearance there in 1844 and surely knew the picture, fashioned his hunter as an avatar of freedom, a lightly domesticated westerner who understood the past and had a vision for the future.

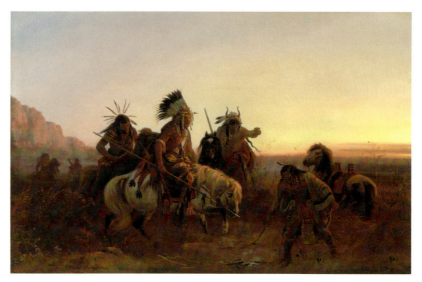

Cat. no. 55B. Leopold Grozelier, *Western Life, The Trapper,* after Deas, *Long Jakes.*

Carl Wimar (American [b. Germany], 1828–1862), *The Lost Trail,* ca. 1856. Oil on canvas, 19½ × 30½ in. Museo Thyssen-Bornemisza, Madrid.

Jackman's engraving fulfilled one of the traditional obligations of prints: to represent a given painting to a broader audience, which it did long after the painting itself was out of public view. In 1950, when John F. McDermott rediscovered Deas's career, he used Jackman's print to stand in for *Long Jakes.* Until the painting returned to public view in the mid-1980s, this print by Jackman and another by Leopold Grozelier signified the archetypal "lost Deas"—a second-generation object that served as both wistful reminder of the missing original and a standard by which to judge putative pretenders to the Deas oeuvre.

55B. Leopold Grozelier (American [b. in France], 1830–65),
 Western Life, The Trapper, ca. 1855
 After Charles Deas, *Long Jakes, "the Rocky Mountain Man"*
Lithograph printed in colors, 23⁹⁄₁₆ × 29⁵⁄₁₆ in. (sheet)
Printed by J. H. Bufford, Boston, for M. Knoedler
Present collection: Yale University Art Gallery, Mabel Brady Garvan
 Collection (1946.9.636)
References: Steinfeldt 1981, p. 24; *Reilly 1987, pp. 179–81; Johns
 1991, p. 70; Ketner 1991, p. 64

This lithograph was commissioned about ten years after *Long Jakes* made its debut at the American Art-Union and seven years after Deas's institutionalization removed him from art-world attention. Published in New York City by art dealer Michael Knoedler, it may have been inspired by the appearance of *Long Jakes* at the 1853 Washington Exhibition, a presentation in New York City of paintings that celebrated, among other things, George Washington as a national hero.

In every respect, the print is first-rate. Its lithographer, Leopold Grozelier, who was born and apprenticed in France, immigrated to the United States in 1851 and settled in Boston about 1853. He brought a skilled hand and sensitive eye to his drawing. The printer, the well-regarded firm of John Henry Bufford in Boston, spared

no expense: the print was executed in folio size, using the *chine-collé* technique in which an image is printed on a thin sheet of paper whose delicate surface allows for finer detail, then bonded to a heavier support for increased stability. Unlike Jackman's small steel engraving bound into a journal, Grozelier's large lithograph was intended to stand alone as an art object. (On Grozelier, see Sally Pierce and Catharina Slautterback, *Boston Lithography, 1825–1880: The Boston Athenaeum Collection* [Boston: Boston Athenaeum, 1991], 172; on Bufford, see David Tatham, *John Henry Bufford: American Lithographer* [Worcester, Mass.: American Antiquarian Society, 1976].)

As Deas and his work slipped increasingly into obscurity in the second half of the nineteenth century, the burden of representing him and his art fell in part to this print, which enjoyed a far broader audience than most of Deas's paintings. Apparently drawing on and affirming mid-1850s ideas about the heroic nature of the historic mountain man, the Frenchman Grozelier made his *Long Jakes* a more handsome and commanding figure than the one in Deas's painting or Jackman's 1846 engraving (Johns 1991). Grozelier's *Western Life, The Trapper* inspired several artists. Carl Wimar, a German-American painter from St. Louis, appears to have borrowed from Deas the pose of the central horse and rider in *The Lost Trail* of 1856, which he painted in Düsseldorf (Ketner 1991). Wimar was only a boy newly arrived from Germany in 1844, when the light of *Long Jakes*'s New York fame reflected back to St. Louis. Thus, although he might have known of Deas's painting, the timing of this inspiration suggests that Grozelier's print had made its way to Düsseldorf. While Wimar transformed Deas's trapper into an Indian chief in full regalia, other artists painted copies that were more direct; at least eight pictures based on *Long Jakes* appear to date from the late nineteenth century. To judge from the figures' handsome face, such as that of an unknown artist's work (now at the Yale University Art Gallery), most of these painters drew their inspiration from Grozelier's lithograph. Only one of these works is

Unknown artist, after Deas, *Long Jakes*. Oil on canvas, 33½ × 26 in.
Yale University Art Gallery, Mabel Brady Garvan Collection (1932.292).

Cat. no. 56. *Dragoons Fording Stream*.

by a known painter: William G. M. Samuel (1815–1902), who fought
in the Mexican War and with the Confederate Army, after which he
lived in San Antonio (Steinfeldt 1981).

56. *Dragoons Fording Stream,* ca. 1844
Oil on canvas, 12¼ × 18 in.
Present collection: Collection of Gerald and Kathleen Peters
Provenance: Philip Kearny; bequeathed to his son John Watts
 Kearny; by descent in the family; to David Silvette, Richmond, Va.,
 1951; to Dewey Galleries, Santa Fe, and Gerald P. Peters Gallery,
 Santa Fe, 1985; to William B. Ruger, Sr., 1992; to Christie's sale
 (New York City, December 5, 2002, lot no. 168); to the present col-
 lection, 2002
Alternative title: Dragoons Crossing River
References: *Schimmel 1988, pp. 56, 84; Conzelman 2002, p. 132,
 cat. no. 47

A "small" painting with the title *Dragoons Fording Stream* is listed
on the inventory of Philip Kearny's art collection that was drawn up
soon after his death. Unsigned, undated, and not listed under any
artist's name in the Kearny inventory, this painting is attributed to
Deas on the basis of its style. Both Kearny (1815–1862) and Deas
were on the 1844 Wharton expedition from Fort Leavenworth to the
Pawnee villages on the Platte River, and the subject of this picture is
likely to be an event from that summer. Another clue to the picture's
approximate date is the way the artist grouped mounted soldiers
above one tying his shoe, a figural combination that Deas employed
in the 1845 *Indian Group* (cat. no. 61), a picture that Philip Kearny
also owned.

 In a panoramic composition suggestive of vast western spaces,
dragoons oversee a procession of men, animals, and wagons
crossing a river. One wagon is marked "Hospital," the other "CF."
Although this subject is not documented in the diaries of either
Major Clifton Wharton (Wharton 1923–25) or Lieutenant J. Henry

Carleton (Carleton 1844–45), Deas's picture invokes the expedi-
tion's many arduous river crossings, possibly that of September
11, 1844. On that day, Wharton described the way the hospital and
Company F's wagons forded a river.

 David Silvette (personal correspondence, 1983) suggested that
some of the figures can be identified, notably, Lieutenant Philip
Kearny, who leads his Company F out of the river in the left fore-
ground. It may have been a gift to Lieutenant Kearny, who was not
only a member of Company F on the Wharton expedition but also
was related to Deas by the marriage of Deas's sister into the Watts
branch of Kearny's family. Kearny inherited his family's great
wealth and went on to distinguish himself as a soldier in the war
with Mexico, in which he lost an arm, and then in the Civil War,
where he was killed defending the Union at the battle of Chantilly.
He bequeathed *Dragoons Fording Stream* to his son John Watts
Kearny. It was held at the Kearny's New Jersey home, Bellegrove, un-
til about 1888, sometime after which it was listed on an insurance
policy. This policy specified that, like "Group of Indians" (*Indian
Group*, cat. no. 61), it was valued at $25.

 NOTE: *I am grateful to Adrienne Ruger Conzelman for assisting my study of
 this picture. Rebecca Lawton's astute research guided me to William Styple,
 who kindly provided the Kearny documents and determined the date of the in-
 surance inventory. Thanks, too, to Thayer Tolles for additional assistance.*

57. *The Indian Guide,* by 1845
Present collection: Unknown
Provenance: American Art-Union; distributed to Thomas Tryon, New
 York City, 1845
Alternative title: The Indian Guide; one of the Shawnee Tribe
References: Broadway Journal 1845b; AAU Transactions 1846, no. 19;
 Tuckerman 1846, p. 253; Lanman 1847, p. 16; McDermott 1950,
 pp. 302–303

The *Broadway Journal*'s critic saw *The Indian Guide* in the rooms of the American Art-Union, declared it "an admirable companion" to *Long Jakes,* which the artist had submitted the year before, and described it in detail:

> The Indian Guide is a half-breed; a tall gaunt figure, mounted on a pony, moving at a rapid gallop across a prairie; there is no other figure in sight, excepting an emigrant standing at his wagon in the extreme distance. The pony must be a veritable portrait; he is as characteristic in his hide and trappings as his rider. He has been shorn of every thing not essential to vitality—ears, mane, and tail; and his hide has been branded by the marking iron of successive owners. The Guide carries a long-barrelled fowling piece in his hand; and slung at his back, there is some kind of game that he has just killed. The purple sky, though apparently greatly exaggerated in color, is doubtless true to nature, and it helps to give an air of mystery and wildness to the whole composition. . . . The Indian stands at an impassable remove from civilization, but the half-breed forms a connecting link between the white and red races; we feel a sympathy for the Indian Guide that we never could for the painted savage, for we see that he has a tincture of our own blood, and his trappings show that he has taken one step towards refinement and civilized life.

The Art-Union distributed this painting in December 1845 and on the distribution list expanded its title to *The Indian Guide; one of the Shawnee Tribe.* Tuckerman elaborated in his December 1846 article on Deas, identifying the subject of *The Indian Guide* as a man "whose prototype was a venerable Shawnee who accompanied Major Wharton"— information that Tuckerman may have received from Deas. (Perhaps the expedition had more than one guide, but Carleton, one of the officers on the 1844 expedition, identified their guide as a Delaware Indian named Jim Rogers.)

Lanman, writing about the western travels he undertook in the summer of 1846, reported that he saw several pictures in Deas's St. Louis studio. Among them was one he called *The Indian Guide.* He wrote that Deas's subject "represents an aged Indian riding in the evening twilight on a piebald horse, apparently musing upon the times of old. The sentiment of such a painting is not to be described, and can only be felt by the beholder who has a passion for the wilderness." McDermott in 1950 believed that this was not the same *Indian Guide* as the one the *Broadway Journal* described in April and the Art-Union distributed in December 1845. Lanman, however, may have written about a work he had not actually seen and that Deas only described to him. Evidence to support this possibility is within Lanman's text: he also wrote about seeing *Long Jakes,* which had been distributed in December 1844 and so was not in Deas's studio in June 1846 when Lanman was in St. Louis. Further evidence is in the criticism directed at Lanman's book soon after its publication. Francis Bowen, reviewing *A Summer in the Wilderness* in 1849, accused Lanman of fabricating descriptions of sites he had not seen and events he had not witnessed. This may have been a personal or a literary squabble, but Bowen attacked Lanman specifically and viciously. He concluded that there was a risk that Lanman's book "might be fished up at a future day by some mousing historian, and quoted as the evidence of an eyewitness in relation to the aspect of the country, the condition of the Indians, and the conduct of the white traders at the present time in the region about the Upper Mississippi and Lake Superior" (*North American Review* 69, no. 145 [October 1849]: 440). (See also Richard T. Malouf's brief introduction to the 1978 reprint of *A Summer in the Wilderness* [Grand Rapids, Mich.: Black Letter Press].) Although Lanman may have seen *The Indian Guide* or another painting like it in Deas's studio, Bowen's words make me skeptical of Lanman's descriptions.

Whether or not Lanman saw it and whatever its title or its subject's identity, the painting has not been seen publicly since it was distributed to Thomas Tryon, for whom there is no listing in the New York City directories between 1840 and 1850.

58. *Winona,* by 1845

Present collection: Unknown

Alternative titles: Wenona; Winoni

References: Anglo American 1845; AAU Catalogue 1846; Tuckerman 1846, pp. 250–51; St. Louis Weekly Reveille 1847b

In a review of works on view at the American Art-Union in 1845, the critic for the *Anglo American* discussed *The Death Struggle* (cat. no. 59) and *Winona:*

> Of the subject of the other picture, "Winona," the story runs thus:—There was in the village of Keoxa, in the tribe of Wapasha, a young Indian female, whose name was Winona, which signifies "the first born." She had conceived an attachment to a young hunter who reciprocated it; they had frequently met, and agreed to an union in which all their hopes were centered; but on applying to her family the hunter was surprised to find himself denied; and his claims superseded by those of a warrior of distinction, who had sued for her. The efforts of her parents and relations to unite her with the man she disliked proved unavailing; remonstrance having failed, threats were resorted to, and the day was fixed for her nuptials with the warrior. "Well," said Winona, "you will drive me to despair; I said I loved him not, I could not live with him; I wished to remain a maiden, but you would not. You say you love me; that you are my father, my brothers, my relations, yet you have driven me from the only man with whom I wished to be united; you have compelled him to withdraw from the village alone, he now ranges through the forest, with no one to assist him, none to spread his blanket, none to build his lodge, none to wait on him; yet was he the man of my choice. Is this your love! But even it appears that this is not enough; you would have me do more; you would have me rejoice in his absence; you wish me to unite with another man, with one whom I do not love, with whom I never can be happy." The Indian camp was on the margin of Lake Pepin, from which arise precipices to a sheer height of 150 to 450 feet. While all were engaged in busy preparations for the festival, she wound her way slowly to the top of the hill; when she had reached the summit, she called out with a loud voice to her friends below; she upbraided them for their cruelty to herself and her lover. "You," she said, "were not satisfied with opposing my union with the man I had chosen, you endeavoured by deceitful words to make me faithless to him, but when you found me resolved upon remaining single, you dared to threaten me; you knew me not if you thought that I could be terrified into obedience; you shall soon see how well I can defeat your designs." The light winds which blew at the time, wafted the words towards the spot where her friends were; they immediately rushed, some towards the summit of the hill to stop her, others to the foot of the precipice, while all, with tears in their eyes, entreated her to desist from her fatal purpose. But she was resolved; she threw herself from the precipice, and fell, a lifeless corpse, near her distressed friends. The spot is still called the Maiden's Rock. Cases parallel to Winona's are not wanting in the civilized world.
>
> Winona is represented in the picture as in the act of throwing herself from the rock. It is a picture, that to our fancy will not compare with the "Death Struggle." The figure has, perhaps, in expression, too much of the *maniac*. The features, too, while they may be of the tribe of Wapasha, are not as interesting as those of a more beautiful female (for such might have been supposed Winona) would have been—there is a fullness in the breasts almost too great for "a maiden;" while the feet are not those of the young Indian beauties which we have usually seen represented; nevertheless, there is a very great deal to admire in the picture—the same bold effect, and good colour, which generally pervades the works of Mr. Deas.

The American Art-Union catalogue of October 10, 1846, listed *Winoni* (no. 201) among the three works Deas had "For Sale," distinguished from the list "For Distribution." Because the Art-Union managers did not purchase *Winona* in 1845, it may have been retained by or returned to the Art-Union in 1846, when it was called *Winoni.* Once again the Art-Union managers did not purchase it.

Cat. no. 59. *The Death Struggle*.

William Morris Hunt (American, 1824–1879), *The Horses of Anahita*, or study for *The Flight of Night*, ca. 1848, this cast, before 1880. Plaster, tinted, 18½ × 28 × 12 in. (47 × 72.4 × 30.5 cm). The Metropolitan Museum of Art, Gift of Richard Morris Hunt, 1880 (80.12). Image © The Metropolitan Museum of Art.

The story of Winona took various forms. The *Anglo American*'s critic proposed one motivation for her suicide—that her parents would not permit her to marry the man of her choice. Tuckerman offers another motivation—that she had been abandoned by her lover. In his December 1846 biographical sketch of Deas, Tuckerman described a painting he saw at the Art-Union (he did not specify the year):

> [It was] of an Indian maiden standing on a rock and gazing forth upon an immense prairie, her figure relieved against the evening sky and her whole air full of the poetry of grief. One could have surmised the tale at once. She had been abandoned by her lover, and was about to cast herself from that precipice. There she stood alone, calm and voiceless, watching the sun go down—as she had often done beside the faithless object of her devotion.

The painting received one more critical mention. Advocating for Deas's bid to fill the empty panel in the United States Capitol with a painting of *Rogers Clark and the Indian Council* (cat. no. 67), the critic for the *St. Louis Weekly Reveille* cited *Wenona* among the achievements that qualified Deas for the job, stating that "the artist who has shown his pathos in *Wenona,* his fierce passion in the *Death Struggle,* and his historic grasp in the embodying, we might say, of *Rogers Clark and the Indian Council,* may well be supported by the west as an artist worthy to represent it in the Capitol."

59. *The Death Struggle*, 1845
Oil on canvas, 30 × 25 in.
Inscribed, lower right: C Deas. / 1845
Present collection: Shelburne Museum, Shelburne, Vermont
Provenance: George W. Austen, New York City, 1845 until at least 1847; T. B. A. Hewlings, Philadelphia, by 1852; E. P. H., Philadelphia, by 1855; E. Hewlings, Philadelphia, by 1857, until at least 1858; Maxim Karolik, Newport, R.I., by 1954; to Electra Havemeyer Webb, New York City and Shelburne, Vt., for the present collection, 1959

Alternative title: Contest for a Beaver
References: Anglo American 1845; Broadway Journal 1845d; Herbert 1846b; *Athenaeum 1847, cat. no. 75; St. Louis Weekly Reveille 1847b; St. Louis Weekly Reveille 1847c; US Magazine 1847a, p. 64; NY Evening Post 1848a; *PAFA 1852, cat. no. 211; *PAFA 1855, cat. no. 427; *PAFA 1857, cat. no. 303; *PAFA 1858, cat. no. 213; McDermott 1950, pp. 303, 307; *Smithsonian Institution, 1954, p. 8, cat. no. 16; Coen 1969, pp. 125–26; Dorment 1971, p. 48; Parry 1974, pp. 143, 146; Glanz 1982, pp. 46–47; *Clark 1987, pp. 65–68; Johns 1991, pp. 73–78; *Schimmel 1991, p. 165; Thistlethwaite 1991, p. 23; Lubin 1994, pp. 89–91

The *Anglo American* announced in its review of September 6, 1845, that George W. Austen, "a gentleman of superior taste, and possessing a small but very select collection of pictures by the first American Artists," had acquired *The Death Struggle,* which, according to the *Broadway Journal,* was on view (no. 11) at the American Art-Union as the property of the artist. George Washington Austen, an auctioneer, became the treasurer of the Art-Union in 1846 and served on its Committee of Management until the organization ceased operation in 1851. Austen probably sold *The Death Struggle* in the wake of financial losses after the demise of the organization (see J. Gray Sweeney, "'Endued with Rare Genius': Frederic Edwin Church's *To the Memory of Cole,*" *Smithsonian Studies in American Art* 2, no. 1 (Winter 1988): 69n21). By 1852, *The Death Struggle* had been added to the collection of T. B. A. Hewlings, who was associated with Philadelphia and is listed in an 1857 city directory as a "broker." Hewlings also apparently lived in Washington, D.C., where in 1851 he commissioned from Thomas U. Walter an Italianate villa called Ingleside, with grounds designed by Andrew Jackson Downing. (The house still stands at 1818 Newton Street NW.) The last time *The Death Struggle* was shown at the Pennsylvania Academy of the Fine Arts annual exhibitions was in 1858, after which it disappeared from public view. Maxim Karolik acquired it, from a source unknown to me, almost a century later; it was published in his collection in 1954.

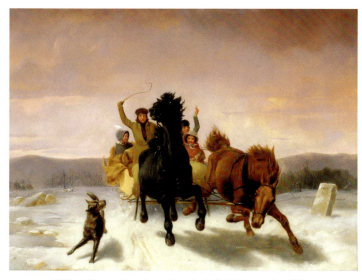

William Ranney (American, 1813–1857), *Sleighing,* ca. 1847. Oil on canvas, 30¾ × 42 in. Private collection.

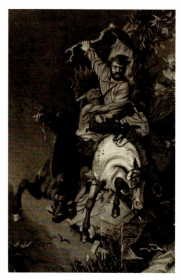

Cat. no. 59A. William G. Jackman, after Deas, *The Death Struggle.*

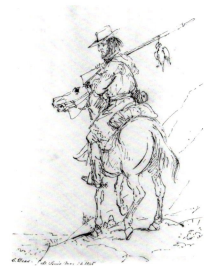

Cat. no. 60. *The Hunter.*

Deas's extraordinary frontal view of two terrified horses bears a provocative relationship to two works by his contemporaries. In 1848, William Morris Hunt modeled a relief sculpture of three plunging horses and an attendant that he later cast into plaster. One of the casts, called *The Horses of Anahita, or the Flight of Night,* is in the Metropolitan Museum of Art. The two horses at the right are strikingly similar to those in *The Death Struggle.* Hunt was living in Europe when *The Death Struggle* was exhibited in New York City and Boston, but he may have had access to William G. Jackman's reproductive print. Or both artists may have been inspired by a common source, such as plaster casts of antique or Renaissance/ Baroque sculpture. Kathryn Greenthal first proposed Robert Le Lorrain's (1666–1743) relief sculpture *Horses of the Sun* (1736–37) on a façade of the stables of the Hôtel de Rohan, Paris, as a source for *The Horses of Anahita.* (For a summary of scholarship on Hunt's sculpture, see Kathryn Greenthal, Paul M. Kozol, and Jan Seidler Ramirez, *American Figurative Sculpture in the Museum of Fine Arts, Boston* [Boston: Museum of Fine Arts, 1986], pp. 139–41.) Unless the Le Lorrain sculpture was reproduced as a print, it is difficult to see how Deas could have known of it.

William Ranney transformed Deas's two horses in *The Death Struggle* into the pair that thunders into our space in *Sleighing,* completed in time to be shown at the National Academy of Design in 1847 (Thistlethwaite 1991). Ranney was living in New York City and had a work on view at the American Art-Union in 1845, the year that *The Death Struggle* was shown there.

In 1971, Richard Dorment compared the "heroic sacrifice" he discerned in *The Death Struggle* to that of a work by British artist Benjamin Robert Haydon (1786–1846) titled *Marcus Curtius Leaping into the Gulf* (1836–42, Royal Albert Memorial Museum, Exeter), an idea Dawn Glanz pursued in 1982.

In *The Death Struggle,* Deas depicted a moment in a narrative that appears to be of his own creation: a white fur trapper and an Indian, mounted on horses who appear to be as terrified as their riders, plunge over a cliff in a fight to possess a beaver still caught in a trap.

Another Indian appears in the background, straining forward for a better look at the action. Deas combined highly finished details of gear and clothing with sketchier, blocked-in areas of shadow, particularly visible at the right.

NOTE: *I am indebted to Christopher Kent Wilson for suggesting to me the Hunt-Deas relationship and to Sally Webster for discussion about it.*

59A. William G. Jackman, *The Death Struggle,* 1846
 After Charles Deas, *The Death Struggle*
Steel engraving, 5¾ × 4¾ in., bound into volume
Inscribed in plate: C. Deas / W. G. Jackman / The Death Struggle / From the Original in the Possession of G. W. Austen, Esq. / Engd. for the N.Y. Illustrated Magazine
Present collection: American Antiquarian Society, Worcester, Massachusetts
References: Herbert 1846b; McDermott 1950, p. 303

Lawrence Labree, editor of the *New York Illustrated Magazine of Literature and Art,* commissioned this engraving of Deas's painting for the September 1846 issue. Like the engraving after *Long Jakes* (see cat. no. 55) in an earlier issue of the journal, this print accompanied a narrative commissioned from Henry William Herbert.

McDermott reproduced the engraving in 1950, using it as a stand-in for Deas's painting, which disappeared from public view in 1858 and was not rediscovered until 1954.

60. *The Hunter,* 1845
Pen and brown ink on paper, 8⁹⁄₁₆ × 6⅝ in.
Inscribed, lower left: C. Deas—St Louis. May 23, 1845
Present collection: Private collection
Provenance: From an album presented by Julia Colt Pierson (Mrs. William Jenkins Emmet) to "E. H. M.," in December 1856; Lydia Field Emmet, New York City; to Hester Alida Emmet (Mrs. Louis Bancel La Farge); to Benjamin La Farge; to Mr. and Mrs. Stuart P.

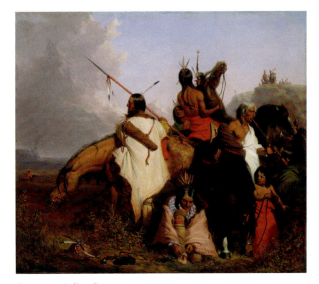

Cat. no. 61. *Indian Group.*

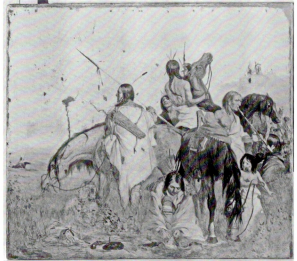

Infrared reflectography of Indian Group. Kimbell Art Museum Conservation Department.

Feld, New York City, 1968; by descent to the present collection
Reference: Clark 1987, p. 64

This drawing, which bears a modern title, is unusual for Deas in at least two ways. It is inscribed with a specific date and is executed in a medium that, as far as we know, the artist rarely chose. Whether designed to be an illustration or made as a gift for a friend, its first known appearance was in an album of drawings presented by Julia Colt Pierson Emmet (1829–1908) to a recipient known only by the initials "E. H. M." The painter Lydia Field Emmet (1866–1952), Julia Emmet's daughter, later owned the album and passed it along in the family. It is interesting to visualize this image of a rough westerner in an album belonging to a succession of accomplished eastern women who were at home in Paris, New York City, and the Berkshires and for whom hunting meant riding to hounds. An accomplished artist, Lydia Emmet may have appreciated Deas's deftly and boldly drawn image.

The subject of *The Hunter* relates it to descriptions of *The Indian Guide* (cat. no. 57).

NOTE: *I am grateful to Stuart P. Feld and Benjamin La Farge for their assistance in constructing the provenance of this drawing.*

61. *Indian Group,* 1845
Oil on canvas, 14⅛ × 16½ in.
Inscribed, lower left: C. Deas 1845
Present collection: Amon Carter Museum, Fort Worth, Texas
 (1980.42)
Provenance: Philip Kearny; bequeathed to his son John Watts
 Kearny, 1862; descended in the Kearny family; to Selkirk sale (St.
 Louis, May 5–10, 1980, lot no. 463); to James Maroney, Inc., New
 York City; to the present collection, 1980
*Alternative titles: Hunting Party of American Pawnee Indians; A Group
 of Sioux*
References: Tyler 1986; *Clark 1987, pp. 63–65

The first definitive listing of this picture, as "Indian Group" by "C. Deas," is in an inventory of the collection of Philip Kearny drawn up soon after Kearny's death fighting for the Union at the battle of Chantilly in 1862. Philip Kearny bequeathed *Indian Group* to his son John Watts Kearny. It was held at the Kearny's New Jersey home, Bellegrove, until at least 1888, sometime after which it was listed as "Group of Indians" on an insurance policy. The picture was valued at $25, and a handwritten note on the policy specifies that the picture hung in the dining room (documents in the William B. Styple Collection, Kearny, N.J.). When the Amon Carter Museum acquired this painting in 1980, before the Kearny documents were available, it was given the title *A Group of Sioux,* a picture first mentioned by Tuckerman in 1846 as "among the subjects which have recently occupied [Deas]" (p. 253). Nothing more is known of the work Tuckerman mentioned, and no painting by Deas has yet come to light that fits Tuckerman's title; *Indian Group* and *A Group of Sioux* may be the same picture.

Experts on Indian attire and appearance in the 1840s agree that the Indians in this picture appear to be Sioux. The date of this picture suggests that it is related to Deas's experience on the Wharton expedition in the summer of 1844. Lieutenant Philip Kearny, the painting's first owner, served on that expedition. Lieutenant J. Henry Carleton's description of the Pawnee conflict with the Sioux may help viewers understand what is being portrayed in *Indian Group:*

This tribe [the Pawnee]—being at war with many of its neighbors, and living as it does upon a vast prairie, where it is liable to attack at any moment, from the hordes of Camanches [*sic*] and Sioux, who lead a sort of nomadic life, like the Arabs, and are continually moving from place to place, making war indiscriminately with all whom they may meet, and subsisting entirely upon the buffalo, which they follow from one spot to another—is obliged continually to guard itself from surprise by keeping sentinels posted on the high bluffs for miles and miles on every side of its town. In summer

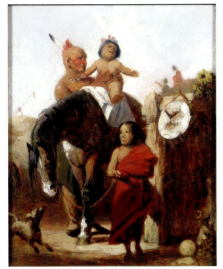

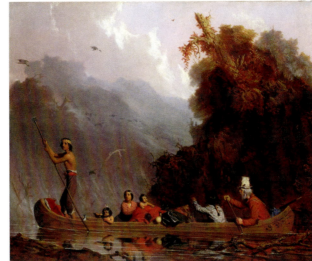

Cat. no. 62. *Figure Group of Sioux.*　　　　Cat. no. 63. *The Voyageurs.*

and winter, day and night, storm and sunshine, still are they there and watching out in every direction, with the eyes of eagles. Unseen themselves, they see everything that moves between them and the horizon. Where we should be unable hardly to distinguish a moving speck in the distance, they would at once recognise, for instance, a band of horsemen, or a herd of buffalo. Trained up to this duty from childhood, and being naturally quick and far-sighted, no doubt they are the best sentries in the world. (Carleton 1844–45, vol. 14, no. 48 [January 25, 1845]: 571)

As was his practice with other Native subjects, Deas filled this composition with specifically observed objects and attire. Notable are the spear; the catlinite pipe bowl; the quiver strapped to the back of one man and the bow and arrows held by another; the striped trade-cloth shirts over which are worn buffalo robes with painted borders; leggings and garters; feathered headdresses; ribbons and beads woven through braids; and the elk horn saddle on the darkest horse. The viewer's eye is drawn to the arrangement of still-life elements in the foreground. Carefully painted grasses provide a backdrop for a *gos-to-weh* (helmet) with feathers and beadwork, a flint-lock pistol and bullet pouch, and a pipe-tomahawk, all of which direct attention to the man who kneels to tie his moccasin.

Examination of *Indian Group* under infrared reflectography, undertaken by Claire Barry for the Amon Carter Museum, revealed that Deas sketched in and later scraped off a figure of a child under the neck of the horse on the left.

The frame appears to be original: it dates to the 1840s and was on the picture in 1980 when the painting was auctioned from the collection of a Kearny descendent.

NOTE: *I am grateful for the expertise of Claire Barry, chief conservator at the Kimbell Art Museum, Fort Worth, Texas, who undertook a full examination of the picture, and for the help of Rebecca Lawton and Thayer Tolles in my pursuit of the Kearny connection. William Styple kindly searched for references to Deas's pictures in his collection of Kearny documents; his research determined the date of the insurance inventory. For their help in identifying the dress and accoutrements in this picture I am grateful to Evan Maurer, David Penney,*

William Sturtevant, and Herman Viola. I owe an additional debt of gratitude to David Penney for many conversations that illuminated this painting for me.

62. *Figure Group of Sioux,* ca. 1845
Oil on canvas, 7⅜ × 6 in.
Present collection: The Westervelt Warner Museum of American Art, property of the Westervelt Company, Tuscaloosa, Alabama
Provenance: Ambassador J. William Middendorf II, Washington, D.C.; to James Maroney, Inc., New York City, 1984; to Mr. and Mrs. Al Luckett, Jr., New York City, 1984; to Sotheby's sale (New York City, December 3, 1987, lot no. 127); to the present collection
Alternative title: Figure Group
References: Clark 1987, p. 64

This oil sketch bears a compositional relationship to *Indian Group* (cat. no. 61). The sketch's heavy impasto as well as the shield and the large flowers at the upper right are unusual. One of these apparent inconsistencies may be explained by Lieutenant J. Henry Carleton's description of the Pawnees' cornfield as "literally fenced in by sunflowers" (Carleton 1844–45, vol. 14, no. 48 [January 25, 1845]: 571). The child in this picture resembles the one Deas painted out of *Indian Group.*

63. *The Voyageurs,* 1845
Oil on canvas, 31½ × 36½ in.
Inscribed, lower left: C. Deas. 1845.
Present collection: The Rokeby Collection
Provenance: Ancestors of the present owners by at least the 1860s; by descent to the present collection
References: *Clark 1987, pp. 68–71; *Schimmel 1991, pp. 176–78; Miller 1992, pp. 6–7; Schoelwer 1992, pp. 161–64

One of the present owners of *The Voyageurs* believes that his family may have purchased it soon after the Civil War from an impoverished Virginia family living in Washington, D.C., and that

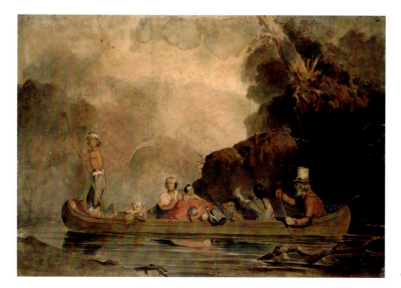

Cat. no. 64. *The Trapper and His Family.*

by the mid-1870s it was hanging at Rokeby, the family's home in the Hudson River Valley. Descendents believe that the subject of fur traders was appealing to the family because it related to the business of their Astor branch (correspondence, February 4, 1986). The painting has been on loan to the Metropolitan Museum of Art since 1968.

In 1984, Charles Collins, who seems not to have known of this painting, suggested that Deas's undated watercolor *The Trapper and His Family* (cat. no. 64) was a source for George Caleb Bingham's 1845 *Fur Traders Descending the Missouri* (The Metropolitan Museum of Art). Although there is no record of *The Voyageurs* having been on public view in St. Louis, Bingham may have seen the oil or the watercolor in Deas's studio after Bingham returned to that city in 1845.

The Voyageurs depicts a mixed-race family of fur traders headed upriver in a forbidding, beautifully realized landscape. Deas included a silver-striped, blue trade-cloth shirt; a typically European American high beaver hat; and Native headdresses and jewelry. He also painted domestic objects, such as the coffeepot strapped onto a covered pile of cargo. By inscribing the stern of the canoe "St. Pierre," Deas may have invoked the trading post at St. Peters, the early name of the village of Mendota across the Mississippi River from Fort Snelling.

64. *The Trapper and His Family,* ca. 1845
Graphite, watercolor, and opaque color on cream paper, 13⅜ × 19½ in.
Present collection: Museum of Fine Arts, Boston, Gift of Maxim
 Karolik for the M. and M. Karolik Collection of American
 Watercolors and Drawings, 1800–1875 (60.412)
Provenance: Maxim Karolik, Newport, R.I.; to the present collection,
 1960
References: *MFA Boston 1962, vol. 1, cat. no. 252; Collins 1984

Little is known of Deas's working methods, but this watercolor, neither signed nor dated, and sketchy and unfinished in areas,

may be a study for the finished oil *The Voyageurs* (cat. no. 63). In 1984, Charles Collins suggested that this undated watercolor was a source for George Caleb Bingham's 1845 *Fur Traders Descending the Missouri* (The Metropolitan Museum of Art).

65. *Hunters on the Prairie,* by 1846
Present collection: Unknown
Reference: Tuckerman 1846, p. 253

This painting is known only by Tuckerman's inclusion of the title in a list of Deas's "recent" works.

66. *The Oregon Pioneers,* by 1846
Present collection: Unknown
Provenance: American Art-Union; distributed to D. A. Noble,
 Monroe, Mich., 1846
References: AAU Transactions 1847, no. 122; St. Louis Weekly
 Reveille 1847a; US Magazine 1847a, p. 64; McDermott 1950, p.
 307

The American Art-Union paid $230 for Deas's framed painting *The Oregon Pioneers* (Minutes of the Executive Committee, December 24, 1846, Records of the American Art-Union, New-York Historical Society Library) and distributed the picture to D. A. Noble of Monroe, Michigan. This individual was probably David Addison Noble (1802–1876), a Massachusetts-born attorney and politically active Democrat who moved to Monroe in 1831. In addition to his law practice, Noble served as Monroe city recorder (1838, 1839, and 1844–50), mayor (1852), prosecuting attorney, probate judge, two-term alderman, member of the Michigan House of Representatives (1847, 1848), U.S. Congressman (1853–55), and manager of the Louisville, New Albany and Chicago Railroad. In 1864, he was a delegate to the Democratic National Convention.

The critic for the *United States Magazine and Democratic Review* saw *The Oregon Pioneers* at the Art-Union and lamented how far

Deas had declined from his high achievement the year before with *The Death Struggle:*

> Visitors to the [American Art-Union] exhibition of last year will have remembered Mr. Deas' picture of the "Death Struggle," which is one of the most spirited and effective works ever hung upon its walls. This painting displayed powers of a very high order, and the admiration it elicited was general and enthusiastic. The same artist shortly afterwards produced one entitled the "Oregon Pioneers," which was so inferior as to have led us at first to doubt that it was executed by him. There has seldom been a more lamentable falling off. This work has been treated in the most careless, and certainly not the happiest style of the painter. The coloring is gaudy, and the composition devoid alike of that species of grace and character that we might naturally have looked for in the treatment of this subject. The faces appear to have been drawn from one model, and that a somewhat unmeaning one. The poney [*sic*] introduced, which is partially hid, is, with the exception of the head, remarkably defective. The artist has carefully concealed the legs and feet in order to avoid the trouble of painting them. That he could have done so with the greatest success is amply shown by the many admirable horses he has painted. Mr. Deas, when he puts forth all his capabilities, is one of our ablest painters. In the delineation of Indian life and physical characteristics, we believe he is unsurpassed, and it is therefore [a] matter of regret that he should allow any work to leave his easel which cannot be regarded as at least equal to those he has already produced. The subjects in which he excels, fortunately admit the display of a knowledge of the figure and bold execution, and these requisites he possesses in an eminent degree.

On February 8, 1847, the *St. Louis Weekly Reveille* excerpted part of this review. In a show of hometown pride, the St. Louis newspaper left out all the negative comments and so carried no mention of *The Oregon Pioneers.*

67. *Rogers Clark and the Indian Council,* by 1846
Present collection: Unknown
References: Journal of the U.S. House 1846, p. 124; Journal of the U.S. Senate 1846, p. 86; St. Louis Weekly Reveille 1846c; Tuckerman 1846, p. 253; Anglo American 1847a; Lanman 1847, p. 17; St. Louis Weekly Reveille 1847b; St. Louis Weekly Reveille 1847d; NY Evening Express 1848; Fairman 1927, p. 107

Described by Tuckerman as "the most important epic subject which has engaged [Deas's] attention" and by Lanman as "the picture upon which Mr. Deas's fame will probably rest," *Rogers Clark and the Indian Council* is known today only through written descriptions. The work was Deas's bid to fill the panel in the Rotunda of the U.S. Capitol left vacant by the sudden death of Henry Inman, the artist originally chosen. The replacement was to be selected by a congressional competition to which Deas submitted a colored sketch (probably in oil) on the theme of General George Rogers Clark (1752–1818).

The Rotunda competition offered an opportunity for regional favorites to vie for a chance to show their work in the national seat of democracy. St. Louis was keen to have western interests represented by a local artist, and the city rallied around one of its most prominent resident painters. Support for Deas ranged from promotional newspaper articles to an impressive petition to Congress, drafted by Charles Drake on behalf of a group of St. Louis citizens. Petitions were submitted to the House and to the Senate on November 25, 1846, and were referred to the Committee on the Library for consideration (National Archives, Record Group 128, 29th Congress [House and Senate]). In the end, however, Deas lost to another westerner: William Powell of Ohio won the commission for his *Discovery of the Mississippi by De Soto, A.D. 1541.*

Deas's subject, as reported by Lanman, was the moment in 1786 when Clark, "about to be murdered by a council of Indians at North-Bend, threw the war-belt in the midst of the savages, with a defying shout, and actually overwhelmed them with astonishment, thereby

saving his own life and those of his companions." The House and Senate petitions stated that Deas's sketch "represented the assemblage at the moment of General Clark's stomping his foot upon the wampum."

Lyman C. Draper, the first superintendent of the State Historical Society of Wisconsin, searched for the Deas sketch in the early 1870s while he was preparing a biography of George Rogers Clark. He could not locate the sketch but did discover that it might have been based on an earlier work by an amateur artist. In notes of his 1868 interview with Meriwether Lewis Clark, Draper stated, "General M. L. Clark drew the original sketch of the [George Rogers] Clark treaty [of] Jan. 1786, which Chs. Deas painted—intending to be a candidate, Col. [Thomas Hart] Benton aiding, for a large picture for a panel in the National capitol" (Lyman Copeland Draper Papers, State Historical Society of Wisconsin).

Deas's sketch, which was delivered to Congress by U.S. Representative James B. Bowlin of Missouri, is still missing.

68. *Setting Out for the Mountains,* by 1846
69. *Returning from the Mountains,* by 1846
Present collection: Unknown
Reference: Lanman 1847, pp. 16–17

This pair of pictures is known only through the reporting of Lanman, who described them in great detail after seeing them in Deas's studio in the summer of 1846:

> In a picture called Setting out for the Mountains, Mr. Deas has represented a species of American Cockney, who has made up his mind to visit the Rocky Mountains. He is mounted on a bob-tailed, saucy-looking pony, and completely loaded down with clothing, pistols, guns, and ammunition. He is accompanied by a few covered wagons, a jolly servant to be his right-hand man, and two dogs, which are frolicking on the prairie ahead, and while the man directs the attention of his master to some game, the latter shrugs

his feeble shoulders, seems to think this mode of travelling exceedingly fatiguing, and personifies the latter end of a misspent life. You imagine that a few months have elapsed, and, turning to another picture, you behold our hero Returning from the Mountains. Exposure and hardships have transformed him into a superb looking fellow, and he is now full of life and buoyancy, and riding with the most perfect elegance and ease a famous steed of the prairies. The wagons, servant and dogs, are now in the rear of our adventurer, who, comically dressed with nothing but a cap, a calico shirt, and pair of buckskin pantaloons, is dashing ahead, fearless of every danger that may happen to cross his path. These pictures completely epitomize a personal revolution which is constantly taking place on the frontiers.

70. *Western Prairie,* by 1846
Oil on canvas, 34 × 49 in.
Present collection: Unknown
Provenance: Gift of the artist to the St. Louis Mercantile Library, 1846
Reference: Clark 2000, p. 15

Charles Deas gave *Western Prairie* to the St. Louis Mercantile Library in its founding year. The library rewarded his generosity with a five-year beneficiary membership, making him the institution's first artist-member (Board of Direction Minutes, March 10, 1846). According to Clarence Miller, who was director of the library betwen 1942 and 1958, *Western Prairie* was the first work of art exhibited at the library ("Forty Years of Long Ago: Early Annals of the Mercantile Library Association and Its Public Hall, 1846–1886," unpublished manuscript, St. Louis Mercantile Library, p. 7). Its residence there was brief; it has been lost since 1859.

71. *The Wounded Pawnee,* by 1846
Present collection: Unknown
Provenance: American Art-Union; distributed to Edwin Rostron, Providence, R.I., 1848

Alternative title: Wounded Pawnee Chief

Reference: AAU Catalogue 1846; Tuckerman 1846, p. 253; Home
 Journal 1848; AAU Transactions 1849, no. 213

The American Art-Union catalogue of October 10, 1846, listed *The
Wounded Pawnee* (no. 221) among the three works Deas had "For
Sale," distinguished from the list "For Distribution." Whether Deas
left it at the Art-Union for two years or submitted it again, the man-
agers purchased it in October 1848 (calling it *Wounded Pawnee
Chief*) with two other paintings for $250 (Minutes of the Committee
of Management, October 5, 1848, Records of the American Art-
Union, New-York Historical Society Library). In December 1848, the
Art-Union distributed the picture to Edwin Rostron of Providence,
R.I. There are no listings for Rostron in the Providence directories
of this period. Because this is an unusual name, this individual may
have been the artist "Rostron" who in September 1854 showed a
Newport seascape and listed his home address as New York City in
the catalogue of the first annual exhibition of the Rhode Island Art
Association. The New York City directories of this time, however, list
no one by that name.

Tuckerman (pp. 250–51) described a picture he saw at the Art-
Union (he did not specify the year) that is possibly *The Wounded
Pawnee,* declaring that it "represented a Pawnee galloping on an
unshorn and unharnessed horse across the prairie. Its authenticity
was self-evident, and everything about the rider and his steed in per-
fect keeping."

72. *The Last Shot,* 1846
Oil on canvas, 36 × 28 in.
Present collection: Unknown
Provenance: American Art-Union; distributed to F. H. Flagg,
 Tallahassee, Fla., 1847
Alternative title: Captain Walker's Encounter with the Ranchero
References: St. Louis Weekly Reveille 1846b; Tuckerman 1846, p.
 253; Anglo American 1847a; Lanman 1847, p. 17; Literary World

1847a; Literary World 1847e, p. 303; NY Evening Post 1847; AAU
Transactions 1848, no. 86

The Last Shot represents an incident from the Mexican War, during
the battle of Resaca de la Palma on May 9, 1846. There the former
Texas Ranger Samuel H. Walker (1817–1847), a captain in Major
General Zachary Taylor's army, fought a ranchero, one of the irregu-
lar Mexican cavalrymen in Mexico's Major General Mariano Arista's
army.

The *Weekly Reveille* reported on August 31, 1846, that Deas's
painting was on view "in a new picture frame establishment in
Glasgow's row." (This is probably Wooll's but possibly Jones's, both
of which sold frames and exhibited paintings on Glasgow's Row, the
popular name for Fourth Street.) The painting struck a chord with
the public. The *Reveille*'s critic went on to describe the picture:

> The subject is selected from late events upon the Rio Grande, and
> represents the Texan hero, *Walker,* prostrate upon the ground, his
> horse shot under him by a Mexican *Ranchero*. The latter, holding
> his horse by the rein, has received the fire of the fallen Ranger's
> pistol at the moment he was approaching to stab him with his
> knife. The position of the parties is natural, and the scene wild
> and picturesque. The firm, determined countenance of the pros-
> trate soldier, the falling knife of the treacherous enemy, and his
> look of mingled surprise and agony as he staggers back from the
> deadly fire of his supposed helpless foe, —the bleeding horse of
> the conqueror, and the startled and restive attitude of the wounded
> Mexican's steed, all make up a highly spirited and striking picture.
> The painting is destined for Cincinnati. It yesterday attracted the
> attention of hundreds, and received from connoisseurs high praise
> as a work of art.

Although there is no record of the painting's visit to Cincinnati,
it surfaced at the American Art-Union in New York City in 1847 and
met with a more restrained reception there. A critic for the *Anglo*

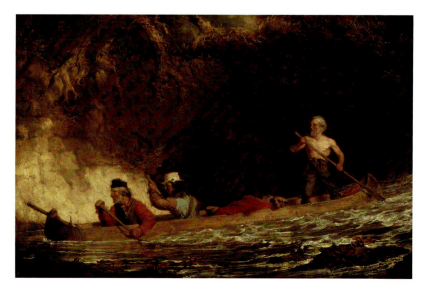

Cat. no. 73. *Voyageurs.*

American reported seeing it there on February 6, 1847, and noted that "the picture is kitcat size [an English canvas size of 36 × 28 inches], has all the force, boldness and freedom of drawing and color characteristic of this artist's works, and though the subject may not be so desirable for a permanent collection, it will doubtless find a ready purchaser." On October 30, 1847, the *Literary World*'s critic used a line (150) from Chaucer's Prologue to *The Canterbury Tales* to mock Deas's picture or to attack those of falsely refined sensibilities, as Chaucer had done:

> The subject of [*The Last Shot*] will, undoubtedly, find an occasional admirer, but we think the committee unwise to purchase it for a promiscuous distribution. They have much to answer for should it fall to the lot of some meek-minded individual, some poor man, "Who all is conscience and tender heart;" for the horror of the picture would curdle all the milk of human kindness in his breast. The hideous aspect of the dying "ranchero" would haunt him like a night-mare, and the daily contemplation of it at breakfast-time would destroy his appetite, and his peace of mind for ever.

Henry Tuckerman wrote much of the art criticism published in the *Literary World,* yet I find it unlikely that he was the author of this piece. Tuckerman preferred genre and landscape to history paintings such as this, but he made no negative statements about *The Last Shot* when he mentioned it in his biographical article on Deas published in *Godey's* in December 1846. (On Tuckerman's authorship of the *Literary World*'s art criticism, see David Dearinger, "Annual Exhibitions and the Birth of American Art Criticism to 1865," in *Rave Reviews: American Art and Its Critics, 1826–1925,* ed. Dearinger [New York: National Academy of Design, 2000], pp. 76–77.)

Against the "advice" of the *Literary World*'s critic, the American Art-Union managers purchased *The Last Shot,* together with *The Mountain Pass (The Trapper,* cat. no. 75), for $340 (Minutes of the Executive Committee, April 14, 1847, and October 9, 1847, Records of the American Art-Union, New-York Historical Society Library). F. H. Flagg, to whom *The Last Shot* was distributed in December 1847, was probably Francis H. Flagg (1811–1872), a Massachusetts-born merchant and alderman soon to be appointed honorary secretary of the American Art-Union. In later years, Flagg became treasurer of the Florida Central Railroad. An undated note attached to the back of the frame of *Mounted Soldier* (cat. no. 4) states that *The Last Shot* belonged to a collector in the Middle West, which may indicate yet another owner.

Walker was killed in the Mexican War on October 9, 1847, and became a national hero. One contemporary critic noted that the figure is "said to be a good portrait" and that the picture "possesses unusual interest at the present time" because Captain Walker had recently died in Mexico (undated, unidentified review of pictures at the Art-Union in 1847, newspaper cuttings, vol. 1, AAU Records).

NOTE: *Thanks to Howell Chickering for helping me interpret the Chaucer passage.*

73. *Voyageurs,* 1846
Oil on canvas, 13 × 20¼ in.
Inscribed, lower left: C. Deas. / 1846.
Present collection: Museum of Fine Arts, Boston, Gift of Maxim Karolik for the M. and M. Karolik Collection of American Paintings, 1815–1865 (46.855)
Provenance: James E. Yeatman, by 1860 until at least 1871; Healy Galleries, St. Louis, by 1922; C. W. Lyon and Co., New York City, by 1935; to Macbeth Gallery, New York City, 1935; to Stephen C. Clark, New York City, 1935; to Macbeth Gallery, 1936; to Francis P. Garvan, New York City, 1936; to Estate of Francis P. Garvan, 1937; to Macbeth Gallery, 1943; to Stephen C. Clark, 1943; to Macbeth Gallery, 1944; to Maxim Karolik, Newport, R.I., 1944; to the present collection, 1946

Alternative titles: The Voyageur; Canadian Voyageurs; Running the Rapids; Shooting the Rapids

References: Tuckerman 1846, p. 253; Literary World 1847c, p. 397; *NAD 1847, cat. no. 124; St. Louis Weekly Reveille 1847d; U.S. Magazine 1847b, p. 464; *Western Academy 1860, cat. no. 131; *Mississippi Valley Sanitary Fair 1864, cat. no. 42; *St. Louis Mercantile Library, 1871, cat. no. 97; Baur 1947, p. 281; MFA Boston 1949, cat. no. 97; McDermott 1950, pp. 308–309; Glanz 1982, pp. 47–48; *Clark 1987, pp. 70–71

The Art-Union expressed interest in the progress of this picture: "What of the Voyageurs? Have you nothing now under weigh for me?" wrote corresponding secretary Robert F. Fraser to Deas on November 18, 1846 (Records of the American Art-Union, New-York Historical Society Library). Yet Deas submitted it instead to the National Academy of Design. In a letter from St. Louis dated February 1, 1847, Deas informed the National Academy's curator, John F. E. Prud'homme, that Deas had just sent him two works: *Voyageurs* and *The Mountain Pass* (*The Trapper*, cat. no. 75). He asked that if they failed to sell (at $200 each), Prud'homme send them to the Art-Union at the close of the National Academy exhibition (John F. Kensett Papers, Manuscripts and Special Collections, New York State Library, Albany). Because Deas did not send *Voyageurs* to the Art-Union, the painting may have found a buyer during the National Academy show despite its poor critical reception while on view there. This buyer may have been a fellow St. Louisan, James E. Yeatman (1818–1901), for *Voyageurs* was in Yeatman's collection by 1860 and remained there until at least 1871. Yeatman was a banker, a civic leader, and an art collector who was the first president of the St. Louis Mercantile Library and a founder of that city's Western Academy of Art. He showed *Voyageurs* at the Western Academy in 1860 and at the Mississippi Valley Sanitary Fair in 1864 as part of his wide-ranging efforts to raise funds for medical relief of Union soldiers during the Civil War.

Tuckerman included a picture he called *The Voyageur* "among the subjects which have recently occupied [Deas]." The critic may have referred to a now-unknown single-figured picture, to the Museum of Fine Arts painting, or to *The Voyageurs* of 1845 (cat. no. 63). Deas significantly transformed the theme of figures navigating a western river that he had established in his earlier treatment of the subject: three men replace the mixed-race family of the earlier picture, and they navigate in a more constricted space, squeezed between a tangle of tree roots across the top of the composition and the foreground's whitewater. None of these voyageurs engages viewers. They concentrate instead on navigation: even the dog peers anxiously over the port side.

Deas painted no more rugged, even grizzled, troop than this trio of voyageurs, which, curiously, was owned by a trio of important American art collectors in the 1930s and 1940s. Robert McIntyre of the Macbeth Gallery guided the passage of the picture he first called *Shooting the Rapids* from collection to collection over a period of a dozen years. The gallery's records do not specify why Stephen C. Clark owned the picture twice, but McIntyre traded on the artist's rarity to increase its price from $275, at which he sold it to Clark in 1935, to $1,500, the price Maxim Karolik paid in 1944 (Macbeth Gallery Papers, Archives of American Art, Smithsonian Institution). Clark may have used this painting in trade for other American pictures that McIntyre helped him acquire for the New York State Historical Association's newly organized Fenimore Art Museum in Cooperstown. (On Clark's nineteenth-century American purchases, see Gilbert T. Vincent and Sarah Lees, "A Life with Art: Stephen Carlton Clark as Collector and Philanthropist," in *The Clark Brothers Collect Impressionist and Early Modern Paintings,* by Michael Conforti, James A. Ganz, Neil Harris, Sarah Lees, and Gilbert T. Vincent, with contributions by Daniel Cohen-McFall et al., 160–65 [Williamstown, Mass.: Sterling and Francine Clark Art Institute; New Haven, Conn.: Yale University Press, 2006].)

Cat. no. 74. *Judge Luke E. Lawless.*

74. *Judge Luke E. Lawless,* ca. 1846
Oil on canvas, 30 × 25 in.
Present collection: Missouri Historical Society, St. Louis
Provenance: Alexander J. P. Garesché, St. Louis; gift to the present
 collection, 1882
References: McDermott 1950, p. 301; Clark 2000, p. 26

Luke Edward Lawless was born in Dublin in 1781. He went to St. Louis in 1824 to practice law and was elected to a three-year term as judge of the circuit court in 1831. When fellow attorney Alexander Garesché presented Deas's portrait of Lawless as a gift to the Missouri Historical Society in 1882, the society's secretary, O. W. Collet, used the occasion as an opportunity to reminisce specifically about Deas, whom he had known slightly, and to comment more generally about the status of artists in 1840s St. Louis. Collet wrote that Deas probably had "a hard struggle to maintain himself, as painters were but poorly remunerated in St. Louis when he lived here; and this may have had a depressing effect upon his spirits." He acknowledged that Deas had to paint portraits "less from preference than necessity" and that while Deas's "portraits are the less meritorious of his productions, and show more his deficiencies . . . [the Lawless portrait] is, perhaps, one of Deas['s] best efforts in portraiture." Collet lamented that "already Deas is well nigh forgotten in the city in which he long dwelt and practiced his art" (Minutes, June 20, 1882, pp. 167–78, Missouri Historical Society). Just how forgotten is suggested by a photograph of Lawless's portrait taken in 1906 that shows a "Geo. Bingham" signature added at the lower right. It was removed sometime in the 1980s.

The portrait is unsigned and undated, but Collet believed that Deas had painted it not long before Lawless's death in September 1846. Deas showed the lawyer in a formally posed, three-quarter view and holding over his left arm a robe that might refer to his position as a judge. Deas set a severe mood for the portrait by contrasting the white of Lawless's pleated shirtfront with the black of his jacket and cravat, and Deas revealed nothing beneath the judge's public mask. The only animation in Lawless's stiff demeanor is his left hand tugging slightly at his jacket. From tightly clasped lips to hawklike nose, Lawless's sharp facial features are crisply defined. As in many portraits of European Americans of the period, his eyes focus on something beyond us in what historian Alan Trachtenberg called "the guise of introspection or reflection" in the "traditional style of eminence and dignity" (*Reading American Photographs: Images as History, Mathew Brady to Walker Evans* [New York: Hill and Wang, 1989], p. 46). Deas might or might not have known something of Lawless's record. Among the judge's rulings was his refusal to hear the case against the murderers of a black man named Francis McIntosh who in 1836 was burned at the stake by a mob in St. Louis. Lawless gave as his reason the fact that a majority of the citizens of St. Louis countenanced the act. The abolitionist press continued to cite Lawless's name into the next decade (see, for example, *The American Anti-Slavery Almanac for 1840,* vol. 1, pp. 5, 23 [fig. 2.6, this volume]).

75. *The Trapper,* ca. 1846
Oil on canvas, 26¾ × 34 in.
Present collection: Unknown
Provenance: American Art-Union; distributed to J. W. Bingham, New
 York City, 1847
*Alternative titles: The Mountain Pass; Mountain Trapper; A Hunter
 Pursued by a Party of Indians*
References: Tuckerman 1846, p. 253; Literary World 1847d; Literary
 World 1847e, p. 303; London AAU Journal 1847; *NAD 1847, cat.
 no. 199; St. Louis Weekly Reveille 1847c; St. Louis Weekly Reveille
 1847d; U.S. Magazine 1847b, p. 464; AAU Transactions 1848, no.
 89; McDermott 1950, pp. 308–309; Glanz 1982, pp. 45–46, 49

Writing in *Godey's* in December 1846, Tuckerman included *The Trapper* "among the subjects which have recently occupied [Deas]."

William Ranney, *The Trapper's Last Shot,* ca. 1850. Oil on canvas, 18 × 24 in. Courtesy of The Anschutz Collection.

Soon after, on February 8, 1847, the *St. Louis Reveille* reported that a painting with this title was on view at Wooll's picture-framing establishment. The newspaper offered a detailed description:

We yesterday, in Mr. Wooll's store, on Fourth Street, enjoyed the pleasure of viewing another masterly production, by the talented *western* artist, Deas. The picture represents a *Trapper* on horseback upon a platform of the mountains, sketched at the moment, apparently, when some noise in his rear has awakened his attention. Resting his right foot in the heavy wooden stirrup, he has drawn the other out, and, with body turned in the saddle, is holding his rifle ready for any hostile surprise. The horse, his head turned on one side, is also listening attentively to the alarm. In the back ground is a cold, bleak sky, slightly tinged by the setting sun; and directly in the solitary wayfarer's path lies a skull, bearing in its cloven front the mark of a savage murder. The whole picture conveys at a glance the lonely, perilous and daring character of the western trapper. The artist, in every point, has given it to the life; dress, accoutrements, horse, everything, is as it might be met in the neighborhood of the Sweetwater, the Red Buttes, or the Wind River mountains. There is no fear portrayed in the countenance—no surprise; but a calm, collected face, clear eye and firm mouth—the very personation of a mountain rover, used to danger and ready for the encounter. Our ability to describe this truly fine painting falls far below its merit; we can but direct the attention of connoisseurs to it—when seen it speaks for itself.

Deas then submitted the picture to the National Academy of Design. He called it *The Mountain Pass,* stated its dimensions, and priced it at $200 when he wrote to the National Academy's curator, John F. E. Prud'homme, on February 1, 1847, that he was sending it, along with *Voyageurs* (cat. no. 73), for the spring exhibition (John F. Kensett Papers, New York State Archives). He chose the National Academy over the Art-Union despite the interest that Charles D. Drake, an honorary secretary and agent of the Art-Union in St.

Louis, had expressed the month before in the artist's "just finished . . . picture of a Rocky Mountain Man" (letter to Robert F. Fraser, corresponding secretary, American Art-Union, New York City, January 19, 1847, Records of the American Art-Union, New-York Historical Society Library). That Drake and Deas referred to the same picture by different names is confirmed by the *Reveille*'s critic who on February 15, 1847, wrote that Deas was sending his picture of a trapper east with *Voyageurs*. The *Reveille*'s critic combined the two previous titles and called it *Mountain Trapper.*

Interestingly, when London's *Art-Union Monthly Journal* included it in a review of the National Academy of Design's exhibition, the critic emphasized an Indian presence (implied or actual?) in the work that earlier critics had ignored: "His best picture is in the present exhibition: the subject, 'A Hunter pursued by a party of Indians;' he has just mounted the top of a rocky eminence, and checks his horse to reconnoitre his pursuers. There is an air of wildness and daring in the whole composition—of half-savage life and freedom from the restraints of civilization, of which the readers of Cooper's novels can form but an inadequate conception."

The critic for the *Literary World* (June 12, 1847), who saw *The Mountain Pass* at the National Academy of Design exhibition, thought it was better than *Voyageurs* (cat. no. 73) but was not as enthusiastic as the London critic: "This is the best picture by this artist in the present exhibition. The action of the figure turning in the saddle, as if in sudden surprise, is good. The horse, too, appears to have caught the alarm, which is happily expressed in his eye. The neck of the horse is badly inserted, and the fore feet stand too rigid and uniform for the position of the hind feet. In color the picture is not altogether agreeable—it partakes too much of the pink, and the execution is crude, sketchy."

The painting did not find a buyer at the National Academy of Design. In the fall, Deas submitted it to the American Art-Union, whose managers purchased it (as *The Mountain Pass,* as it had been called at the National Academy of Design), along with *The Last Shot*

Cat. no. 77. *Indians Coming down a Defile.*

(cat. no. 72), for $340 (Minutes of the Executive Committee, April 14 and October 9, 1847). J. W. Bingham, to whom the painting was distributed in December 1847, may be John W. Bingham, listed as a cabinetmaker in the New York City directories.

Deas's contemporaries admired and wrote about his painted representations of horses. One such notice appeared in the *St. Louis Weekly Reveille* (April 5, 1847). Giving no further context, the *Reveille*'s critic wrote that "Charles Deas has just completed a picture which, in the opinion of many, is his masterpiece, so far. If you want to see a horse with an actual hide on, go and look at this painting." This critic may have referred to *The Trapper* or to *Prairie on Fire* (cat. no. 78), which the *Literary World*'s critic reported to have seen in the artist's studio in April 1847 (April 24, 1847).

The *Reveille*'s description of the figure twisting in his saddle (February 8, 1847) suggests that *The Trapper* may have inspired William Ranney's versions of *The Trapper's Last Shot,* as Dawn Glanz proposed in 1982 (p. 49).

76. *Landscape,* by 1847
Present collection: Unknown
References: Anglo American 1847b; Literary World 1847c, p. 396;
 *NAD 1847, cat. no. 110; U.S. Magazine 1847b, p. 464; McDermott
 1950, p. 309

Critics gave a cold reception to *Landscape,* which Deas exhibited at the National Academy of Design's exhibition of 1847. The focus of their distaste was Deas's use of color. The *Anglo American* observed that "the thing which startles the spectators in general is the colours which the painter has made very peculiar in this painting, but which may be correct enough in the West, where we suppose is the location of this landscape." The *Literary World* was harsher: "It is very evident that landscape is not this artist's forte. In color this picture is positively bad, and there is little else in it to entitle it to consideration." While the critic for the *United States Magazine and*

Democratic Review seems to cover all three pictures Deas showed at the National Academy of Design in 1847 (the other two are *Voyageurs,* cat. no. 73, and *The Mountain Pass,* or *The Trapper,* cat. no. 75), his comments accord with the critiques that others lodged against *Landscape:* "Mr. Deas seems determined to see, or at least to paint everything *couleur de rose.* His skies, his mountains, his water, his men and his horses, all appear to have dipped into some maiden lady's carmine saucer, so roseate are they. 'Tis a pity that he thus spoils good pictures."

The only landscape painting by Deas dated 1847 that has come to light is *Indians Coming down a Defile* (cat. no. 77), which may be the landscape he showed at the National Academy of Design and that received these reviews.

77. *Indians Coming down a Defile,* 1847
Oil on canvas, 14 × 20 in.
Inscribed, lower left: C. Deas / 1847.
Present collection: Stark Museum of Art, Orange, Texas
Provenance: Kennedy Galleries, New York City, 1969; to private collection, St. Louis, 1982; to Gallery of the Masters, St. Louis, ca. 1982; to private collection, Minneapolis, ca. 1982; to Winthrop Art Gallery, Indianapolis, 1992; to the present collection, 1992

This landscape was given a modern title when it was acquired by Kennedy Galleries in 1969. The light of a pink sunset starkly outlines a lone, bare tree trunk in the left middle ground and casts into shadow the disproportionately large figure at the right who, wrapped in a red blanket, leads a group of mounted Indians down a hill.

This landscape might be the one Deas exhibited at the National Academy of Design in 1847 (see information given for cat. no. 76).

The stencil on the back, "PREPARED / BY / ED*WD* / DECHAUX / NEW-YORK," identifies the canvas maker. This stencil mark is in a form used by the Dechaux company in the 1840s (Katlan, *American*

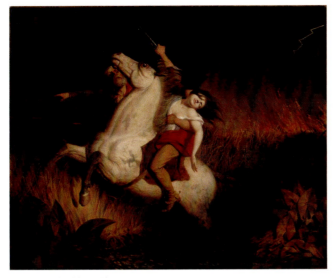

Cat. no. 78. *Prairie on Fire.*

Artists' Materials Suppliers Directory, vol. 1, p. 18). The Dechaux company's stencil also appears on the verso of the *Portrait of Robert Watts* (cat. no. 8) and on the verso of *A Solitary Indian, Seated on the Edge of a Bold Precipice* (cat. no. 81).

78. *Prairie on Fire,* 1847
Oil on canvas, 28¾ × 35¹⁵⁄₁₆ in.
Inscribed, lower right: 1847. / C Deas.
Present collection: Gift of Mr. and Mrs. Alastair Bradley Martin, the
 Guennol Collection, Brooklyn Museum (48.195)
Provenance: Maxim Karolik; John Levy Galleries, New York City; to
 M. Knoedler and Co., New York City, 1947; to Alastair Bradley
 Martin, Glen Head, N.Y., 1947; to the present collection, 1948
Alternative title: *Prairie Fire*
References: Literary World 1847b; St. Louis Missouri Republican
 1847; Baur 1947, p. 281; McDermott 1950, pp. 308–309; *Clark
 1987, pp. 71–72; Johns 1991, p. 235 n. 3; Ketner 1991, pp. 53–56;
 Carbone 2006, vol. 1, pp. 449–50

Prairie on Fire captured the attention of the *Missouri Republican*'s critic, who saw it at the St. Louis Mechanics' Institute Fair in 1847 and declared that "the whole picture is one of the finest that we have ever seen." A "correspondent" reporting from St. Louis to the *Literary World* wrote a biographical sketch of Deas and concluded with a long description of *Prairie on Fire*. This critic gave no source for the story he spun around the picture, which suggests that Deas may have provided this context:

> Seeing this picture in his studio has suggested to us these few re-marks. The subject is a group escaping from the fearful peril of a prairie on fire. The figures represent an old hunter on his horse, whose face, and grey beard, and hair, tell the tale of many a hardy adventure through which he has passed. Riding by his side and seated on a noble animal is another figure, the most prominent

of the picture, clasping in his arms a young girl, to whom he is be-trothed, and supposed to be the daughter of the old hunter. She rests apparently exhausted in the arms of her lover, her hair di-sheveled and streaming in the wind. Behind them furiously rages the burning prairie; and one can almost imagine that he hears the crackling of the dry grass beneath the resistless flames. They have just reached a small stream, and are supposed to have gained a place of safety. The lights and shadows are well managed, giving a thrilling and exciting effect to the scene.

> The design and execution of this picture are admirable—the best to our mind which we have had from the easel of Deas. We are ignorant of its destination; but we trust that the lovers of the Fine Arts in New York will have an opportunity of seeing and examining this production of the "Far West."

Whether or not *Prairie on Fire* made its way to New York City, it disappeared from public notice after this review was published and did not reappear for a century. Knoedler's records indicate that Maxim Karolik owned the picture, and I deduce that Karolik sold it to John Levy Galleries. *Prairie on Fire* has been surpassed only by *The Death Struggle* (cat. no. 59) and *Long Jakes* (cat. no. 55) in recent criti-cal notice.

A notice that appeared without further context in the *St. Louis Weekly Reveille* (April 5, 1847) mentioned, "Charles Deas has just completed a picture which, in the opinion of many, is his master-piece, so far. If you want to see a horse with an actual hide on, go and look at this painting." This critic may have referred to *Prairie on Fire* or to *The Trapper* (cat. no. 75), whose equine presence the *Reveille* had noted two months earlier, on February 8, 1847, and which Deas had sent to New York City for the annual exhibition at the National Academy of Design.

NOTE: *My thanks to Teresa Carbone, Nancy Little, and Alastair Bradley Martin for help with my research on this picture.*

Cat. no. 79. *River Man.* Cat. no. 80. *Indian Brave.*

79. *River Man,* 1847
Oil on cardstock, 6¾ × 5⅜ in.
Inscribed, lower left, in ink: Charles. Deas. / 1847
80. *Indian Brave,* 1847
Oil on cardstock, 7¹³⁄₁₆ × 6⅛ in.
Inscribed, lower left, in ink: Charles. Deas. / 1847.

Present collection: Gilcrease Museum, Tulsa, Oklahoma
Provenance: Robert Palmiter, Bouckville, N.Y.; to Charles D. Childs,
 Childs Gallery, Boston, 1952; to M. Knoedler and Co., 1952; to
 Thomas Gilcrease, 1959; to Thomas Gilcrease Foundation, 1962;
 to the present collection, 1963
Reference: *Hassrick 1984, pp. 52, 56

These two oils carry modern titles. Because their supports are of dif-
ferent sizes and the figures of different scales, it seems unlikely that
they were originally intended to be framed together, as they have
been since 1952. Yet they are related: each is signed and dated in the
same way and in the same place, and each is a portrait in oval for-
mat on a rectangular support. They may be two in a series of generic
portraits of western types that by 1847 already evoked the past.

Deas portrayed each man stereotypically. The one in *Indian Brave*
is seminude, and he wears silver earrings and a feather headdress.
Deas effectively conveyed fury in this man's parted lips; his large,
glaring eyes; and the unkempt hair streaming around his face. The
one in *River Man* appears to be a voyageur, and the landscape set-
ting seems more like a lake, perhaps one of the Great Lakes, than a
river. The presence of boats is suggested by the rope rigging behind
his right shoulder. He wears a vest, a patterned silk neckcloth, and a
French knitted cap. Deas echoed the red-striped crown of this cap in
the sleeves and collar of his shirt.

The two characters are opposites in every way: in contrast to the
youthful Indian warrior, the voyageur is grizzled and gray-haired
and his eyes are unfocused. He seems more present to us, how-

ever, than the Indian because curls of smoke rise from the clay pipe
clamped tightly in his lips.

 NOTE: *I am indebted to the perceptive observations of James Ronda about
 these two images.*

81. *A Solitary Indian, Seated on the Edge of a Bold Precipice,* 1847
Oil on canvas, 36¼ × 26 in.
Inscribed, center right: C. Deas. / 1847.
Present collection: Museum of the American West, Autry National
 Center (93.173.1)
Provenance: Mrs. Treat, St. Louis, by 1864; Frederick Quick,
 Rochester, N.Y., by about 1900; by descent in the Quick family; to
 Christie's sale (New York City, September 22, 1993, lot no. 90); to
 the present collection, 1993
*Alternative titles: The Last Indian; Indian Warrior on the Edge of a
 Precipice*
References: St. Louis Weekly Reveille 1847g; *Mississippi Valley
 Sanitary Fair 1864, cat. no. 69; McDermott 1950, pp. 309–10; Kilgo
 1994, p. 140; Dippie 1998, p. 63; Clark 2000, p. 27

The critic for the *St. Louis Weekly Reveille* wrote the first review of
this work, noting that it was at "Mr. Wool's." He referred to Wooll's
picture-framing shop on Glasgow's Row (the popular name for
Fourth Street). The review was positive, calling attention to "the art-
ist's fine, bold style" and claiming that this picture "will add to his
high reputation as a painter of western subjects." By the time the
review appeared, on November 1, 1847, Deas had left St. Louis and
returned to New York City.

The photographer Thomas Easterly arrived in St. Louis a few
months before Deas departed. Whether or not the two artists
met is not known, but Easterly made a quarter-plate daguerreo-
type of *A Solitary Indian.* The daguerreotype carries a modern title,
Indian on a Rock. Indians were important subjects for both art-
ists, but Easterly's daguerreotypes of painted images of Indians

Cat. no. 81. *A Solitary Indian, Seated on the Edge of a Bold Precipice.*

Thomas M. Easterly (American, 1809–1882), *Indian on a Rock,* 1847. Daguerreotype (quarter plate; cased). National Museum of American History, Smithsonian Institution, Washington, D.C.

are rare: only this one of Deas's picture and a now-lost plate of Seth Eastman's *Indian Burial* (1847; Gilcrease Museum, Tulsa, Oklahoma) are known. Because Deas left the painting behind in St. Louis, Easterly could have made his daguerreotype at a later date, but he probably made it and the one of Eastman's painting in 1847. The precise purpose of these reproductive daguerreotypes or of the one that Isaiah Clark made of *Long Jakes* (cat. no. 55) is not clear; however, the painters' constructions of Indians in romanticized settings and poses may have imaginatively extended the directness of the photographic images taken from life. Dolores Kilgo published Easterly's daguerreotype after *A Solitary Indian* in her 1994 catalogue. She made the connection to Deas from contemporary reviews of the painting in the St. Louis press. Deas's painting came to light in 1993, apparently too late to be included in her catalogue.

In October 1868, William Henry Blackmore (1826–1878), the voracious English collector of Native Americana and amateur ethnologist, went to St. Louis to purchase images of Indians for his museum in Salisbury, England. This daguerreotype of *A Solitary Indian* was among those he acquired. On the way back to England, Blackmore left some three hundred images in Washington, D.C., to be duplicated by the artist Antonio Zeno Shindler (1823–1899) for the Smithsonian Institution. Shindler never returned the daguerreotypes to Blackmore; in 1932, they were transferred to the Smithsonian Institution and are now held by the National Museum of American History. The 6½ × 8½ inch glass-plate negative that Shindler made from Easterly's daguerreotype of *A Solitary Indian* was exhibited and published as no. 237 in the so-called Shindler Catalogue: *Photographic Portraits of North American Indians in the Gallery of the Smithsonian Institution* (1869 [misdated 1867 on cover]). Shindler's negative is now in the National Anthropological Archives, National Museum of Natural History. (See Paula Richardson Fleming, *Native American Photography at the Smithsonian: The Shindler Catalogue* [Washington, D.C.: Smithsonian Books, 2003].)

A Solitary Indian was most likely the picture exhibited as *The Last Indian* at the 1864 Mississippi Valley Sanitary Fair by its owner, referred to as Mrs. Treat, who must have been Caroline Bryan Treat. She was the wife of Samuel Treat (1815–1902), a lawyer who was appointed federal district judge for eastern Missouri, sitting in St. Louis, in 1857. Judge Treat passed some of his later years with his daughter in Rochester, New York, not far from Geneseo, his wife's hometown. Frederick Quick, of Rochester, received *A Solitary Indian* about 1900 as payment for legal services, according to one of his descendents, who sold it at Christies in 1993. Although there is no documentary evidence connecting the Treats' *Last Indian* to the picture we know to have been in Quick's collection, the coincidence of professions and locale suggests that they are the same picture.

Deas set this highly detailed evocation of Native life in a sky of purple storm clouds and against a lake that resembles Minnesota's Lake Pepin. The lone Indian focuses his gaze on something out of our view but at his own lofty height. He seems unaware of his only company, a group of eagles silhouetted against the cliffs below, or of the cataract rushing beneath him. He seems equally oblivious to the fact that he has lost a moccasin, something the *Reveille* critic did not miss. The figure is muscular and tattooed, and his left arm rests on a securely planted leg. He holds a pipe-tomahawk in his right hand. Deas bedecked him with a roach made of deer hair dyed red and a white eagle feather with a black tip; a shell-and-beaded necklace; and metal earrings, armbands, bracelets, and rings. A quiver of arrows and a bow worked in quills, from which hang silver bells, is secured to his chest by a strap. The white robe, perhaps of buffalo or elk skin, is painted with a red, geometric border.

The stencil on the back, "PREPARED / BY / [EDWD] DECHAUX / NEW YORK," identifies the canvas maker. It is "the most common New York City stencil mark" and is in a form the Dechaux company used in the 1840s (Katlan, *American Artists' Materials Suppliers Directory,* vol. 1, p. 18). The Dechaux company's stencil also appears on the verso of *Portrait of Robert Watts* (cat. no. 8) and on the verso of *Indians Coming down a Defile* (cat. no. 77).

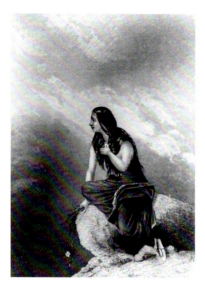

Cat. no. 82. De Lay Glover, after Deas, *The Watcher by the Sea*.

NOTE: *I am grateful to James Nottage for sharing with me his research on this painting.*

82. De Lay Glover (American, ca. 1823–ca. 1863), after Charles Deas, *The Watcher by the Sea*, ca. 1847
Steel engraving, 6⅞ × 4¼ in., bound into volume
Inscribed in plate: C. Deas. / D. L. Glover / The Watcher by the Sea / R. Andrews, Printr.
Present collection: American Antiquarian Society, Worcester, Massachusetts
Reference: Rose of Sharon 1847

This engraving was published in the gift book *The Rose of Sharon: A Religious Souvenir for 1847*. It was an illustration for a poem also called "The Watcher by the Sea," which recounts the plight of a young Indian woman called Orena who had been abandoned by her lover. The poem concludes,

> Thou art watching for the lover,
> Far distant o'er the sea,
> Whose painted image on thy breast
> Is worth the world to thee.
>
> Poor maiden! Watch no longer;
> A fairer bride has won
> All the fervent warmth and brightness
> Of thy heart's long-worshiped sun.
>
> And thou, like that frail wildflower
> Wilt droop and fade away,
> Without the Christian woman's hope,
> In suffering, to pray!

Like this anonymous poet, the critic for the *Anglo American* (September 6, 1845), reviewing Deas's painting *Winona* (cat. no. 58) at the American Art-Union, compared the lives of Indian and "white" women, concluding that "cases parallel to Winona's are not wanting in the civilized world."

When he made this reproductive engraving, De Lay Glover was active as an engraver in Boston, where he worked from 1846 to 1854.

Henry Tuckerman, at the conclusion of his 1846 article on Deas, records among the artist's recent works "two illustrations from the history of 'Winona'" (p. 253). Because the stories of Orena and Winona have similar themes, this print may be one of the illustrations referred to by Tuckerman.

83. Landscape, by 1848
Present collection: Unknown

This entry recognizes the existence of a landscape painting that was rejected by the American Art-Union with the notation "injured by heat" (Minutes of the Executive Committee, April 14, 1848).

84. Landscape, by 1848
Present collection: Unknown
References: Family Companion 1848b, p. 78; *NAD 1848, cat. no. 264; NY Evening Post 1848a

The New York *Evening Post*'s critic admired the landscape that Deas showed at the National Academy of Design, calling it "a charming little picture, with a sweet free touch and great breadth of effect." He contrasted it to *A Head of Christ* (*The Lord*, cat. no. 85), which he judged "unsuited to the talents of this fine painter."

85. *The Lord,* by 1848
Present collection: Unknown
Alternative titles: Head of the Saviour; The Saviour; A Head of Christ
References: NY Evening Express 1847; Family Companion 1848a; Literary World 1848a, p. 107; Literary World 1848c, p. 350; *NAD 1848, cat. no. 229; NY Evening Post 1848a; McDermott 1950, p. 311

The first notice of this picture may be a sentence in the *New York Evening Express:* "Charles Deas has lately completed a scripture piece which we hear highly recommended." If this critic referred to *The Lord,* this was the picture's only positive mention, and the critic claimed only to have heard of it, not to have seen it.

While there are no published descriptions of *The Lord,* the catalogue listing for the 1848 National Academy of Design exhibition provides context: "And the Lord turned and looked upon Peter. And Peter remembered the word of the Lord, how he had said unto him, Before the cock crow, thou shalt deny me thrice. And Peter went out, and wept bitterly.—*Saint Luke,* xxii, 61, 62."

In their reviews of the National Academy of Design exhibition of 1848, several of the New York City newspapers mentioned Deas's submission, calling it *The Saviour* and *A Head of Christ.* This new, religious inclination in Deas's work was not well received. Although the critic for the *Literary World* (1848c) did not specify in June 1848 that Deas had been admitted to the Bloomingdale Asylum for the Insane in May, he offered the artist's recent "derangement" as one reason the National Academy of Design had even included the picture in its annual exhibition: "Of Mr. Deas' picture of *The Saviour* (229), we forbear to speak. The late melancholy circumstances of his derangement may somewhat account for the exhibition of the picture, and shield it from the shafts of criticism. We have heard of the unfortunate occurrence with much pain, but we trust that the evil may in time be remedied, and the talented artist restored to his friends and to the Art of which he is so much an ornament."

Commenting on Deas's two submissions to the National Academy of Design exhibition, the critic for the *Evening Post* shared this low opinion of the artist's religious painting: "A head of Christ and small landscape. The former we do not at all admire; and we conceive it to be an order of composition unsuited to the talents of this fine painter. The landscape is a charming little picture, with a sweet free touch and great breadth of effect. Why does not Mr. Deas stick to the class of subjects in which he is so effective, and which

have given him such a high reputation. We have hope he will paint us more works like 'Long Jaques,' 'The Death Struggle,' etc."

The critic for the *Family Companion* was even less charitable: "We should have supposed this the attempt of a schoolboy, and bad at that."

86. *Elijah at Horeb,* likely by 1848
Present collection: Unknown
Provenance: Catherwood family by 1864
Reference: *Mississippi Valley Sanitary Fair 1864, cat. no. 146

The subject of Elijah at Horeb corresponds to a biblical passage in which God comes to the prophet as a still, small voice (1 Kings 19:1–18).

This work is known only by its entry in the catalogue of the Mississippi Valley Sanitary Fair of 1864, in which the name of its owner is given as "Catherwood." The St. Louis city directory for this year lists a family by this name as residing at 186 Olive Street.

Deas offered a biblical subject to the National Academy of Design in 1848 (*The Lord,* cat. no. 85), and he may have painted *Elijah at Horeb* about that time. But because the only reference to the picture is in a St. Louis exhibition, he may have painted it while still living there. If so, this would be the only painting with a religious subject that he is known to have done in the West.

87. *Wild Jake,* possibly by 1848
[Oil?], 6 × 7½ in.
Present collection: Unknown
Provenance: John F. Kensett; to Somerville sale (Kensett collection, New York City, 1873, lot no. 278); to "Mr. Martin"
Reference: Somerville Sale 1873

The title suggests that Deas probably painted this work by 1848, because no western pictures are known from his years in asylums. The "Mr. Martin" who bought *Wild Jake* for $45 at the Kensett estate sale

Cat. no. 88. *Western Scenery.*

in 1873 may have been the landscape painter Homer Dodge Martin (1836–1897).

NOTE: *I am grateful to George Friend for first bringing this work to my attention and to John Driscoll for providing me a copy of the Kensett sale catalogue annotated with the names of buyers.*

88. *Western Scenery,* 1848
Oil on canvas, 13½ × 17 in.
Inscribed, lower right: C. Deas. / 1848
Present collection: Private collection
Provenance: American Art-Union; distributed to Mary L. Plumb, Albany, N.Y., 1848; Schryver estate; to Fell's Auction, Rhinebeck, N.Y., 1969; to Herbert Doynow, Hastings-on-Hudson, N.Y., 1969; to Bob Shepard Antiques, Bronxville, N.Y., 1969; to William H. Bender, Jr., Bronxville, N.Y., 1969; Estate of Mrs. William H. Bender, Jr.; to Sotheby Parke Bernet sale (New York City, November 17–19, 1977, lot no. 536); to Gallery of the Masters, St. Louis, 1977; to the present collection, 1977
Alternative titles: Landscape—Western Scenery; Western Landscape
References: NY Evening Post 1848b; AAU Transactions 1849, no. 215; *Albany Gallery 1849, cat. no. 49

Deas submitted a work called *Western Scenery* to the American Art-Union in the fall of 1848; the managers paid $250 for it and two other pictures (Minutes of the Committee of Management, October 5, 1848). In reviewing paintings at the Art-Union, the critic for the *Evening Post* described it only as "a pretty bit of Western Scenery" (November 13, 1848). The painting was distributed to Mary L. Plumb in December 1848; she lent it to a show in Albany in 1849.

Collector and art historical sleuth William H. Bender purchased a Deas landscape in 1969 and doggedly researched its provenance. Bender concluded that because it was dated 1848 and had been found in the Hudson River town of Rhinebeck, New York, it was the painting that the American Art-Union had distributed in that year to Mary Plumb of Albany, about fifty miles north of Rhinebeck

(correspondence 1969–71, William H. Bender Papers, Archives of American Art, Smithsonian Institution). Bender therefore named his landscape *Western Scenery.* While conjectural, Bender's reasoning is plausible.

Deas, as he did in *Indians Coming down a Defile* (1847; cat. no. 77), framed a distant mountain range between rock outcroppings and included a tall, solitary, expressive dead tree trunk. Here, too, he inserted man's presence, but only in the form of a single figure emerging from the valley below. This figure is small in proportion to the vast landscape and if not for his blue shirt and white hat would go unnoticed by the viewer. More obvious is the large black bird at the right.

89. Landscape, by 1849
Oil on canvas, 30 × 25 in.
Present collection: Unknown
Provenance: American Art-Union; distributed to Richard R. Field, Brooklyn, New York, 1849
References: AAU Bulletin 1849, p. 44; AAU Transactions 1850, no. 272

This work's title, size, and description are known only by its listing in the bulletins of the Art-Union, with the first mention occurring in October 1849: "*Landscape* (30 × 25) Autumnal scenery. A gorge in the mountains nearly hidden by thick vapor." The Art-Union purchased this landscape painting for $100 (Minutes of the Executive Committee, September 3, 1849, Records of the American Art-Union, New-York Historical Society Library) and distributed it to Richard R. Field. Although there is unanimous agreement on the recipient's place of residence—Brooklyn—there is some uncertainty about his name. Of the various Art-Union distribution lists, one names R. Orfield (R. R. Field misheard?), and in 1950 McDermott, without explanation, named Richard R. Hooper. Richard R. Field seems correct, because this is the only name of the three that is included in the city directory for 1851. He lived in Brooklyn Heights.

90. *The Slippery Log—Indian History,* by 1849
Present collection: Unknown

This work was submitted to the American Art-Union in June 1849; it was then withdrawn, only to be resubmitted in early September. The Art-Union declined to purchase the painting for distribution (at $150), and it was returned to Deas (or his agent) on March 21, 1850 (Register, Works of Art, Records of the American Art-Union, New-York Historical Society Library). While no description of this work survives, the title is suggestive. In some Indian cultures, a "slippery log" is the means of passage to the Happy Hunting Ground; unworthy souls fall off and are deprived of a pleasant afterlife.

91. Two Sketches, by 1849
Present collection: Unknown

The entry "Two Sketches" appeared in the register of the American Art-Union on September 3, 1849 (nos. 1267 and 1268). The register further stipulated that the works were withdrawn from consideration for purchase (for $100) and were returned to Deas (or his agent) the same month (Records of the American Art-Union, New-York Historical Society Library).

92. Two Sketches (Pair): Autumn Scenery in the Far West, by 1849
[Oil?], 12 × 9 in.
Present collection: Unknown
Provenance: American Art-Union; distributed to Jonathan V. Nichols, Newark, N.J., 1850
Reference: AAU Bulletin 1850, no. 306

The Art-Union paid Deas $100 for "2 sketches" in 1849 (Minutes of the Executive Committee September 3, 1849, Records of the American Art-Union, New-York Historical Society Library). Because no sketches were distributed in 1849, these two works might be those listed and described as follows in an 1850 bulletin:

306. Two Sketches—pair (12 × 9)
Autumn scenery in the Far West. In one are seen Indian wigwams, and in the other a trapper on horseback.

Jonathan V. Nichols, to whom the pair of paintings was distributed in 1850, was one of the first directors of the Firemen's Insurance Company of Newark, organized in 1855, as well as the architect of the Gothic Revival Christ Church and parsonage in Newton, New Jersey, erected in 1868.

93. *A Vision,* by 1849
Present collection: Unknown
Alternative title: A Vision of Hell
References: Albion 1849; Holden's 1849, p. 315; Home Journal 1849; Knickerbocker 1849, p. 470; *NAD 1849, cat. no. 145; Historical Magazine 1860; Tuckerman 1867, p. 429; Coen 1976, p. 128 n. 15; Husch 2000, p. 79

A Vision was shown in the spring of 1849 at the National Academy of Design. The *Albion* critic described it as "the concentrated essence of a thousand night-mares." The *Knickerbocker* was more specific:

What have we here? How [do we] disentangle the human sufferers from those winding serpents, and release them from those fangs, so wild, so horrible, of shapeless unknown monsters? Until we *do* disentangle, we can make nothing of this extraordinary effort of paint. You must separate the beings that struggle and die in the blue waves of the mystic sea, and then when you have done so, you will be astonished at the beauty and delicacy of the handling, and the correctness of the drawing. A "vision" is it? Yes, and a horrid one! Despair and Death are together, and Frenzy glares from the blood-red sockets of the victims, and haunting weird thoughts arise, as we reflect over this singular effort of talent.

The critic for *Holden's Dollar Magazine* added more detail to a description of a picture he deemed to be "a vision of Hell": "The

Cat. no. 97. *Harbor Scene.*

Cat. no. 98. *Temple Scene.*

principal figure in the picture is the body of a naked youth which is apparently falling into the bottomless pit and is clenched by indescribable monsters that are striving to pull it in opposite directions." The *Holden's* critic specified that Deas had painted it at Bloomingdale: "This promising artist, it may not be generally known, has been an inmate of the Insane Asylum at Bloomingdale nearly a year, and during his confinement there the picture of which we speak was painted."

On September 3, 1849, the painting went to the American Art-Union (no. 1271). The Art-Union managers declined to purchase it and returned it to the artist (or his agent) on March 20, 1850 (Register, Works of Art, 1849, Records of the American Art-Union, New-York Historical Society Library). The painting then disappeared, even though it has been sought since at least 1860, when "E.K.," reading the old review in *Holden's Dollar Magazine,* made inquiries about the picture, which he gave the title *A Vision of Hell,* in the *Historical Magazine.* In 1867, Tuckerman described a picture that might be *A Vision* or another of what he called Deas's "wild pictures," stating that it was "one of [Deas's] wild pictures, representing a black sea, over which a figure hung, suspended by a ring, while from the waves a monster was springing, [which] was so horrible, that a sensitive artist fainted at the sight."

94. Landscape, by 1850
Present collection: Unknown

The March 22, 1850, entry for a landscape by Deas in the American Art-Union's Register of Works (no. 1937) leaves blank the column recording the eventual disposition of the object (Records of the American Art-Union, New-York Historical Society Library).

95. *The Maniac,* by 1859
Present collection: Unknown
Provenance: Dr. J. S. Clarke by 1859
References: *Chicago Exhibition 1859, cat. no. 273; McDermott 1950, p. 311 n. 22

This painting is known only by its listing in the catalogue for the 1859 Chicago Exhibition of the Fine Arts. The painting was submitted by its owner, Dr. J. S. Clarke. John S. Clark is listed as a physician in D. B. Cooke and Company's Chicago directory for 1859–60.

96. *The Pursuit,* by 1860
Present collection: Unknown
Provenance: John Snedecor, New York City; to Leeds sale (Snedecor collection, New York City, 1860, lot no. 140)
Reference: Leeds Sale 1860

This may be a western painting of an earlier date, yet its title is ambiguous enough that it could be referring to a picture painted during Deas's confinement rather than a western subject. The only recorded information is that it was sold in 1860. John Snedecor was an auctioneer who sold artists' supplies as well as paintings at his New York City shop between 1855 and 1861. His inventory was dispersed at auction in 1860 and 1861.

97. *Harbor Scene,* 1865
Oil on canvasboard, 18 × 24 in.
Inscribed, lower left: C Deas NY / 1865

98. *Temple Scene,* 1865
Oil on canvasboard, 18 × 24 in.
Inscribed, lower left: C Deas / 1865
Present collection: Collection of Roger and Susan Ferguson
Provenance: Greensburg, Penn., estate; to private collection, Greensburg, Penn., 1992; to present collection, 2001

This pair of paintings, whose titles are recent and descriptive, dates from Deas's second and last stay at New York City's Bloomingdale Asylum for the Insane. He signed and dated them after having been institutionalized for seventeen years. Deas possibly derived their compositions from printed views available in New York City, perhaps even in Bloomingdale's library. Although they cannot be linked to any specific sources, both images appear indebted to lith-

ographs made after the drawings of David Roberts (1796–1864), the Scottish artist whose large-format lithographs of Egypt and the Holy Land were widely circulated in the 1840s. Roberts's fine, detailed works are characterized by the same kind of reportorial passion that colors Deas's studies of American frontier life. In both scenes, Deas borrowed Roberts's hallmark device of deploying brightly costumed figure groups in a sweeping vista to create a sense of scale. *Temple Scene* includes a column in the middle ground that seems to have been drawn from Roberts's lithograph of Karnak from *Egypt and Nubia* (1846–49).

NOTE: *My thanks to Russell Burke for bringing these paintings to my attention and to John Davis for steering me toward Roberts's prints.*

Selected References

The following list of publications is the key to citations listed under "References" in the catalogue entries. Citations before 1867, the year Deas died, approach a complete listing of publications that mention Deas or his works. (Excepted are publications that merely repeat titles of Deas's paintings, such as the various bulletins, catalogues, transactions, and broadsides of the American Art-Union.) Inclusion of citations after 1867 is selective.

1838

NAD 1838. *Catalogue of the Thirteenth Annual Exhibition.* New York: National Academy of Design.

NY Commercial Advertiser 1838. E. R. "Exhibition of the National Academy—No. 4. Concluded." *New-York Commercial Advertiser* (June 4): 2.

NY Mirror 1838. "National Academy of Design." The Fine Arts. *New-York Mirror* 16, no. 2 (July 7): 15.

NY Morning Herald 1838. "National Academy of Design." *New York Morning Herald* (June 1): 2.

Stuyvesant Institute 1838. *Catalogue . . . of the Exhibition of Select Paintings, by Modern Artists* ["Dunlap Exhibition"]. New York: Stuyvesant Institute.

1839

Apollo 1839. *Catalogue of Paintings, &c. by Modern Artists.* New York: Apollo Association.

NAD 1839. *Catalogue of the Fourteenth Annual Exhibition.* New York: National Academy of Design.

NY Commercial Advertiser 1839a. "National Academy of Design." *New-York Commercial Advertiser* (April 24): 2. Reprinted in *New-York Spectator* (April 25, 1839): 3.

NY Commercial Advertiser 1839b. E. "National Academy of Design, No. IV." *New-York Commercial Advertiser* (June 17): 1. Reprinted in *New-York Spectator* (June 17, 1839): 4.

NY Evening Post 1839a. "The Exhibition of the National Academy of Design." *New York Evening Post* (May 3): 2.

NY Evening Post 1839b. "National Academy of Design." *New York Evening Post* (May 13): 2.

NY Literary Gazette 1839. "Exhibition of the National Academy—No. II: Pictures of Incident and Character." *New York Literary Gazette* 1, no. 15 (May 11): 118.

NY Mirror 1839. "Charles Deas." *New-York Mirror* 17, no. 20 (November 9): 159.

NY Morning Herald 1839a. "The National Academy." *New York Morning Herald* (May 4): 2.

NY Morning Herald 1839b. "National Academy." *New York Morning Herald* (May 17): 2.

1840

Apollo 1840. *Catalogue of the Sixth Exhibition, at Clinton Hall.* New York: Apollo Association.

Artists' Fund Society 1840. *Catalogue of the Fifth Exhibition.* Philadelphia: Artists' Fund Society.

Knickerbocker 1840. [Lewis Gaylord Clark?]. "National Academy of Design." *Knickerbocker* 16, no. 1 (July): 81–83.

NAD 1840. *Catalogue of the Fifteenth Annual Exhibition.* New York: National Academy of Design.

NY Commercial Advertiser 1840. "National Academy." *New-York Commercial Advertiser* (April 25): 2.

NY Mirror 1840. "The Apollo Gallery." *New-York Mirror* 18, no. 15 (October 3): 119.

NY Morning Herald 1840a. "National Academy." *New York Morning Herald* (June 25): 2.

NY Morning Herald 1840b. "National Academy." *New York Morning Herald* (July 4): 2.

1841

Apollo Transactions 1841. *Transactions of the Apollo Association, for the Year 1840.* New York: Apollo Association.

Artists' and Amateurs' Association 1841. *Catalogue of the Second Exhibition.* Philadelphia: Artists' and Amateurs' Association.

St. Louis Missouri Republican 1841. "Mechanics' Fair." *St. Louis Daily Missouri Republican* (November 27): 2.

1842

St. Louis Missouri Republican 1842. "List of Articles Exhibited at the Fair of the Mechanics' Institute, Concluded." *St. Louis Daily Missouri Republican* (November 7): 2.

St. Louis New Era 1842a. S. D. T. Review of *Inda, a Legend of the Lakes,* by Lewis Foulk Thomas. *St. Louis New Era* (August 24) [not paginated].

St. Louis New Era 1842b. "The [Mechanics' Institute] Fair." *St. Louis New Era* (November 3) [not paginated].

St. Louis New Era 1842c. "The [Mechanics' Institute] Fair." *St. Louis New Era* (November 4) [not paginated].

Thomas 1842. Lewis Foulk Thomas. *Inda, a Legend of the Lakes; with Other Poems.* St. Louis: Vespasian Ellis.

1843

PAFA 1843. *Catalogue of Paintings, Statues, and Casts (Addendum).* Philadelphia: Pennsylvania Academy of the Fine Arts.

1844

Artists' Fund Society 1844. *Catalogue of the Ninth Annual Exhibition.* Philadelphia: Artists' Fund Society.

Carleton 1844–45. [J. Henry Carleton]. "Occidental Reminiscences: Prairie Log Book; or, Rough Notes of a Dragoon Campaign to the Pawnee Villages in '44." *Spirit of the Times* 14, nos. 37–52 and 15, nos. 2–7 (November 9, 1844–April 12, 1845). Subsequently abridged and republished as *The Prairie Logbooks: Dragoon Campaigns to the Pawnee Villages in 1844, and to the Rocky Mountains in 1845.* Chicago: Caxton Club, 1943. Reprint, edited and with an introduction by Louis Pelzer (Lincoln: University of Nebraska Press, 1983).

Izard 1844. Ralph Izard. *Correspondence of Mr. Ralph Izard, of South Carolina, from the Year 1774 to 1804; with a Short Memoir.* Vol. 1. Edited by Anne Izard Deas. New York: Charles S. Francis.

NAD 1844. *Catalogue of the Nineteenth Annual Exhibition.* New York: National Academy of Design.

New Mirror 1844. "The Extraordinary Masterpiece of Art . . ." *New Mirror* 3, no. 24 (September 14): 384.

NY Morning Herald 1844. "National Academy of Design, Continued." *New York Morning Herald* (May 26): 1.

St. Louis Weekly Reveille 1844. John Brown [Richard S. Elliott]. "Movements among the Red Skins." *St. Louis Weekly Reveille* (October 7): 97.

1845

AAU Transactions 1845. *Transactions of the American Art Union, for the Year 1844.* New York: American Art-Union.

Anglo American 1845. "Pictures by Mr. Deas, at the Art-Union." *Anglo American* 5, no. 20 (September 6): 474–75. Reprinted in *St. Louis Weekly Reveille* (September 22, 1845): 503.

Broadway Journal 1845a. "The Art Union Pictures." The Fine Arts. *Broadway Journal* 1, no. 1 (January 4): 13.

Broadway Journal 1845b. "The Indian Guide." The Fine Arts. *Broadway Journal* 1, no. 16 (April 19): 254.

Broadway Journal 1845c. "A New Painting by C. Deas." The Fine Arts. *Broadway Journal* 1, no. 25 (June 21): 397.

Broadway Journal 1845d. "The Paintings at the American Art-Union." The Fine Arts. *Broadway Journal* 2, no. 9 (September 13): 154–55.

St. Louis Weekly Reveille 1845. "Mechanics' Fair." *St. Louis Weekly Reveille* (May 19): 356.

US Magazine 1845. "American Humor." *United States Magazine and Democratic Review* 17, no. 87 (September): 212–19.

1846

AAU Catalogue 1846. *Catalogue of Pictures at the Rooms of the American Art-Union.* Broadside, October 10. [New York: American Art-Union.]

AAU Transactions 1846. *Transactions of the American Art-Union, for the Year 1845.* New York: American Art-Union.

Herbert 1846a. Henry William Herbert. "Long Jakes, the Prairie Man." *New York Illustrated Magazine of Literature and Art* 2 (July): 169–74. Reprinted in *Life and Writings of Frank Forester (Henry William Herbert),* edited by David W. Judd (London: Frederick Warne, 1882), 204–17.

Herbert 1846b. Henry William Herbert. "The Death Struggle." *New York Illustrated Magazine of Literature and Art* 2 (September): 289–94. Reprinted in *Life and Writings of Frank Forester (Henry William Herbert),* edited by David W. Judd (London: Frederick Warne, 1882), 173–87.

Journal of the US House 1846. *Journal of the House of Representatives of the United States of America: Being the Second Session of the Twenty-ninth Congress.* Washington, D.C.: Ritchie and Heiss [for U.S. House of Representatives], 1846–47.

Journal of the US Senate 1846. *Journal of the Senate of the United States of America: Being the Second Session of the Twenty-ninth Congress.* Washington, D.C.: Ritchie and Heiss [for U.S. Senate], 1846–47.

NY Illustrated Magazine 1846. "Great Improvement Ahead!" Editor's Notes. *New York Illustrated Magazine of Literature and Art* 2 (June): 128.

Spirit of the Times 1846. "New Publications." *Spirit of the Times* 16, no. 18 (June 27): 216.

St. Louis Weekly Reveille 1846a. "Very Fine Paintings." *St. Louis Weekly Reveille* (March 23): 798.

St. Louis Weekly Reveille 1846b. "A New Picture by Deas." *St. Louis Weekly Reveille* (August 31): 980.

St. Louis Weekly Reveille 1846c. "Paintings in the Rotunda." *St. Louis Weekly Reveille* (October 12): 1032.

Tuckerman 1846. [Henry T. Tuckerman]. "Our Artists—No. V: Deas." *Godey's Magazine and Lady's Book* 33 (December): 250–53. Subsequently included in Tuckerman, *Artist-Life; or, Sketches of American Painters* (New York: D. Appleton, 1847). *Artist-Life* was reprinted as *Sketches of Eminent American Painters* (New York: D. Appleton, 1849); revised and published as *Book of the Artists: American Artist Life* (New York: G. P. Putnam and Son, 1867); distributed under that title by James F. Carr, New York, in 1966.

1847

AAU Transactions 1847. *Transactions of the American Art-Union, for the Year 1846.* New York: American Art-Union.

Anglo American 1847a. "Fine Arts." *Anglo American* 8, no. 16 (February 6): 381.

Anglo American 1847b. "National Academy of Design." *Anglo American* 9, no. 3 (May 8): 69.

Athenaeum 1847. *Catalogue of the Twenty-first Exhibition of Paintings and Statuary.* Boston: Athenaeum Gallery.

Lanman 1847. Charles Lanman. *A Summer in the Wilderness: Embracing a Canoe Voyage up the Mississippi and around Lake Superior.* New York: D. Appleton, 1847. Section on Deas excerpted in "The Mississippi," *Anglo American* 9, no. 4 (May 15, 1847): 87. Reprinted in *Adventures in the Wilds of the United States and British American Provinces* (Philadelphia: J. W. Moore, 1856).

Literary World 1847a. The Fine Arts. *Literary World* 1, no. 1 (February 6): 16.

Literary World 1847b. "Mr. Deas." The Fine Arts. *Literary World* 1, no. 12 (April 24): 280. Reprinted as "Mr. Chas. Deas," *St. Louis Weekly Reveille* (May 10, 1847): 1270.

Literary World 1847c. "Exhibition at the National Academy, Second Saloon." The Fine Arts. *Literary World* 1, no. 17 (May 29): 396–97.

Literary World 1847d. "Exhibition at the National Academy, Second Saloon." The Fine Arts. *Literary World* 1, no. 19 (June 12): 447.

Literary World 1847e. "The Art Union Pictures (Continued)." The Fine Arts. *Literary World* 2, no. 39 (October 30): 302–303.

Literary World 1847f. Review of *Artist Life; or, Sketches of American Painters,* by Henry T. Tuckerman. *Literary World* 2, no. 39 (October 30): 297–99.

London AAU Journal 1847. B. C. F. "Twenty-first [*sic*] Annual Exhibition of the National Academy of Design, New York." Fine Arts in America. *Art Union: A Monthly Journal of the Fine Arts* 9 (June 1): 216. Reprinted in *Literary World* 1, no. 22 (July 3, 1847): 517–18.

NAD 1847. *Catalogue of the Twenty-second Annual Exhibition.* New York: National Academy of Design.

NY Evening Express 1847. "Jottings on Art and Artists." Fine Arts. *New York Evening Express* (December 16): 2.

NY Evening Post 1847. "The Art Union." *New York Evening Post* (February 4): 2.

NY Illustrated Magazine 1847. Editor's Table. *New York Illustrated Magazine of Literature and Art* 3 (January): 46–48.

NY Morning Express 1847. "Art Intelligence." *New York Morning Express* (May 20): 1.

Rose of Sharon 1847. "The Watcher by the Sea." In *The Rose of Sharon: A Religious Souvenir for 1847.* Edited by S. C. Edgarton. Boston: A. Tomkins.

St. Louis Missouri Republican 1847. "Mechanics' Fair." *St. Louis Daily Missouri Republican* (April 10): 2.

St. Louis Weekly Reveille 1847a. "Arts Union." *St. Louis Weekly Reveille* (January 4): 1126.

St. Louis Weekly Reveille 1847b. "The Vacant Panel." *St. Louis Weekly Reveille* (February 1): 1155.

St. Louis Weekly Reveille 1847c. "The Trapper—A Picture by Deas." *St. Louis Weekly Reveille* (February 8): 1163.

St. Louis Weekly Reveille 1847d. "Art and Artists." *St. Louis Weekly Reveille* (February 15): 1171.

St. Louis Weekly Reveille 1847e. "Mr. Charles Deas." *St. Louis Weekly Reveille* (April 5): 1228.

St. Louis Weekly Reveille 1847f. "Charles Deas." *St. Louis Weekly Reveille* (August 23): 1390.

St. Louis Weekly Reveille 1847g. "A New Painting, by Deas." *St. Louis Weekly Reveille* (November 1): 1468. Reprinted in *Boston Daily Evening Transcript* (November 9, 1847): [2].

St. Louis Weekly Reveille 1847h. "Fine Indian Painting." *St. Louis Weekly Reveille* (November 29): 1502.

US Magazine 1847a. "American Works of Painting and Sculpture." *United States Magazine and Democratic Review* 20, no. 103 (January): 56–66.

US Magazine 1847b. "The Arts." Gossip of the Month. *United States Magazine and Democratic Review* 20, no. 107 (May): 462–66.

1848

AAU Transactions 1848. *Transactions of the American Art-Union, for the Year 1847.* New York: American Art-Union.

Boston Transcript 1848. "Charles Deas." *Boston Transcript* (June 28): 2.

Family Companion 1848a. "National Academy of Design, Sixth Notice." *Family Companion* 2, no. 4 (June 10): 51.

Family Companion 1848b. "National Academy of Design, Seventh Notice." *Family Companion* 2, no. 6 (June 24): 78–79.

Home Journal 1848. "The American Art-Union." The Fine Arts. *Home Journal* 48, no. 146 (November 25): 2.

Literary World 1848a. "Fine Art Gossip." The Fine Arts. *Literary World* 3, no. 58 (March 11): 106–107. Reprinted as "National Academy," *Home Journal* 12 (March 18, 1848): 2.

Literary World 1848b. "Recent Publications." *Literary World* 3, no. 58 (March 11): 108.

Literary World 1848c. "National Academy Exhibition (Concluded)." The Fine Arts. *Literary World* 3, no. 70 (June 3): 350–51.

Literary World 1848d. "Pictures in Washington." The Fine Arts. *Literary World* 3, no. 90 (October 21): 753.

Literary World 1848e. "Art Items." The Fine Arts. *Literary World* 3, no. 92 (November 4): 792.

NAD 1848. *Catalogue of the Twenty-third Annual Exhibition.* New York: National Academy of Design.

NY Evening Express 1848. "Charles Deas, the Artist." *New York Evening Express* (June 27): [3]. Reprinted as "Charles Deas, the Artist," *Daily Missouri Republican* (July 6, 1848): 2.

NY Evening Post 1848a. "National Academy of Design." *New York Evening Post* (June 5): 1.

NY Evening Post 1848b. "The Art Union Gallery." *New York Evening Post* (November 13): 2.

1849

AAU Bulletin 1849. *Bulletin of the American Art-Union.* October.

AAU Transactions 1849. *Transactions of the American Art-Union, for the Year 1848.* New York: American Art-Union.

Albany Gallery 1849. *Catalogue of the Fourth Exhibition*. Albany, N.Y.: Albany Gallery of the Fine Arts.

Albion 1849. "National Academy of Design." *Albion* 8, no. 15 (April 14): 177.

Holden's 1849. "Topics of the Month." *Holden's Dollar Magazine* 3, no. 5 (May): 313–20.

Home Journal 1849. "National Academy of Design." *Home Journal* 18, no. 168 (April 28): 2.

Knickerbocker 1849. [Lewis Gaylord Clark?]. "National Academy of Design." Editor's Table. *Knickerbocker* 33, no. 5 (May): 468–70.

NAD 1849. *Catalogue of the Twenty-fourth Annual Exhibition*. New York: National Academy of Design.

1850

AAU Bulletin 1850. *Bulletin of the American Art-Union*. December.

AAU Transactions 1850. *Transactions of the American Art-Union, for the Year 1849*. New York: American Art-Union.

Daily Cincinnati Gazette 1850. "Art-Union in St. Louis." *Daily Cincinnati Gazette* (April 17): 2.

1852

PAFA 1852. *Catalogue of the Twenty-ninth Annual Exhibition*. Philadelphia: Pennsylvania Academy of the Fine Arts.

1853

Washington Exhibition 1853. *The Washington Exhibition, in Aid of the New-York Gallery of the Fine Arts, at the American Art-Union Gallery*. New York: Geo. F. Nesbitt and Co., Printers.

NY Times 1853. "The Fine Arts: The Washington Exhibition at the Art Union Rooms." *New-York Times* (March 17): 2.

1855

PAFA 1855. *Catalogue of the Thirty-second Annual Exhibition*. Philadelphia: Pennsylvania Academy of the Fine Arts.

1856

Crayon 1856. "Sketchings: The Indians in American Art." *Crayon* 3, no. 1 (January): 28.

1857

PAFA 1857. *Catalogue of the Thirty-fourth Annual Exhibition*. Philadelphia: Pennsylvania Academy of the Fine Arts.

1858

PAFA 1858. *Catalogue of the Thirty-fifth Annual Exhibition*. Philadelphia: Pennsylvania Academy of the Fine Arts.

Ranney Exhibition 1858. "Fine Arts: The Ranney Exhibition." Unidentified clipping bound into "The Ranney Scrapbook." New-York Historical Society Library.

Tuckerman 1858. Henry T. Tuckerman. "Art in America, Its History, Condition, and Prospects." *Cosmopolitan Art Journal* 3, no. 1 (December): 1–8.

1859

Chicago Exhibition 1859. *Catalogue of the First Exhibition of Statuary, Paintings, Etc.* Chicago: Chicago Exhibition of the Fine Arts.

Crayon 1859. "Sketchings: Domestic Art Gossip." *Crayon* 6, no. 12 (December): 379–81.

St. Louis Mercantile Library 1859. "Catalogue of the Art Department." *Thirteenth Annual Report for 1858*. St. Louis: St. Louis Mercantile Library.

Leeds Sale 1859. *Catalogue of Very Valuable Oil Paintings . . . Sold by Order of the Assignee of Rollin Sanford*. Auction catalogue, November 10. New York: Henry H. Leeds.

1860

Historical Magazine 1860. E. K. "Queries: Charles Deas." *Historical Magazine, and Notes and Queries Concerning the Antiquities, History, and Biography of America* 4, no. 8 (August): 250.

Leeds Sale 1860. *Catalogue of J. Snedecor's First Annual Sale*. Auction catalogue, January 31–February 1. New York: Henry H. Leeds.

Western Academy 1860. *Catalogue of the First Annual Exhibition*. St. Louis: Western Academy of Art.

1864

Metropolitan Sanitary Fair 1864. *Catalogue of the Art Exhibition at the Metropolitan Fair, in Aid of the U.S. Sanitary Commission*. New York: [Metropolitan Sanitary Fair Commission].

Mississippi Valley Sanitary Fair 1864. *Catalogue of the Art Gallery*. St. Louis: Mississippi Valley Sanitary Fair.

1867

NY Evening Post 1867. Obituary of Charles Deas. *New York Evening Post* (March 26): 3.

NY Times 1867. Obituary of Charles Deas. *New-York Times* (March 24): 5.

Tuckerman 1867. Henry T. Tuckerman. *Book of the Artists: American Artist Life*. New York: G. P. Putnam and Son, 1867. Distributed by James F. Carr, New York, in 1966. Also see Tuckerman 1846.

After 1867

St. Louis Mercantile Library 1871. *Catalogue of the St. Louis Mercantile Library, Exhibition of Paintings*. St. Louis: St. Louis Mercantile Library.

Somerville Sale 1873. *Executors Sale: The Collection of over Five Hundred Paintings and Studies, by the Late John F. Kensett*. Auction catalogue, March 24–29. New York: Robert Somerville.

Frémont 1887. John C. Frémont. *Memoirs of My Life*. Vol. 1. Chicago: Belford, Clarke.

Fifth Avenue Art Galleries Sale 1897. *Executors' Sale . . . of the Late Marshall O. Roberts, Modern Paintings*. Auction catalogue, January 19–21. Fifth Avenue Art Galleries, New York.

Wharton 1923–25. "The Expedition of Major Clifton Wharton in 1844." *Collections of the Kansas State Historical Society* 16 (1923–25): 272–305.

Fairman 1927. Charles E. Fairman. *Art and Artists of the Capitol of*

the United States of America. Washington, D.C.: U.S. Government Printing Office.

Metropolitan Museum 1937. *Sporting Prints and Paintings.* New York: Metropolitan Museum of Art.

Metropolitan Museum 1939. *Life in America: A Special Loan Exhibition of Paintings Held during the Period of the New York World's Fair.* New York: Metropolitan Museum of Art.

Cowdrey and Williams 1944. Bartlett Cowdrey and Hermann Warner Williams, Jr. *William Sidney Mount, 1807–1868: An American Painter.* New York: Columbia University Press for the Metropolitan Museum of Art.

MFA Boston 1944. *Sport in American Art.* Boston: Museum of Fine Arts.

Baur 1947. John I. H. Baur. "Unknown American Painters of the 19th Century." *College Art Journal* 6, no. 3 (Spring): 277–82.

MFA Boston 1949. *M. and M. Karolik Collection of American Paintings, 1815 to 1865.* Cambridge, Mass.: Harvard University Press for the Museum of Fine Arts, Boston.

McDermott 1950. John Francis McDermott. "Charles Deas: Painter of the Frontier." *Art Quarterly* 13, no. 4 (Autumn): 293–311.

Miller 1950. Clarence Miller. "'Exit Smiling': Reflections Culled from the Autobiography of Clarence Miller, Librarian of the Mercantile Library of St. Louis." *Bulletin of the Missouri Historical Society* 6, no. 3 (April): 353.

Smithsonian Institution 1954. *Nineteenth Century American Paintings, 1815–1865, from the Private Collection of Maxim Karolik.* Washington, D.C.: Smithsonian Institution.

MFA Boston 1962. *M. and M. Karolik Collection of American Water Colors and Drawings: 1800–1875.* 2 vols. Boston: Museum of Fine Arts.

Bloch 1967. E. Maurice Bloch. *George Caleb Bingham: The Evolution of an Artist.* Berkeley: University of California Press.

Coen 1969. Rena Neumann Coen. "The Indian as the Noble Savage in Nineteenth Century American Art." Unpublished Ph.D. dissertation, University of Minnesota.

Dorment 1971. Richard Dorment. "American Mythologies in Painting: Part 1, The Indian." *Arts Magazine* 46, no. 1 (September–October): 48.

Hoopes and Moure 1974. Donelson F. Hoopes and Nancy Wall Moure. *American Narrative Painting.* Los Angeles: Los Angeles County Museum of Art.

Parry 1974. Ellwood Parry. *The Image of the Indian and the Black Man in American Art, 1590–1900.* New York: George Braziller.

Coen 1976. Rena Neumann Coen. *Painting and Sculpture in Minnesota, 1820–1914.* Minneapolis: University of Minnesota Press.

Glanz 1978. Dawn Glanz. "The Iconography of Westward Expansion in American Art, 1820–1879." Unpublished Ph.D. dissertation, University of North Carolina.

Steinfeldt 1981. Cecilia Steinfeldt. *Texas Folk Art: One Hundred Fifty Years of the Southwestern Tradition.* Austin: Texas Monthly Press.

Glanz 1982. Dawn Glanz. *How the West Was Drawn: American Art and the Settling of the Frontier.* Ann Arbor: UMI Research Press.

Collins 1984. Charles D. Collins. "A Source for Bingham's *Fur Traders Descending the Missouri.*" *Art Bulletin* 66, no. 4 (December): 678–81.

Hassrick 1984. Peter H. Hassrick. *Treasures of the Old West: Paintings and Sculpture from the Thomas Gilcrease Institute of American History and Art.* New York: Harry N. Abrams.

Berry-Hill Galleries 1985. *American Paintings III.* New York: Berry-Hill Galleries.

Stewart 1986. Rick Stewart. *The American West: Legendary Artists of the Frontier.* Dallas: Hawthorne.

Tyler 1986. Ron Tyler. "Charles Deas: A Group of Sioux." In *American Paintings: Selections from the Amon Carter Museum,* by Linda Ayres, Jane Myers, Mark Thistlethwaite, and Ron Tyler, with an introduction by Jan Keene Muhlert, 26–27. Birmingham, Ala.: Oxmoor House.

Clark 1987. Carol Clark. "Charles Deas." In *American Frontier Life: Early Western Painting and Prints,* by Ron Tyler, Carol Clark, Linda Ayres, Warder H. Cadbury, Herman J. Viola, and Bernard Reilly, Jr., with an introduction by Peter H. Hassrick, 51–77. Fort Worth: Amon Carter Museum; New York: Abbeville Press.

Reilly 1987. Bernard Reilly, Jr. "The Prints of Life in the West, 1840–60." In Tyler, *American Frontier Life,* 167–92.

Schimmel 1988. Julie Schimmel. *The West Explored: The Gerald Peters Collection of Western American Art.* Santa Fe: Gerald Peters Gallery.

Clark 1989. Carol Clark. "Charles Deas: Long Jakes." In *American Paintings from the Manoogian Collection,* 86–89. Washington, D.C.: National Gallery of Art.

McElroy 1990. Guy C. McElroy. *Facing History: The Black Image in American Art, 1710–1940.* San Francisco: Bedford Arts; Washington, D.C.: Corcoran Gallery of Art.

Johns 1991. Elizabeth Johns. *American Genre Painting: The Politics of Everyday Life.* New Haven, Conn.: Yale University Press.

Ketner 1991. Joseph D. Ketner II. "The Indian Painter in Düsseldorf." In *Carl Wimar: Chronicler of the Missouri River Frontier,* by Rick Stewart, Joseph D. Ketner II, and Angela L. Miller, 30–75. Fort Worth: Amon Carter Museum.

Rash 1991. Nancy Rash. *The Painting and Politics of George Caleb Bingham.* New Haven, Conn.: Yale University Press.

Schimmel 1991. Julie Schimmel. "Inventing the Indian." In *The West as America: Reinterpreting Images of the Frontier, 1820–1920,* edited by William H. Truettner, 149–89. Washington, D.C.: Smithsonian Institution Press.

Thistlethwaite 1991. Mark Thistlethwaite. *William Tylee Ranney: East of the Mississippi.* Chadds Ford, Penn.: Brandywine River Museum.

Miller 1992. Angela Miller. "The Mechanisms of the Market and the Invention of Western Regionalism: The Example of George Caleb Bingham." *Oxford Art Journal* 15, no. 1: 3–20.

Schoelwer 1992. Susan Prendergast Schoelwer. "The Absent Other: Women in the Land and Art of Mountain Men." In *Discovered Lands, Invented Pasts: Transforming Visions of the American West,* by Jules David Prown, Nancy K. Anderson, William Cronon, Brian W. Dippie, Martha A. Sandweiss, Susan Prendergast Schoelwer, and Howard R. Lamar, 135–65. New Haven, Conn.: Yale University Press.

Kilgo 1994. Dolores A. Kilgo. *Likeness and Landscape: Thomas M. Easterly and the Art of the Daguerreotype.* St. Louis: Missouri Historical Society Press.

Lubin 1994. David M. Lubin. *Picturing a Nation: Art and Social Change*

in *Nineteenth-Century America*. New Haven, Conn.: Yale University Press.

Dippie 1998. Brian W. Dippie. *West-Fever*. Los Angeles, Calif.: Autry Museum of Western Heritage.

Mack and Savage 1999. Angela D. Mack and J. Thomas Savage. "Reflections of Refinement: Portraits of Charlestonians at Home and Abroad." In *In Pursuit of Refinement: Charlestonians Abroad, 1740–1860,* by Maurie D. McInnis, Angela D. Mack, J. Thomas Savage, Robert A. Leath, and Susan Ricci Stebbins, 23–38. Columbia: University of South Carolina Press.

Husch 2000. Gail E. Husch. *Something Coming: Apocalyptic Expectation and Mid-Nineteenth-Century American Painting.* Hanover, N.H.: University Press of New England.

Clark 2000. Carol Clark. "'Four Oil Paintings of Indian Chiefs': Charles Deas and the St. Louis Mercantile Library." In *St. Louis and the Art of the Frontier,* edited by John Neal Hoover, 14–31. St. Louis: St. Louis Mercantile Library.

Clark 2001. Carol Clark. "Portraits by Charles Deas." *The St. Louis Mercantile Library Report to Members, 2001–2002* (December): 8–13.

Conzelman 2002. Adrienne Ruger Conzelman. *After the Hunt: The Art Collection of William B. Ruger.* Mechanicsburg, Penn.: Stackpole Books.

Carbone 2006. Teresa A. Carbone. *American Paintings in the Brooklyn Museum: Artists Born by 1876.* 2 vols. Brooklyn, N.Y.: Brooklyn Museum; London: D. Giles.

Exhibition Checklist

Works are by Charles Deas unless otherwise noted.

Turkey Shooting
by 1838
Oil on canvas
24¼ × 29½ in.
Virginia Museum of Fine Arts, Richmond,
the Paul Mellon Collection.

The Devil and Tom Walker
1838
Oil on canvas
17½ × 21 in.
Collection of Richard P. W. Williams.

Walking the Chalk
1838
Oil on canvas
17⅜ × 21⅜ in.
The Museum of Fine Arts, Houston. Museum
purchase with funds provided by the Agnes Cullen
Arnold Endowment Fund.

Portrait of a Man
1839
Oil on canvas
12⅛ × 10⅛ in.
From the collections of the St. Louis Mercantile
Library at the University of Missouri–St. Louis.

Portrait of a Woman
1840
Oil on paperboard attached to wood panel
12⅛ × 9¾ in.
From the collections of the St. Louis Mercantile
Library at the University of Missouri–St. Louis.

Self-Portrait
1840
Graphite on buff wove paper
9½ × 6¹¹⁄₁₆ in. (sheet)
National Academy Museum, New York (1981.86).

The Trooper
1840
Oil on canvas
12¼ × 14 in.
Private collection.

Sho-ko-ni-ka/Little Hill
by 1841
Oil on paper
8¼ × 6¼ in.
Courtesy of The Lunder Collection, Colby College
Museum of Art, Waterville, Maine.

Wa-kon-cha-hi-re-ga/Rolling Thunder
by 1841
Oil on paper
8¼ × 6¼ in.
Courtesy of The Lunder Collection, Colby College
Museum of Art, Waterville, Maine.

Lion
1841
Oil on canvas
49½ × 67½ in.
Art Collection of the Minnesota Historical Society.

Fort Snelling
ca. 1841
Oil on canvas
12¼ × 14¼ in.
Harvard University, Peabody Museum.

Portrait of Lieutenant Henry Whiting
ca. 1841
Oil on canvas
14 × 10½ in.
Private collection.

*Winnebago with Bear-Claw Necklace and
Spiked Club*
by 1842
Oil on canvas
36 × 30 in.
From the collections of the St. Louis Mercantile
Library at the University of Missouri–St. Louis.

*Winnebago (Wa-kon-cha-hi-re-ga)
in a Bark Lodge*
by 1842
Oil on canvas
36 × 30 in.
From the collections of the St. Louis Mercantile
Library at the University of Missouri–St. Louis.

*Winnebago with Bear-Claw Necklace and
Spear*
by 1842
Oil on canvas
36 × 30 in.
From the collections of the St. Louis Mercantile
Library at the University of Missouri–St. Louis.

Winnebago with Peace Medal and Pipe
by 1842
Oil on canvas
36 × 30 in.
From the collections of the St. Louis Mercantile
Library at the University of Missouri–St. Louis.

Winnebagos Playing Checkers
1842
Oil on canvas
12½ × 14½ in.
Private collection, New York.

Sioux Awaiting the Return of Friends
1843
Watercolor on paper
7½ × 9½ in.
Collection of Thomas A. and Jane Petrie.

Winnebagoes
1843
Watercolor on paper
7 × 9¼ in.
Private collection.

Sioux Playing Ball
1843
Oil on canvas
29 × 37 in.
Gilcrease Museum, Tulsa, Oklahoma.

Long Jakes, "the Rocky Mountain Man"
1844
Oil on canvas
30 × 25 in.
Jointly owned by the Denver Art Museum and The Anschutz Collection; purchased in memory of Bob Magness with funds from 1999 Collectors' Choice, Sharon Magness, Mr. and Mrs. William D. Hewit, Carl and Lisa Williams, the Estelle Rae Wolf-Flowe Foundation, and the T. Edward and Tullah Hanley Collection by exchange (1998.241).

Dragoons Fording Stream
ca. 1844
Oil on canvas
12¼ × 18 in.
Collection of Gerald and Kathleen Peters.

The Death Struggle
1845
Oil on canvas
30 × 25 in.
Shelburne Museum, Shelburne, Vermont.

The Hunter
1845
Pen and brown ink on paper
8⁹⁄₁₆ × 6⅝ in.
Private collection.

Indian Group
1845
Oil on canvas
14⅛ × 16½ in.
Amon Carter Museum, Fort Worth, Texas.

The Voyageurs
1845
Oil on canvas
31½ × 36½ in.
The Rokeby Collection

Voyageurs
1846
Oil on canvas
13 × 20¼ in.
Museum of Fine Arts Boston, Gift of Maxim Karolik for the M. and M. Karolik Collection of American Paintings, 1815–1865 (46.855).

Indians Coming down a Defile
1847
Oil on canvas
14 × 20 in.
Stark Museum of Art, Orange, Texas.

Prairie on Fire
1847
Oil on canvas
28¾ × 35¹⁵⁄₁₆ in.
Gift of Mr. and Mrs. Alastair Bradley Martin, the Guennol Collection, Brooklyn Museum (48.195).

River Man
1847
Oil on cardstock
6¾ × 5⅜ in.
Gilcrease Museum, Tulsa, Oklahoma.

Indian Brave
1847
Oil on cardstock
7¹³⁄₁₆ × 6⅛ in.
Gilcrease Museum, Tulsa, Oklahoma.

A Solitary Indian, Seated on the Edge of a Bold Precipice
1847
Oil on canvas
36¼ × 26 in.
Courtesy of the Museum of the American West, Autry National Center (93.173.1).

Western Scenery
1848
Oil on canvas
13½ × 17 in.
Private collection; courtesy of Kodner Gallery, St. Louis, Missouri.

William G. Jackman
Long Jakes
1846
Steel engraving, bound into the *New York Illustrated Magazine of Literature and Art* 2 (July 1846).
5¾ × 4¾ in.
Newberry Library, Chicago.

William G. Jackman
The Death Struggle
1846
Steel engraving, bound into the *New York Illustrated Magazine of Literature and Art* 2 (September 1846).
5¾ × 4¾ in.
Courtesy of American Antiquarian Society, Worcester, Massachusetts.

Thomas M. Easterly
Indian on a Rock
1847
Daguerreotype (quarter plate; cased)
National Museum of American History, Smithsonian Institution, Washington, D.C.

Plan for an Indian Gallery and accompanying letter from Mr. Henry D. Lesesne to Mr. James Simons, November 28, 1848
Manuscript
1848
Ink on paper
approx. 15 × 8 in.
Private collection.

Leopold Grozelier
Western Life—The Trapper
ca. 1855
Lithograph
26¼ × 19½ in. (sheet)
Amon Carter Museum, Fort Worth, Texas.

Index

Page numbers in italic type refer to illustrations.